Richard Serra/Sculpture

Richard Serra/Sculpture

Rosalind E. Krauss

**Edited and with an introduction
by Laura Rosenstock**

Essay by Douglas Crimp

The Museum of Modern Art
New York

Published on the occasion of an exhibition at
The Museum of Modern Art, New York
February 27–May 13, 1986

Library of Congress Catalog Card Number 85-62476
Paperbound ISBN 0-87070-590-3
Clothbound ISBN 0-87070-592-X

Edited by Jane Fluegel
Designed by Richard Haymes
Production by Tim McDonough
Typeset by Concept Typographic Services, New York
Printed and bound by Dai-Nippon, Tokyo
Distributed outside the United States and Canada
 by Thames and Hudson Ltd., London

The Museum of Modern Art
11 West 53 Street
New York, New York 10019

Printed in Japan

Acknowledgments

The Museum of Modern Art takes pride in presenting the first retrospective in an American museum of the work of Richard Serra, one of the outstanding artists working today. This exhibition consists of ten significant sculptures representative of Serra's accomplishment of the past twenty years. This book, published on the occasion of the exhibition and reproducing a selection of nearly 120 works, provides an in-depth review of Serra's sculptural career. The preparation of both projects has required the assistance and collaboration of many people, to whom, on behalf of the Trustees of The Museum of Modern Art, I wish to express a great debt of gratitude.

First and foremost, I wish to thank Richard Serra. It has been a rewarding experience to work with him. His participation has been wholehearted and essential, and I am grateful for his openness in exchanging ideas and for what I have learned from his work.

Rosalind Krauss, with whom I have had the pleasure of directing the exhibition, is to be thanked for her many contributions. We are all in her debt for her collaboration in the selection of the exhibition and for her perceptive and thoughtful writing on Serra's sculpture. She joins me in thanking Douglas Crimp for his essay on Serra's public sculpture.

My very warm thanks are due Clara Weyergraf Serra. Her kind cooperation and patient collaboration in providing essential information about the artist's work have been invaluable. Particular thanks also go to Leo Castelli, whose association with the artists now spans eighteen years, and Alexander von Berswordt-Wallrabe, who has collaborated with him for the past ten. Both have willingly assisted in locating works and have enthusiastically provided needed information.

Most sincere appreciation is due the lenders to the exhibition. Graciously consenting to share their works with us are the Grinstein Family, Los Angeles; the Saatchi Collection, London; Walker Art Center, Minneapolis; Leo Castelli Gallery, New York; and Galerie m, Bochum, West Germany.

Important to the exhibition are the consulting engineer Malcolm Graff of Malcolm Graff Associates, who supervised the challenging installation, and Ray LaChapelle and Sons, responsible for the rigging. We thank them.

Generous grants from the National Endowment for the Arts and the New York State Council on the Arts have provided needed support for the exhibition

itself. The cooperation of The Port Authority of New York and New Jersey is also deeply appreciated.

Many colleagues at The Museum of Modern Art have been generous in lending their interest and assistance. William Rubin, Director of the Department of Painting and Sculpture, has strongly supported this exhibition from the time it was originally proposed by Kynaston McShine, Senior Curator, and the continued encouragement of both is greatly appreciated. My special thanks go to Alicia Legg, Curator, for her expert advice on dealing with large sculpture and for enthusiastically exchanging ideas. Marjorie Frankel Nathanson, Curatorial Assistant, joined this project during the final stages of the preparation of this book and assisted in the installation of the exhibition. Most especially I should like to thank Alexandra Muzek. She has ably handled a multitude of details—from providing documentation and obtaining photographs to typing correspondence and manuscript for this book—all with professionalism, efficiency, and good will. Her help has been invaluable and very much appreciated. Ruth Priever has also frequently provided assistance.

I should particularly like to thank Richard E. Oldenburg, Director of the Museum, for his interest and support. Richard Palmer, Coordinator of Exhibitions, and Betsy Jablow, Associate Coordinator of Exhibitions, have ably handled the scheduling of the exhibition at the Museum and supervised the many administrative details in its organization. I am indebted to Jerry Neuner, Production Manager, for his enthusiastic cooperation and attention to the installation of the exhibition. Among many other members of the Museum's staff who have contributed in various ways I would like to thank John Limpert, Jr., Director of Development; Darryl Brown, Grants Officer; Richard Tooke, Supervisor of Rights and Reproductions; Philip Yenawine, Director of Education; Jeanne Collins, Director of Public Information; Eloise Ricciardelli, Registrar; The Department of Conservation; Jon Gartenberg, Assistant Curator of Film; Barbara London, Assistant Curator of Video; and Paula Baxter, Associate Librarian for Research.

A special debt is owed the Department of Publications and those directly responsible for the preparation of this book. Jane Fluegel edited it with perception, thoroughness, and enthusiasm. Richard Haymes has enriched this publication with his design; he has been ably assisted by Lesley Mandel and Tim Metevier. Timothy McDonough, Production Manager, has overseen the production of the book with skilled professionalism. Frederic McCabe, Director of Publications, Harriet Schoenholz Bee, Managing Editor, and Nancy Kranz, Manager of Book Distribution, were particularly helpful.

The expertise and contributions of all are deeply appreciated.

Laura Rosenstock
Assistant Curator
Department of Painting and Sculpture
The Museum of Modern Art

Contents

Preface

The Museum of Modern Art has an ongoing commitment to supporting the best contemporary art, and has always accepted that this involvement may—indeed, almost inevitably will—entail controversy. As long ago as 1976, we decided to devote an exhibition to Richard Serra because we felt that the pieces he had then been producing—most of them indoor and landscape-sited works—were of the highest order of creative energy and quality. Various delays attendant on the construction of the Museum regrettably forced postponement of the project; and all the while the artist's body of work, more than only fulfilling our early estimation of his talents, continued to expand in the area of urban projects and to gain even more dramatic public prominence. In planning the exhibition over several years, we had not expected that assessments of Serra would become so intensely focused on but one aspect of his sculpture and so enmeshed in larger debates over the purposes of public art. We are happy now to provide, through the exhibition and this accompanying publication, the occasion for a better awareness of the full range of this important artist's work and of the impact he has had on our visual consciousness these past two decades.

We have been pleased to work with guest curator Professor Rosalind Krauss, codirector of the exhibition with curator Laura Rosenstock of our staff. We are grateful to both Richard Serra and Rosalind Krauss for their work in constituting the exhibition and to Professor Krauss for her excellent contributions to the catalog as both author and editor. We hope their efforts will make evident to our visitors the great originality and power that first drew our curatorial staff to Serra's work.

The installation in our galleries reaffirms the vitality of the artist's continuing engagement with indoor sculpture. Naturally, the Museum cannot exhibit that other aspect of Serra's work which has lately been the center of so much discussion, his large and challenging urban-sited pieces. However, given the extraordinary circumstances of last spring's hearing on the fate of *Tilted Arc* and the outpouring of comment it has occasioned, we felt it appropriate that the artist's position on these matters should be represented in the catalog in the way he personally deemed most effective. The Museum of Modern Art disagrees with the rhetorical tone and historical polemic of much that has been written about *Tilted Arc* here as elsewhere. Yet, however differently our curators would argue for Serra's position,

we have chosen, at an exceptionally embattled moment in the artist's career, to air this debate in the fashion he and his guest curator requested—thereby fulfilling one of the Museum's roles, as a forum for the widely differing ideas and opinions that give dynamism to public dialogue on the art of our time.

William Rubin
Director
Department of Painting and Sculpture
The Museum of Modern Art

Introduction

Laura Rosenstock

I think most work comes out of work and out of the perception of work.
—Richard Serra, 1985

Richard Serra has created a wealth of complex and sophisticated sculpture since 1965, much of it the result of exploring directions indicated to him by his own work. In the winter of 1969–70, as he splashed molten lead against a small steel plate wedged into the corner of Jasper Johns's studio (pl. 51), he realized that if the juncture of floor and walls alone would hold up this plate, it would support a large steel plate as well. A year later, at the Lo Giudice Gallery, New York, he made *Strike* (pl. 52), lodging an eight-by-twenty-four-foot steel plate in the corner of a room, where it stood without any additional means of support. When, in 1972, he participated in Documenta 5, in Germany, he extended this concept by wedging four steel plates into the four corners of a square space and called the piece *Circuit* (pl. 66).[1]

Serra's works involve the viewer in this creative, exploratory process. They heighten perceptual awareness and virtually force interaction. They compel the viewer to confront his experience and perception of them in relation to both space and time and to focus on their physical properties and the manner in which they were created. All Serra's sculptures are concerned with what can actually be experienced and observed. Some reveal the process of their making, some clarify aspects of their physical properties, and others redefine the nature of the space they occupy. It is only in tracing these interactions, in "working" to understand the pieces, that they become fully comprehendible and meaningful.

Illustrated on the pages that follow are nearly one hundred and twenty works made by Serra in his twenty years as a sculptor. They range from early rubber and neon-tubing pieces to some of his most recent large-scale works in steel. This book is published in conjunction with an exhibition of ten works that span the same time period and represent some of the artist's most innovative investigations of the sculpture medium.

In forming his body of work, Serra has challenged some of sculpture's long-accepted conventions. In the late 1960s, he composed a verb list that specified the processes involved in and the constraints on making sculpture. One verb, "to splash," was exemplified by a series the artist executed from 1968 to 1970. These

Splash Pieces can be termed "process art," insofar as their forms recount the method of their making. Molten lead was splashed, or cast, into the angle formed by floor and wall; when it hardened it was "unmolded," turned over to rest on the floor, and another "cast" made until the desired number was completed. *Casting,** 1969–86, recovers this process (for a similar work, see pl. 32). By interpreting literally the verb "to cast" ("to throw or fling with a quick motion and sudden release"), Serra declared his independence of a sculptural tradition, that of casting or reproducing a form by pouring molten metal into a mold.[2] These process works were not only active, in the artist's manipulation of the material, but effective, for in seeing the multiple casts removed from the wall and turned over to lie on the floor, the viewer could reconstruct the process involved in making the piece and in so doing sense the passage of time.

With his 1969 Prop Pieces, Serra turned his attention to the physical properties of sculpture, its weight and materials, presenting them in a nonillusionistic manner so that the principles of the works' construction could be grasped. Weighted and cantilevered against each other, the floor, the wall, or a seven-foot lead pole, without benefit of the welding typical of Cubist-derived sculpture, were four-foot-square lead plates, joined to effect not an *illusion* of balance but an *actual* balance. In *One Ton Prop (House of Cards),** 1969 (pl. 33), four lead plates propped each other up; in *1-1-1-1,* 1969 (pl. 45, now destroyed; steel version,* 1969–86), a pole was balanced across the four plates, holding them in place by pressing down on them. Serra made us aware of sculpture's physical properties by not disguising them. In the Props he retained the intrinsically dull, raw finish of lead, as he would later maintain the "natural" rusting of steel. Lead is heavy yet malleable, stable but able to be undermined. The dichotomy between the stability of the material and its potential for disorder is reflected in the structure of the works. Held together solely by weight and force of gravity, the Prop Pieces tended to stay upright but paradoxically suggested the possibility of collapse. (Aspects of weight and balance would figure in all Serra's subsequent sculpture, including *Two Plate Prop,** 1986.) Like the process works, the Prop Pieces alluded to time and movement—yet here motion was arrested and time implied in the potential of the pieces for change and movement.

The large steel structures of the 1970s and '80s have brought a new dimension to the viewer's involvement in Serra's sculpture; they alter and reshape the viewer's perception of space. As only parts of these works can be seen from any one vantage point, they require that time be spent in walking, looking, anticipating, and remembering. The pieces change configuration with the viewer's every step, making him aware of the relation of the works to himself and to the space they occupy. The body's movement around and through the works gives fuller information about the pieces and their space. Their meaning unfolds through the viewer's continually changing physical experience of the sculpture. Five works illustrate these points.

*Circuit, II,** 1972–86 (a version of pl. 66, the Documenta piece of 1972), redefines and articulates the space of a room. The four plates, ten feet tall and therefore too high to look over, are arranged so that only one quadrant of the room is visible at a time—except at the open center. Thus one must walk through the work in order to comprehend it fully. The four elements in *Equal Parallel and Right Angle Elevations,** 1973–83 (a version of pl. 72), are identical in height, but they do not read so perceptually. Arranged in a large room, and therefore all resting on flat ground, the two short, two long pieces seem to shift in height as one moves through the space—the indoor counterpart to outdoor landscape works such as *Shift,* 1970–72 (pl. 60), where elevations are perceived to change as one crosses the rolling ground. *Two Corner Curve,** 1986, another ten-foot-high work, arcs diagonally across the room, its two ends resting in opposite corners, its two sides—one concave, one convex—conveying completely different sensations of space. As in the case of *Slice,* 1980 (pl. 87), each side is viewed from its own entrance; and, depending on viewpoint, the work seems to contract or expand with the compression or extension of the space. The incline of the twelve-foot-high, thirteen-foot-long outdoor sculpture *Modern Garden Arc,** 1986—how far it leans, its relationship to the ground as it leans—can be gauged against the architecture. As the viewer orients himself to a leaning, vertical curve, he, in effect, measures himself against the perpendicular context in which the work is placed. *Delineator, II,** 1974–86, like its first version (pl. 74), consists of two rectangular plates, one flat on the floor, the other attached to the ceiling but positioned crosswise to the lower plate. Serra has said of the earlier version: "The juxtaposition of the steel plates forming this open cross generates a volume of space which has an inside and outside, openings and directions, aboves, belows, rights, lefts—co-ordinates to your body that you understand when you walk through it.... You sense a volume of verticality lifting up from the floor to the ceiling that you become part of."[3]

The concept of volume expressed in *Delineator* had become essential to Serra's work shortly after he produced the first Prop Pieces. *One Ton Prop,* for example, could be walked around, viewed from all sides, but it could not be entered. However, sculptures such as *Five Plates, Two Poles,** 1971 (pl. 64), could be "walked into"; the interior space had been made accessible. It could not, however, be walked through; that would only become possible with the large steel interior installations and outdoor urban and landscape works of the 1970s and '80s. *Five Plates, Two Poles,* its rhythm of rectangular planes tilted off axis and seemingly distorted into trapezoids and parallelograms slanting in various directions, denoting mass and openness, anticipated works such as *Terminal,* 1977 (pl. 77), *Slat,* 1980–84 (pl. 111), and *Carnegie,* 1985 (pl. 118), where Serra's interest in enclosed volume and inside/outside dialogue is more fully considered. The ambiguous multisided exteriors of those highly vertical later works, their aspects constantly changing as one walks around them, contrast with their interior spaces, which are regular and visible in their entirety.

Although the viewer must move around Serra's large-scale works to comprehend them fully, some pieces, particularly the urban and architectural works that

*Asterisk indicates works in the exhibition at The Museum of Modern Art, New York.

involve more than one element and have an active "dialogue" with their own parts, seem to propel the viewer around them, exerting a sense of speed. This is particularly true of *Clara-Clara,* 1983 (pl. 104), in which two identical sections of a cone, a shape that has different radiuses at top and bottom, are placed side by side with one inverted, so that the two parts incline in the same direction, enhancing and distorting the viewer's sensations of speed and mobility as he passes between them. In contrast, *Modern Garden Arc,* a single section of a cone, does not produce these same sensations, but provokes a strong feeling of disequilibrium because it both inclines more steeply and rises more vertically than *Clara-Clara.*

Serra's desire to involve the viewer with his work both spatially and temporally parallels his desire to create works that respond to a specific site. He structures his work as an integral part of the site in which it is to be placed. It is designed in relation to the site, which it then redefines. It is perhaps easier to comprehend site specificity in relation to an outdoor plaza or landscape setting, but Serra also takes cues from the site in his large indoor installations. They are built within the context of the architecture, and their scale and placement are determined by the size and shape of the room and by the limitations of access space and weight load. Many of the works in the exhibition are site specific: *Casting* is "splashed" along a length of wall in the gallery; *Circuit* is designed to occupy a square room, its dimensions determining the length of the plates that would, if extended, intersect in the center; the elements of identical height in *Equal Parallel and Right Angle Elevations* must be placed in a room that is large enough for these heights to be perceived to alter; *Modern Garden Arc* rests on an underground supporting beam that determines its height, size, and scale.

Serra's work can be analyzed and characterized in many ways. Grégoire Müller, writing in *The New Avant-Garde,* observes:

> It is impossible to dissociate the physical properties of a [Serra] piece and the psychological conditions of its perception. Materials, processes, thought mechanisms, time, horizontality, verticality, composition, weight, disorder, perspectives, Gestalt, Knowledge, structures and physicality are some of the different aspects under which his pieces may be considered, but, they are actually all interconnected.[4]

It is the interrelation of all these elements that invests Serra's work with its expressive power and presence, with a particular eloquence that, while generated by attention to perceptual awareness, extends beyond perception alone.

The artist himself has said: "The structures are the result of experimentation and invention. In every search there is always a degree of unforeseeability, a sort of troubling feeling, a wonder after the work is complete, after the conclusion. The part of the work which surprises me, invariably leads to new works."[5] For Serra, "most work comes out of work and out of the perception of work." His structures evolve from earlier pieces and from his experience of those pieces. The viewer, too, must "work" to understand the pieces. By participating in the work, by confronting his perceptions and exploring the paths revealed by the sculptures, the viewer discovers the complexity and meaning of the structures and ultimately shares in the excitement the artist derives from his work.

Notes

1. Richard Serra, 1985, in conversation. In the course of writing this introduction, I was fortunate to have had conversations with the artist, for which I am most grateful. The importance of *Splash Piece: Casting, 1969–70,* for Serra's upright steel plates is documented by Douglas Crimp, in "Richard Serra's Urban Sculpture: An Interview," *Richard Serra: Interviews, Etc. 1970–1980* (Yonkers, N.Y.: The Hudson River Museum, 1980), p. 181.

2. For an analysis of differences between Serra's casting process and that of conventional methods, see Wade Saunders, "Hot Metal," *Art in America,* vol. 68, no. 6 (Summer 1980), pp. 90–91. "For example, traditional castings are hollow and usually bulge out from an implied or existing void. The elements in the surviving Serra piece are solid and seem to sag in....In casting, hot metal is normally introduced into a mold all at once. The actual pouring is thus antithetical to shaping; the metal fills a created void and so duplicates a pre-existing thing. We see only the metal that was in contact with the mold, metal which is usually patinated and preserved. Serra made his piece incrementally, a ladleful of molten lead at a time....We see the mold surface in several of the parts, but we also see a new, active surface, a surface simultaneously depending on and effacing the underlying one. This surface is a series of discrete parts coming together to make a whole, while a traditional cast surface is a whole which is sometimes inflected into parts. Casting is partly about making congruent and independent things that can be distributed. Serra shows he knows this by casting the corner three times—doing an edition within the piece. Yet in his sculpture the parts are not congruent, but similar. They are not an image of something but an instance of it. They must be kept together to make the whole. The sculpture is absolutely site specific, embedded. It wouldn't be the same if moved or reinstalled."

3. From an interview by Liza Bear, "Richard Serra: 'Sight Point '71–'75/Delineator '74–'76,'" in *Serra: Interviews,* pp. 58, 61–62.

4. In Grégoire Müller and Gianfranco Gorgoni, *The New Avant-Garde: Issues for the Art of the Seventies* (New York, Washington, London: Praeger, 1972), p. 19.

5. Richard Serra, quoted in "Extended Notes from Sight Point Road," in *Richard Serra: Recent Sculpture in Europe 1977-1985* (Bochum, West Germany: Galerie m, 1985), p. 11.

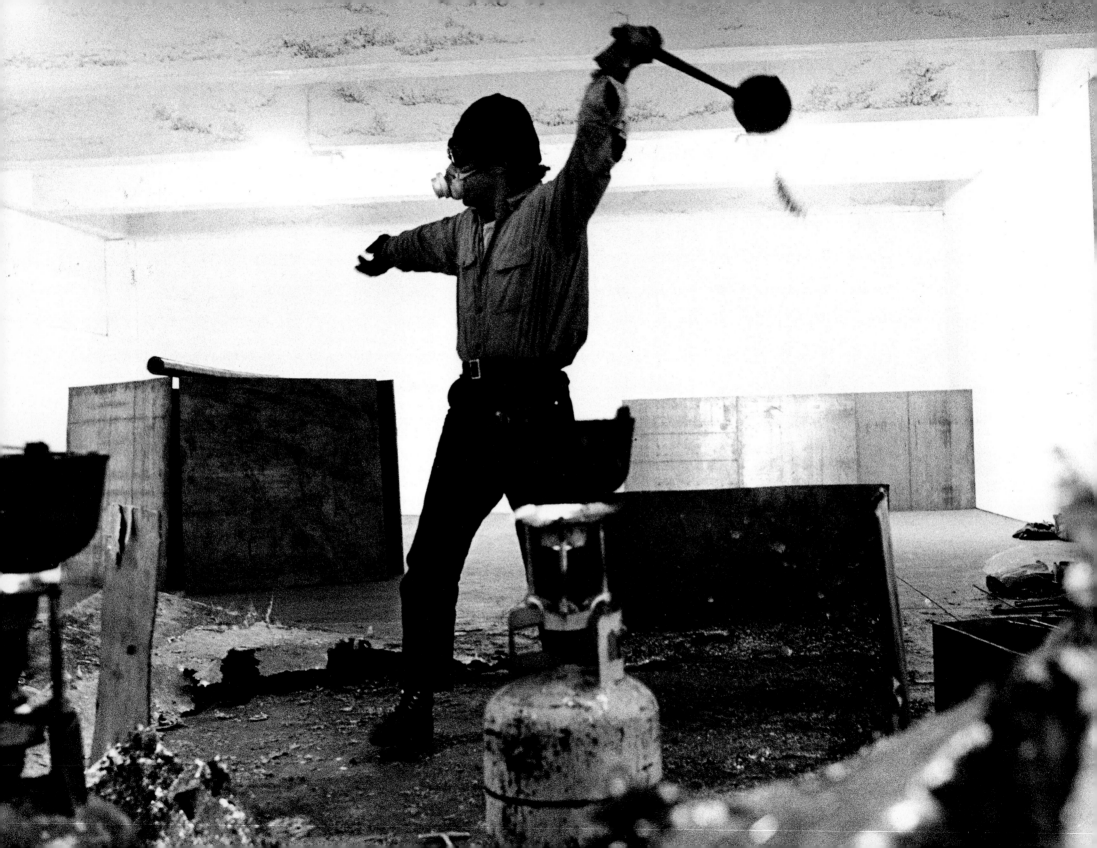

Richard Serra Sculpture

Rosalind E. Krauss

Portrait of the Artist...Throwing Lead

The artist appears in a photograph. Backlit against the luminous distance of the far wall of a room, his body is reduced to silhouetted gesture: legs braced, arms outstretched, the instrument in his hand whirling above his head like a slingshot about to release its stone. Dressed as though for battle, he is helmeted, goggled, gas-masked. The field on which he stands is strewn with slag. In the foreground is an acetylene tank and two large iron pots. Behind him several vertical planes describe precarious geometries. At the top of this image, above the ceiling of the room, above the picture itself, we read the title of the book for which this portrait serves as cover: *The New Avant-Garde: Issues for the Art of the Seventies.*[1] The artist so portrayed (fig. 1) is Richard Serra and what he is doing, ladle in hand, is throwing molten lead.

The history of twentieth-century art is punctuated by famous portraits of the artist at work. It is impossible to look at Serra's gesture without remembering the lithe athleticism of Jackson Pollock in the photographs depicting him balanced above his floor-bound canvases, the balletic master of flung paint. And having opened the door to that image, we realize that behind it stands a whole series of others, artists at work with brush and paint deployed in vigorous gestures, as in the famous films of Pablo Picasso and Henri Matisse magically creating something out of nothing as each demonstrates his art for us upon the transparent surface of a pane of glass.

We are interested in the process of their work as it is revealed through their passion, their intensity, their caprice, their skill. Matisse draws a line that is hopelessly, wrenchingly simple, just an arc that a slight pressure of the brush causes to widen at one end. But the flank of a body magically appears—sensuous, immediate, complete—and the economy of the gesture is revealed in all its mastery, in its total, wanton perfection. The artist is at work.

Although it focuses on the physical act of making, this portrait of Matisse is conceptually compatible with another of which we have only written accounts, of Saint-Pol-Roux, who posted the sign on his door every night before going to bed: "Poet working." For both the labor of producing dreams and the work of spinning a web of line upon the surface of an indifferent world presuppose the same nature for the creative act. The externalization of the artist's perceptions, feelings, ideas, this act is expressive, elaborating a trace or index of interior states. So that the picture of the artist at work comes to stand in a symmetrical relationship with the artist's works: all are images of the man himself. In Pollock's portraits—in their still-photographic and filmic versions—this symmetry is insisted upon. What we see as we look at that black-shirted figure, blurred in the rapidity of its motion, reduced to a kind of graphic sign, is a fusion between expressivity and expression, between gesture and trace: Portrait of the Artist…as a Work.

Serra's throwing lead mimes Pollock's flinging paint, but with a difference that makes all the difference. The first aspect of that difference is the gas mask.

The mask entered the art of this century as a challenge to psychology, a refusal of the personal, individualized, privatized interior space that had been the construction of nineteenth-century naturalism. From the African shaman to the Balinese dancer or the celebrant of Carnival, the wearer of the mask performs a role that he may assume but did not invent, a role that is culturally or socially given, that is delivered to him from outside the boundaries of his private self. The mask may be expressive, but what it expresses has little to do with a romantic conception of selfhood or with individual creative will. The Portrait of the Artist Masked thus does not line up with that series of portraits just described, for the mask, opaque and impassive, is the enemy of expression. To the impersonal status of the mask, the gas mask adds the depersonalizing conditions of industrial work, having associations with repetition, seriality, things-in-a-row all alike, but also associations with labor itself, with a kind of work in which a task is given in relation to a set of materials, in which operations are fixed by matter rather than inspiration. Thus the mask not only collectivizes the notion of expression, but it folds creativity back into the condition of labor.

There is another aspect of the difference between Serra's portrait and those of Picasso, Matisse, and Pollock. That is the absence within the frame of this image of the work on which the artist is working. If Serra's gesture has an issue, it is nowhere in the picture. Indeed, one of the documents reproduced in *The New Avant-Garde* is Serra's list of verbs, compiled in 1967–68, suspended in the grammatical midair of the infinitive: "to roll, to crease, to fold, to store, to bend, to shorten, to twist, to twine…." These verbs describe pure transitivity. For each is an action to be performed against the imagined resistance of an object; and yet each infinitive rolls back upon itself without naming its end. The list enumerates forty-four acts before something like a goal of the action is pronounced, and even then the condition of object is elided: "of waves," we read, "of tides," or again, "of time." The image of Serra throwing lead is like this suspension of action within the infinitive: all cause with no perceivable effect.

An action deprived of an object has a rather special relation to time. It must occur in time, but it does not move toward a termination, since there is no terminus, no proper destination so to speak. So, while the list of active verbs suggests the temporal, it is a temporality that has nothing to do with narrative time, with something having a beginning, a middle, and an end. It is not a time within which something develops, grows, progresses, achieves. It is a time during which the action simply acts, and acts, and acts.

One of the founding arguments about visual art's relation to narrative turns on the essential distinction between the medium of narration—time—and that of the depicted image—space. In this difference, Gotthold Lessing had argued in the *Laocoön* (1766), one should locate both the separate problems of the various aesthetic mediums as well as the genius particular to each. He concluded that the problem for the visual artist, who is limited to just one moment in a narrative sequence, is to find the most suggestive or most pregnant moment, the one that will imply both what has already happened and what is to come.[2] Lessing's treatise had enormous resonance for late-eighteenth- and early-nineteenth-century painting, for which the depiction of historical subjects was the central issue. But, it can be argued, Modernism has dispensed not only with historical narratives but with all narrative, to achieve the stunning simultaneity of the experience with the work itself, the picture as pure aesthetic object.

This supposed voiding of narrative within Modernism is, however, only seeming. For Modernist art's simultaneity is still understood as a "most pregnant moment"—an experience extended and made replete with a certain kind of understanding, a certain kind of ecstatic or spiritual dilation, a certain kind of drive to completion.[3] Within this situation, the genre of the Portrait of the Artist has a special role. It is the signifier of art's hidden but persistent narrativity; for the unfolding of the artist's gesture in *this* work, which is a model on a small scale for the larger unfolding of all his gestures into that totality of his works to which we give the name *oeuvre*, this is the story of the artist that each portrait can encapsulate. It tells of those larger movements of the artist's personality, his persistence, his intuitiveness, his cunning, his triumph. The portrait is always pregnant, we could say, with his development: beginning, middle, and end.

There are many types of portraits of the artist. We have spoken of photographs and films, and obviously we could mention paintings. But there are as well texts, like this one, monographic studies that are also conceived as portraits of the artist: at work, making works, and through those works, producing the story of his *oeuvre*. But it is against this easy, culturally given cliché that the Portrait of the Artist Throwing Lead operates as a kind of cautionary sign, warning one not to think that the point of a portrait's story is already given by its form. This caution is like the one that in 1966 Jean-Luc Godard pronounced for his films, which themselves had a strong effect on the way narrative was reconceived in the 1960s. Stories had beginnings, middles, and ends, he conceded, "but not necessarily in that order." Chronologically speaking, the portrait of Richard Serra throwing lead stands very near the beginning of his career. But whether we are also to understand

this as signifying the beginning of his *story*—that is the warning we must read off the gesture in which an act is spun into pure repetition by avoiding its object.

One of the verbs on Serra's 1967–68 list, "to grasp," specifically opens up a work that underscores this relation to time. In his 1968 film *Hand Catching Lead* (fig. 2), a fixed frame centers on an extended arm, fingers splayed. Into the frame, at regular intervals, there falls a succession of pieces of lead, which the hand endeavors to catch. Sometimes missing its prey, sometimes capturing it—but in the latter case immediately releasing the metal scrap, allowing it to continue on its way out the bottom of the frame—the hand opens and closes in a performance of the same slightly irregular pulse as the falling lead. Simultaneously tense and desultory, the hand in its relation to the object is both intentional—catching lead is what it is doing—and pointless, for making a catch does not seem to be its objective. In its insistence on the constitutive act itself, the film produces an image of what came to be known in the late 1960s as "pure process." Yet insofar as this action is pulsional, made up of regular beats, it also creates the kind of special seriality that Donald Judd had described in a famous characterization of his own work's structure as "just one thing after another."[4]

This spatial repetitiveness, and its refusal to deploy the organizing, hierarchical devices of those compositional schemes upon which most of Western art is based, had entered the vocabulary of the American avant-garde with Minimalist painting and sculpture: with the repetitive bands of Frank Stella's Stripes, with the stacked, identical boxes of Donald Judd's wall reliefs, with the blankly juxtaposed metal plates of Carl Andre's "rugs." Turning this spatial seriality into a temporal hum was the work of a group of musicians slightly younger than the first Minimalists and exactly contemporary with Serra. Indeed one of the most important, Philip Glass, had been a part of Serra's aesthetic apprenticeship. Serra's year in Paris on a traveling fellowship from Yale had been spent with Glass, cementing a friendship and working relationship that was not to be diminished by their return to New York in 1966. It was in New York that Serra and Glass encountered those figures who would be working out of Minimalism and into the later manifestations of process. Serra made special contact with Steve Reich and Michael Snow, composer and filmmaker; Sol LeWitt and Walter de Maria, conceptualist modifiers of Minimalism; Eva Hesse, early process artist. He also formed important friendships with Carl Andre and Robert Smithson, whose rhetorical gifts made their theoretical sparring, night after night at the bar downstairs at Max's Kansas City, a kind of continuous intellectual circus, one extremely important for Serra's intense need to theorize his own position, an attitude that had been if not formed then particularly focused during his studies at Yale.

There is a final aspect of *Hand Catching Lead* that addresses Serra's attitude toward the problem of producing art within Modernism, no matter what the conviction about process or seriality. This is the condition of self-reflexiveness that Serra builds into this film. The falling lead's passage into and out of the frame imitates, and thereby pictures, the movement of the celluloid strip of film itself and its steady passage down into the gate of the projector and out again. In imaging

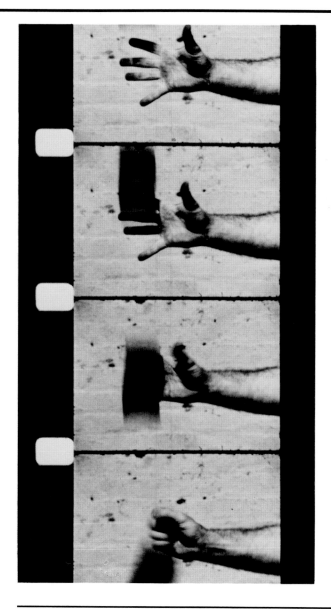

Fig. 2. Frames from the film *Hand Catching Lead*, 1968

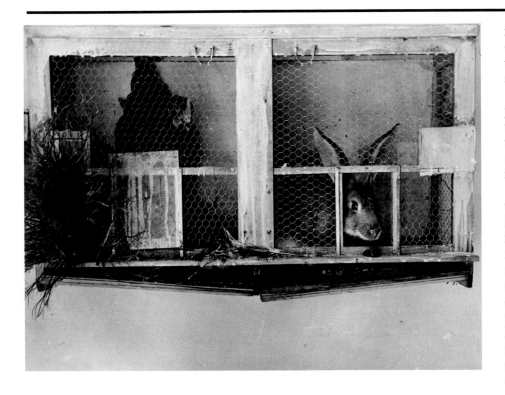

Fig. 3. *Live Animal Habitat.* 1965–66
Mixed media, approx. 16 x 34 x 10″
Galleria La Salita, Rome

forth the movement of the band of film as it unwinds from reel to reel, *Hand Catching Lead* participates in the experience of the auto-referential, that sense of the way the content of a work exists as an echo of its formal, and even material, structure, which we associate with High Modernism.

Three things combine, then, to produce the peculiar flatness of the temporal profile of *Hand Catching Lead*: a Modernist-derived concern with the representation of the work's physical support; a Minimalist-connected critique of composition—of those organizing hierarchies that had come to be regarded as merely arbitrary; and a process-conditioned exchange of the goal, or object, of the action for the logic of the action itself.

It would not be wholly accurate to say that Serra had no interest at all in what the hand in *Hand Catching Lead* is catching. Or to put it another way, it is not irrelevant that what falls through the frame in representational reflection of the filmic support is *lead*, which is to say, the metallic support of another medium, namely sculpture. The logic of process that had led Serra to turn to film as a way of manifesting a pure operation on a physical material was also a way of opposing the rigid geometries of Minimalist sculpture, in which a viewer was presented with an object whose construction was a closed system, secreted away within the interior of the object, invisible and remote. For this reason, process artists such as Eva Hesse had turned to materials such as latex, fiberglass, and clay, materials that would yield to the imprint of the action applied to them, and carry it on their surface as their only mark of structure. "To catch" is a process conceived within the strategic terms of this critique, but "to catch lead" represents a decision that what is at stake in this critique is the status of sculpture.

Serra was not yet a sculptor when he went to Paris. His training at Yale had been as a painter (he had been a teaching assistant in Josef Albers's famous color course and had helped proof the plates of Albers's book *The Interaction of Color*, 1963), and in Paris in 1965 he continued to paint. But he also found himself drawn to the Brancusi atelier reconstructed at the Musée National d'Art Moderne (located then on the avenue Président Wilson), where he returned day after day to sketch his way into the internal logic of Brancusi's way of thinking about sculpture. The following year Serra went to Florence on a Fulbright, and there his identity as a painter was submerged in the rising tide of the logic of process. Serra's last paintings consisted of grids that he would fill with color, understanding the application of pigment as an act ("to paint") to be determined by the arbitrary measure of a unit of time, meted out in this case by a stopwatch. But it soon occurred to Serra that having turned paint into a brute material, there was no reason to grant it privilege above any other material; and as this reasoning took hold of him, painting receded as a coherent and therefore possible medium. Before leaving Italy for New York, Serra had an exhibition at the Galleria La Salita, Rome, where his pictorial grids were transformed into the three-dimensional geometric latticework of a set of cages, and his "material" was the aesthetically disarticulated medium of biological life: he filled these cages with animals, both live and stuffed (fig. 3). "Somewhere between Kienholz and Samaras and

Rauschenberg," as he himself has characterized it, this exhibition confirmed what had been building since his entry into the intense but provisional coherence of the space of Brancusi's studio: that painting no longer held his imagination.

To Prop, to Prop, to Prop...

Shortly after composing his list of transitive verbs, Serra discovered the enormous flexibility of lead as a support for the actions he had projected. *Thirty-five Feet of Lead Rolled Up* (fig. 4) of 1968, *Tearing Lead from 1:00 to 1:47* (fig. 5) of 1968, and *Casting* (fig. 6) of 1969, all result from the variability of this material—soft enough to be torn, malleable enough to be rolled, easily melted and thus able to be cast. It was during a performance of the last of these possibilities, in 1969, that the portrait of Serra throwing lead was made, recording the throwing of molten metal into an angled "mold" along the floor of the Castelli Warehouse. He had made *Casting* earlier that year, at the Whitney Museum of American Art, this time throwing molten metal into the mold formed by the angle of floor and wall of the gallery, pulling the resultant casting away from the angle when hardened to allow for yet another wave of molten liquid.[5] The logic of *Casting* demanded, of course, that it be exhibited in immediate proximity to the place where it had been made, so that the relationship between the cast element's shape and the mold that had determined it would remain clear. The castings were therefore displayed directly on the floor in the order in which they had been pulled away from the wall. *Tearing Lead* was also, perforce, displayed on the floor where the ten-foot square "rug" of lead had lain while Serra tore successive strips of metal from its edges, leaving these clustered at the four corners.

But in less than a year, Serra was to look back critically on this idea of "displaying" process against the background of the floor and thereby, paradoxically, rendering the result pictorial. "A recent problem with the lateral spread of materials, elements on the floor in the visual field," he explained, "is the inability of this...mode to avoid arrangement qua figure ground: the pictorial convention."[6] To organize material by means of a physical process applied to that material is obviously to strip the work of art of all possible illusionism, to imbed its existence in the world in which *tearing, rolling,* or *casting* physically take place. But Serra's critique arose from his sense that there was a fissure in the logic of process; because as long as nonrigid materials were employed and the floor had to be used as the vehicle of display, then the procedure took on a figurative quality, and one was faced with the "picture" of tearing, the "image" of rolling, the "tableau" of casting. "When pieces are viewed from above," he declared, "the floor functions as a field or ground for the deployment of decorative linear and planar elements. The concern with horizontality is not so much a concern for lateral extension as it is a concern

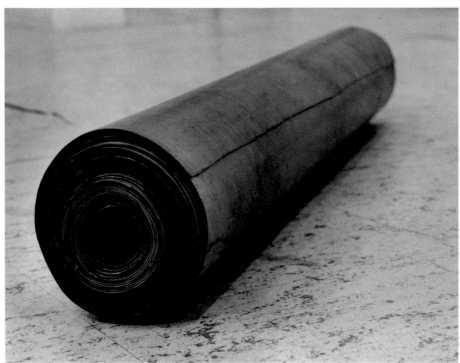

Photo: Peter Moore

Fig. 4. *Thirty-five Feet of Lead Rolled Up.* 1968
Lead, approx 5 x 24"
Collection Holly and Horace Solomon,
New York

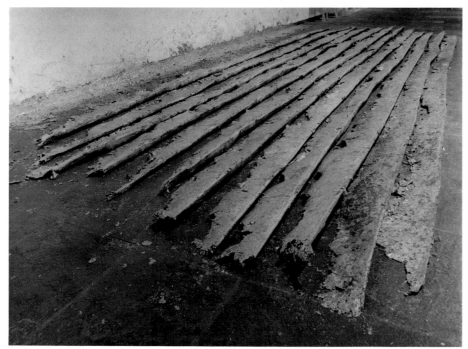

Photos: Peter Moore

with painting. Lateral extension in this case allows sculpture to be viewed pictorially—that is, as if the floor were the canvas plane."[7]

Thus the logic of process had gone full circle: although a material operation was used to break the grip of the "image," the image had come back to lay hold of the operation and to convert it into the terms of painting, to threaten it with a space that was virtual rather than actual. One of the constant arguments that had kept Andre and Smithson going until three o'clock in the morning at Max's was just this question with regard to the logic of Andre's work. *Lever* (fig. 7), Andre's 1966 thirty-foot row of bricks placed end to end, functioned for him with the most insistent anti-illusionism: "My first problem has been to find a set of particles, a set of units and then to combine them according to laws which are particular to each particle, rather than a law which is applied to the whole set, like glue or riveting or welding....No extraneous forces apply to the set to make them have properties which an individual particle does not have."[8] Smithson didn't see it that way. Receding along the luminous plane of the floor, *Lever* read for Smithson as a "line." By 1970 Serra had come to agree.

In 1968, in addition to the actions to *cast, roll,* and *tear,* Serra had used lead to enact another transitive relationship: to prop. One sheet of lead, tightly rolled to form a pole, was inclined against another, still-flat sheet, hoisted on the plane of a wall, the dense inert weight of the one propping up the leaden expanse of the other. Insofar as *Prop* (pl. 22) depended upon the wall plane as a ground, it was of course open to much the same criticism from its maker as *Casting* and *Tearing....* But where it differed from the others was in the process informing this work: it was not something applied to the materials of the object, imprinting itself upon them, an external force coming from outside them to leave its trace so to speak. In *Prop* the process was a function of the relationship between the two elements of the piece, working against each other in a continuous labor of elevation. It was in this constantly renewed tension, active within the object at each moment, necessary to the very prolongation of its existence, that Serra located a special aspect of his vocation as a sculptor.

The Prop Pieces of 1969—*One Ton Prop (House of Cards)* (fig. 8), *5:30* (pl. 44), *2-2-1* (pl. 46)—provided the basis for Serra's criticism, voiced in 1970, of his earlier work. For these sculptures are resolutely vertical, their internal dynamic securing their independence of any external ground, be it floor or wall. And the extremely simple principle of their verticality rests in the heaviness of lead and its earnest response to the downward pull of gravity; for in that pull there operates the resistance that is the principle of the prop—stability achieved through the conflict and balance of forces. In *One Ton Prop (House of Cards)* four lead slabs (each weighing 500 pounds) maintain their mutual erectness through the reciprocity of their leaning sides, propping each other up by weighing each other down. And in *2-2-1,* five lead slabs of the same dimensions remain upright through no other agency than the crushing inertia of a rolled bar, which, barely kissing each of the slabs at one corner, presses down on their resistant forms, goading them into a continuously precarious verticality.

In this continuous remaking, the temporality organized by these props has shifted from the register of time in which *Hand Catching Lead* was inscribed. The serial nature of the film, its "one thing after another," its flattened profile in which an action is denied its climax, its point, has here been powerfully recharged into something more like a perpetual climax, an end point that continues, and continues, and continues. In the Prop Pieces, Serra discovered what might be called an erotics of process. And this erotics of process can be thought of as a new site within which to locate the problematics of sculpture.

Serra has said that a whole generation of American artists was indebted to Constantin Brancusi's *Endless Column* (1918):

> The fact that [it] measured a definite space from floor to ceiling anticipates Judd's thinking from floor to ceiling, and what Andre had done from wall to wall. The idea of the infinite implied by the module extension was most impressive in Brancusi. It changed the sensibility of the entire sixties.... Stella's black pictures and Judd's serial relationships are indebted to the *Endless Column.* But the problems in the *Endless Column* didn't interest me at that time. I was more interested in Brancusi's open pieces, like the *Gate of the Kiss.*[9]

As opposed to the flattened serial rhythm of the *Endless Column*, there is the Brancusi of *The Kiss* (fig. 9), the Brancusi of the technics of a body whose feeling is found within the pressure of opposition. Over and over again, in 1907, 1910, 1912, 1915, 1921, 1933, 1937, Brancusi explored that line of compression between two figures meeting in a kiss, a line that simultaneously breaks apart the singleness of the stone monolith, a fission into two separate bodies, and forges the endless moment of integration as those bodies enact their fusion. Rippling down the center of the block in a constant making and unmaking of union, this line describes what could be called a phenomenological fissure at the center of the stone, a point of compression in which each body experiences itself only along that surface crushed against its mate.

The phenomenological fissure, in which the body's Gestalt is radically opened and differentiated, occurs with great frequency in Brancusi's work and is the peculiar invention of his particular sculptural drawing. For Brancusi's unitary forms, his painstaking geometries, his ovoids, fins, and rhomboids, open themselves to a kind of found drawing, a line that forms and reforms itself as light and reflection are cast along the smooth surfaces of these objects. In the polished bronze ovoid of *Beginning of the World* (fig. 10) of 1924, for example, the line that describes the median of the prone form, dividing it into a lower and upper half, is cast onto the surface by opposing sets of reflections from above and below the work, reflections that meet at the physical crest of the object and form, through an optical moment, a line of opposition. It is in the grip of this optical crossfire that the actual symmetry of the object is rewritten as a powerful disequilibrium between its two halves. The underside, mirroring the dense smoothness of the base on which the sculpture lies, appears slightly flattened by the heaviness of the object's weight

Fig. 5. Opposite above: *Tearing Lead from 1:00 to 1:47.* 1968
Lead, 10 x 10′
Konrad Fischer Gallery, Düsseldorf

Fig. 6. Opposite below: *Casting.* 1969
Lead, 4″ x 25 x 15′
Installed Whitney Museum of American Art, New York. Destroyed

Fig. 7. Carl Andre
Lever. 1966
Firebrick, 4″ x 30′ x 4″
National Gallery of Canada, Ottawa

bearing down on a resistant ground; yet the upper half, carrying on its surface the scatter of random reflections from space at large, seems almost to float as it expands outward into its surroundings.

In the sense of a body's yielding to pressure while simultaneously dissolving toward an absence of sensation, there is configured the radical dyssymmetry of the lived body, the body as experienced from within. In Brancusi's work, a whole series of ovoid heads leads up to *Beginning of the World*: heads nestled against a supporting base as they figuratively drift toward sleep (*Sleeping Muse*, 1910; fig. 11); heads shattering their profiles through the contortion of a cry (*The Newborn*, 1915); heads spilling their weight into the prop of a supporting palm (*A Muse*, 1917). The reconfiguration of external relationships as the ovoid "remakes" itself in relation to lived sensation is the work of the reflective line that constantly splits and resutures the Brancusian geometries.

Serra made a videotape called *Boomerang* (1974) in which the fixed frame isolates the head and shoulders of Nancy Holt, the work's only participant, focusing on them as smooth oval and firm neck, while there forms, muselike, an image of the constant splitting and remaking of the performing persona. Wearing a technician's headset, Holt spends the ten minutes of the tape talking against the distraction of audio feedback, since her words are audible to her in a delay of about one second after she has actually pronounced them. It is the mechanism of the delay that creates, automatically, a dyssynchrony between speech and audition, so that "saying" and "hearing oneself speak" ("thinking") become actions divided in consciousness. Describing the confusion she feels, Holt explains: "Sometimes I find I can't quite say a word because I hear a first part come back and I forget the second part, or my head is stimulated in a new direction by the first half of the word." This stimulation "by the first half of the word" is, of course, less like the condition of speaking than it is like the situation of listening—listening to the speech of someone else, to information not known by the listener in advance. In moving back and forth between the self-possession of speech and the outward thrust of intentionality in order to grasp the words of another, Holt performs what Brancusi had earlier pictured: the rent in the body's Gestalt that we have been calling the phenomenological fissure.

To form, thus, an image of the human subject as disarticulated, and to show it in the process of recomposing itself, is to create through this "muse" an analogue of the sculptural Props. *One Ton Prop*, in breaking with the closed, preformed geometries of Judd's boxes or Tony Smith's prisms, does not merely put in place the paradox of an unstable geometric form. It forces a certain analogy between that form and the human body, which, like the Prop, "continues."

In some sense, of course, all sculpture configures the human body; that is, it operates as a model—of wildly divergent kinds—of the human subject: as an image of ideal repose or of the purposiveness of action; of the centeredness of reason or the abandon to feeling. Further, it does this no matter how reduced it might be in the manner of its actual likeness to the human body. A generation of Early Modernist sculptors demonstrated sculpture's capacity to model the human

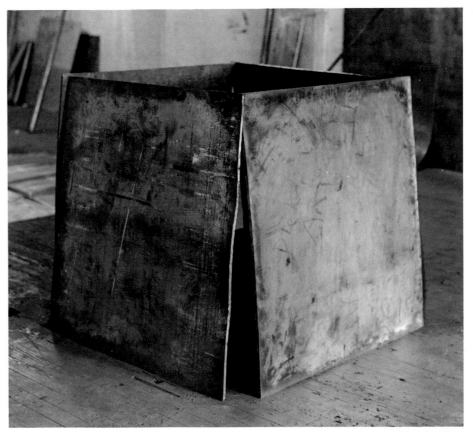

Photo: Peter Moore

Fig. 8. *One Ton Prop*
(House of Cards). 1969
Lead antimony, four plates, each 48″ x 48″
Collection the Grinstein Family, Los Angeles

Fig. 9. Opposite, top left: Constantin Brancusi
The Kiss. c. 1912
Limestone, 23 x 13 x 10″
Philadelphia Museum of Art,
Louise and Walter Arensberg Collection

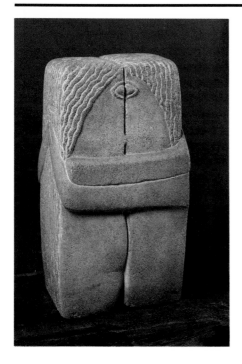

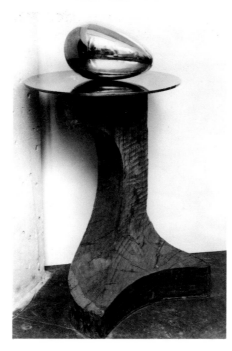

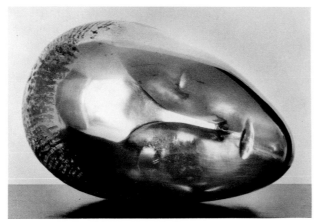

subject from the simplest forms and from the most ordinary ones: from the shape of an egg to the presentation of a teacup. The issue, then, is not that the Props create for their viewer the experience of the human subject; rather, the question must be what kind of subject they insist on modeling.

That subject, specific to Serra's sculptural Props, might be located in another passage of Holt's self-description, from within the space constructed for her by *Boomerang.* Still attempting to analyze her experience, she says: "I'm throwing things out in the world and they are boomeranging back…boomeranging…eranginging…anginging." Which is a way of conjuring an image of subjectivity as a function of objective space, of what is external to the self, of what impresses itself upon the subject not by welling up from within but by appearing to it from without. They, as we have heard, are boomeranging back.

Serra, of course, belonged to a generation of artists who had grown up with the vastly inflated rhetoric of the claims made by some critics for Abstract Expressionism. Calling this movement "Action Painting," Harold Rosenberg went on to declare that the work produced was "inseparable from the biography of the artist," from which it also followed for him that "the act-painting is of the same metaphysical substance as the artist's existence."[10] This supposed metaphysical sharing between painting and painter could be seen to generate an aesthetic model in which the virtual or illusionistic space of the picture—the space that opens backward from its surface into the luminous atmosphere of Pollock's linear webs, for example, or into the chiaroscuro of Willem de Kooning's smeared impastoes—could be understood as an expression or manifestation of what was interior to the artist, what was behind *his* physical surface—his impassive face, his stolid body. Painting could thereby be conceived as a way of displaying those two interior spaces, of aligning the one with the other, of using the first as a registration of the second, a registration whose value was, in some way, confessional. Comparing this notion of confession to religious conversion, Rosenberg spoke of the works as attempts "to resurrect the saving moment in *his* story" when a given painter first felt himself freed from certain aspects of tradition, entering in a wild plunge of subjectivity the realm of the Uncertain. "The result," he exulted, "has been the creation of private myths."[11]

But what, logically, could a private myth be? Since a myth's function is to account for phenomena collectively, to use narrative to knit together the social fabric, a private myth is a contradiction in terms, a story told not in public but in confidence. This is the confidentiality of the psychologistic, something that the generation of the 1960s found distasteful. Speaking about the painterly registration of "expression," Judd found himself saying: "It certainly involves a relationship between what's outside—nature or a figure or something—and the artist's actually painting that thing, his particular feeling at the time. This is just one area of feeling, and I, for one, am not interested in it for my own work."[12] The insideness of Abstract Expressionist space—the analogy its depths can be seen to set up with the interiority of the painter—meant that this experience of the psychologistic involved a claim on the viewer's time, as though a failure to plumb the depths of the

23

work was to render a judgment that both artist and, by implication, viewer were *shallow*. But speaking of this demand in the mid-1960s, Frank Stella objected: "I wouldn't particularly want to do that and also I wouldn't ask anyone [else] to do that in front of my paintings. To go further, I would like to prohibit them from doing that in front of my painting. That's why I make the paintings the way they are, more or less."[13]

In this prohibition, this walling up, this opacity, this insistence on the shallowness, the surfaceness of the work, we can to some degree take the measure of the power of rejection behind the flat blandness of that "I, for one, am not interested in it." But Judd and Stella, in the same discussion as this announcement of disinterest, tied the decisions they had made for their art to alternative models of reality, of what the world is like and how the human subject is constituted. Their objection was precisely at the level of the metaphysic used by writers like Rosenberg and Thomas B. Hess to defend Action Painting. For what they were questioning was "a philosophy," one that, as Judd said, "is based on systems built beforehand, *a priori* systems; they express a certain type of thinking and logic that is pretty much discredited now as a way of finding out what the world's like."

If the expression of the private myth had come to seem illogical, absurd, pretentious, it did so against an attack on the notion of private language—the idea that meanings of words are tied to ideas that I, as a speaker, have in my head when I utter them, so that, for example, what I mean when I say "I have a headache" is dependent upon a sensation uniquely available to me—my headache—for its truth. Not only did this Idealist view of language seem impossibly to multiply the meanings of a given word (John's headache, Mary's headache, Elizabeth's…), but it raised strange problems in the *practice* of language, making it somehow puzzling as to how one would ever learn the meaning of a word, locked out as one was from all those private spaces.

The generation of the 1960s no longer accepted such a view either of language or of human experience. For both structural linguistics and ordinary language philosophy, as well as the returns from the laboratories of perceptual psychology, were demonstrating the way our very sensations are dependent upon the language we use to name them and not the other way round. So that, for example, if the color spectrum, which is wholly continuous, is broken at point *a* to create "blue" and point *b* to create "green," this is an operation of segmentation that language performs on the spectrum and not a reality that our senses first report to us and that we go on to name. It is language that teaches us to see "green" and to experience "headache," language that, like myth, is nothing if not public, or to use Ludwig Wittgenstein's term, a "form of life."

It was the extraordinary ambition of post-Abstract-Expressionism to take this notion of "forms of life" seriously: to make an art devoted to the way the human subject is a function of his ambience, his culture, his media bombardment, his promiscuous reading, his vicariousness. In a movement that began with Jasper Johns and Robert Rauschenberg, the generation of the 1960s made an art of the human subject turned inside out, a function of space-at-large, the setting, the siting, the impress of everything outside that once-sacred virtual space of art that had been the "inside" of the pictorial space, the "inner being" of the sculptural one.

Coming at the end of this decade, Serra's Prop Pieces obviously participated in this project, already formulated by much of Minimalism. The way *One Ton Prop* creates a geometric form that is all outside, nothing but exterior, so that one's sense of the "inner being" of this form is utterly demystified, is part of this problematic of public versus private. Steve Reich, comparing this phase of Serra's work with what he was then doing musically, said: "The analogy I saw with Serra's sculpture, his propped lead sheets and pole pieces (that were, among other things, demonstrations of physical facts about the nature of lead), was that his works and mine are both more about materials and process than they are about psychology."[14] But by making the very constitution of this "outside" a question of an always precarious, restabilizing balance, a matter of propping, a function of an equilibrium that has constantly to be resecuring itself from within the pressures of time, *One Ton Prop* reformulates the inside/outside issue, for the "outside" itself is now understood as organized within the temporal: "of waves," we had read, "of tides…of time…to continue."

The Skullcracker series, made during the summer of the Prop Pieces, expanded the principles of *2-2-1* and *One Ton Prop* to mammoth scale. The lead Props were to the stacked slabs of Skullcracker as cottage industry is to a steel mill. The making of the Props had been a matter, to use Serra's term, of "choreography." Together with friends serving as assistants, Serra "would map out what to do; two people would be on each plate. There were four or five plates. And then Phil and I would fit in the overhead roll." But in the summer of 1969 the Art and Technology program organized by the Los Angeles County Museum of Art had commandeered a variety of technological sites within which artists could choose to work, and Serra had chosen the Kaiser Steel Corporation yard at Fontana, California. There, in what was called the Skullcracker Yard, he worked with an overhead magnetic crane stacking and propping massive elements of steel—slabs and crop—to form a constantly changing array of precariously equilibrated, giant constructions, towering sometimes forty feet into the air and anchored by nothing but their own crushing weight (pls. 35–37).

"The first day," Serra recalls, "I built a cantilevered work from slabs stacked up forty feet which tilted twelve feet off axis. It leaned as far as it could while remaining stable. It was at the boundary of its tendency to overturn."[15] *Stacked Steel Slabs* (fig. 12), one of the sculptures in this series, presents just such a picture of a pile of identical elements canting off axis, so that each addition to the stack extends its mass while at the same time threatening its existence. The plumb line around which this work is organized is the stack's center of gravity, a matter of tensions constantly in force, tensions externalized by the principle of the "stack." Insofar as the meaning of *Stacked Steel Slabs* is the struggle for verticality, the vehemence of uprightness and balance, it continues to locate its aesthetic energies in relation to the human body. It matters very little that the scale of this work (twenty feet high) is vastly over life size. In this respect the work participates in the

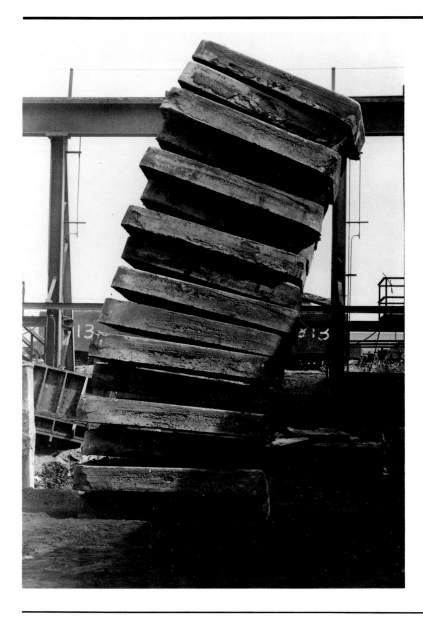

Fig. 12. *Skullcracker Series: Stacked Steel Slabs.* 1969
Hot rolled steel, 20 x 8 x 10'
Installed Kaiser Steel Corporation,
Fontana, California. Destroyed

kind of expansion of sculptural scale that would preoccupy Serra throughout the 1970s, leading to works such as *Strike* (pl. 52) of 1969–71, *Shift* (pl. 60) of 1970–72, *Circuit* (pl. 66) of 1972, and *Delineator* (pl. 74) of 1974–75. But as would be true of them as well, *Stacked Steel Slabs* is concerned with the dynamics of a relationship between a center and an outside, which exercises a powerful pull on that center, which is, one could say, the very meaning of its existence. And what is at issue in that relation of center to periphery continues to be the nature of the human subject.

...to Continue

For all but the most amateur, or the most perverse, or the most minimal, making a movie entails joining several pieces of film together: splicing different shots to form the complex web of continuity that we call film, a matter of an action or event persuading us that it continues even across enormous gaps in our view of it. The logic of this "continuity" ensures, for example, that during an angle-reverse-angle sequence—in which individual shots of two different people on, say, a couch are spliced together to create the impression of that continuous presence of both parties necessary to what we understand to be a conversation—we are convinced that we are seeing two aspects of a single space, that the unity we attribute to our world undergirds the separate images of the film. The illusion organized by this logic was patiently explored during the heroic years of film experimentation in postrevolutionary Russia. In 1920 Lev Kuleshov demonstrated for his Moscow film classes the way the cut functioned as a magical interstice: a severance that also, and at the same time, seamed; an index of difference or separateness within a prevailing matrix of "the same." The mere juncture, it was revealed, of two strips of celluloid was enough to convince that the White House stood solid and indestructible in the heart of Moscow, or that filmed details of several different women could fuse beyond the cut to form a single body. Over and over these experiments revealed the primacy of spatial continuity—showing that the cut would have to wedge into it very deeply indeed before that continuity would break.

The films of the Russian avant-garde—Sergei Eisenstein, Dziga Vertov, I. V. Pudovkhin, Alexander Dovzhenko—were recycled regularly in the programming of the Anthology Film Archives, New York, which Jonas Mekas had opened in 1970 and which was devoted both to the historical, cinematic avant-garde and to the contemporary one. There, in an architecturally bizarre visual solitude, one could view over and over the deft precision of Russian film form. And there, several nights of every week, sat Richard Serra, often accompanied by Robert Smithson or Joan Jonas, building on his already formidable film education begun at Yale, extended at the Cinémathèque in Paris, and refined in New York in the late 1960s. There he sat, intently becoming the master of this syntax.[16]

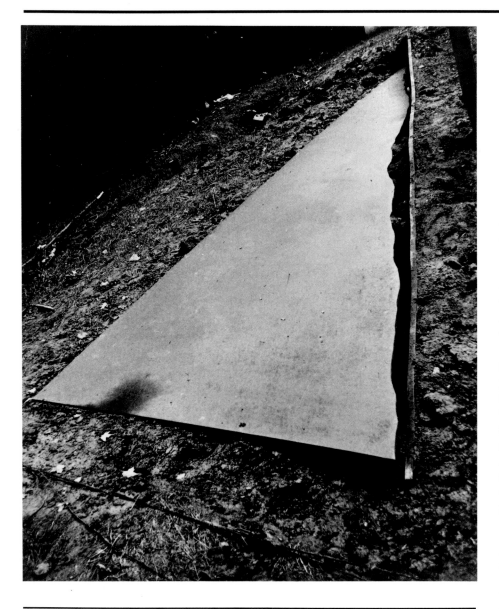

Fig. 13. Untitled. 1970
Hot rolled steel, rectangular plate 8 x 24' x 1⅜,"
cut according to elevational fall
Collection Roger Davidson, Toronto

"To cut" had been the sixteenth item on the 1967–68 list of verbs, but when Serra started making sculpture by means of cutting, it became evident that he intended this cut to operate like the one in film—to function as the ineluctable marker of the continuity of experience across a break, to be the very thing that articulates continuum. *Cutting Device: Base Plate Measure* (pl. 34) of 1969 is about the juncture of disparateness, as lead sheets, steel piping, a wooden beam, and a marble slab are aesthetically joined by the very operation that hacks into their substance and splays them apart. These materials, having been laid sequentially on a two-foot-wide steel base plate, their disparate lengths extending beyond it on either edge, were sliced through by a circular saw, to fall and scatter on both sides of the relatively narrow base/template.

But the Gestalt that magically forms through the agency of this cut seems to exist both "inside" the work—holding it together—and manifestly "outside," an operation performed on the latency of matter. Opening the performance of this unity to the viewer's inspection, displaying it in slow motion, as it were, it is as if we could see just that leap in the dark where the site of one filmed detail joins another, or as if we were at just that moment of dawning perceptual sense when the object that disappears, by passing in back of another, reappears to the infantile viewer not as a third object but as the same one as before, seamed together in his cognitive understanding by the transformational idea "behind."

Continuing to operate with this linear device in which the cut paradoxically forges the wholeness of the work, in 1970 Serra made an extremely lyrical untitled piece (fig. 13), in which a twenty-four-foot steel plate was wedged into a gentle fall of ground and then torch-cut along its exposed portion to produce a fallen triangle visibly wedded to its now mostly invisible mate: the other half of the original plate, still buried, below its exposed cut edge, in the earth. And in the same year he created what was perhaps his most extravagantly Dada version: *Sawing Device: Base Plate Measure* (fig. 14), in which twelve twenty-five-foot massive logs, each about four and a half feet in diameter, were cut on a cement base plate seven feet wide and fifty feet long, filling the main space in the Pasadena Art Museum with a massive challenge to the very concept of the gallery as a site for sculpture.

By 1972 something fundamental had happened to Serra's conception of the cut. In that year he had made *Circuit* (pl. 66) and *Twins* (fig. 15), in which cutting was no longer a force exerted on the patient body of the world outside the viewer, but was, somehow, what tied that world to the viewer, what shaped his perception, and, in so doing, could be shown to shape him. Intervening between the Base Plate Measure series and these later works, in 1969–71, was *Strike* (pl. 52), a sculpture conceived as performing a cut on space itself and organizing it in relation to the viewer's body, so that the interdependence of body and space—coming apart and being put back together—is choreographed in relation to the work.

Strike is simply a steel plate eight feet high and twenty-four feet long butted into the corner of two walls for its only means of vertical support, the steel plate transecting the right-angled volume of the space. As the viewer moves around the work, plane is perceived as contracting to line (or edge) and then expanding back

into plane. Reciprocally, the space is blocked off and then opened out and subsequently reblocked. In this movement, open-closed-open, the space itself is experienced as the matter on which the cut, or slice, of *Strike* operates, as though it were the space of the room that had been laid across the work's steel template and severed in three. And, as in the earlier work, it is the cut that knits together the raveled sleeve of experience, that unites it beyond the split into the splice. And because it is the viewer, moving through the space, who is himself the operator of this cut, its activity becomes a function of his perceptual work as well; he is working with it to reconvene the continuity of his own lived world.

In *Circuit* the viewer's body is unavoidably implicated in the action of the work, since the only place to experience the sculpture is at its center, as one stands in the three-foot opening in the midst of the jut of four plates—each eight by twenty-four feet—pushing diagonally from the four corners of a room to stop just short of its midpoint. The viewer must turn 360 degrees in order to see the work, and the wholeness of his own body becomes the guarantor of the reconstructible wholeness of the room's continuity beyond the cellular segmentation of the separate quadrants, or "shots," into which the plates cut the architectural space.

With *Twins*, this drama of a perceptual center is played in a variant that combines the *Strike* phenomenon with the earlier notion of cut. A huge steel plate, forty-two feet in length, is bisected diagonally, and one half is then flipped so that when the two elements are projected from opposing corners of an oblong room, they form two triangular fins, parallel in plan but inverse in elevation, each presenting a profile that stretches from high in one corner to narrow at a point on the floor when it reaches the wall across the room. Given the simplicity of the geometrical relationships, it is extremely easy to reconstruct the original single plate, to understand, that is, the way the cut has bifurcated and dispersed the formerly unified plane. But standing between the two walls of the work is to *feel* this reconstruction in a very special relation to one's own body, to experience it through an extraordinarily acute sensation of the body's own symmetry—of the way that symmetry works not as an identity between right and left sides, but as an inverse, mirror relationship—or through a heightened sense of the manner in which what is present to me in the space behind my back shares in the formation of what I experience in front of my eyes.

Standing between these two fins is a matter of perceiving how one giant element has been sheared off from the other and, rotated back-to-front into place, now exposes the outer surface of its mate to the inner area within which the viewer stands. Thus the plate that is at the viewer's back is, literally, the "back" of the plate he faces. And with this incredibly simple maneuver, orientation—or what phenomenology would call "situation"—is added to geometry. What might have been understood as a simple geometrical enclosure—a kind of box articulated by two walls and two fins—has been articulated in relation to a point of view onto, or within, this construction. And this, it must be underscored, is not an abstract point of view, like the projective point of Renaissance perspective, which suspends a disembodied single "eye" before the visual array. This is a point of view that is

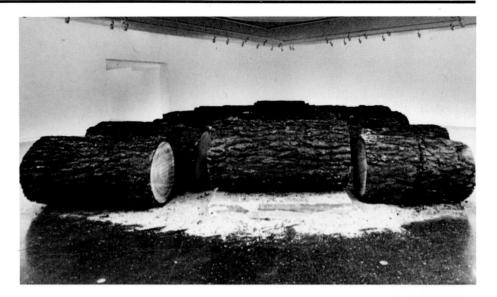

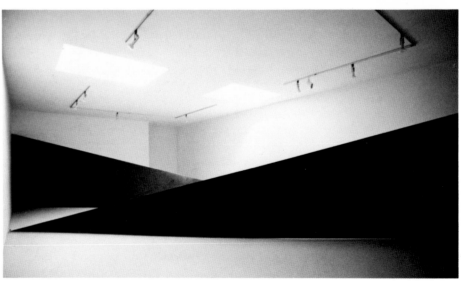

Fig. 14. *Sawing Device: Base Plate Measure.* 1970
Twelve fir trees and cement block, overall approx. 4′6″ x 55 x 35′
Installed Pasadena Art Museum, Pasadena, California. Destroyed

Fig. 15. *Twins: To Tony and Mary Edna.* 1972
Hot rolled steel, two plates, each 8 x 42′ x 1½″
Collection Giuseppe Panza di Biumo, Varese, Italy

situated instead in a body, a body that itself has a back and a front. Thus insofar as *Twins* articulates its own concern with the double-sidedness of each element, it coordinates this with the conditions of its viewer's body: the fact that that body has a front from which it sees and a back which it knows to be there but cannot see. Yet it is this very unseen, and unseeable, side that thickens the world for the perceiver, that assures him that things have reverse sides, namely, those aspects that, being hidden from him, are revealed to each other. And just as the continuous presence of the body provides the ground of continuity for seaming together the cuts of *Circuit*, so the sitedness of that body is revealed as the precondition for "knowing" the density and multiple-aspectedness of the structure of *Twins*.

Two years after making *Twins*, Serra constructed yet another work that articulated itself against the background or horizon of the viewer's physical self, given an added density and corporeality by feeling itself to be the very precondition for experiencing the density and weight and inner relationship of the work. The sculpture in question is *Delineator* (pl. 74), of 1974–75, consisting of two steel plates, each ten by twenty-six feet, one laid directly on the floor, the other hung from the ceiling right above it, the two plates at right angles to each other. One could of course read this juxtaposition as a notion of abstract coordinates and relate it to the red bars crossing black of Kasimir Malevich's Suprematism or the graphic crosses of Piet Mondrian's Plus and Minus series. But that would be to omit the way a space is corporealized by those two anonymous plates, a space called into being in relation to the viewer's body. "When you're outside the plates," Serra explains, "the overhead plate appears to press upward against the ceiling. That condition reverses itself as you walk underneath. There aren't any direct paths into it. As you walk towards its center, the piece functions either centrifugally or centripetally. You're forced to acknowledge the space above, below, right, left, north, east, south, west, up, down. All your psychophysical coordinates, your sense of orientation, are called into question immediately."[17] Explaining that he was not interested in a reading of *Delineator* as a kind of column or zone of light suspended between the two planes, he added: "It's not opting for opticality as its content. It has more to do with a field force that's being generated, so that the space is discerned physically rather than optically."[18]

Delineator is thus to *Twins* as *Twins* is to *Circuit*. In all three, what is experienced is a powerful imbrication of the visual with the physical, as the space that one sees is shown to be interdependent with the space corporealized within oneself, and that space in turn relies for its meaning upon space at large. This concern with the body as the "ground" of the sculptural experience is in part comparable to the way the abstract conditions of the body were modeled by *One Ton Prop (House of Cards)*, or by *Stacked Steel Slabs*: the body as a will toward erectness, as the seeking of containment through balance. Where the three 1970s sculptures depart from the Props and Stacks, however, is that the body is the precondition not for existing but for perceiving. Indeed throughout the decade of the 1970s Serra conceived of the sculptural project as a problem in the domain of perception—perception, that is, grounded in a living, moving, reacting body.

To Pair … to Bind … to Bond

Richard Serra makes several different appearances in *The New Avant-Garde: Issues for the Art of the Seventies*. We see him and Robert Smithson from the back, setting off on the rocky road of the *Spiral Jetty*; we see him making the casting piece in the Castelli Warehouse; and we see one actual torso-length close-up of him—amazingly dirty, in overalls and a tee-shirt, hair wild and face spattered with white. And as with the Portrait of the Artist Throwing Lead, precedents come to mind. For there is another twentieth-century sculptor who relished being portrayed as though in a cocoon of studio grime, who wore the dirt of his artistic life as a kind of filmy, glamorous veil: Alberto Giacometti, with plaster in his hair, in the deep grooves along his cheeks, in his lashes, on his clothing. And curiously enough, Giacometti was the focus for a certain phase of Serra's attempt to assimilate the fact of Paris as a living center for art, during the first year in Europe after Yale.

In the course of several months he and Philip Glass would go, many times a week, to La Coupole, the Montparnasse restaurant to which Giacometti repaired every evening toward midnight to eat his dinner. Sometimes alone, but more often accompanied by his brother Diego and a few assistants, Giacometti would arrive covered in plaster, the noble workman of the rue du Moulin Vert. Every night he would eat a bowl of mussels and drink red wine. And every night Richard Serra and Philip Glass would watch him eat. Later, at Phil's insistence, they would go to the café where Samuel Beckett could usually be counted upon to show up for endless games of snooker. One night Giacometti acknowledged this youthful audience of two. There are many stories of Giacometti's having found this kind of attention highly irritating, but that evening he seemed intrigued by these gawkers at the marks of his labor. He invited them to come to see him the next day; but when they got there, no one was home.

For Serra, riveted to what he was experiencing as Brancusi's abstractness, this failure to enter Giacometti's studio was not an aesthetic tragedy, for Giacometti's postwar work was determinedly figurative, presenting again and again the rigid, standing body of his model. It is only from a later perspective that that meeting—which could have taken the title "to miss"—assumes the character of a charming historical irony. For Serra and Giacometti did later "meet"—if only to miss—over a text that strangely enough could serve as a kind of theoretical key to both their work, and that, even despite the radical difference between them.

The text in question is Maurice Merleau-Ponty's *The Phenomenology of Perception* (1945) from which passage after passage could be cited to illuminate the nature of Serra's sculptural elaboration of the perceptual field. We remember, for instance, the question of back and front as it was developed in *Twins*, and we read:

To see is to enter a universe of beings which *display themselves*, and they would not do this if they could not be hidden behind each other or

behind me. In other words: to look at an object is to inhabit it, and from this habitation to grasp all things in terms of the aspect which they present to it. But insofar as I see those things, too, they remain abodes open to my gaze, and being potentially lodged in them, I already perceive from various angles the central object of my present vision. Thus every object is the mirror of all others.[19]

Yet the *Phenomenology of Perception* was first thought not to address issues raised by Serra, but to create a kind of explanatory ground for the late Giacometti. For the matter of his sculpture—those attenuated figures, rising like stalks, built up as though through a process of destruction, an erosion that establishes them as a kind of crumbled vagueness at the center of vision—this attack on matter was often seen as the parallel in sculptural terms to phenomenology's recharacteriza- tion of perception as a function of intentionality, as the simultaneous cause and result of the viewer's "gearing into the world," his *prise sur le monde*. In the light of this notion of seeing as a kind of grasping or meshing, no objects are imagined as being given to us neutrally, to be then modified by the distance from which we see them or the angle of view we are forced to take. The distance and the viewpoint are not added to the object, it is argued, but inhere in the object's meaning, like the sounds that infuse our language with an always-already-given ground of sense, separating it at the start from mere noise or babble. "Is not a man *smaller* at two hundred yards than at five yards away?" Merleau-Ponty asks. "He becomes so if I isolate him from the perceived context and measure his apparent size. Otherwise he is neither smaller nor indeed equal in size: he is anterior to equality and inequality; he is *the same man seen from farther away*."[20] Perceptual data are thus recharacterized by phenomenology. They are no longer neutral stimuli to enter the bodily sensorium for point-by-point processing but are now defined as the *meanings* that things present to a given point of view. "Convergence and apparent size are neither signs nor causes of depth: they are present in the experience of depth in the way that a *motive*, even when it is not articulate and separately posited, is present in a decision."[21] Or further: "They do not act miraculously as 'causes' in producing the appearance of organization in depth, they tacitly motivate it insofar as they already contain it in their significance, and insofar as they are both already a certain way of looking at distance."[22]

It was precisely "a certain way of looking at distance" that set the formal conditions of Giacometti's postwar sculpture. And his work, insofar as it appeared to represent the mutual relationship between the object and its spectator, the viewer and the viewed, was directly associated with phenomenology. The "dis- tance" imprinted on those represented bodies, inscribed there by means of their hieratic removal, their frontality, their rigidity, their kneaded and blurred surfaces, could not be effaced by moving close up to the sculpture to examine it, by peering into the clefts of its surfaces. These bodies were, instead, marked by a meaning that nothing could erase: their separation from the viewer, their existence as a kind of limiting condition of his gaze. Forever caught in the field of the spectator's look,

the works constructed the sitedness of vision, of what it means to be seen "by" another "from" the place from which he views. "He chose," Jean-Paul Sartre wrote about Giacometti, "to sculpt *situated* appearance and discovered that this was the path to the absolute. He exposes to us men and women as *already seen* but not as already seen by himself alone. His figures are already seen just as a foreign language that we are trying to learn is already spoken. Each of them reveals to us man as he is seen, as he is for other men, as he emerges into interhuman surroundings…."[23]

Published in 1948, this reading established the critical ambience within which Giacometti's art was assimilated. The sponsorship by Sartre meant that for American receivers of the work, for the most part unaware of Merleau-Ponty's still untranslated *Phenomenology of Perception*, Giacometti exemplified the moral lessons of Existentialism, what man-in-a-situation signified for human respon- sibility, human choice, human freedom. Also, figuration seemed to be a minimum requirement for these kinds of issues to emerge, for how else would one get at the question of "interhuman surroundings"?

But by the time American readers encountered *Phenomenology of Perception* (it was translated into English in 1962), their aesthetic horizons had been restruc- tured by a belief in the necessity of abstraction. The Minimalist generation, becoming aware of phenomenology against a background of the problematic inherited from Jackson Pollock, Barnett Newman, and Clyfford Still, did not read it as a call for figuration. For the Minimalists, the interest of phenomenology was located precisely in its assumption of a "preobjective experience" underlying all perception and guaranteeing that even in its *abstractness* it is always and already meaningful; otherwise, without an expectation of meaning located precisely in it, we would have no reason to go on to commit acts of seeing, hearing, moving. This description was pertinent to *their* ambitions, seeming to eclipse those of postwar France. The generation of the 1960s encountered in Merleau-Ponty's text the analysis of "a spatiality without things," which gave intellectual and theoretical ballast to their own preoccupations with a seriously intended abstract art. "Once the experience of spatiality is related to our implantation in the world," they could read there, "there will always be a primary spatiality for each modality of this implantation. When, for example, the world of clear and articulate objects is abolished, our perceptual being, cut off from its world, evolves a spatiality without things. This is what happens in the night….Night has no outlines; it is itself in contact with me."[24]

In the context of this desire for abstraction and this welcoming of "a spatiality without things," we might read what Serra wrote about the far-flung structure he constructed during the period from 1970 to 1972, a work that extends over 300 yards of field in rural Canada and that he titled *Shift* (fig. 16; pl. 60):

> Surrounded on three sides by trees and swamp, the site is a farming field consisting of two hills separated by a dog-leg valley. In the summer of 1970, Joan [Jonas] and I spent five days walking the place [figs. 17, 18]. We discovered that two people walking the distance of the field opposite one another, attempting to keep each other in view despite the curvature

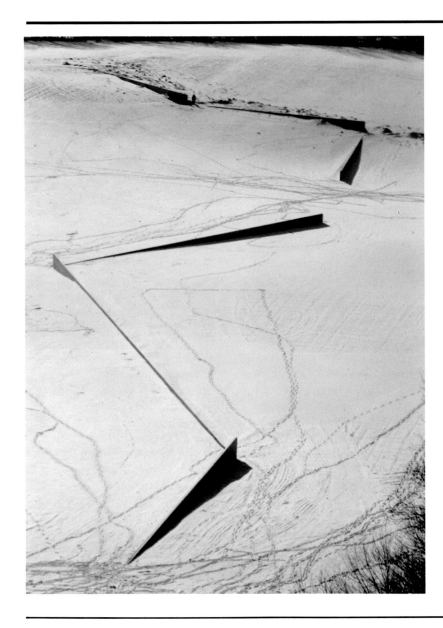

of the land, would mutually determine a topological definition of the space. The boundaries of the work became the maximum distance two people could occupy and still keep each other in view. The horizon of the work was established by the possibilities of maintaining this mutual viewpoint. From the extreme boundaries of the work, a total configuration is always understood. As eye-levels were aligned—across the expanse of the field—elevations were located. The expanse of the valley, unlike the two hills, was flat.

What I wanted was a dialectic between one's perception of the place in totality and one's relation to the field as walked. The result is a way of measuring oneself against the indeterminacy of the land....

Insofar as the stepped elevations [the six "walls" that are the built elements of the work] function as horizons cutting into and extending towards the real horizon, they suggest themselves as orthogonals within the terms of a perspective system of measurement. The machinery of renaissance space depends on measurements remaining fixed and immutable. These steps relate to a continually shifting horizon, and as measurements, they are totally transitive: elevating, lowering, extending, foreshortening, contracting, compressing, and turning. The line as a visual element, per step, becomes a transitive verb.[25]

Verbs surface once more in this description, a list of verbs that might remind us of that earlier sequence of actions contemplated by the Artist Throwing Lead: "to splash, to knot, to spill, to droop, to flow...to swirl." And like the earlier set of named actions, these also appear to float in grammatical space, in a free-fall divorce from any specific object. But there is no real synonymy between these lists. For the parade of infinitives suggests acts to be performed *on* an object, in its passivity. Whereas this list of gerunds, even as it is enacted by the continuity of the progressive tense, seems to indicate an action that is reflexive—modifying the enacting subject in the very process of modifying the object. Neither pole of the action is named, but the type of action imagined—foreshortening, contracting, turning—implies a field of reciprocity, as though it were impossible to think of an object without thinking at the same time about the way *it* carved out and determined a place for *oneself.*

Thus from the coming into being of *Shift* as the recorded trace of the mutual sighting of two people as they walk opposite sides of a hilly ground but struggle to keep each other in view; to its construction as a network of perspectives that would establish an internal "horizon" for the work (as opposed to the real horizon), which in turn would continually define one's vision of the object through one's physical relation to it; to its transitive relationship to the viewer, marking the activity of his connection to the world: Serra's conception of *Shift* seems to arise quite naturally from the kind of phenomenological setting in which it is argued: "I cannot understand the function of the living body except by enacting it myself, and except insofar as I am a body which rises towards the world."[26]

Fig. 16. *Shift.* 1970–72
Concrete, six sections, 60″ x 90′ x 8″,
60″ x 240′ x 8″, 60″ x 150′ x 8″, 60″ x 120′ x 8″,
60″ x 105′ x 8″, and 60″ x 110′ x 8″; overall 815′
Installed King City, Ontario, Canada;
view from East Hill
Collection Roger Davidson, Toronto

Fig. 17. Opposite above: Elevational plan for *Shift,* 1970

Fig. 18. Opposite below: Videotape of landscape survey for *Shift,* 1970

The opening movement in the making of *Shift* is a kind of choreographed version of that determination to experience the self only, as Sartre had said, "as he is for other men, as he emerges in interhuman surroundings." (It is perhaps a mark of the distance separating the postwar era from that of the post-1960s that Serra's connected space dispenses with the "interhuman" as something naturally to be articulated "for other men," and instead it is articulated through both sexes: "Joan Jonas and I.") And in the next movement, whereby one passes from the interpersonal into an interaction with space itself, it seems to follow that one will discover a network of horizons, a system that will constantly reorganize itself not as one stands back and surveys the terrain but as one gives way to the topographical embrace. It is in this movement, in which the horizon is redefined not as a spatial limit operated by measurement but as a coordinating limit operated by meaning, that we hear the echo of phenomenology's account of perception: "because to look at the object is to plunge oneself into it, and because objects form a system in which one cannot show itself without concealing others. More precisely, the inner horizon of an object cannot become an object without the surrounding objects becoming a horizon, and so vision is an act with two facets."[27]

Shift does not, of course, relate to the *Phenomenology of Perception* as work to source. Rather, the ideas developed by Merleau-Ponty had been generally assimilated by a first generation of Minimalist artists, affecting the assumptions of Judd and Robert Morris that sculpture had better own up to what it had, in its former Idealism, attempted to hide, namely, that "if the object is an invariable structure, it is not one *in spite of* the change of perspective, but *in that change or through* it."[28] In the play of perspectives in which Minimalism now grounded the object, abstract geometries were constantly submitted to the redefinition of a sited vision. And it is against this background that Serra arrived at the choreography of *Shift*, in which a work could be conceived as the mutually established "horizon" of two people at a distance.

Within this context, too, we understand how Serra's idea of "seeing at a distance" can never coincide with or map onto that of Giacometti. For where Giacometti located the depiction of distance in the object world, and specifically in the representation of the human figure, it was Serra's assumption that the ground for the perception of distance was to be found not in figuration but in abstraction, an abstraction that parallels the notion of the preobjective experience. For Serra, the only way to approach that primordial, preobjective world is through a use of form that, though palpable and material—directly engaging the viewer's body—is rigorously nonfigurative, insistently abstract.

The abstract elaboration of the plane in *Twins*, *Circuit*, and *Strike* is deployed throughout the vast expanse of *Shift*. Moving over the ground of the work, one experiences the walls as elements in constant transformation: first as line and then as barrier, only once more to become line. From the vantage of high ground, the upper edges of the walls are the vectors along which one sights as one stands looking down, and they thereby establish one's connection to the distance. Whereas from the vantage of one's "descent," they broaden and thicken to become

Fig. 19. Section from *Shift,* 1970–72

an enclosure that binds one within the earth (fig. 19). Felt as barrier rather than as perspective, they then heighten the experience of the physical place of one's body. Without depicting anything specific, the walls' oscillation between the linear and the physical articulates both a situation and a lived perspective. And it does this in the most abstract way possible: by the rotation in and out of depth of a plane.

The opening sections of *Phenomenology of Perception* sketch something of the preobjectival world when they speak of the internal horizon of an object as that network of views from everywhere within which it is caught:

> When I look at the lamp on my table, I attribute to it not only the qualities visible from where I am, but also those which the chimney, the walls, the table can "see"; the back of my lamp is nothing but the face which it "shows" to the chimney. I can therefore see an object insofar as objects form a system or a world, and insofar as each one treats the others round it as spectators of its hidden aspects which guarantee the permanence of those aspects by their presence.[29]

This passage opens a section titled "The Body," in which Merleau-Ponty argues that it is from the interconnectedness of "back" and "front" within a system of the meanings of these relationships, given preobjectively by the space of the body, that we can construct a primordial model to explain perception. The body as the preobjective ground by which we experience the relatedness of objects is, indeed, the first "world" explored by the *Phenomenology of Perception.*

As the plane of *Shift* rotates to become now internal, now external horizon, it functions as a kind of syntactical marker—an equivalent within the abstract language of sculpture for the connection between the body's "horizon" and that of the world beyond. The abstraction of *Shift*, like that of *Twins*, is therefore a function of the abstractness of its vectors, the possible coordinates that are mapped in their latency, rather than a matter of the nonfigurative character of the plane itself. Constructivist sculpture had, throughout the opening half of the century, based its own claim to abstraction on the nonobjective, nonreferential forms of the elements it put to use: smoothly transparent rectangles of celluloid, shiny grids of aluminum, mattely deadpan ovals of wood or metal. The realness of these materials—their associations to workplace, to laboratory, to transport—did nothing to interfere with the aura of the "abstract" within which these shapes located the Constructivist object. For that object seemed to exist in the ideal space of geometric diagrams, of textbook structures, of engineering tables. The transparency of the materials seemed to underscore the way these intellectualist models, these diagrams for objects, could be opened to the inspection of thought, which penetrated them from all sides at once, entering and acquiring them. Thus translucency to thought became the real "subject" of Constructivism, marking a triumph over matter by the formal operations of logic or of science, the object baptized in the ether of reason. In this way the Constructivist plane acts to overcome the appearances of things and to redefine the object itself as the

Fig 20. *Different and Different Again.* 1973
Hot rolled steel, four elements, two 12″ x 15′ x 6″,
two 12 x 14 x 6″
Leo Castelli Gallery, New York, and collection the artist

géométral of all possible perspectives, which is to say, the object seen from nowhere, or as phenomenology critically characterizes it, the object as seen by God: "For God, who is everywhere, breadth is immediately equivalent to depth. Intellectualism and empiricism do not give us any account of the human experience of the world; they tell us what God might think about it."[30]

Now, no matter how geometrical in form, the planes in *Shift* locate the meaning of the work in a place utterly distinct from that of Constructivism. These planes do not enter the formal domain of transparency, and this not because they are literally opaque (made of concrete, half-buried in the earth, at one with the compactness of the land), but because they participate in a system that finds abstraction only when it is carnally enacted as the dual coordination of a lived perspective supported by the preobjectival space of the body, "an act with two facets." Acknowledging that vision is this "act with two facets," the planes in *Shift* serve to mark the thickness of the body and that of the world, as well as the mutual, motile engagement that is at the heart of perception. Further, because Constructivist sculpture is seen from a vantage point in the Absolute, its viewer is represented as immobile, hovering somewhere above it in that total, simultaneous presence to its being that has no need of movement. But *Shift*'s viewer is represented (through the sculpture) in constant motion; and this bridging of the body's horizon with that of the world, this abstract transitivity—"foreshortening," "contracting," "compressing," "turning"—must be seen as the subject matter of the work.

Chiasma is a relationship of crossing and exchange. It can be used linguistically to chart the reflexive crossovers between words, or it can be used to describe a spatial transitivity, as in the mutual interaction of seer and seen—their activity as they exchange positions through visual space, each to leave a mark on the other. By the 1970s this formal loop, this chiasmatic trajectory, became the subject of much of Serra's work. It is an abstract subject, most often given visual form by correspondingly "abstract" elements, like the diagonally oriented fifteen-foot-long bars and the two steel blocks that they displace within the spectator's field of vision in the 1973 work called *Different and Different Again* (fig. 20). But it is a subject one can continue to experience abstractly, syntactically, even when the medium through which it is expressed is not the geometrical plane of *Shift* or *Twins* but a real, functional, functioning object, an industrial object, for example.

It was precisely a bridge, a revolving turnbridge, that became the medium of the chiasmatic loop in the film *Railroad Turnbridge* (fig. 21), which Serra made in the summer of 1976 as a kind of encomium to his revered masters of the Soviet filmic avant-garde—to the Eisenstein of the raising-of-the-bridge sequence in *October* (1927) and to the Vertov of the steel mills in *Enthusiasm* (1931). In Serra's film the camera, from a position at one end of the bridge, sights down its entire length to make of the bridge itself a giant viewfinder, a kind of semaphore of vision, reaching like an extended bellows toward the remote landscape. The view beyond this tunnel-like construction is thus entirely a function of the distant aperture at the bridge's end, and the lens of the camera and the opening at the far end of the

Fig. 21. Frames from the film *Railroad Turnbridge,* 1976

bridge enter into a mirror relationship: two frames set at either edge of a trajectory of space, each reflecting the other. View and viewer are thus mutually implicated, at the level both of form and the *dispositif* of vision; the majestically slow turning of the sunstruck bridge operates simultaneously on the position of the seer and on that limited part of the world available to be seen. As Serra says about his work: "Not only does it use the device of the tunneling of the bridge to frame the landscape, but then it returns on itself and frames itself. In that, there is an illusion created that questions what is moving and what is holding still. Is the camera moving and bridge holding still or vice versa? That is contained within the framing structure of the material of the bridge itself, right down to its internal functioning element—the gear."[31]

Indeed, in *Railroad Turnbridge,* nothing of the bridge's physical existence or its historical density (such as its material place in the development of truss construction within the nineteenth century's conquest of spans) is banished from sight, and nothing of the landscape toward which the entire filmic apparatus— camera, bridge, viewer—projects is denied. But what occurs instead is that each of these, in their objective character, is eclipsed by the film's abstract subject, by that thing that fills the frame and is not so much a thing as a relationship, a transitivity.

That film could be abstract without turning its back on the world, without denying the quotidian spaces of rooms and streets, had been part of the ethos of Serra's generation of independent filmmakers. Thus in 1967 Michael Snow had made *Wavelength,* a forty-five-minute film that consists of a single camera movement—a zoom—that traverses the space of a Downtown New York loft, seeming to distill with startling purity an abstract experience of "suspense."[32] Right after Snow's film was made, Serra had taken it with him on a working tour in Europe and had insisted on showing it everywhere he went. Over and over he had watched that dawning of the irreversible, the inexorable, as something that could be not so much pictured as plotted. It was when he saw the turnbridge on a trip to the Pacific Northwest that he realized the relation he could project between this abstract, filmic drive and his own specific subject.

In *Railroad Turnbridge,* Serra found access to a space made visible in and of itself by the fact that it is in motion, a space swollen by a brilliant luminosity that serves as a metaphor for vision, yet a space traversed by the mutual implication of back and front, thus creating a visual figure for the preobjective space of the body. The physical turnbridge is the medium, the support, the pretext for this experience, not its subject. The subject of the film remains absolutely consonant with that of *Shift.* Another aspect of the abstract subject emerges from reading *Railroad Turnbridge* and *Shift* together, and that is their parallel preoccupation with time as the medium within which movement unfurls the complications of its connections. For if, for Serra, the abstract subject can only be a function of time, this is because any subject that is timeless—fixed, isolated, and unchanging—lapses into an image. And an image is by definition not abstract. Always an image of something, it always acts to depict: this person, that chair, this concept. Giacometti's sculpture has, in this sense, constant recourse to images, not just because it is figurative but

because it is resolutely static, a function of the "image" of *distance* become "picture." Stamped onto the surface of his works through the indelible facture of the modeling, through the abruptness with which the sides of the sculpted faces recede before our eyes, this frozen picture ensures that, whether physically far or near, we will always be presented with this idea of *distance* as an image.

For Serra the abstract subject only becomes available to the artist once space and time are acknowledged as functions of one another. It is within the very moment of a shift in vision that what is seen is experienced as not bounded by the condition of being fixed, as is an image. In this insistence on an abstraction that fuses the temporal with the spatial, so that the bridge of Serra's film is imaginable as a medium only because, like the gears of the camera itself, it is turning, one continues to feel a phenomenological preoccupation: "This quasi-synthesis is elucidated if we understand it as temporal. When I say that I see an object at a distance, I mean that I already hold it, or that I still hold it, it is in the future or in the past as well as being in space.... But co-existence, which in fact defines space, is not alien to time, but is the fact of two phenomena belonging to the same temporal wave."[33] And once again Merleau-Ponty links the space of this continuum to something preobjective and abstract: "There is, therefore, another subject beneath me, for whom a world exists before I am here, and who marks out my place in it. This captive or natural spirit is my body, not that momentary body which is the instrument of my personal choices and which fastens upon this or that world, but the system of anonymous 'functions' which draw every particular focus into a general project."[34]

But Not Necessarily in That Order

The landscape sculptures—the *Pulitzer Piece: Stepped Elevation* (pl. 59) of 1970–71, *Shift* (pl. 60) of 1970–72, *Spin Out: For Bob Smithson* (pl. 70) of 1972–73, and *Plumb Run: Equal Elevations* (pl. 105) of 1983—marry form to topography, with the form bringing into a kind of relief the continuousness of the landscape, its meander, its sprawl, its aimless sliding this way and that. The sculptures lay bare a need to read the landscape but assert that no determinate reading can be arrived at, no closure to this experience, no final figure that will resolve once and for all the "ground." The sculptures "point to the indeterminacy of the landscape," Serra has said, adding: "The dialectic of walking and looking into the landscape establishes the sculptural experience."[35]

But the arcs that Serra went on to construct—*St. John's Rotary Arc* (pl. 90) of 1980, *Tilted Arc* (pl. 93) of 1981, *Clara-Clara* (pl. 104) of 1983, *La Palmera* (pl. 106) of 1982–84—presuppose a flat site, within which is set the segment of a regular, geometrical shape. And these two regularities—horizontal plane and vertical

arc—might now suggest a different subject for the work, a different relationship between sculpture and meaning.

"Et in Utah ego," wrote Robert Smithson in an essay about his 1970 *Spiral Jetty* (fig. 22). Composing a section of his film on the work, Smithson had choreographed a shot to be taken from its very center, at the end point of its trajectory as it spirals out from shore to curl around and into itself. Conceived as a continuous camera movement, that shot is a 360-degree pan along the horizon of the Great Salt Lake at Rozel Point, Utah, a horizon now mimed, redefined, and displaced by the outer rim of the *Jetty*. On the storyboard of the film Smithson composed the shot; it begins:

> North—Mud, salt crystals, rocks, water
> North by East—Mud, salt crystals, rocks, water
> Northeast by North—Mud, salt crystals, rocks, water
> Northeast by East—Mud, salt crystals, rocks, water
> East by North—Mud, salt crystals, rocks, water
> East—Mud, salt crystals, rocks, water...[36]

Moving steadily through the points of the compass—north, then east, then south, then west—Smithson's camera captures the sameness of a monotonous immensity. Unlike the Constructivist triumphal entry into the heart of the material object to conquer it cognitively, this centering acknowledges instead a kind of perceptual defeat, a great entropic assault on intuition that would, as Smithson wrote, "end in sunstroke." Looking for a geometry to end geometry, to collapse it utterly, Smithson found it in the "immense roundness" of his site, which he compared to a "rotary that enclosed itself." This site seemed to provide the means to undermine what Smithson viewed as the presumptuousness of the certainties produced by the art he knew. "No ideas, no concepts, no systems, no structures, no abstractions," he wrote, "could hold themselves together in the actuality of that evidence."[37]

In 1980 Serra located a work within a rotary, a site he found as crushingly disorienting as the sweep of Rozel Point. This site, a traffic roundabout at the New York City exit from the Holland Tunnel, Serra described as "a space polluted by exhaust fumes, a scene of incessant change, a hub, a place of rush hour glut, a place of disorientation and permanent rotation where, at various times of the day, the density of traffic screens the inner center of the Rotary, enforcing the distinction between the inside and the outside of the space so that the space seems to open and close with the traffic flow."[38]

St. John's Rotary Arc (figs. 23, 24) is thus, like Smithson's *Jetty*, a regular geometric form placed on a level, regularized "base," a ground that in its flatness compares to the "thermal mirror" of the Great Salt Lake from which the *Jetty* rises. And like Smithson, Serra imagined a certain narrative for the viewing of this work, a kind of cinematic scenario even though for a film never really contemplated. Further, like Smithson's shot plan, this scenario projects its angles according to the points of the compass: first east, then south, then west, then north—although it

must be noted that these compass points are urban, functions of the metropolitan grid. The scenario begins:

> On the East, Varick Street runs South, downtown: walking down Varick Street, the Arc foreshortens, expands and flattens to a plane. Standing on line with the visual center of the work (halfway down the block) its top edge curves outward and up at the limits of peripheral vision. Walking Varick, the Arc can be read as a site-specific metaphor in that it echoes the content of a tunnel: traffic appears, disappears, reappears.[39]

If Smithson's refrain, "mud, salt crystals, rocks, water," relates to the repetitive hum of Serra's contemporaneous *Hand Catching Lead*, the narrative of the *Rotary Arc* breaks away from that earlier serialized sameness. For, from its very outset—"the Arc foreshortens, expands and flattens to a plane"—we are introduced to change. Further, as was the case with the landscape pieces ("The sculptural elements act as barometers for reading the landscape"[40]), we are being invited to a "reading"; we are asked to enter a space with the expectation that it will yield up meaning. But that meaning arises, we also realize, within a network of coordinates for which there is no single center. We understand that for the *Rotary Arc*, no matter the geometrical regularities involved—the juxtaposition of the segment of a circle to the rectilinear, circumscribed ground of an urban setting (Varick Street, Laight Street, Hudson Street, Ericsson Street)—the preobjectival ground of sense is to be found in a fundamental experience of the body's own coordinates defined as pure difference. North-south-east-west equals, then, front/back, left/right.

The *Rotary Arc* locates two different centers. The first is its own center, the center of the circle of which it is a segment: "standing on line with the visual center of the work" is the filmic direction. But the second is the center of the site, that formed-but-formless *terrain vague* of gravel, whose center is given by the urban network "On the East, Varick Street runs South." The *Rotary Arc* is thus a 200-foot section of a vast circle much larger than the urban base of the Rotary on which it stands. That larger, projected circle, which would be 800 feet if completed, has as its center not the center of the Rotary but a point at its edge: "at the asphalt edge of the Rotary (Varick Street side) where the oval begins to contract." Hence the play of continual difference, the oscillating attractions of two eccentric orbits: the center of the site versus the center of the arc.

To be "inside" one space is to experience concavity, enclosure. To be "inside" the other is to witness the exteriority and the objectification of the convex. But as one walks around this work, which operates at the scale of the city itself, one is never wholly inside or outside; one is always moving "toward," reflexively defined as pure destination, as intentional movement. We return to the scenario:

> On the South, Ericsson Street runs East to Varick: walking across the exit ramp onto Ericsson Street toward Hudson Street, the curve snakes back on itself and reads as a half circle. Moving further down to the

Fig. 22. Robert Smithson
Spiral Jetty. Great Salt Lake, Utah. 1970
Black rock, salt crystals, earth, and water, coil
1,500' long, approx. 15' wide

Fig. 23. Opposite above: *St. John's Rotary Arc*,
1980, aerial view
Cor-Ten steel, 12 x 200' x 2½"
Installed Holland Tunnel exit, New York
Leo Castelli Gallery, New York

Fig. 24. Opposite below: *St. John's Rotary Arc*,
1980, view from northeast

corner of Hudson, the concavity is overlapped, abridged. The convex curve moves outward and away in a seemingly unending arc.

On the West, Hudson Street runs North, uptown: walking up Hudson Street the convexity of the Arc appears enigmatic, obdurate, wall-like. It flattens gradually to an elongated, slow curve, which appears concentric with the roundabout, when standing on axis with Hubert Street. Here, on line with the visual center of the convexity, the top edge curves downward and away at the limits of the peripheral vision.[41]

From this outside, then, facing this "obdurate, wall-like" closure, a viewer finds as the work's "inner horizon" the pull of peripheral vision itself, the activation of a field beyond, behind, outside of. Thus whether the work maps a trajectory ("the convex curve moves outward and away in a seemingly unending arc") or a barrier ("obdurate, wall-like"), it operates in the play of passage between a constant exchange of horizons. It is not so much an object as it is the map of a fluctuating set of exchanges. Serra's plot underscores this resistance to a condition for the work as object, fixed and knowable before, or outside of, lived experience. Neither the driver who circumnavigates the *Rotary Arc* nor the pedestrian who moves toward and along it "can ascribe the multiplicity of views to a Gestalt reading of the Arc. Its form remains ambiguous," Serra insists, "indeterminable, unknowable as an entity."[42]

That something might be "unknowable as an entity" does not affect the possibility of its entering into a system with a viewer who moves toward it intending to know, and uncovering through it the resonance of this intention. It does not matter from what angle such a viewer approaches the object, for there is no correct entry into this experience. A rational set of coordinates—north, west, south, east—may exist, "but not necessarily in that order." The film metaphor that Serra uses to plot the experience of *St. John's Rotary Arc* brings us back to that remark about narrative that Godard had placed in the mouth of one of the characters of *Two or Three Things I Know about Her* (1966), a film that also, interestingly enough, surveys an urban space by means of a 360-degree pan. "Stories have beginning, middles, and ends," we remember, "but not necessarily in that order." How one enters and where one leaves is variable; but all trajectories live in the indissoluble marriage of the spatial with the temporal, an experience which, if we can have it intensely enough, brings us to that preobjective condition for meaning I have been calling "the abstract subject" of Serra's art.

The abstract subject can be supported by a functional object, as in *Railroad Turnbridge*, and remain nonetheless abstract. It can be supported by the precise limits and conditions of a specific site as in *Rotary Arc*, with its concatenation of city streets at its boundaries, or *Tilted Arc*, positioned as it is at the particular interface between two eras of government construction. Nonetheless it remains abstract. The specificity of the site is not the subject of the work, but—in its articulation of the movement of the viewer's body-in-destination—its medium. In all of this—the imbrication of the abstract subject within the most carefully

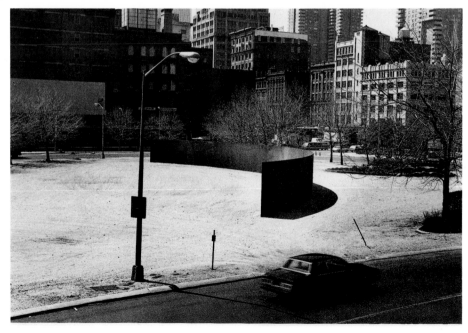

observed specificities of place, for it is only through the placing of the one in the other that the abstract subject can be made to appear—in this we may be reminded of another text, which, like the *Phenomenology of Perception*, serves to illuminate Serra's project without in any way being taken as a source. Rather, from some considerable distance, it functions as a thematic ground and a means of orientation.

The text to which I refer appears near the opening of Marcel Proust's *Remembrance of Things Past*, at the end of the section called "Combray." It involves a perception, or rather an interlocking set of perceptions, which we are shown not once but twice in succession: first in the narrative time within which the book is being written and then as a citation of a textual fragment written many years earlier and set down immediately after the author has just had the experience in question. By its narrative doubling, Proust underscores what he has already stated: this fragment possesses a talismanic quality in being the first real "writing" he ever produced; and as such it stands as a kind of promise for him of the possibilities of his art. This is all the more so, since, as he explains, it was accomplished at the moment when he despaired of ever becoming an author.

The text, simply an intensely specific description of the constant pivoting on the visual horizon of the two bell towers of the Cathedral of Martinville (Caen) and the one of Vieuxvicq, interrupts Proust's youthful notions that writing should concern itself with abstract ideas, or with "a philosophic theme." Siding with quite another set of experiences, it is a text that involves itself in the voluptuous, *changeant* glitter reflecting off the surfaces of things. Beneath this perceptual covering, the young Proust is sure that there lies something hidden, something important to grasp, although certainly nothing to do with the abstract truths so necessary to his literary ambitions. In search of this buried treasure, Proust tells us:

> I would concentrate upon recalling exactly the line of the roof, the colour of the stone, which, without my being able to understand why, had seemed to me to be teeming, ready to open, to yield up to me the secret treasure of which they were themselves no more than the outer coverings. It was certainly not any impression of this kind that could or would restore the hope I had lost of succeeding one day in becoming an author and poet, for each of them was associated with some material object devoid of any intellectual value, and suggesting no abstract truth. But at least they gave me an unreasoning pleasure, the illusion of a sort of fecundity of mind....[43]

The struggle to find this source of pleasure, this ground that lay beneath the surface of the objects without, however, suggesting for one instant that it could be translated into the realm of concepts, this perceptual thickening of experience into which he wished to delve, eluded Proust until the day he rode in an open coach down the winding road that first approached and then retreated from Martinville. Observing the perceptual network articulated by the towers, and his own ever-changing relation to them, he mapped his lived perspective within his written text, a section of which reads:

> ...we had left Martinville some little time, and the village, after accompanying us for a few seconds, had already disappeared, when lingering along on the horizon to watch our flight, its steeples and that of Vieuxvicq waved once again, in token of farewell, their sunbathed pinnacles. Sometimes one would withdraw, so that the other two might watch us for a moment still; then the road changed direction, they veered in the light like three golden pivots, and vanished from my gaze. But, a little later, when we were already close to Combray, the sun having set meanwhile, I caught sight of them for the last time, far away, and seeming no more now than three flowers painted upon the sky above the low line of fields.[44]

The "fecundity of mind," the meaning that operates at the heart of perception, is released, then, within a specific site, a precise situation that the young writer actually inhabits. The choreography that sets his movement and that of the towers into a mutually established set of limits—convex and concave, luminous and dark, expanding and contracting—makes apparent to him the spatio-temporal web that connects him to his world, that defines him as coexistent with it, being buoyed by it on "the same temporal wave." It is this subject—the temporality that connects him to things—that is released by a site articulated by the towers of Martinville.

The doubling of the Martinville passage models in small scale the repetitions of that same pleasure, released over and over again by specific sites established throughout Proust's novel, on which can be enacted other versions of that movement, renewed each time by the different conditions of the changed context. In a similar relation to what Proust had therefore called "Place Names," each of Serra's Arcs unfurls before its viewer within utterly new situations and thus new mediums for meaning.

Thus the *Rotary Arc*'s exchange between tunnel and street cannot open perspective in the same way that meaning occurs for the *Tilted Arc,* with its different conditions of interior and exterior, its relation between workplace and civic spaces. And neither of these can figure within the experience of movement created by the 1983 *Clara-Clara* in its original site. There its special momentum as one passed between its two opposing, but mirroring, halves, operated preobjectivally on the idea of the "gate," situated as it was along that magical trajectory of Parisian monuments that begins with the Arc de Triomphe, proceeds to the Place de la Concorde, and sweeps off to the Louvre.[45]

The repetition that is involved in the relocation of this same "simple" form is thus far removed from the kind of repetition that had defiantly been referred to in the 1960s as "just one thing after another." For in the meantime, this elusive thing that dilates within the body, this preobjectival, abstract ground of *meaning*, this pure intentionality, had emerged for Richard Serra behind the obdurate physical object, as his subject. Just one thing after another, we now might say, but not necessarily in that order.

Notes

1. Grégoire Müller and Gianfranco Gorgoni, *The New Avant-Garde: Issues for the Art of the Seventies* (New York, Washington, London: Praeger, 1972).

2. Gotthold Lessing, *Laocoön* (1766), trans. Ellen Frothingham (New York: Noonday, 1957), p. 92.

3. The kind of understanding to which I am referring has been variously characterized by those critics generally identified with "formalism." Clive Bell's idea of "significant form" could stand for this notion of a moment in which understanding subsumes and unifies the formal integers of a work. Stanley Cavell, in *Must We Mean What We Say?* (New York: Scribner's, 1969), p. 191, describes this aesthetic moment, in which the *sense* of the work of art is revealed, as follows: "…works of art are objects of the sort that can only be *known in sensing*…seeing *feels* like knowing. ('Seeing the point' conveys this sense, but in ordinary cases of seeing the point, once it's seen it's known, or understood; about works of art one may wish to say that they require a continuous seeing of the point.)" Michael Fried, in "Art and Objecthood," in Gregory Battcock, ed., *Minimal Art* (New York: Dutton, 1968), p. 146, conceives this "seeing of the point" as something that suffuses a given work, guaranteeing its experience as an instantaneously intuited whole. It follows from this, for example, that in viewing a great work of sculpture, the succession of different views of the work are *"eclipsed* by the sculpture itself—which it is plainly meaningless to speak of as only *partly* present. It is this continuous and entire presentness, amounting, as it were, to the perpetual creation of itself, that one experiences as a kind of *instantaneousness*: as though if only one were infinitely more acute, a single infinitely brief instant would be long enough to see everything, to experience the work in all its depth and fullness, to be forever convinced by it."

4. Donald Judd, "Specific Objects," *Arts Yearbook,* vol. 8 (1965), p. 82.

5. The photograph of Serra throwing lead was taken during the making of *Splashing with Four Molds: To Eva Hesse* (1969) at the Castelli Warehouse. This explored the same principle as *Casting* (1969), made for the 1969 exhibition "Anti-Illusion: Procedures/Materials," at the Whitney Museum of American Art, New York.

6. From *Richard Serra: Interviews, Etc. 1970–1980* (Yonkers, N.Y.: The Hudson River Museum, 1980), pp. 15–16.

7. *Ibid.,* p. 16.

8. Phyllis Tuchman, "An Interview with Carl Andre," *Artforum,* vol. 8 (June 1970), p. 55.

9. *Serra: Interviews,* pp. 48, 49. Carl Andre explains the importance of Brancusi and the *Endless Column* for his own development as a sculptor, in "An Interview with Carl Andre," pp. 55 and 61.

10. Harold Rosenberg, *The Tradition of the New* (New York: McGraw-Hill, 1965), pp. 27–28.

11. *Ibid.,* p. 31.

12. From Bruce Glaser's 1964 interview with Donald Judd and Frank Stella, reprinted in Battcock, ed., *Minimal Art,* p. 161.

13. *Ibid.,* p. 159. For Judd's objection to the metaphysics of the Action Painters, see p. 151.

14. Emily Wasserman, "An Interview with Composer Steve Reich," *Artforum,* vol. 10 (May 1972), p. 48.

15. *Serra: Interviews,* p. 168.

16. *Serra: Interviews,* pp. 94–95.

17. *Ibid.,* p. 61.

18. *Ibid.,* p. 62.

19. Maurice Merleau-Ponty, *The Phenomenology of Perception* (Paris, 1945), trans. Colin Smith (London: Routledge & Kegan Paul, 1962), p. 68.

20. *Ibid.,* p. 261.

21. *Ibid.,* p. 258.

22. *Ibid.,* p. 259.

23. Jean-Paul Sartre, "La Recherche de l'absolu," *Les Temps modernes,* vol. 3 (1948), p. 1161. Reprinted in *Situations III* (Paris: Gallimard, 1948), pp. 289–305.

24. Merleau-Ponty, p. 283.

25. *Serra: Interviews,* pp. 25–28. Serra further describes the piece: "There are two sets of stepped walls, with three elements in each set. The walls span two hills which are, at their height, approximately 1500 feet apart. Each element begins flush with the ground and extends for the distance that it takes the land to drop five feet. The direction is determined by the most critical slope of the ground"; *ibid.,* p. 25.

26. Merleau-Ponty, p. 75.

27. *Ibid.,* p. 67.

28. *Ibid.,* p. 90.

29. *Ibid.,* p. 68.

30. *Ibid.,* p. 255.

31. *Serra: Interviews,* p. 99.

32. See Annette Michelson, "Toward Snow," *Artforum,* vol. 9 (June 1971), pp. 30–37.

33. Merleau-Ponty, p. 265.

34. *Ibid.,* p. 254.

35. *Serra: Interviews,* p. 72.

36. *The Writings of Robert Smithson,* ed. Nancy Holt (New York: New York University Press, 1979), p. 113.

37. *Ibid.,* p. 111.

38. *Serra: Interviews,* p. 154.

39. *Ibid.,* p. 156.

40. Richard Serra and Peter Eisenman, "Interview," *Skyline* (April 1983), p. 16.

41. *Serra: Interviews,* p. 160.

42. *Ibid.,* p. 161.

43. Marcel Proust, *Swann's Way,* trans. C. K. M. Scott-Moncrieff (New York: Vintage, 1970), p. 137.

44. *Ibid.,* p. 139.

45. For a brilliant and precise analysis of this work, see Yve-Alain Bois, "A Picturesque Stroll around *Clara-Clara,"* *October,* no. 29 (Summer 1984), pp. 32–62.

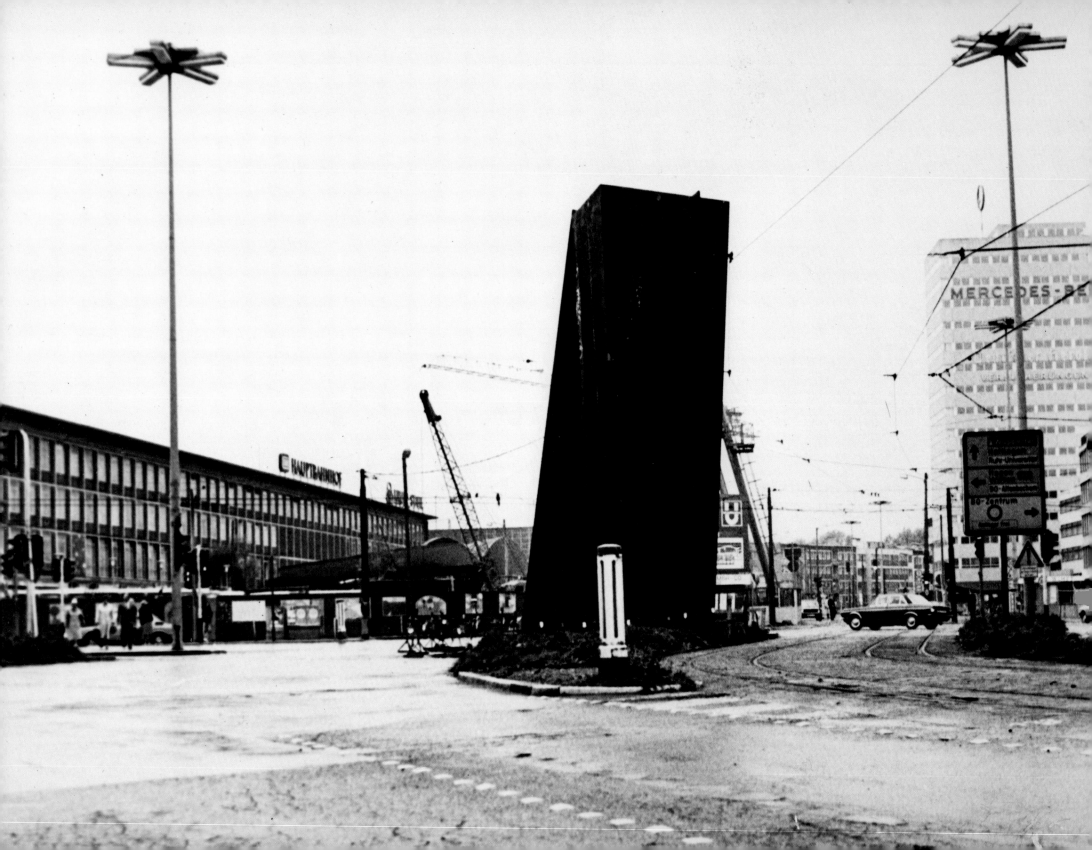

Serra's Public Sculpture: Redefining Site Specificity

Douglas Crimp

I know that there is no audience for sculpture, as is the case with poetry and experimental film. There is, however, a big audience for products which give people what they want and supposedly need, and which do not attempt to give them more than they understand.

—Richard Serra, "Extended Notes from Sight Point Road"

It is better to be an enemy of the people than an enemy of reality.

—Pier Paolo Pasolini, "Unhappy Youths"

Fig. 1. Opposite: *Terminal.* 1977
Cor-Ten steel, four trapezoidal plates, each 41′ x
12 to 9′ (irregular) x 2½″
Installed Bochum, West Germany
Stadt Bochum, West Germany

Author's note: This essay represents my position on site specificity as I was led to consider the issue in relation to the crisis over Richard Serra's *Tilted Arc*, a crisis that pushed my earlier ideas in a new direction, redefining the very terms of the problem. That this position may be at variance with that of The Museum of Modern Art, indeed of most art institutions, will be obvious from the argument. Transcending the differences between the Museum and myself, however, is our shared conviction of the importance of Serra's work. D.C.

The site was an old warehouse on the Upper West Side in Manhattan used by the Leo Castelli Gallery for storage; the occasion, an exhibition organized by Minimal sculptor Robert Morris; the moment, December 1968. There, strewn upon the cement floor, affixed to or leaning against the brick walls, were objects that defied our every expectation regarding the form of the work of art and the manner of its exhibition. It is difficult to convey the shock registered then, for it has since been absorbed, brought within the purview of normalized aesthetics, and, finally, consigned to a history of an avant-garde now understood to be finished. But, for many of us who began to think seriously about art precisely because of such assaults on our expectations, the return to convention in the art of the 1980s can only seem false, a betrayal of the processes of thought that our confrontations with art had set in motion. And so we try again and again to recover that experience, to make it available to those who now complacently spend their Saturday afternoons in SoHo galleries viewing paintings that smell of fresh linseed oil and sculptures that are once again cast in bronze.

Of the things in that warehouse, certainly none was more defiant of our sense of the aesthetic object than Richard Serra's *Splashing* (fig. 2). Along the juncture where wall met floor, Serra had tossed molten lead and allowed it to harden in place. The result was not really an object at all; it had no definable shape or mass; it created no legible image. We could, of course, say that it achieved the negation of categories that Donald Judd had, some years earlier, ascribed to "the best new work": "neither painting nor sculpture."[1] And we could see that by effacing the

Fig. 2. *Splashing.* 1968
Lead, 18″ x 26′
Installed Castelli Warehouse, New York
Destroyed

line where the wall rose up perpendicular to the floor, Serra was obscuring a marker for our orientation in interior space, claiming that space as the ground of a different kind of perceptual experience. Our difficulty with *Splashing* was in trying to imagine its very possibility of continued existence in the world of art objects. There it was, attached to the structure of that old warehouse on the Upper West Side, condemned to be abandoned there forever or to be scraped off and destroyed. For to remove the work meant certainly to destroy it.

"To remove the work is to destroy the work." It is with this assertion that Serra sought to shift the terms of debate in a public hearing convened to determine the fate of *Tilted Arc* (1981).[2] Serra's sculpture had been commissioned by the General Services Administration (GSA) Art-in-Architecture Program and installed in the plaza of the Jacob K. Javits Federal Building in Lower Manhattan during the summer of 1981. In 1985, a newly appointed GSA regional administrator presumed to reconsider its presence there, to ask whether it might be "relocated" elsewhere. In testimony after testimony at that hearing, artists, critics, museum officials, and others pleaded the case for site specificity that Serra's assertion implied. The work was conceived for the site, built on the site, had become an integral part of the site, altered the very nature of the site. Remove it and the work would simply cease to exist. But, for all its passion and eloquence, the testimony failed to convince the adversaries of *Tilted Arc.* To them the work was in conflict with its site, disrupted the normal views and social functions of the plaza, and, indeed, would be far more pleasant to contemplate in a landscape setting. There, presumably, its size would be less overwhelming to its surroundings, its rust-colored steel surface more harmonious with the colors of nature.

The larger public's incomprehension in the face of Serra's assertion of site specificity is the incomprehension of the radical prerogatives of a historic moment in art practice. "To remove the work is to destroy the work" was made self-evident to anyone who had seen *Splashing*'s literalization of the assertion, and it is that which provided the background of *Tilted Arc* for its defenders. But they could not be expected to explain, within the short time of their testimonies, a complex history which had been deliberately suppressed. The public's ignorance is, of course, an enforced ignorance, for not only is cultural production maintained as the privilege of a small minority within that public, but it is not in the interests of the institutions of art and the forces they serve to produce knowledge of radical practices even for their specialized audience. And this is particularly the case for those practices whose goal was a materialist critique of the presuppositions of those very institutions. Such practices attempted to reveal the material conditions of the work of art, its mode of production and reception, the institutional supports of its circulation, the power relations represented by these institutions—in short, everything that is disguised by traditional aesthetic discourse. Nevertheless, these practices have subsequently been recuperated by that very discourse as reflecting just one more episode in a continuous development of modern art. Many of *Tilted Arc*'s defenders, some representing official art policies, argued for a notion of

site specificity that reduced it to a purely aesthetic category. As such, it was no longer germane to the presence of the sculpture on Federal Plaza. The specificity of *Tilted Arc*'s site is that of a particular public place. The work's material, scale, and form intersect not only with the formal characteristics of its environment, but also with the desires and assumptions of a very different public from the one conditioned to the shocks of the art of the late 1960s. Serra's transfer of the radical implications of *Splashing* into the public realm, deliberately embracing the contradictions this transfer implies, is the real specificity of *Tilted Arc.*

When site specificity was introduced into contemporary art by Minimal artists in the mid-1960s, what was at issue was the idealism of modern sculpture, its engagement of the spectator's consciousness with sculpture's own internal set of relationships. Minimal objects redirected consciousness back upon itself and the real-world conditions which ground consciousness. The coordinates of perception were established as existing not only between the spectator and the work but among spectator, artwork, and the place inhabited by both. This was accomplished either by eliminating the object's internal relationships altogether or by making those relationships a function of simple structural repetition, of "one thing after another."[3] Whatever relationship was now to be perceived was contingent upon the viewer's temporal movement in the space shared with the object. Thus, the work belonged to its site; if its site were to change, so would the interrelationship of object, context, and viewer. Such a reorientation of the perceptual experience of art made the viewer, in effect, the subject of the work, whereas under the reign of Modernist idealism, this privileged position devolved ultimately upon the artist, the sole generator of the artwork's formal relationships. The critique of idealism directed against modern sculpture and its illusory sitelessness was, however, left incomplete. The incorporation of place within the domain of the work's perception succeeded only in extending art's idealism to its surrounding site. Site was understood as specific only in a formal sense; it was thus abstracted, aestheticized. Carl Andre, who made the claim that sculpture, formerly equated with form and structure, was now to be equated with place, was asked about the implications of moving his works from one place to another. His reply: "I don't feel myself obsessed with the singularity of places. I don't think spaces are that singular. I think there are generic classes of spaces which you work for and toward. So it's not really a problem where a work is going to be in particular."[4] And Andre enumerated these spaces: "Inside gallery spaces, inside private dwelling spaces, inside museum spaces, inside large public spaces, and outside spaces of various kinds too."[5]

Andre's failure to see the singularity of the "generic classes of spaces" he "worked for and toward" was the failure of Minimal art to produce a fully materialist critique of Modernist idealism. That critique, initiated in the art production of the following years, would entail an analysis of, and resistance to, art's institutionalization within the system of commerce represented by those spaces listed by Andre. If modern artworks existed in relation to no specific site and were therefore said to be autonomous, homeless, that was also the precondi-tion of their circulation: from the studio to the commercial gallery, from there to the collector's private dwelling, thence to the museum or lobby of a corporate headquarters. The real material condition of modern art, masked by its pretense to universality, is that of the specialized luxury commodity. Engendered under capitalism, modern art became subject to the commodification from which nothing fully escapes. And in accepting the "spaces" of art's institutionalized commodity circulation as given, Minimal art could neither expose nor resist the hidden material conditions of modern art.

The task was taken up in the work of artists who radicalized site specificity, artists as various as Daniel Buren and Hans Haacke, Michael Asher and Lawrence Weiner, Robert Smithson and Richard Serra. Their contributions to a materialist critique of art, their resistance to the "disintegration of culture into commodities,"[6] were fragmentary and provisional, the consequences limited, systematically opposed or mystified, ultimately overturned. What remains of this critique today are a history to be recovered and fitful, marginalized practices that struggle to exist at all in an art world more dedicated than ever before to commodity value.

That history cannot be recovered here; it can only be claimed as necessary for any genuine understanding of Richard Serra's *Splashing* and what he was to make afterward. We need hardly be reminded of the dangers inherent in divorcing art practices from the social and political climates in which they took place; in this case, the very mention of the year 1968 as the date of *Splashing* should serve sufficient notice. The following paragraphs, written in France by Daniel Buren just one month after the events of May '68 and published the following September, may provide a reminder of the political consciousness of artists of the period.

We can find challenges to tradition back in the 19th century—indeed (considerably) earlier. And yet since then countless traditions, academicisms, countless new taboos and new schools have been created and overthrown!

Why? Because those phenomena against which the artist struggles are only epiphenomena or, more precisely, they are only the superstructures built on the base that conditions art and is art. And art has changed its traditions, its academicisms, its taboos, its schools, etc., at least a hundred times, because it is the vocation of what is on the surface to be changed, endlessly, and so long as we don't touch the base, nothing, obviously, is fundamentally, *basically,* changed.

And that is how art evolves, and that is how there can be art history. The artist challenges the easel when he paints a surface too large to be supported by the easel, and then he challenges the easel and the over-large surface by turning out a canvas that's also an object, and then just an object; and then there is the object to be made in place of the object made, and then a mobile object or an untransportable object, etc. This [is said] merely by way of an example, but intended to demonstrate that if there is a possible challenge it cannot be a formal one, it can only be basic, on the level of art and not on the level of the forms given to art.[7]

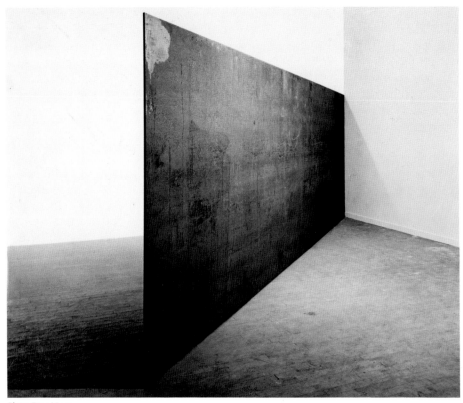

Fig. 3. *Strike: To Roberta and Rudy.* 1969–71
Hot rolled steel, 8 x 24′ x 1″
Installed Lo Giudice Gallery, New York, 1971–72
Collection Giuseppe Panza di Biumo, Varese, Italy

The Marxist terminology of Buren's text locates him in a political tradition very different from that of his American colleagues. Moreover, among the artists of his generation, Buren has been the most systematic in his analysis of art in relation to its economic and ideological bases, and thus he has reached a far more radical conclusion: that the changes wrought upon art within practice must be "basic," not "formal." In spite of Richard Serra's continued work with the "forms given to art," however, he has incorporated important components of a materialist critique. These include his attention to the processes and divisions of labor, to art's tendency toward the conditions of consumption, and to the false separation of private and public spheres in art's production and reception. Although Serra's work is not systematic or even consistent in this regard, even the contradictory manner in which he has taken a critical position has produced reactions that are often perplexed, outraged, sometimes violent. Determined to build his work outside the confines of art institutions, Serra has met opposition from public officials who have often been quick to manipulate public incomprehension for the purpose of suppressing the work.[8]

The extraordinary status that has accrued to the work of art during the modern period is, in part, a consequence of the romantic myth of the artist as the most highly specialized, indeed unique producer. That this myth obscures the social division of labor was recognized by Minimal artists. Traditional sculpture's specialized craft and highly fetishized materials were opposed by Minimalism with the introduction of objects industrially fabricated of ordinary manufactured materials. Dan Flavin's fluorescent lights, Donald Judd's aluminum boxes, and Carl Andre's metal plates were in no way products of the artist's hand. Serra, too, turned to industrial materials for his early sculpture, but at first he worked those materials himself or with the help of friends. Using lead, and working at a scale proportionate to hand manipulation, his early torn, cast, and propped pieces were still evidence of the artist's activity, however much the processes Serra employed differed from the conventional crafts of carving, modeling, and welding. But when, in 1971, Serra installed *Strike* (fig. 3) in the Lo Giudice Gallery, New York, his working procedure was transformed. *Strike* was only a single plate of hot-rolled steel, one inch thick, eight feet high, twenty-four feet long, and weighing nearly three tons. That steel plate was not, however, the work. To become the sculpture *Strike,* the steel plate had to occupy a site, to assume its position wedged into the corner of the gallery room, bisecting the right angle where wall met wall. But there is no operation of the artist's craft that would accomplish this simple fact. The steel's tonnage required yet another industrial process than the one which produced the plate itself. That process, known as rigging, involves the application of the laws of mechanics, usually with the aid of machinery, "to put [material] in condition or position for use."[9] Beginning with *Strike,* Serra's work would require the professional labor of others, not only for the manufacture of the sculpture's material elements but also to "make" the sculpture, that is, to put it in its condition or position for use, to constitute the material *as* sculpture (figs. 4–7). It is this exclusive reliance on the industrial labor force (a force signaled with a very

particular resonance in the sculpture's name) that distinguishes Serra's production after the early 1970s as public in scope, not only because the scale of the work had dramatically increased, but because the private domain of the artist's studio could no longer be the site of production. The place where the sculpture would stand would be the place where it was made; its making would be the work of others.

Characterizations of Serra's work as macho, overbearing, aggressive, oppressive, seek to return the artist to the studio, to reconstitute him as the work's sole creator, and thereby to deny the role of industrial processes in his sculpture. While any large-scale sculpture requires such processes, while even the manufacture of paint and canvas require them, the labor that has been expended in them is nowhere to be discerned in the finished product. That labor has been mystified by the artist's own "artistic" labor, transformed by the artist's magic into a luxury commodity. Serra not only refuses to perform the mystical operations of art but also insists upon confronting the art audience with materials that otherwise never appear in their raw state. For Serra's materials, unlike those of the Minimal sculptors, are materials used only for the means of production. They normally appear to us transformed into finished products, or, more rarely, into the luxury goods that are works of art.[10]

The conflict between the product of heavy industry, unavailable for luxury consumption, and the sites of its exhibition, the commercial gallery and museum, intensified as Serra developed the implications of *Strike* toward the total negation of the normal functions of gallery spaces. Rather than subserviently taking their cues from the formal conditions of room spaces, as site-specific works increasingly tied to purely aesthetic ideas began to do, Serra's sculptures worked not "for and toward" but against those spaces. The enormous steel-plate walls of *Strike, Circuit* (1972, pl. 66), and *Twins* (1972, pl. 67) took on new dimensions with *Slice* (1980, pl. 87), *Waxing Arcs* (1980, pl. 86), *Marilyn Monroe–Greta Garbo* (1981, pl. 91), and *Wall to Wall* (1983, pl. 102). These dimensions were also assumed in the horizontal steel-plate works *Delineator* (1974–75, pl. 74) and *Elevator* (1980, pl. 88), and by the forged-steel block pieces *Span* (1977, pl. 78) and *Step* (1982, pl. 96). Testing and straining against the outer limits of structural, spatial, visual, and circulatory capacity, these works pointed to another sort of specificity of the site of art, its specific historical origins in the bourgeois interior. For if the historical form of the modern artwork was conceived for its function in adorning that private interior space, if the museum-goer could always imagine the painting by Picasso or the sculpture by Giacometti transposed back inside the private dwelling, it was hardly so comfortable a thought to imagine a steel wall slicing through one's living room. "Inside private dwelling spaces" would no longer be congenial sites for Serra's sculpture, and thus another of art's private domains was defeated by Serra's use of heavy industrial materials and their mode of deployment. At the same time, art's institutional exhibition spaces, surrogates of the private domicile, were revealed as determining, constraining, drastically limiting art's possibilities.

By the time Serra installed these later works in commercial galleries and museums, he had already transferred much of his activity out-of-doors into the

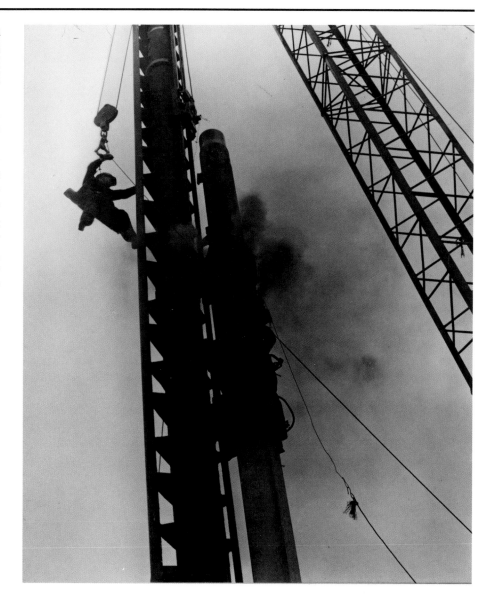

Fig. 4. Pile driver preparing the foundation for *Sight Point* (pl. 71), Stedelijk Museum, Amsterdam, 1974

Fig. 5. Forging of *Berlin Block for Charlie Chaplin* (pl. 80), Henrichshütte, Hattingen, West Germany, 1977

landscape and cityscape. The sheer implausibility of the indoor works, shoehorned as they are into clean white rooms, imposes the terms of a truly public sculptural experience within the confines of the usually private site. In effect, Serra reversed the direction generally taken by sculpture as it ventures into public space, the direction concisely spelled out in one critic's statement of resignation: "All we can ever do is put private art in public places."[11] Unwilling, as we shall see, to accept this calcified idea of private versus public, Serra insists rather upon bringing the lessons learned on the street, as it were, back into the gallery. In the process the gallery-goer (*Marilyn Monroe–Greta Garbo* is subtitled "A Sculpture for Gallery-Goers") is made excruciatingly aware of the gallery's limitations, of the stranglehold it exerts on the experience of art. By turning the tables on the gallery, holding the gallery hostage to sculpture, Serra defies the gallery's hegemony, declares it a site of struggle. That the terms of this struggle hinge in part upon questions of the private versus the public site of art is demonstrated by *Slice* (fig. 8), installed in the Leo Castelli Gallery on Greene Street, New York, in 1980. A continuous curve of steel plates, ten feet high and over one hundred and twenty-four feet long, the sculpture sliced through the gallery's deep space and lodged itself into the two corners of one of the long walls. The room was thereby divided into two noncommunicating areas, an area on the convex side of the curve, which we may designate as public, and a concave interior "private" area. Entering the gallery from the street, the gallery-goer followed the curve from an expansive open space through the compression where curve closed in closer to the long wall and then opened out again into the gallery's back wall. The sensation was that of being on the outside, cut off from the real function of the gallery, unable to see its operations, its office, its personnel. Leaving the gallery and reentering through the door off the lobby, the gallery-goer was now "inside," confined in the concavity of the curve, privy to the gallery's commercial dealings. In thus experiencing the two sides of *Slice* as extraordinarily different spatial sensations, neither imaginable from the other, one also experienced the always present and visible but never truly apparent relations between the gallery as a space of viewing and as a space of commerce. In installing a work that could not partake of the commercial possibilities of commodity circulation, Serra was nevertheless able to make that condition of the gallery a part of the work's experience, if only in abstract, sensory terms.

But possibilities of disrupting the power of galleries to determine the experience of art are exceedingly limited, dependent as they are upon the willingness of the contested institution. This is also true, of course, for museums, even though the latter might claim greater neutrality with respect to all art practices, even those that question the privatization of culture as a form of property. The museum, however, in the benevolence of this neutrality, simply substitutes an ideologically constituted concept of private expression for the gallery's commercial concept of private commodities. For the museum as an institution is constituted to produce and maintain a reified history of art based on a chain of masters, each offering his private vision of the world. Although his work does not participate in this myth, Serra is aware that within the museum it will be seen that way in any case:

In all my work the construction process is revealed. Material, formal, contextual decisions are self-evident. The fact that the technological process is revealed depersonalizes and demythologizes the idealization of the sculptor's craft. The work does not enter into the fictitious realm of the "master."…My works do not signify any esoteric self-referentiality. Their construction leads you into their structure and does not refer to the artist's persona. However, as soon as you put a work into a museum, its label points first to the author. The visitor is asked to recognize "the hand." Whose work is it? The institution of the museum invariably creates self-referentiality, even where it's not implied. The question, how the work functions, is not asked. Any kind of disjunction the work might intend is eclipsed. The problem of self-referentiality does not exist once the work enters the public domain. How the work alters a given site is the issue, not the persona of the author. Once the works are erected in a public space, they become other people's concerns.[12]

When Serra first moved out of the institutions of art, he moved very far indeed. It was 1970. Robert Smithson had built the *Spiral Jetty* (1970) in the Great Salt Lake in Utah; Michael Heizer had carved *Double Negative* (1969) into the Virgin River Mesa of Nevada; Serra himself was planning *Shift* (pl. 60), the large outdoor work in King County, Canada. For all the excitement generated by the development of earthworks, however, Serra found such isolated sites unsatisfactory. An urban artist working with industrial materials, he discovered that the vast and inevitably mythologized American landscape was not his concern, nor were the pathos and mock heroism of working in isolation from an audience. "No," he said, "I would rather be more vulnerable and deal with the reality of my living situation."[13] Serra negotiated with New York City officials for a site in the city, and eventually they granted him a permit to construct a work in an abandoned dead-end street in the Bronx. There, in 1970, Serra built *To Encircle Base Plate Hexagram, Right Angles Inverted* (fig. 9), a circle of steel angle, twenty-six feet in diameter, embedded in the surface of the street. Half the circle's circumference was a thin line, one inch wide; the other half, the angle's flange, eight inches wide. From a distance, at street level, the work was invisible; only when the viewer came directly upon it did the work materialize. Standing within its circumference, the viewer could reconstruct its sculptural bulk, half buried under grade. There was, however, a second approach, also from a distance, from which the work was visible in a different way. The dead-end street gave on to stairways leading up to an adjoining street at a higher level; from there the street below appeared as a "canvas" upon which the steel circle was "drawn." This reading of figure against ground, rather than reconstructing material bulk *in* the ground, worried Serra, seeming to him once again the pictorialism into which sculpture always tended to lapse, a pictorialism he wished to defeat with the sheer materiality and duration of experience of his work. Moreover, this deceptive pictorialism coincided with another way of reading the sculpture that Serra did not

Fig. 6. Rigging of *Elevator* (pl. 88), by Ray LaChapelle and Sons, steelriggers, The Hudson River Museum, Yonkers, N.Y., 1980

Fig. 7. Forming of *Clara-Clara* (pl. 104), steel mill, West Germany, 1983

foresee and that came to represent for him a fundamental deception against which he would position his work. That deception was the *image* of the work as against the actual experience of it.

To Encircle's site was, as Serra described it, "sinister, used by the local criminals to torch cars they'd stolen."[14] Clearly those "local criminals" were not interested in looking at sculpture—pictorial or not—and it was Serra's misconception that anyone from the art world was interested enough in sculpture to venture into that "sinister" outpost in the Bronx. The work existed, then, in precisely the form in which earthworks exist for most people—as documents, photographs. They are transferred back into the institutional discourses of art through reproduction, one of the most powerful means through which art has been abstracted from its contexts throughout the modern era. For Serra, the whole point of sculpture is to defeat this surrogate consumption of art, indeed to defeat consumption altogether and to replace it with the experience of art in its material reality:

> If you reduce sculpture to the flat plane of the photograph, you're passing on only a residue of your concerns. You're denying the temporal experience of the work. You're not only reducing the sculpture to a different scale for the purposes of consumption, but you're denying the real content of the work. At least with most sculpture, the experience of the work is inseparable from the place in which the work resides. Apart from that condition, any experience of the work is a deception.
>
> But it could be that people want to consume sculpture the way they consume paintings—through photographs. Most photographs take their cues from advertising, where the priority is high image content for an easy Gestalt reading. I'm interested in the experience of sculpture in the place where it resides.[15]

Serra's attempts to enforce the difference between an art for consumption and a sculpture to be experienced in the place where it resides would, however, embroil him in constant controversy. The first work Serra proposed for a truly public location was never allowed to occupy the site for which it was intended. After winning a competition in 1971 for a sculpture for the Wesleyan University campus in Middletown, Connecticut, Serra's *Sight Point* was ultimately rejected by the university's architect as "too large and too close to the campus's historical building."[16] It was, of course, just this size and proximity that Serra had wanted. *Sight Point* is one of a number of large-scale works that employ the principles developed in the early Prop Pieces, principles of construction that rely exclusively on the force of gravity. But at their greatly increased scale and in their particular public settings, these works no longer use those principles merely to oppose the formal relationships obtaining in Modernist sculpture; now they come into conflict with another form of construction, that of the architecture of their surroundings. Rather than playing the subsidiary role of adornment, focus, or enhancement of their nearby buildings, they attempt to engage the passerby in a new and critical

Fig. 8. *Slice.* 1980
Cor-Ten steel, 10' x 124'6" x 1½"
Leo Castelli Gallery and Blum Helman Gallery,
New York, and collection the artist

reading of the sculptures' environment. By revealing the processes of their construction only in the active experience of sequential viewing, Serra's sculptures implicitly condemn architecture's tendency to reduce to an easily legible image, to collapse into, precisely, a facade. It is that reduction to facade, the pictorial product of the architect's drawing board, site of the architect's expressive mastery, that, presumably, the Wesleyan University architect wanted to protect for the campus's "historical building."[17]

When asked what *Sight Point* (1971–75, pl. 71) lost by being built in the back court of the Stedelijk Museum in Amsterdam instead of its intended location, Serra replied simply: "What happened with *Sight Point* was that it lost all relationship to a pattern of circulation, which was a major determinate for its original location at Wesleyan."[18] Serra recognized that even public art was generally granted only the function of aesthetic enhancement in the seclusion of museumlike sites, removed from normal circulation patterns and placed, as it were, on ideological pedestals:

> Usually you're offered places which have specific ideological connotations, from parks to corporate and public buildings and their extensions such as lawns and plazas. It's difficult to subvert those contexts. That's why you have so many corporate baubles on Sixth Avenue [New York], so much bad plaza art that smacks of IBM, signifying its cultural awareness.... But there is no neutral site. Every context has its frame and its ideological overtones. It's a matter of degree. There is one condition that I want, which is a density of traffic flow.[19]

It was just such a density of traffic flow that Serra found for *Terminal* (1977, figs. 1, 10), erected in the very center of the German city of Bochum in the central hub of commuter traffic. "The streetcars miss it by a foot and a half."[20]

Terminal is a prop construction of four identical trapezoidal plates of Cor-Ten steel, forty-one feet high. The plates were manufactured at the Thyssen steelworks in the nearby company town of Hattingen, one of a number of such towns in the Revier industrial region of which Bochum is the capital city. Although *Terminal* was initially built in Kassel for Documenta 6, Serra meant the work for its present site, in part because he wanted it located in the center of the steel-producing district where its plates were manufactured.[21] It is this social specificity of its site, however, that would cause a furor over *Terminal*.

At first the work aroused a response not unusual for Serra's public sculpture: graffiti identifying it as a toilet or warning of rats, letters to the editors of local newspapers deploring the huge expenditure of city funds, declaring the work ugly and inappropriate. As the controversy widened, and as city council elections neared, the Christian Democratic party (CDU) seized upon it as the focus for its political campaign against the firmly entrenched Social Democrats, who had voted to purchase the work for the city. Vying for the votes of the steelworkers, who constitute a majority of the region's electorate, the CDU printed campaign posters

Fig. 9. Installation of *To Encircle Base Plate Hexagram, Right Angles Inverted* (pl. 48), 183 Street and Webster Avenue, the Bronx, New York, 1970

Fig. 10. *Terminal.* 1977

showing a photograph of *Terminal* montaged against one of a steel mill (fig. 11). The slogan announced: "This will never happen again—CDU for Bochum." The Christian Democrats' objections to *Terminal* are extremely revealing of the issues raised in Serra's public sculptures, especially insofar as his abstract vocabulary intersects with explicit social and material conditions. It is therefore worth quoting at length from the press release issued by the CDU stating its position on *Terminal*:

> The supporters of the sculpture refer to its great symbolic value for the Revier region generally and for Bochum in particular as the home of coal and steel. We believe the sculpture lacks important qualities that would enable it to function as such a symbol. Steel is a special material whose production demands great craftsmanship, professional and technical know-how. The material has virtually unlimited possibilities for the differentiated, even subtle treatment of both the smallest and the largest objects, both the simplest and the most artistically expressive forms.
>
> We do not believe this sculpture expresses any of these things since it looks like a clumsy, undifferentiated, half-finished "ingot." No steel-worker can point to it positively, with pride.
>
> Steel signifies boldness and elegance in the most varied construc-tions; it does not signify monstrous monumentality. This sculpture is frightening because of its awkward massiveness, untempered by any other attributes. Steel is also a material that, to a great degree, suggests resilience, durability, and resistance to rust. This is especially true of the high-quality steel produced in Bochum. This sculpture, made only of simple steel, is already rusted and disgusting in appearance. Steel is a high-quality material developed from iron and so is not a true raw material. Yet this sculpture gives the impression of raw material... extracted from the earth and given no special treatment.
>
> If, as its supporters claim, the sculpture is to symbolize coal and steel, it must provide the possibility of positive identification for those concerned, that is, for the citizens of this area, especially the steel-workers. We believe that all of the characteristics mentioned provide no positive challenge and identification. We fear the opposite will occur, that rejection and scorn will not only result initially but will intensify over time. That would be a burden not only for this sculpture but for all self-contained modern artworks. Such cannot be the goal of a responsi-ble cultural policy.[22]

For the Christian Democrats, now presiding over record unemployment in Germany,[23] to claim that they represent the steelworkers' interests is hypocritical, and the steelworkers demonstrated at the polls that they were undeceived in this regard: the Social Democrats retained power in the region. What is important here, however, is the nature of the demand made on public art to provide the working class with symbols to which they can point with pride, with which they can positively identify. Now, hidden in this demand, it could be argued, is the

requirement that the artist symbolically reconcile the steelworkers to the brutal working conditions to which they are subjected. Steel, the material which the citizens of the Revier region work with daily, is to be used by the artist only to symbolize boldness and elegance, resilience and durability, the unlimited possibilities for subtle treatment and expressive form. It is, in other words, to be disguised, made unrecognizable to those who have produced it. Serra's work flatly refuses this implicitly authoritarian symbolism, which would convert steel from raw material—although processed, steel is a raw material in the capitalist economic structure[24]— to a signifier of invincibility. Instead Serra presents the steelworker with the very product of his alienated labor, untransformed into any symbol at all. If the worker is then repelled, heaps scorn on *Terminal,* it is because he is already alienated from the material; for although he produced those steel plates, or materials like them, he never owned them; the steelworker has no reason whatsoever to take pride in or identify with any steel product. In asking the artist to give the workers a positive symbol, I would suggest that the CDU is really asking the artist to provide a symbolic form of consumption; for the CDU does not, in any case, wish to think of the worker as a worker, but rather as a consumer.[25]

The Bochum CDU's goal of a "responsible cultural policy" that would not be a burden for "self-contained modern artworks" parallels official public art policies in the United States that have emerged and expanded over the past twenty years. Taking for granted that art is private self-expression, these policies are concerned with the various possibilities of transferring such an art into the public realm without offending public expectations. In an essay tellingly entitled "Personal Sensibilities in Public Places," John Beardsley, who worked for the Art in Public Places Program of the National Endowment for the Arts and was commissioned to write a book about it, explains how the artists' private concerns can be made palatable for the public:

> An artwork can become significant to its public through the incorporation of content relevant to the local audience, or by the assumption of an identifiable function. Assimilation can also be encouraged through a work's role in a larger civic improvement program. In the first case, recognizable content or function provides a means by which the public can become engaged with the work, though its style or form might be unfamiliar to them. In the latter, the work's identity as art is subsumed by a more general public purpose, helping to assure its validity. In both cases, the personal sensibilities of the artist are presented in ways that encourage widespread public empathy.[26]

One of Beardsley's prime examples of the empathy solicited through recognizable content involves a public much like that for *Terminal:*

> [George] Segal was awarded his commission by the Youngstown Area Arts Council. He visited the city and toured its steel mills, finding the

Fig. 11. Christian Democratic party (CDU) campaign poster, Bochum, West Germany, 1979

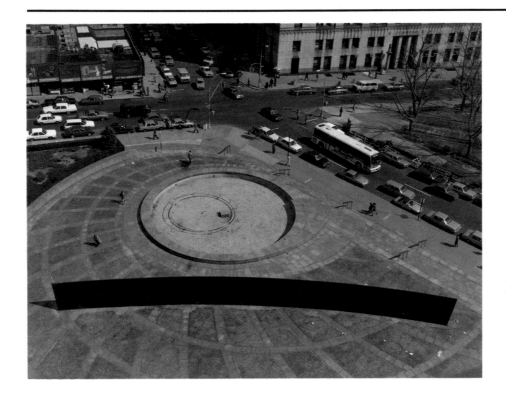

open hearth furnaces "staggeringly impressive." He decided to make steelworkers at an open hearth the subject of his sculpture, and used as models Wayman Paramore and Peter Kolby, two men selected by the steelworkers union from its membership. His commission coincided with a severe economic crisis in Youngstown during which a series of mill shutdowns eventually idled some 10,000 workers. Yet completion of the sculpture became a matter of civic pride. Numerous local businesses and foundations gave money; one of the steel companies donated an unused furnace. Labor unions assisted in fabricating and installing the work. One cannot escape the conclusion that the subject matter was largely responsible for this outpouring of public support. The people of Youngstown sought a monument to their principal industry, even as it collapsed around them. Segal's *Steelmakers* is a tribute to their tenacity.[27]

It is a cynical arts policy indeed that would condone, much less laud, a monument mythologizing work in steel mills when the real historical condition of the steelworkers is that of being forced into the industrial reserve army. Just whose tenacity does this work really pay tribute to? To the steelworkers hopelessly trying to maintain their dignity in the face of joblessness? Or to the society—including the business community, steel companies, and labor unions whose largesse contributed to the work—that will go to any length to ensure that those steelworkers will never recognize the nature of the economic forces arrayed against them? Perhaps the CDU in Bochum would find Segal's *Steelmakers* insufficient as a symbol of the boldness and elegance of steel—the work is, after all, cast bronze—but it can certainly be said to fulfill what I have suggested is the CDU's essential demand: that the sculpture reconcile the workers with their brutal conditions by giving them something with which they can positively identify. That this identification can only be false, that the workers' pride is only intended to make their subjugation more tolerable, is, in the terms of the political analysis I am invoking, precisely what motivates such a cultural policy.[28]

Needless to say, such a cultural policy, whether that of the Right in Germany or of the liberal establishment in the United States, finds the public sculpture of Richard Serra considerably more problematic. Conservatives in this country who argue against all federal funding for culture oppose Serra's work categorically, confident that when all public commissions are once again exclusively paid for by the private sector, there will be no more room for such a "malignant object" (Serra's *Tilted Arc* is illustrated in an article of that title).[29] The cultural bureaucrats want, however, to appear more tolerant, hoping that "Serra's sculpture may eventually win a greater measure of acceptance within its community."[30]

That a difficult work of art requires time to ingratiate itself with its public was a standard line of defense of Serra's *Tilted Arc* (figs. 12, 13) during the public hearing of March 1985. Historical precedents of public outrage meeting now-canonical

Fig. 12. *Tilted Arc.* 1981
Cor-Ten steel, 12 x 120′ x 2½″
Installed Federal Plaza, New York
General Services Administration, Washington, D.C.

Fig. 13. Opposite: *Tilted Arc.* 1981

works of modern art became something of a leitmotif. But this deferral to the judgment of history was, in fact, a repudiation of history, a denial of the current historical moment in which *Tilted Arc* actually confronts its public in all its specificity, as well as a denial of Richard Serra's intransigent rejection of the universal nature of the work of art. For to say that *Tilted Arc* will withstand the test of time is to reclaim for it an idealist position. The genuine importance of *Tilted Arc* can best be understood through an analysis of the crisis that it has precipitated within established cultural policy.

Tilted Arc is built on a site that is public in a very particular sense. It inhabits a plaza flanked by a government office building housing federal bureaucracies and by the United States Court of International Trade. The plaza adjoins Foley Square, the location of New York City's federal and state courthouses. It is thus situated in the very center of the mechanisms of state power. The Jacob K. Javits Federal Building and its plaza are nightmares of urban development, official, anonymous, overscaled, inhuman. The plaza is a bleak, empty area, whose sole function is to shuttle human traffic in and out of the buildings. Located at one corner of the plaza is a fountain that cannot be used, since the wind-tunnel effect of the huge office bloc would drench the entire plaza with water. Serra's *Tilted Arc*, a twelve-foot-high, steel-plate wall, one hundred and twenty feet long, and tilted slightly toward the office building and the trade courthouse, sweeps across the center of the plaza, dividing it into two distinct areas. Employing material and form that contrast radically with both the vulgarized International Style architecture of the federal structures and the Beaux-Arts design of the old Foley Square courthouses, the sculpture imposes a construction of absolute difference within the conglomerate of civic architecture. It engages the passerby in an entirely new kind of spatial experience that is counterposed against the bland efficiency established by the plaza's architects. Although *Tilted Arc* does not disrupt normal traffic patterns— the shortest routes to the streets from the buildings are left clear—it does implant itself within the public's field of vision. Soliciting, even commanding attention, the sculpture asks the office workers and other pedestrians to leave their usual hurried course and follow a different route, gauging the curving planes, volumes, and sight lines that mark this place now as the place of sculpture.

In reorienting the use of Federal Plaza from a place of traffic control to one of sculptural place, Serra once again uses sculpture to hold its site hostage, to insist upon the necessity for art to fulfill its own functions rather than those relegated to it by its governing institutions and discourses. For this reason, *Tilted Arc* is considered an aggressive and egotistical work, with which Serra places his own aesthetic assumptions above the needs and desires of the people who must live with his work. But insofar as our society is fundamentally constructed upon the principle of egotism, the needs of each individual coming into conflict with those of all other individuals, Serra's work does nothing other than present us with the truth of our social condition. The politics of consensus that ensures the smooth functioning of our society is dependent upon the shared belief that all individuals are unique but can exist in harmony with one another by assenting to the benign regulation of the

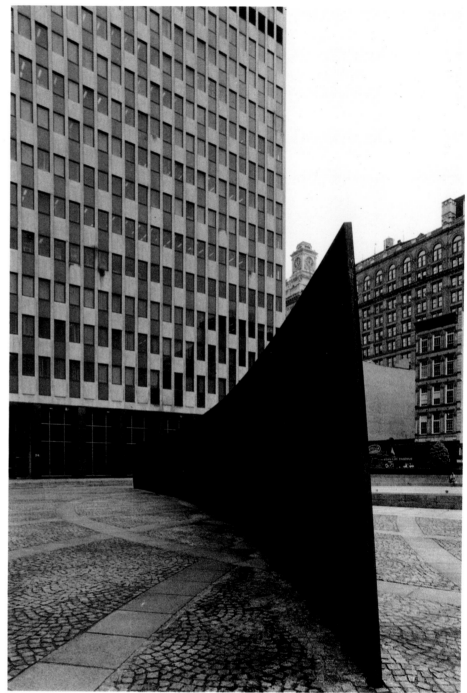

Photo: Jack Manning/NYT Pictures

Fig. 14. Demonstration at Federal Plaza, New
York, June 6, 1984, against U.S. Immigration
and Naturalization Service policies regarding
Central American refugees. Videotape:
Dee Dee Halleck.

state. The real function of the state, however, is not the defense of the citizen in his or her true individuality, but the defense of private property—the defense, that is, precisely of the conflict between individuals.[31] Within the politics of consensus, the artist is expected to play a leading role, offering a unique "private sensibility" in a manner properly universalized so as to ensure feelings of harmony. The reason Serra is accused of egotism, when other artists who put their "private sensibilities in public places" are not, is that his work cannot be seen to reflect his private sensibility in the first place. And, once again, when the work of art refuses to play the prescribed role of falsely reconciling contradictions, it becomes the object of scorn. A public that has been socialized to accept the atomization of individuals and the false dichotomy of private and public spheres of existence cannot bear to be confronted with the reality of its situation. And when the work of public art rejects the terms of consensus politics within the very purview of the state apparatus, the reaction is bound to be censorial. Not surprisingly, the coercive power of the state, disguised as democratic procedure, was soon brought to bear on *Tilted Arc*. At the hearing staged to justify the work's removal,[32] the most vociferous opposition to the work came not from the public at large but from representatives of the state, judges of the courts and heads of federal bureaucracies whose offices are in the Federal Building.

From the moment *Tilted Arc* was installed on Federal Plaza in 1981, Chief Judge Edward D. Re of the United States Court of International Trade began the campaign to have it removed.[33] In a city where many people feel that they have little control over a degraded social environment and that such control is granted only to property owners, Judge Re held out the promise of pleasant social activities, which he claimed could not take place on the plaza unless the steel wall were removed.[34] With accusations that an elitist art world had foisted its experiments upon them, with visions of band concerts and picnic tables presented to them, many office workers signed petitions for *Tilted Arc*'s removal. But it would seem that the judge and his fellow civil servants had a very different view of the public from the beneficent one that saw people gathering to listen to music on their lunch breaks. As I read the existing documentation, the public seems to have consisted, on the one hand, of competitive individuals who could be manipulated to fight it out among themselves over the crumbs of social experience dishonestly offered to them, and on the other hand, of frightening individuals lurking on the other side of the wall, lying in wait for the judge as he left the protection of his chambers and ventured out into the public realm. In one of the many letters written to the GSA complaining of the sculpture, Judge Re made his fears explicit: "By no means of minor importance is the loss of efficient security surveillance. The placement of this wall across the plaza obscures the view of security personnel, who have no way of knowing what is taking place on the other side of the wall."[35]

Judge Re's attitude, as reflected in his letter, was echoed during the GSA hearing by one of those security personnel. Her testimony is worth excerpting at some length, since it gives a clear and chilling sense of the state's current regard for its citizens:

My main purpose here is to present you aspects from the security angle. The arc is what I consider to be a security hazard or a disadvantage. My main contention is that it presents a blast wall effect.... It's 120 feet long, twelve feet high, and it's angled in a direction toward both federal buildings, number one Federal Plaza and 26 Federal Plaza. The front curvature of the design is comparable to devices used by bomb experts to vent explosive forces.... The purpose of these...bomb devices is to vent explosions upward. This one vents an explosion, could vent an explosion both upward and in an angle toward both buildings....

Most of the time the wall was [*sic*] closer to the building. It would, of course take a larger bomb than [those] which have been previously used...to destroy enough for their purposes, but it is possible, and lately we are expecting the worst in the federal sector.... Most people express their opinions against us in either violent ways or with graffiti and other types of ways.... *Tilted Arc* is used more for graffiti purposes than any of the other walls.... Most of the graffiti is done on the other side where we cannot view it.

Loitering for illegal purposes is another problem we experience and we do have a problem with drug dealing, which we cannot see from our side of the building. We, by the way, only concern ourselves with the federal side of the building.[36]

If a public sculpture can have projected upon it such an explicit statement of the contempt in which the public is held by the state, it has served a historical function of great consequence. We now have written into the public record, for anyone who wishes to read it, the fact that the "federal sector" expects only the worst from us, that we are all considered potential loiterers, graffiti scribblers, drug dealers, terrorists. When *Tilted Arc* is converted, in the paranoid vision of a state security guard, into a "blast wall," when the radical aesthetics of site-specific sculpture is reinterpreted as the site of political action, public sculpture can be credited with a new level of achievement. That achievement is the redefinition of the site of the work of art as the site of political struggle. Determined to "be vulnerable and deal with the reality of his living situation," Richard Serra has found himself again and again confronted with the contradictions of that reality. Unwillingly to cover up those contradictions, Serra runs the risk of uncovering the true specificity of the site, which is always a political specificity.

Notes

1. Donald Judd, "Specific Objects," *Arts Yearbook*, no. 8 (1965), p. 74.
2. Serra's actual assertion on this occasion was: "To remove 'Tilted Arc,' therefore, is to destroy it"; see hearing transcript, "The Matter of: A Public Hearing on the Relocation of 'Tilted Arc' at Jacob K. Javits Federal Building," March 6, 1985, p. 43. Held on March 6, 7, 8, 1985, at the Ceremonial Courtroom, International Court of Trade, One Federal Plaza, New York, the hearing took place before a panel consisting of William J. Diamond, Regional Administrator, General Services Administration; Gerald Turetsky, Acting Deputy Regional Administrator, GSA; Paul Chistolini, Public Building Services, GSA; and two outside panelists: Thomas Lewin of the law firm Simpson, Thacher, and Bartlett, and Michael Findlay of the auction house Christie, Manson, and Woods. On April 10, 1985, the panel in a four to one vote recommended relocation of *Tilted Arc*. This recommendation was adopted by Dwight A. Ink, Acting Director of the United States General Services Administration, Washington, D.C., and on May 31, 1985, he announced his decision to relocate the sculpture. Hearing transcript in The Museum of Modern Art Library.
3. Judd, p. 82.
4. In Phyllis Tuchman, "An Interview with Carl Andre," *Artforum*, vol. 7, no. 10 (June 1970), p. 55.
5. *Ibid.*
6. Walter Benjamin, "Edward Fuchs, Collector and Historian," trans. Kingsley Shorter, in *One-Way Street* (London: New Left Books, 1979), p. 360.
7. Daniel Buren, "Peut-il Enseigner l'Art?" *Galerie des Arts* (Paris), September 1968. Translated from the French by Richard Miller.
8. There have been several attempts to remove Serra's work from public sites. Soon after the decision to remove *Tilted Arc* was announced (see n. 2), St. Louis City Alderman Timothy Dee introduced a bill to the Board of Aldermen that would, if passed, allow city voters to decide whether *Twain* (1974–82, pl. 94), a work in downtown St. Louis, should be removed. According to *The Riverfront Times* (St. Louis), September 6–10, 1985, p. 6A, Dee said: "The problem is the real gap between *regular* people—my constituents and the overwhelming majority—and the *elitist art community*, who decide to do something because they've all invested in certain artists" (italics added). The most thoroughly documented case is that of the Christian Democratic party of Bochum, West Germany, against *Terminal* (1977, pl. 77). For this case, see *Terminal von Richard Serra: Eine Dokumentation in 7 Kapiteln* (Bochum: Museum Bochum, 1980), and my discussion below. In addition, a number of major commissions awarded to Serra have never been built, due to opposition to the work from architects and city officials. These include works for the Pennsylvania Avenue Development Corporation in Washington, D.C., the Centre Georges Pompidou in Paris, and works for outdoor sites in Madrid; Marl, West Germany; and Peoria, Ill. *Sight Point* (1971–75, pl. 71), commissioned for the Wesleyan University campus, was not built there. For a discussion of the difficulties Serra has faced in building his work in public, see Douglas Crimp, "Richard Serra's Urban Sculpture: An Interview," in *Richard Serra: Interviews, Etc. 1970–1980* (Yonkers, N.Y.: The Hudson River Museum, 1980), pp. 163–87.
9. *Webster's Eighth New Collegiate Dictionary* (Springfield, Mass.: Merriam-Webster, 1979), p. 989.
10. In volume II of *Capital*, Karl Marx divides the total mass of commodities into a two-department system for the purposes of explaining reproduction. Department I consists of the means of production: raw materials, machinery, buildings, etc.; Department II consists of consumer goods. Later Marxists have added to this scheme Department III to designate those goods that do not play a role in the reproduction of the working class since they are intended for consumption only by the capitalist classes themselves. Department III includes luxury goods, art, and weapons. For a discussion of this relation between art and arms, see Ernest Mandel, *Late Capitalism*, trans. Joris De Bres (London: Verso Editions, 1978), especially chapter 9, "The Permanent Arms Economy and Late Capitalism."
11. Amy Goldin, in "The Esthetic Ghetto: Some Thoughts about Public Art," *Art in America*, vol. 62, no. 3 (May–June 1974), p. 32.
12. Richard Serra, "Extended Notes from Sight Point Road," in *Richard Serra: Recent Sculpture in Europe 1977–1985* (Bochum, West Germany: Galerie m, 1985), p. 12
13. In Crimp, p. 170.
14. *Ibid.*, p. 168.
15. *Ibid.*, p. 170.
16. *Ibid.*, p. 175.
17. On this subject, see Yve-Alain Bois, "A Picturesque Stroll around Clara-Clara," *October*, no. 29 (Summer 1984), pp. 32–62; see also Richard Serra and Peter Eisenman, "Interview," *Skyline*, April 1983, pp. 14–17.
18. Quoted in Crimp, p. 175.
19. *Ibid.*, pp. 166, 168.
20. Richard Serra, in Annette Michelson, Richard Serra, and Clara Weyergraf, "The Films of Richard Serra: An Interview," *October*, no. 10 (Fall 1979), p. 91.
21. *Ibid.*; it is in this interview, in the context of a discussion of the film *Steelmill/Stahlwerk* (1979), by Serra and Weyergraf, that Serra discusses at length his experience working in steel mills. *Steelmill/Stahlwerk* was shot in the mill where the plates of *Terminal* were fabricated, although the shooting took place during the forging of *Berlin Block for Charlie Chaplin* (1977). See also in this regard the testimony by Annette Michelson at the public hearing about *Tilted Arc*; in hearing transcript (March 6, 1985), pp. 66–70. Michelson's testimony was important for the formulation of many of the ideas in the present essay.
22. Press release, CDU representatives to the Bochum City Council, reproduced in *Terminal von Richard Serra*, pp. 35–38.
23. Since 1982, when the CDU came to power in West Germany, the unemployment rate has risen to a postwar record: there are 2.2 million registered unemployed and an estimated 1.3 million unregistered job seekers. Hardest hit have been areas such as the Revier region, where heavy industries are located. In October 1985, the Federation of German Labor Unions staged a week-long protest against the CDU's economic policies to coincide with heated debates on the issue in the Bundestag. In these debates, the full range of the opposition attacked the CDU for contributing to the disintegration of social conditions in Germany.
24. In claiming that steel is not a raw material because it is produced from iron, the CDU attempts to mystify, through an appeal to a natural versus man-made distinction, the place of steel within capitalist production. Steel is, of course, a product of Department I, used for producing the means of production; see n. 10.

25. "To each capitalist, the total mass of all workers, with the exception of his own workers, appear not as workers, but as consumers, possessors of exchange values (wages), money, which they exchange for his commodity." Karl Marx, *Grundrisse: Foundations of the Critique of Political Economy*, trans. Martin Nicolaus (New York: Vintage Books, The Marx Library), p. 419. In the postwar period in Germany, attempts to reconcile the working class to its social conditions has operated precisely on the symbolic level, including language itself. Thus the words *Arbeiter* (worker) and *Arbeiterklasse* (working class) are no longer used in official discussion, as Germany is now said to be a classless society. In this society, there are only *Arbeitnehmer* (one who *takes* work, employee) and *Arbeitgeber* (one who *gives* work, employer). The irony of this linguistic reversal is not lost on the workers themselves, who, for their part, know perfectly well that it is the worker who is the giver of work (*Arbeitgeber*) and the employer who is the taker of work (*Arbeitnehmer*). In such a climate it comes as no surprise that the right-wing party would see art as another possible form of mystification of real social conditions.
26. John Beardsley, "Personal Sensibilities in Public Places," *Artforum*, vol. 19, no. 10 (June 1981), p. 44.
27. *Ibid.*
28. Louis Althusser has specified the role of what he calls Ideological State Apparatuses, among which he includes culture, as "the reproduction of the conditions of production." In order for this reproduction to take place, what must be assured is the workers' "subjection to the ruling ideology." Thus one of the functions of the cultural object confronting workers would be that of teaching them how to bear their subjugation. See Louis Althusser, "Ideology and the Ideological State Apparatuses (Notes towards an Investigation)," in *Lenin and Philosophy*, trans. Ben Brewster (New York and London: Monthly Review Press, 1971), pp. 127–86.
29. Douglas Stalker and Clark Glymour, "The Malignant Object: Thoughts on Public Sculpture," *The Public Interest*, no. 66 (Winter 1982), pp. 3–21. For other neoconservative attacks on public spending for art, see Edward C. Banfield, *The Democratic Muse: Visual Arts and the Public Interest* (New York: Basic Books, 1984); and Samuel Lipman, "Cultural Policy: Whither America, Whither Government?" *The New Criterion*, vol. 3, no. 3 (November 1984), pp. 7–15.
30. Beardsley, p. 45.
31. On this subject, the central texts are the early writings of Karl Marx on the state and civil society; see especially "On the Jewish Question," in *Karl Marx: Early Writings*, trans. Rodney Livingstone and Gregor Benton (New York: Vintage Books, The Marx Library, 1975), pp. 211–41. See also the reinterpretation of the relation between state and civil society and the importance for it of consensus in the work of Antonio Gramsci.
32. I believe the public hearing on *Tilted Arc* was a mockery and that anyone who followed the case closely would agree with me. The hearing was presided over, and the four other panelists were selected by, William Diamond, Regional Administrator of the General Services Administration, who had publicly asked for the removal of *Tilted Arc*, circulated petitions and solicited testimonies for its removal (see "New York Day by Day," *The New York Times*, December 29, 1984, and Grace Glueck, "What Part Should the Public Play in Choosing Public Art," *The New York Times*, section 2, February 3, 1985, pp. 1, 27; see also letter of Gustave Harrow to Dwight A. Ink, Acting Administrator, United States General Services Administration, Washington, D.C., dated March 22, 1985, in The Museum of Modern Art Library). Many testimonies held that the hearing was obviously prejudiced; see especially those by Gustave Harrow (hearing transcript [March 6, 1985], pp. 51–56) and Abigail Solomon-Godeau (hearing transcript [March 8], pp. 564–67).
33. See Chronology of Events, in Dwight A. Ink, "Decision on the Tilted Arc," United States General Services Administration, Washington, D.C., May 31, 1985. It notes that *Tilted Arc* was installed at Federal Plaza on July 16, 1981; soon after, on July 27, "Honorable Edward D. Re, Chief Judge, Court of International Trade wrote Administrator Gerald P. Carmen contending that the sculpture was an architectural barrier which negatively impacts on the spaciousness and utility of the plaza." On August 18, he wrote: "…the views of responsible local citizens were not solicited before the sculpture was erected." An entry for November 18, 1984, reads: "Letter from Judge Re to GSA Administrator Ray Kline continuing to urge removal of the Tilted Arc." Document in The Museum of Modern Art Library.
34. See testimony of Judge Edward D. Re, hearing transcript (March 7, 1985), p. 362. Given the claims of the judge and other public officials that the plaza should be used for social activities, it is curious indeed that they made few attempts to experiment with the possibility of such activities with the sculpture in place. It is interesting to note that at the hearing itself numerous performing artists claimed that the sculpture, in fact, provided a perfect environment for their work. See hearing transcript, the testimonies of Philip Glass (March 6, 1985, p. 112), Joan Jonas (March 7, p. 420), and Alvin Lucier (March 7, p. 505).
35. Letter from Chief Judge Edward D. Re to Ray Kline, Acting Administrator, United States General Services Administration, Washington, D.C., November 5, 1984, p. 3.
36. Testimony by Vickie O'Dougherty, in hearing transcript (March 6, 1985), pp. 139–43.

Plates

Dimensions are cited in the order of height, width, and depth.

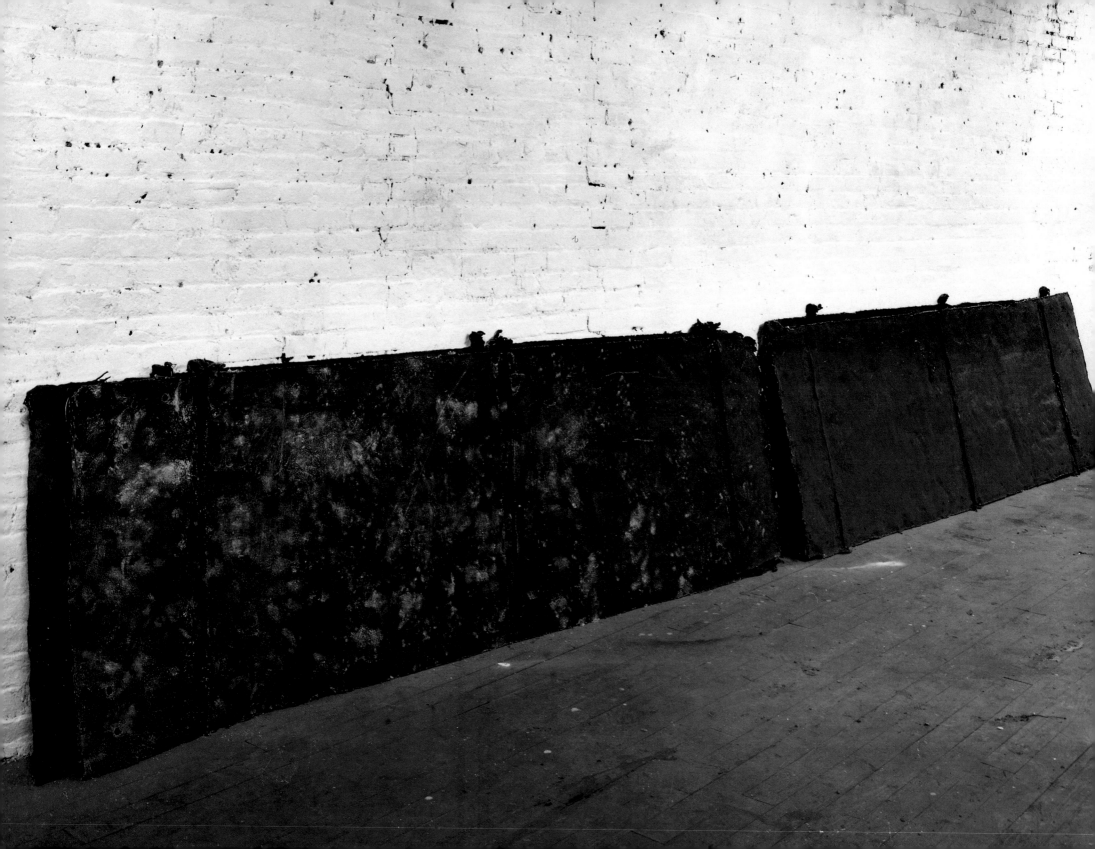

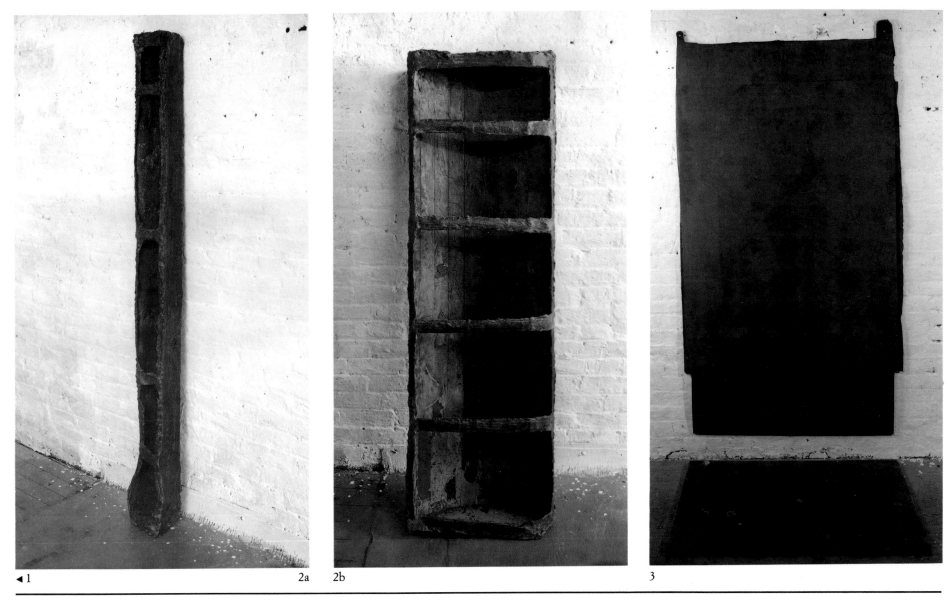

◄ 1 2a 2b 3

1. Opposite: *Doors.* 1966–67
Rubber and fiberglass, four parts, each 36″ x 9′
Akira Ikeda Gallery, Tokyo

2a/b. *Trough Pieces.* 1966–67
Rubber and fiberglass, two parts, 71 x 6 x 6″
and 59½ x 18½ x 6¼″
Museum Ludwig, Cologne, West Germany

3. *Remnant.* 1966–67
Vulcanized rubber, 6′1″ x 38″
Museum Ludwig, Cologne, West Germany

Photos: Peter Moore

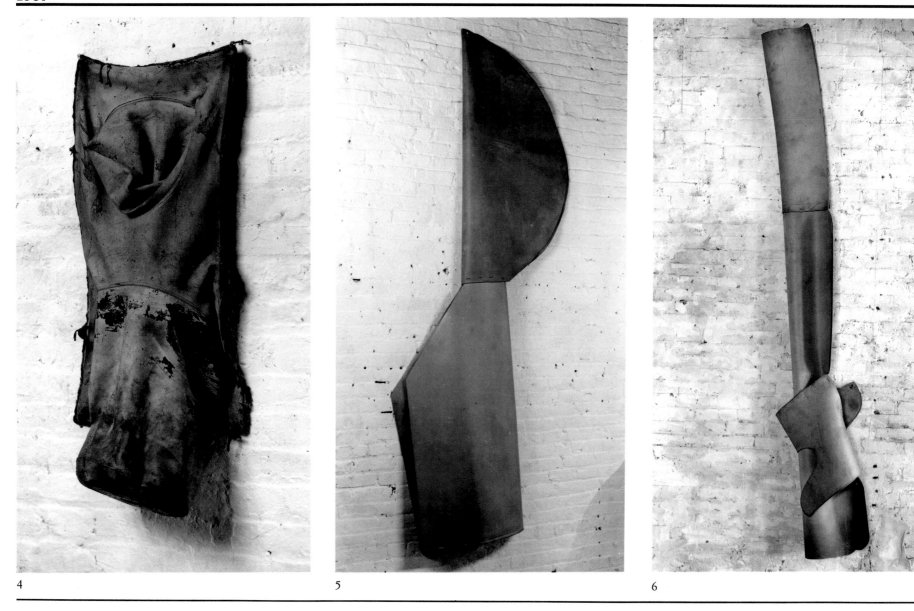

4

5

6

4. *Inverted Bucket.* 1967
Rubber and fiberglass, approx. 36 x 12"
Destroyed

5. Untitled. 1967
Rubber, 8'4" x 42"
Collection the artist

6. *Slant Step Folded.* 1967
Rubber, 8'6" x 28"
Collection Mr. and Mrs. Ronald K. Greenberg, St. Louis

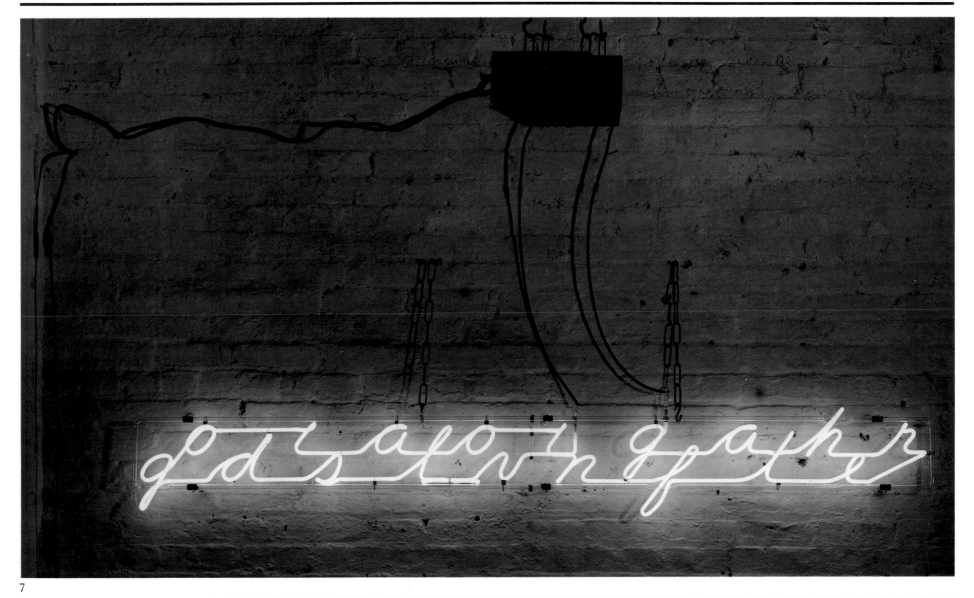

7

7. *God Is a Loving Father.* 1967
Neon tubing, 7″ x 6′8″
Museum Ludwig, Cologne, West Germany

Photos: Peter Moore

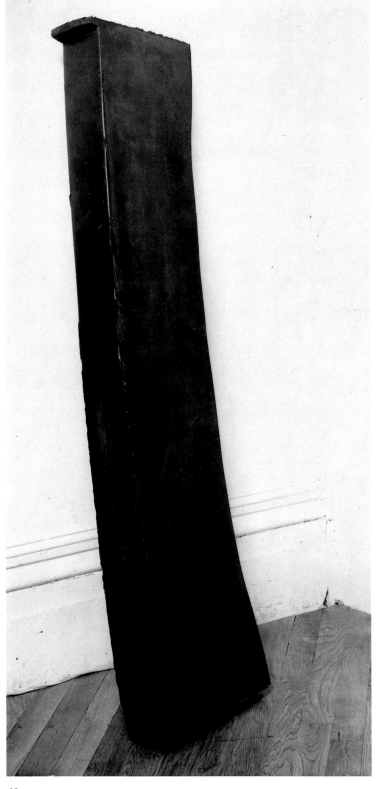

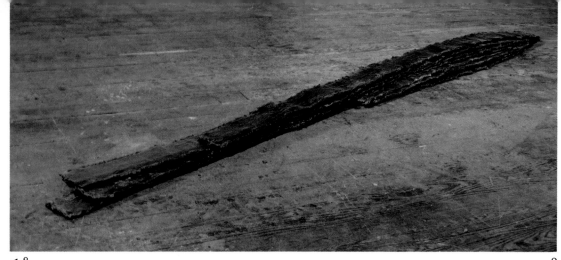

◀ 8

9

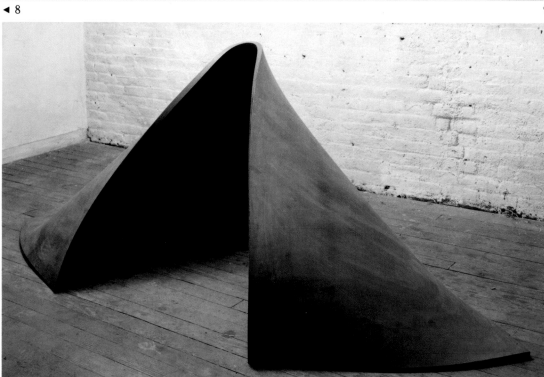

10

11 ▶

8. *Chunk.* 1967
Vulcanized rubber, 52 x 12 x 4″
Collection Barbara and Peter Moore, New York

9. *Angle Slabs.* 1967
Fiberglass encased in rubber, 6 x 6″ x 10′1″
Collection Giuseppe Panza di Biumo,
Varese, Italy

10. *To Lift.* 1967
Vulcanized rubber, 36″ x 6′8″
Galerie Reinhard Onnasch, Berlin

11. Opposite: *Plinths.* 1967
Fiberglass, rubber, and neon tubing, each element 8′ x 8″
Musée National d'Art Moderne,
Centre Georges Pompidou, Paris

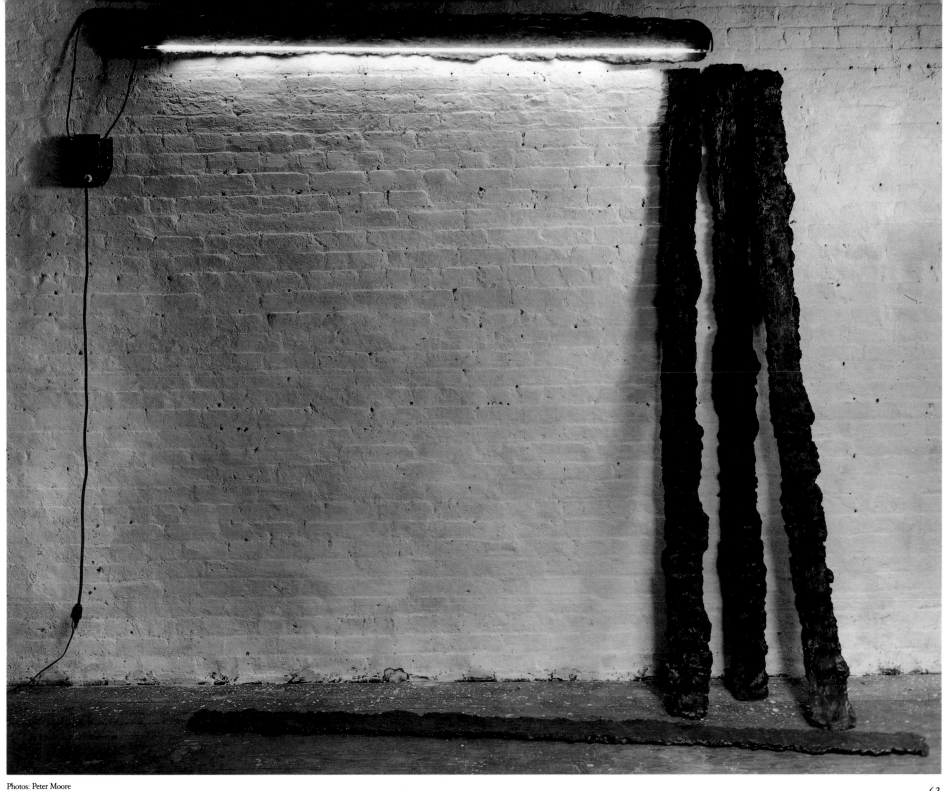

12

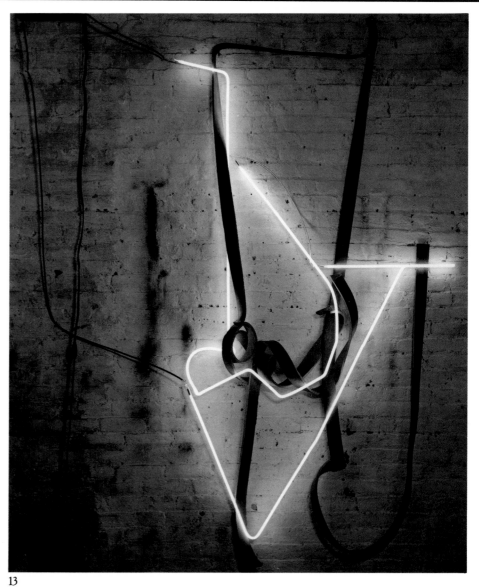

13

12. *Rosa Esman's Piece.* 1967
Vulcanized rubber, 36 x 15″
Leo Castelli Gallery, New York

13. Untitled. 1967
Vulcanized rubber and neon tubing,
approx. 8′ x 60″
Collection Mr. and Mrs. Arthur Workstel,
New York

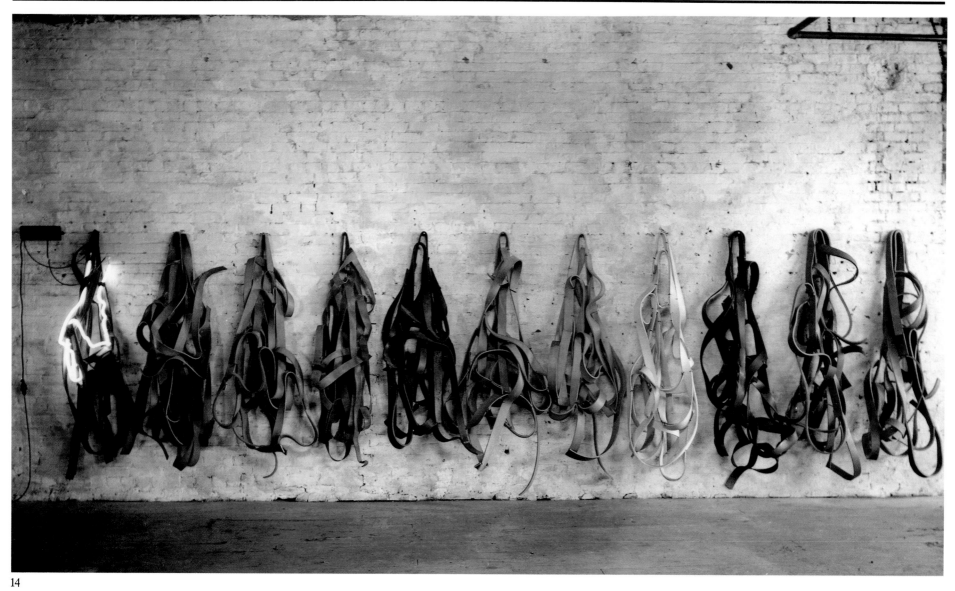

14

14. *Belts.* 1966–67
Vulcanized rubber and neon tubing,
7 x 24′ x 20″
Collection Giuseppe Panza di Biumo,
Varese, Italy

Photos: Peter Moore

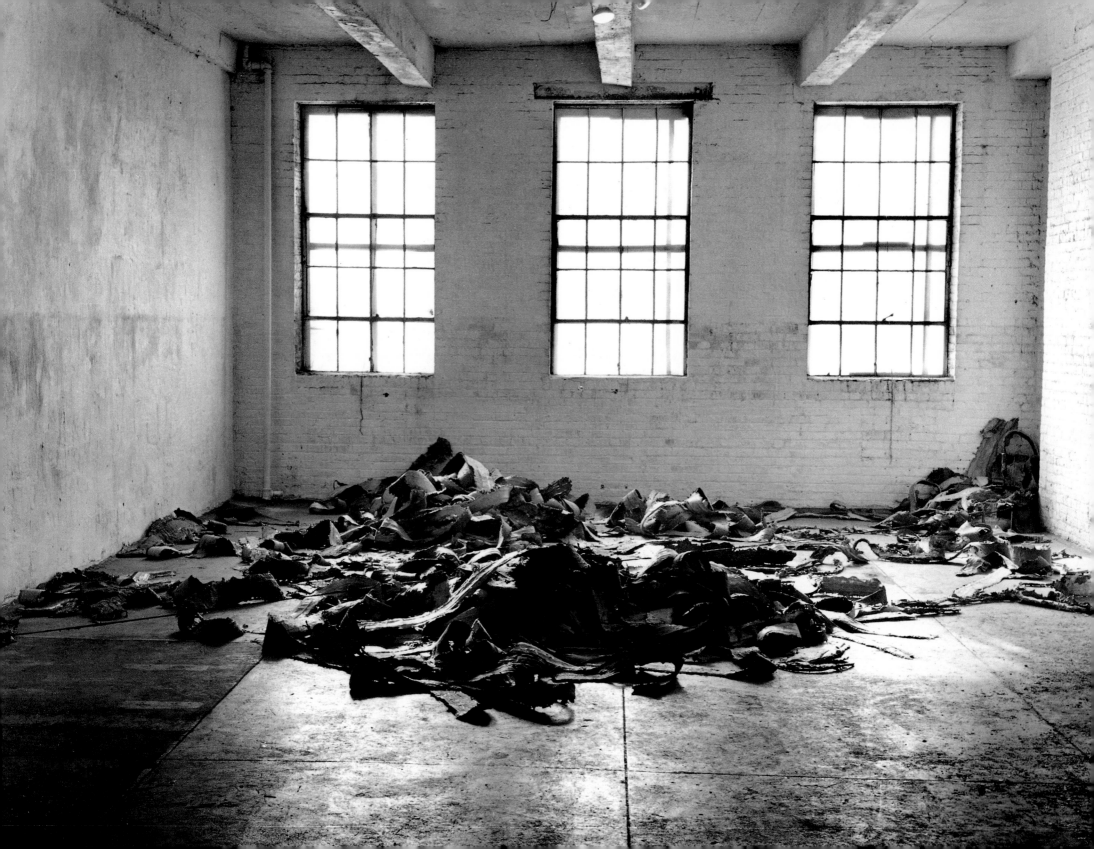

◄ 15

16

17

18

19

15. Opposite: *Scatter Piece.* 1967
Rubber latex, 25 x 25'
Collection Donald Judd, Marfa, Texas

16. Untitled. 1968
Lead, 21" diameter x 2"
Collection Sydney and Frances Lewis

17. *Double Roll.* 1968
Lead, 6 x 6" x 8'
Stedelijk Museum, Amsterdam

18. *Bullet.* 1968
Lead, 6" diameter x 36"
Collection William J. Hokin, Chicago

19. *Slow Roll: For Philip Glass.* 1968
Lead, approx. 10 x 10" x 6'
Akira Ikeda Gallery, Tokyo

Photos, pls. 17, 18, 19: Peter Moore

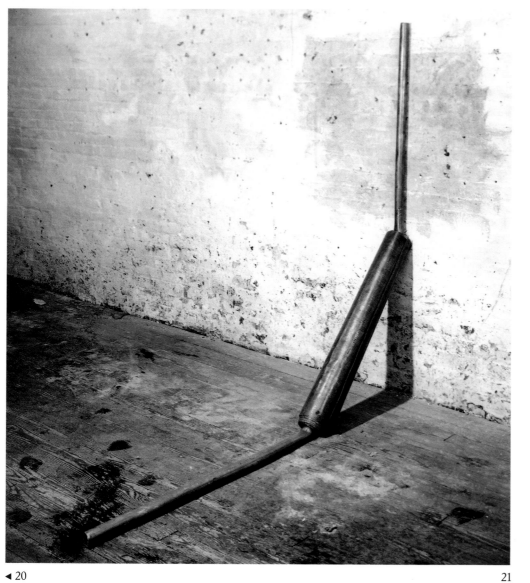

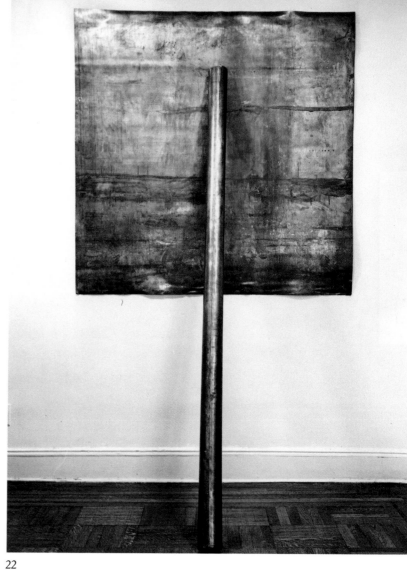

◄ 20 21 22

20. Opposite: *Splashing.* 1968.
Lead, 18″ x 26′
Installed Castelli Warehouse, New York, 1968
Destroyed

21. *Bent Pipe Roll.* 1968
Lead, 56 x 6 x 50″
Collection the artist

22. *Prop.* 1968
Lead antimony, plate 60 x 60″; pole 8′
Whitney Museum of American Art, New York, Gift of the Howard and Jean Lipman Foundation

Photo, pl. 21: Peter Moore

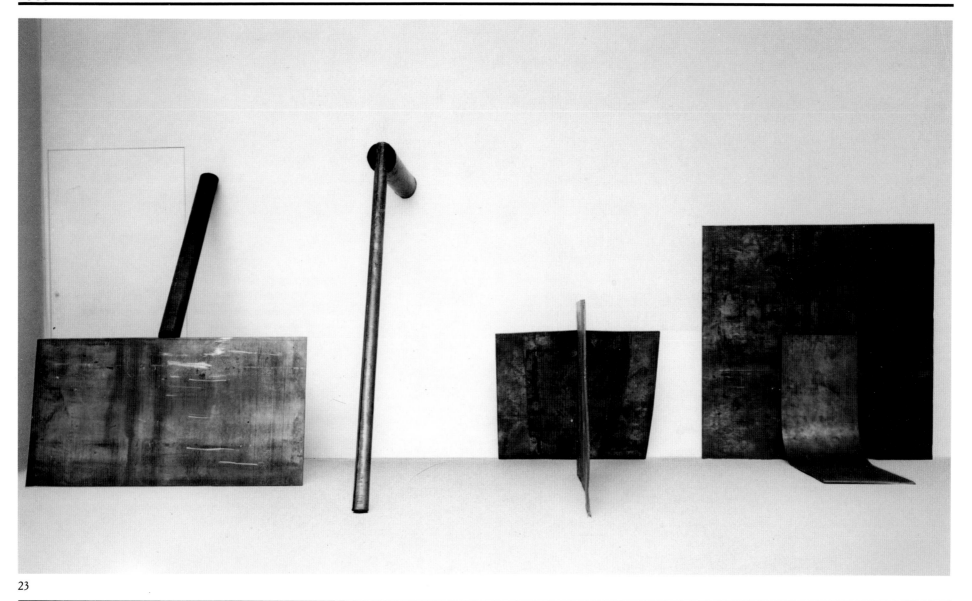

23

23. Installation of lead Props, The Solomon
R. Guggenheim Museum, New York, 1969
From left: *Shovel Plate Prop, Clothes Pin Prop,*
Wall Plate Prop, Right Angle Prop

Photo: Peter Moore

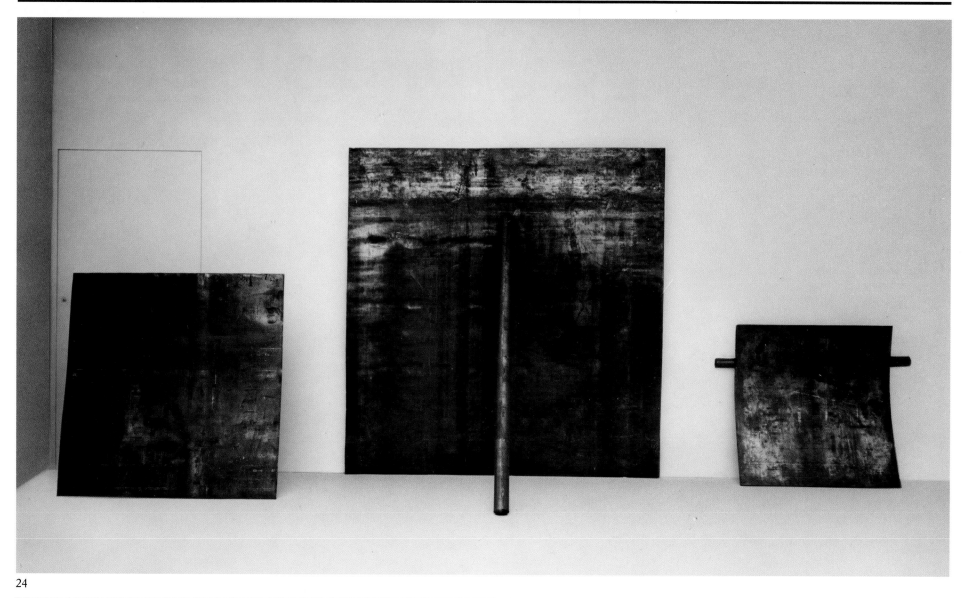

24

24. Installation of lead Props, The Solomon
R. Guggenheim Museum, New York, 1969
From left: *Sign Board Prop, Floor Pole Prop,
Plate Roll Prop*

Photo: Peter Moore

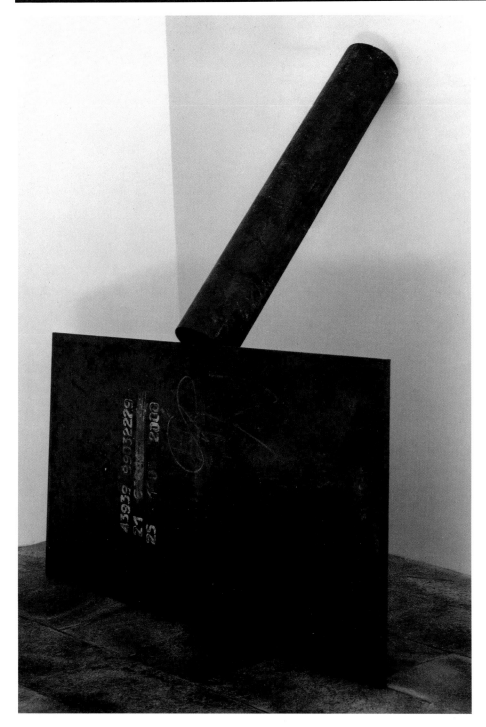

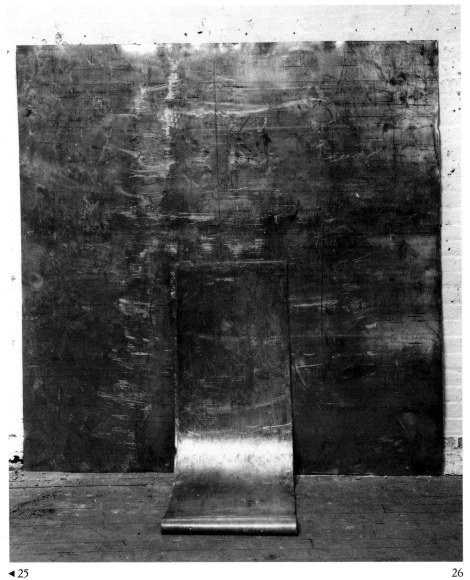

◄ 25 26

25. *Shovel Plate Prop.* 1969
Steel, 6'8″ x 7' x 32″
Collection Giuseppe Panza di Biumo,
Varese, Italy

26. *Right Angle Prop.* 1969
Lead antimony, 6 x 6'
The Solomon R. Guggenheim Museum, New
York, Gift of The Theodoron Foundation

Photo, pl. 26: Peter Moore

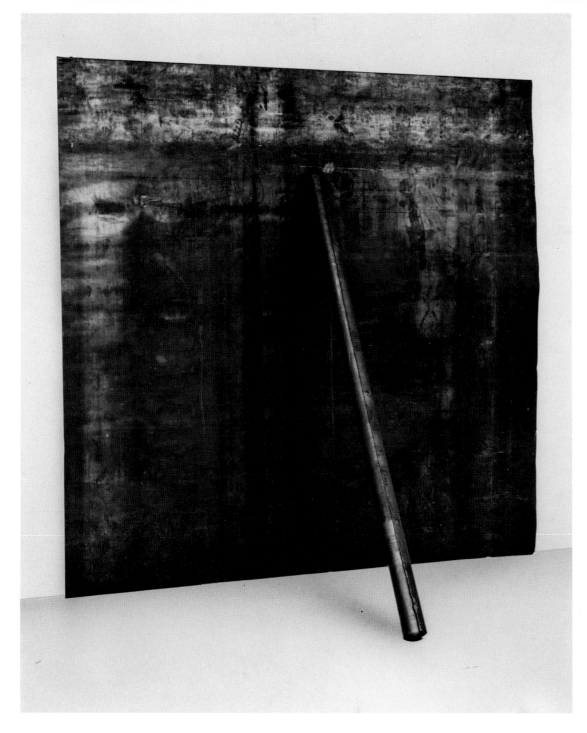

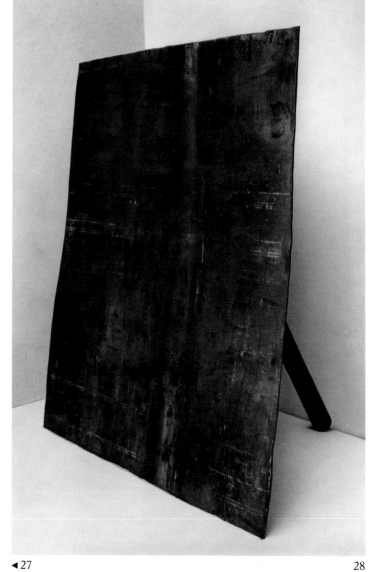

◀ 27

28

27. *Floor Pole Prop.* 1969
Lead antimony, 8′4″ x 8′4″ x 57″; pole 6′8″
Stedelijk Museum, Amsterdam

28. *Sign Board Prop.* 1969
Lead antimony, 64 x 64″; pole 42″
Collection Leo Castelli, New York

Photos: Peter Moore

29

30

31

29. *Two Bricks with Pole.* 1969
Lead antimony, 7′ high
Collection the artist

30. *Clothes Pin Prop.* 1969
Lead antimony, pole 7′6″; tube 6″ diameter x 40″
Collection Giuseppe Panza di Biumo,
Varese, Italy

31. *Corner Prop.* 1969
Lead antimony, box 25 x 25 x 25″; pole 6′8″
Gilman Paper Company Collection, New York

32

32. *Casting.* 1969
Lead, 4″ x 25 x 15′
Installed Whitney Museum of American Art,
New York, 1969
Destroyed

Photos: Peter Moore

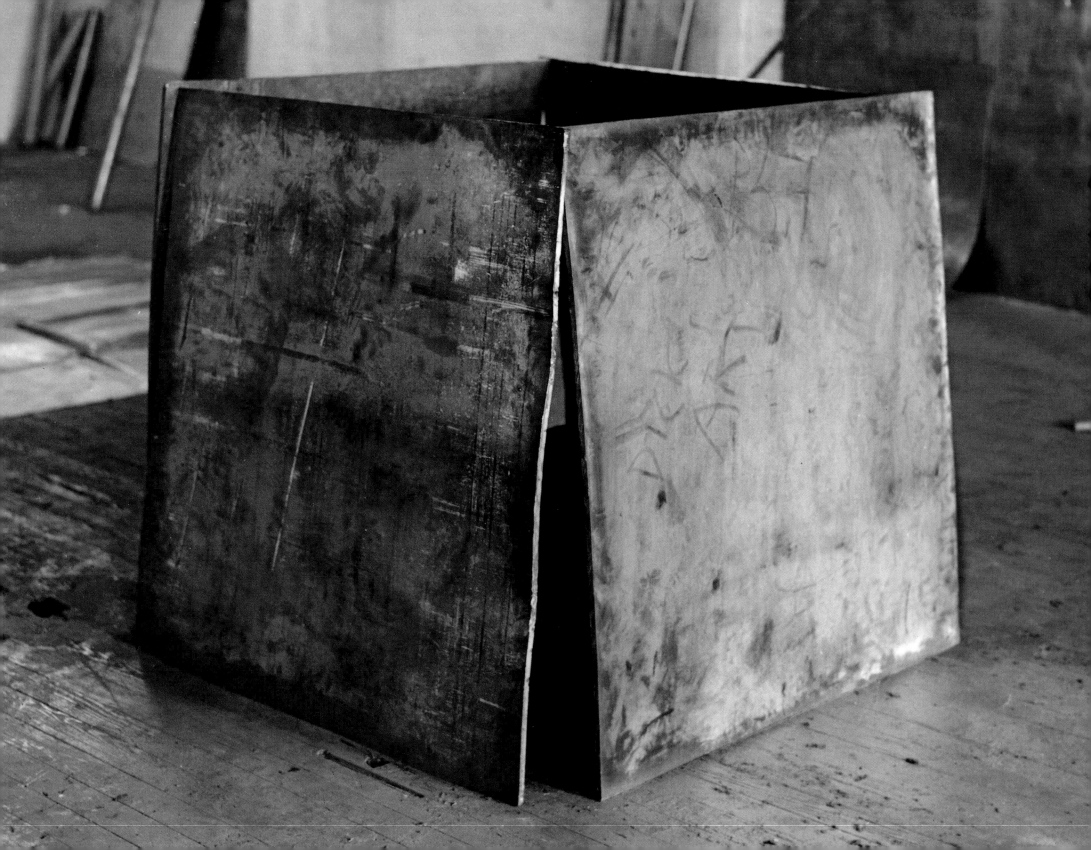

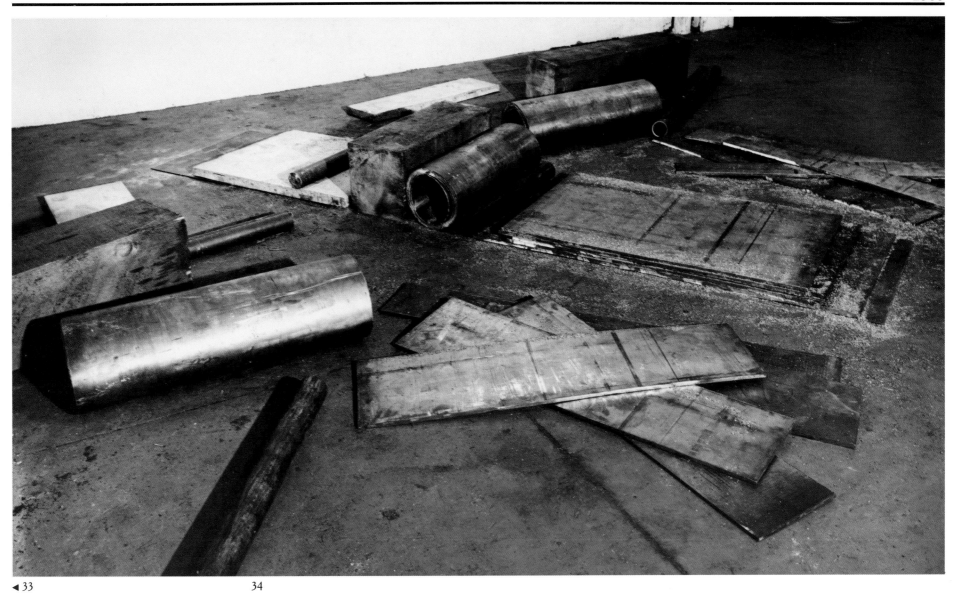

◄ 33 34

33. Opposite: *One Ton Prop (House of Cards).* 1969
Lead antimony, four plates, each 48 x 48″
Collection the Grinstein Family, Los Angeles

34. *Cutting Device: Base Plate Measure.* 1969
Lead, wood, stone, and steel, overall,
12″ x 18′ x 15′7¾″ variable
The Museum of Modern Art, New York,
Gift of Philip Johnson

35. Following page: *Skullcracker Series:
Inverted House of Cards.* 1969
Hot rolled steel, each slab 8 x 10′
Installed Kaiser Steel Corporation,
Fontana, California
Destroyed

Photos: Peter Moore

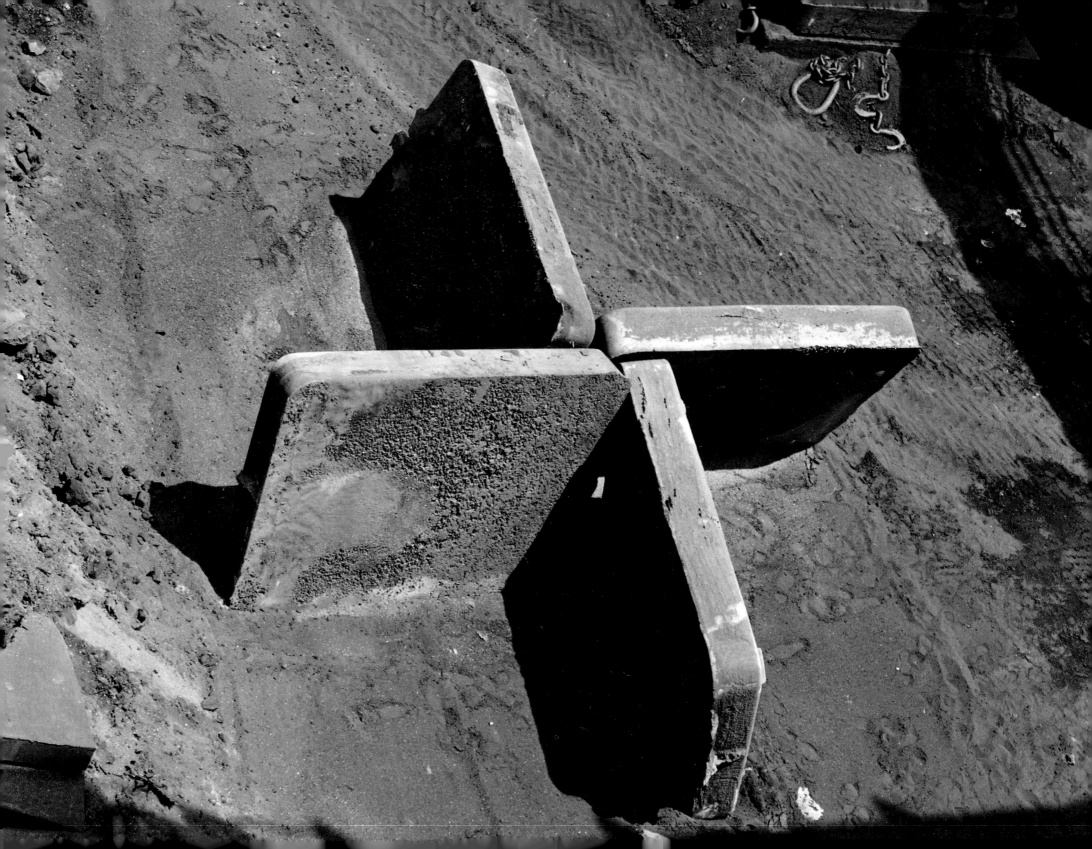

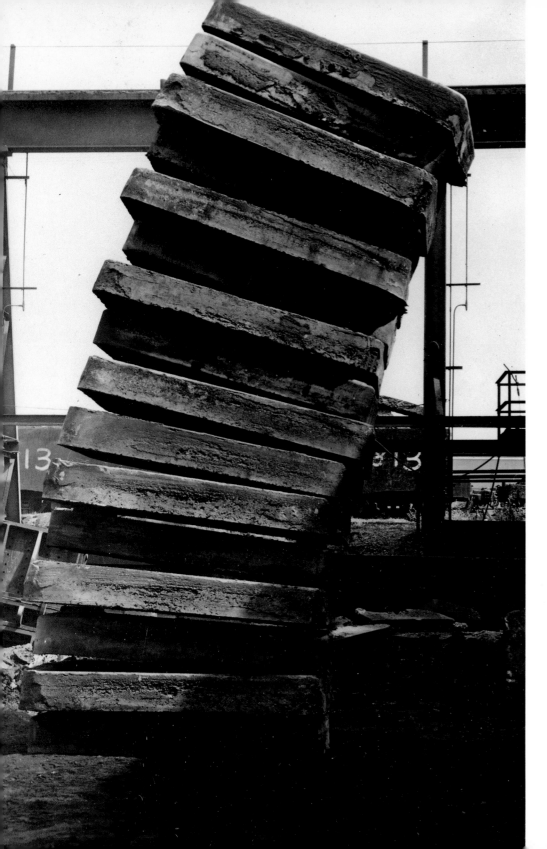

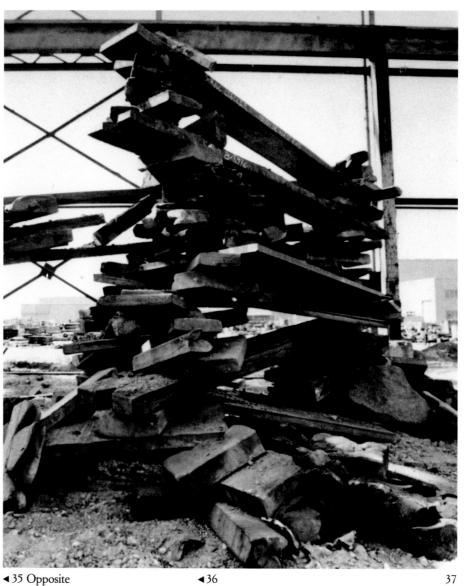

◄ 35 Opposite ◄ 36 37

36. *Skullcracker Series: Stacked Steel Slabs.*
1969
Hot rolled steel, 20 x 8 x 10′
Installed Kaiser Steel Corporation,
Fontana, California
Destroyed

37. *Skullcracker Series: Stacked.* 1969
Steel, 32 x 30 x 25′
Installed Kaiser Steel Corporation,
Fontana, California
Destroyed

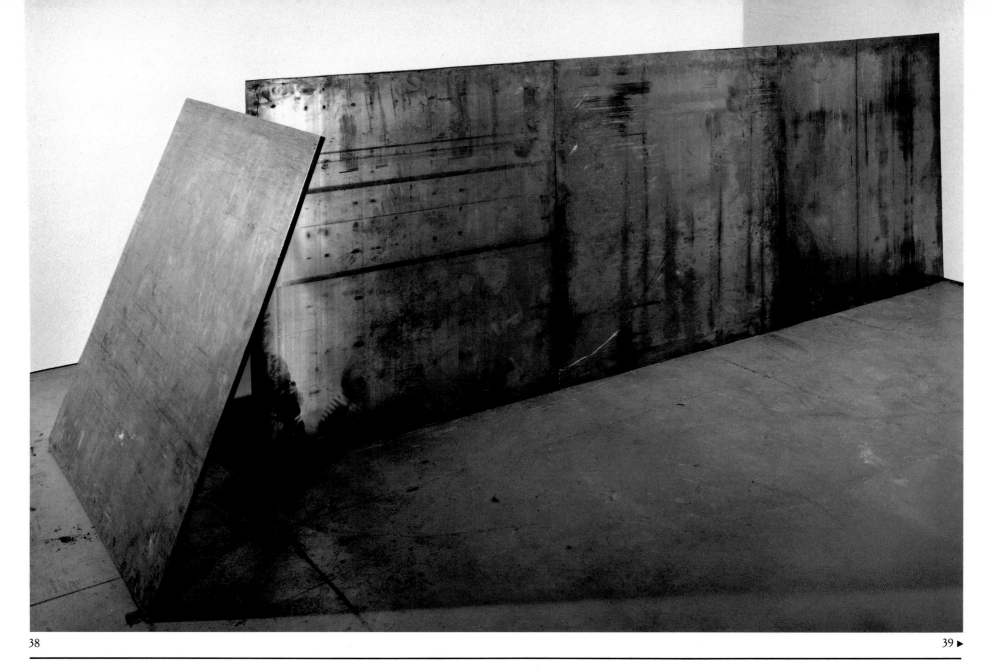

38. *Four Plates Edges Up.* 1969
Lead antimony, approx. 48 x 48″ x 14′
Collection Donald Judd, New York

39. Opposite: *No. 5.* 1969
Lead antimony, two plates, each 48 x 48″;
pole 7′; overall approx. 52″ x 7′ x 48″
Galerie Reinhard Onnasch, Berlin

Photo, pl. 39: Peter Moore

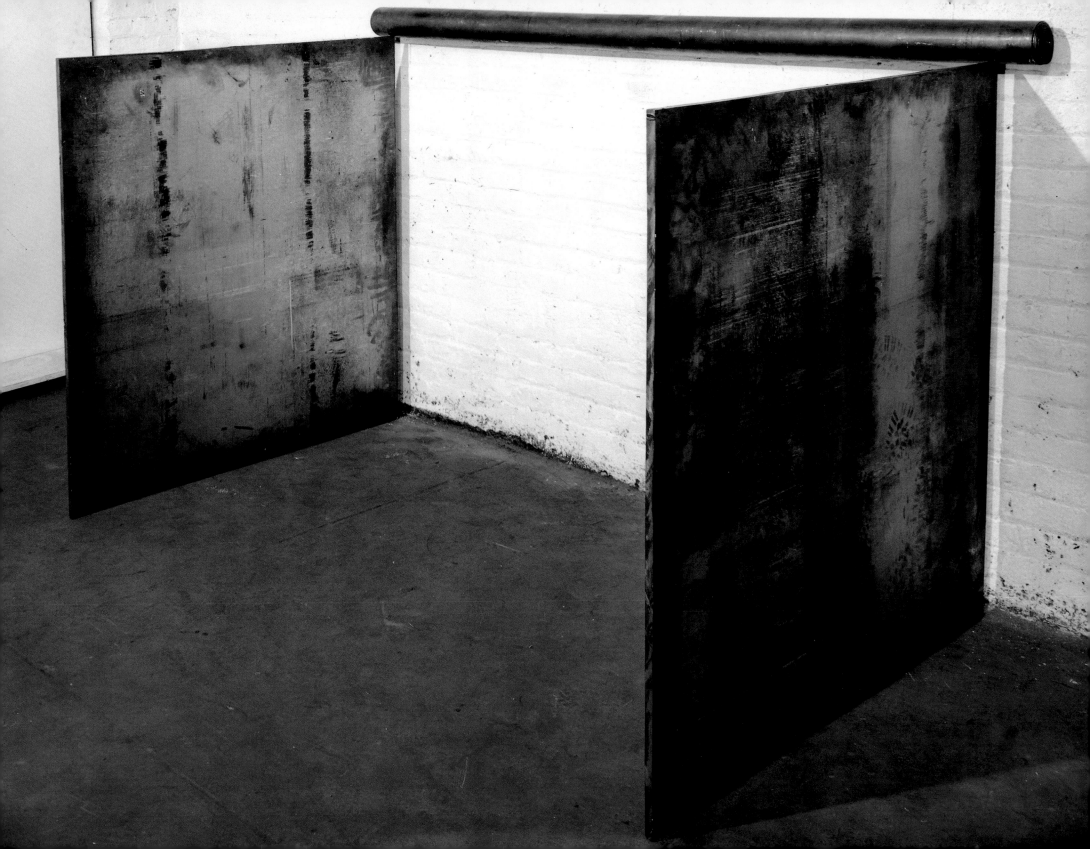

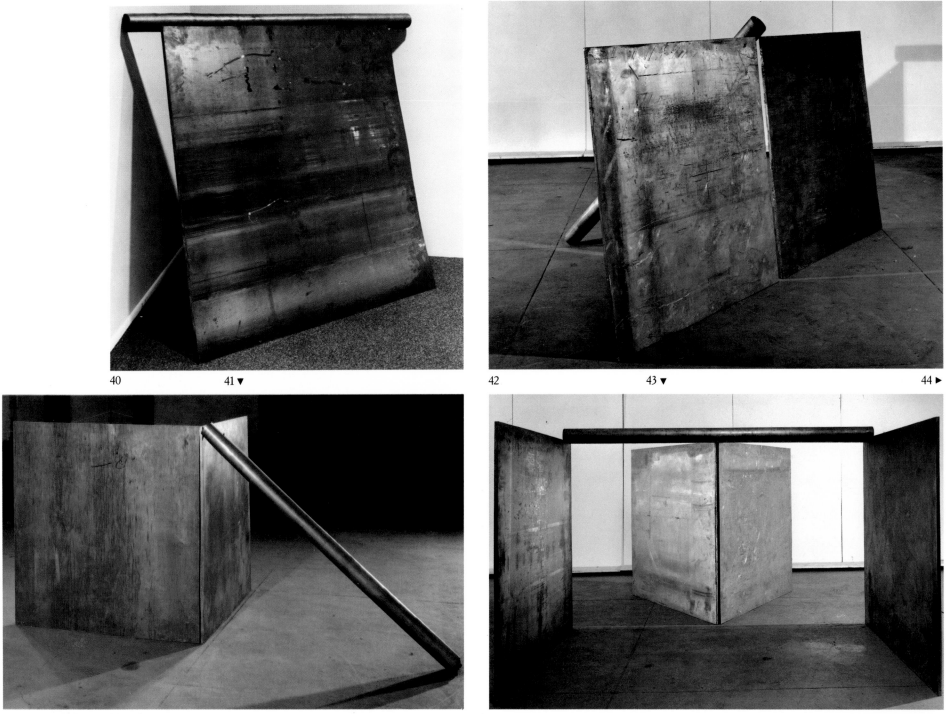

40 41 ▼ 42 43 ▼ 44 ▶

Photos, pls. 41, 42, 43, 44: Peter Moore

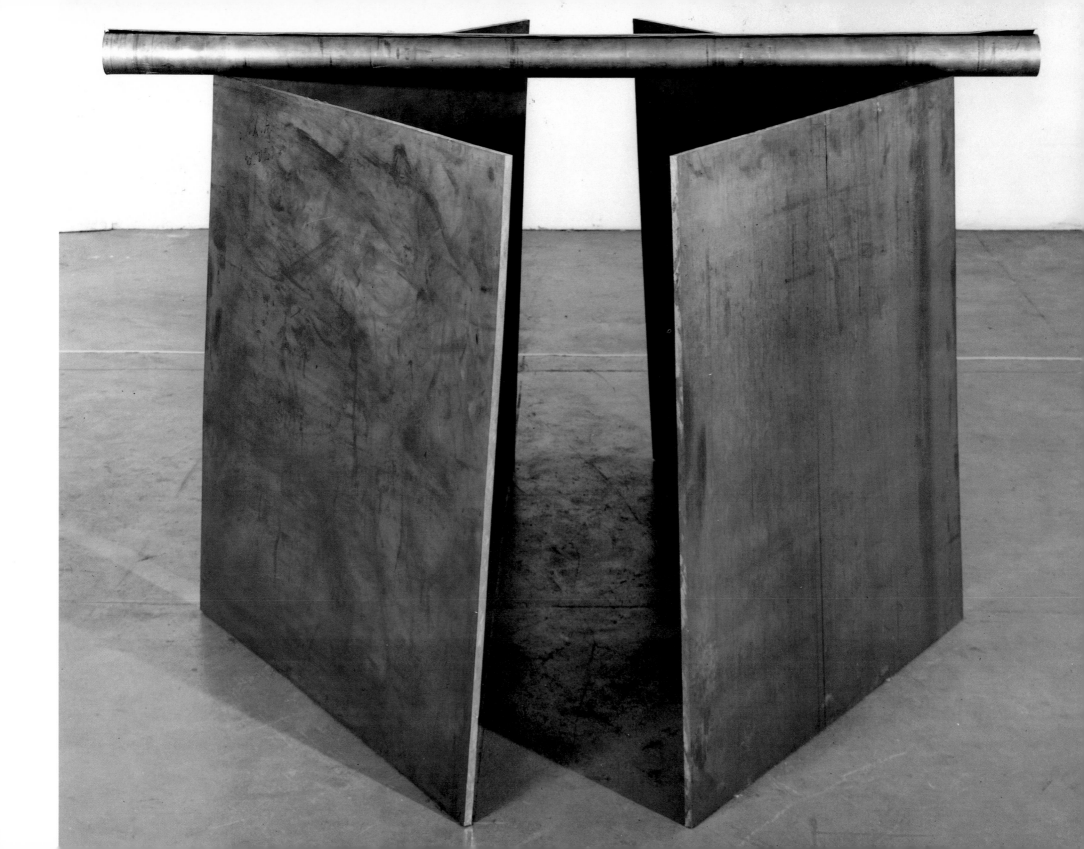

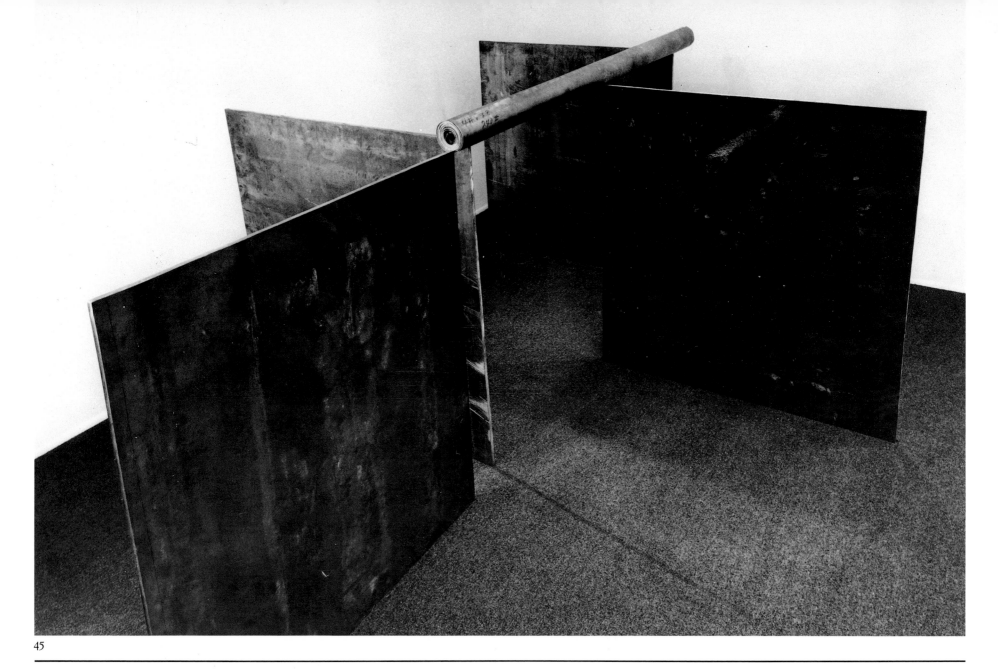

45

Plates 40, 41, 42, 43, 44: preceding pages

40. Untitled (Corner Prop Piece). 1969
Lead, plate 48 x 48"; pole 60" x 3" diameter
Private collection

41. *Right Angle Corner with Pole.* 1969
Lead antimony, two plates, each 48 x 48";
pole 60". Collection the artist

42. *No. 1.* 1969
Lead antimony, two plates, each 48 x 48"; pole
60"; overall approx. 51" x 8'2" x 48"
Collection the artist

43. *V + 5: To Michael Heizer.* 1969
Lead antimony, four plates, each 48 x 48";
pole 7'; overall approx. 52" x 7 x 7'
Collection the artist

44. *5:30.* 1969
Lead antimony, four plates, each 48 x 48";
pole 60". Collection the artist

45. *1-1-1-1.* 1969
Lead antimony, four plates, each 48 x 48";
pole 7'
Destroyed

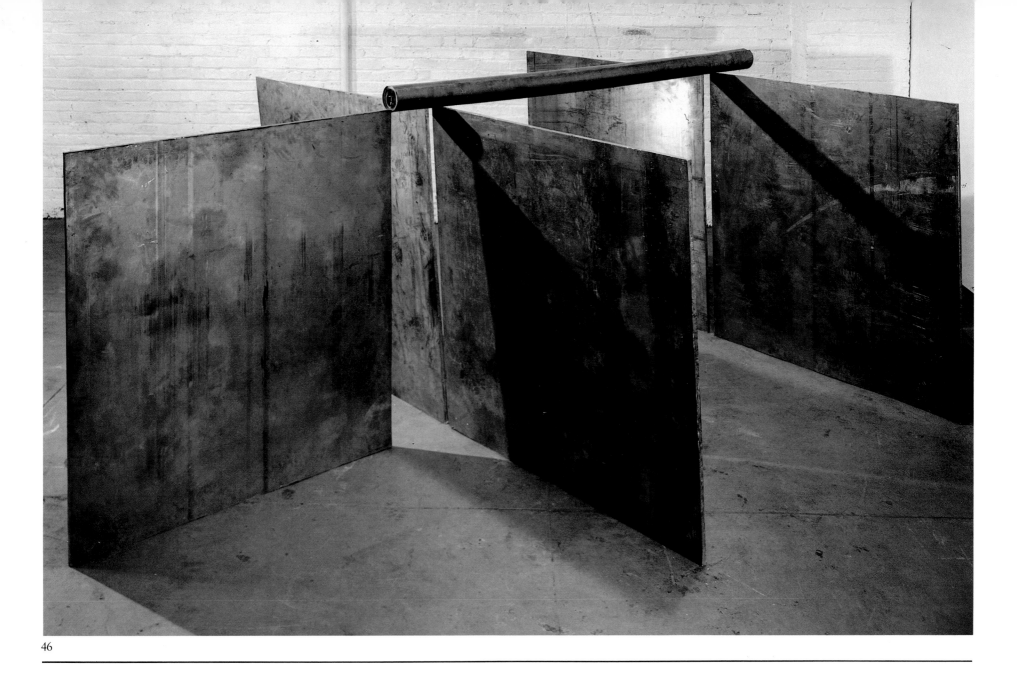

46

46. *2-2-1: To Dickie and Tina.* 1969
Lead antimony, five plates, each 48 x 48″;
pole 7′; overall 52″ x 8′2″ x 11′
Collection the artist

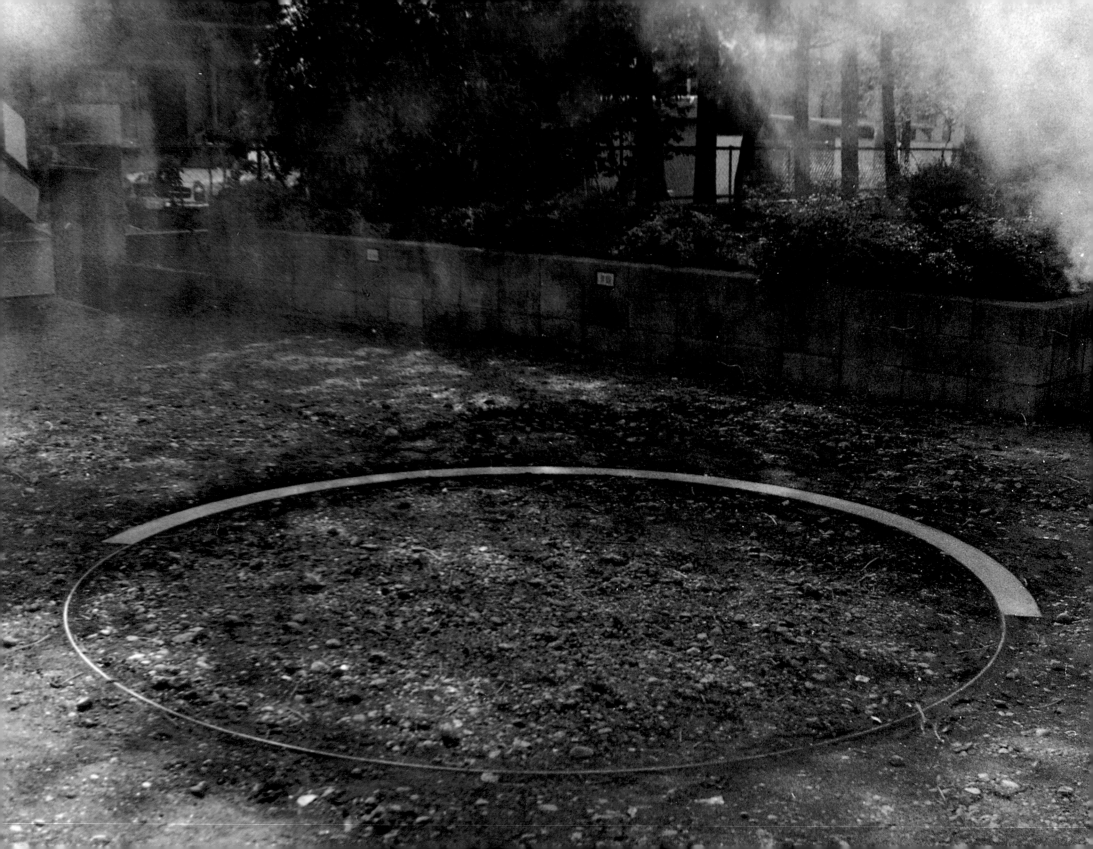

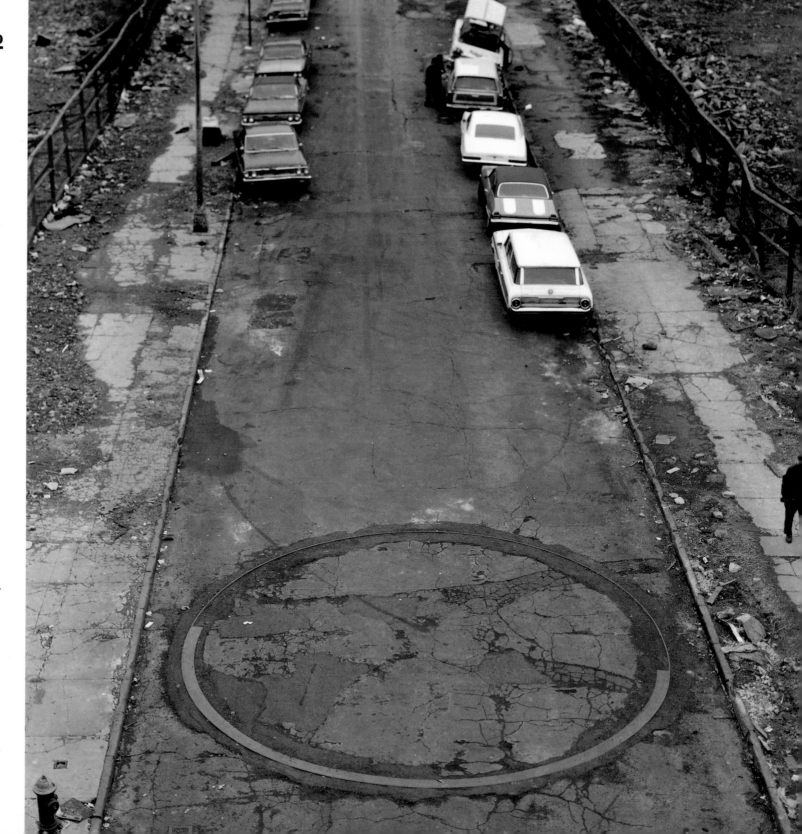

47. Opposite: *To Encircle Base Plate Hexagram, Right Angles Inverted.* 1970
Steel, rim 5″ x 10′10″ diameter
Installed Tama University of Fine Art, Tokyo

48. *To Encircle Base Plate Hexagram, Right Angles Inverted.* 1970
Steel, rim 1 x 8″ x 26′ diameter
Installed 183 Street and Webster Avenue, the Bronx, New York, 1970–72
Collection Mr. and Mrs. Ronald K. Greenberg, St. Louis

Photo, pl. 48: Peter Moore

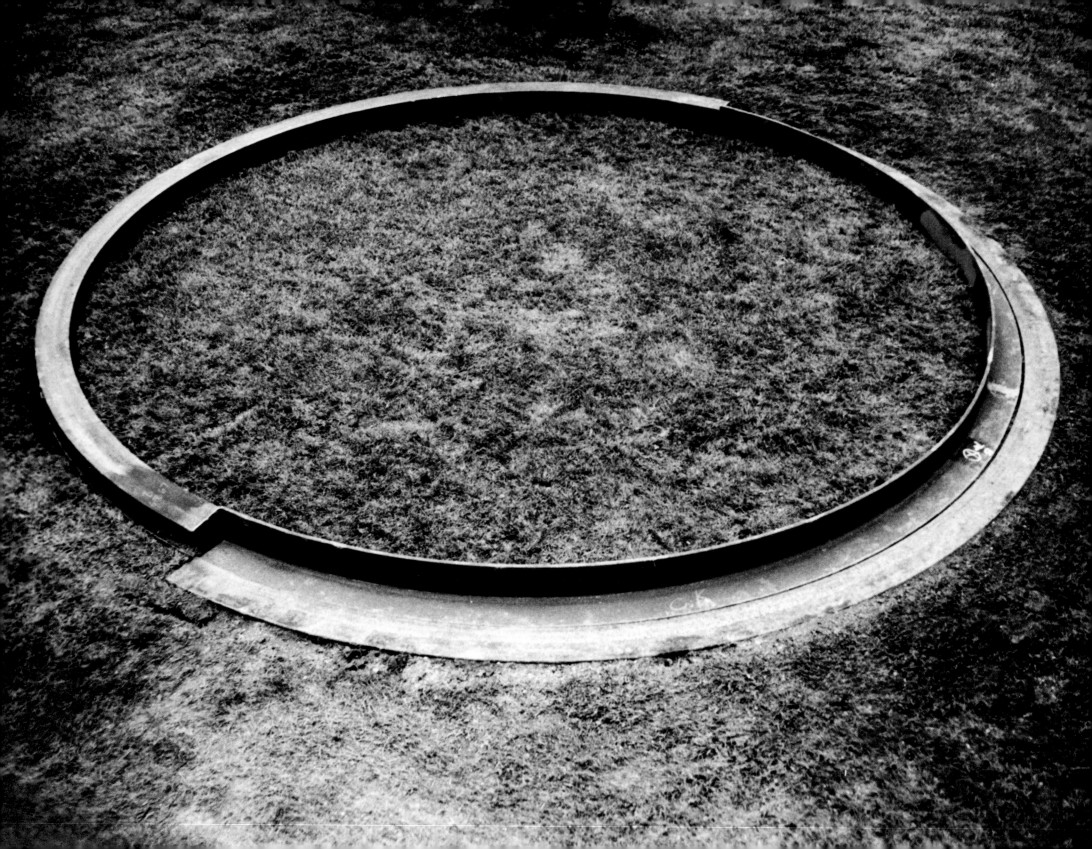

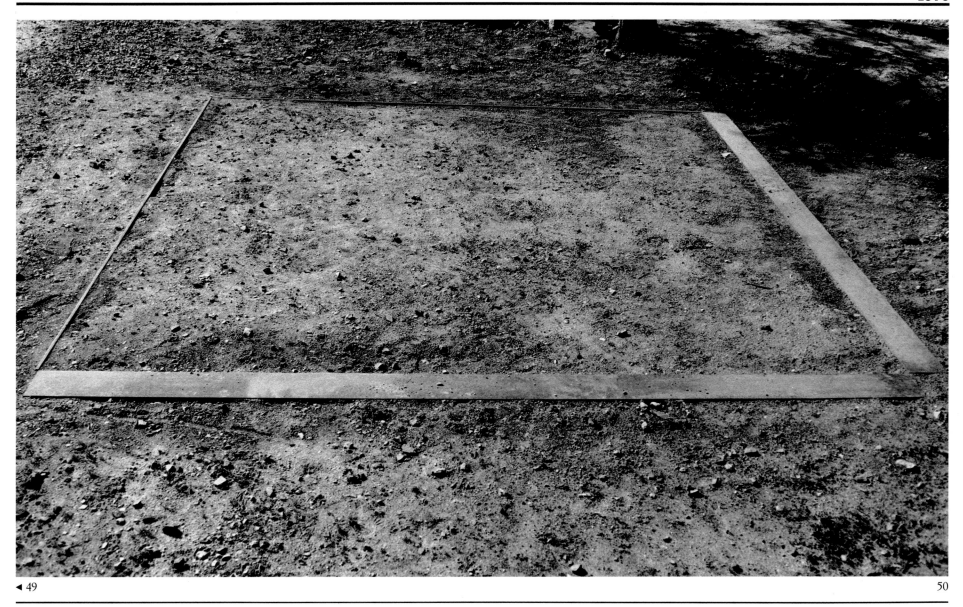

◄ 49

50

49. Opposite: Untitled. 1970
Steel, two circles, 16′ diameter
Collection Roger Davidson, Toronto

50. Untitled (Kyoto Square). 1970
Steel, 5″ x 25 x 25′
Kyoto National Museum of Modern Art,
Kyoto, Japan

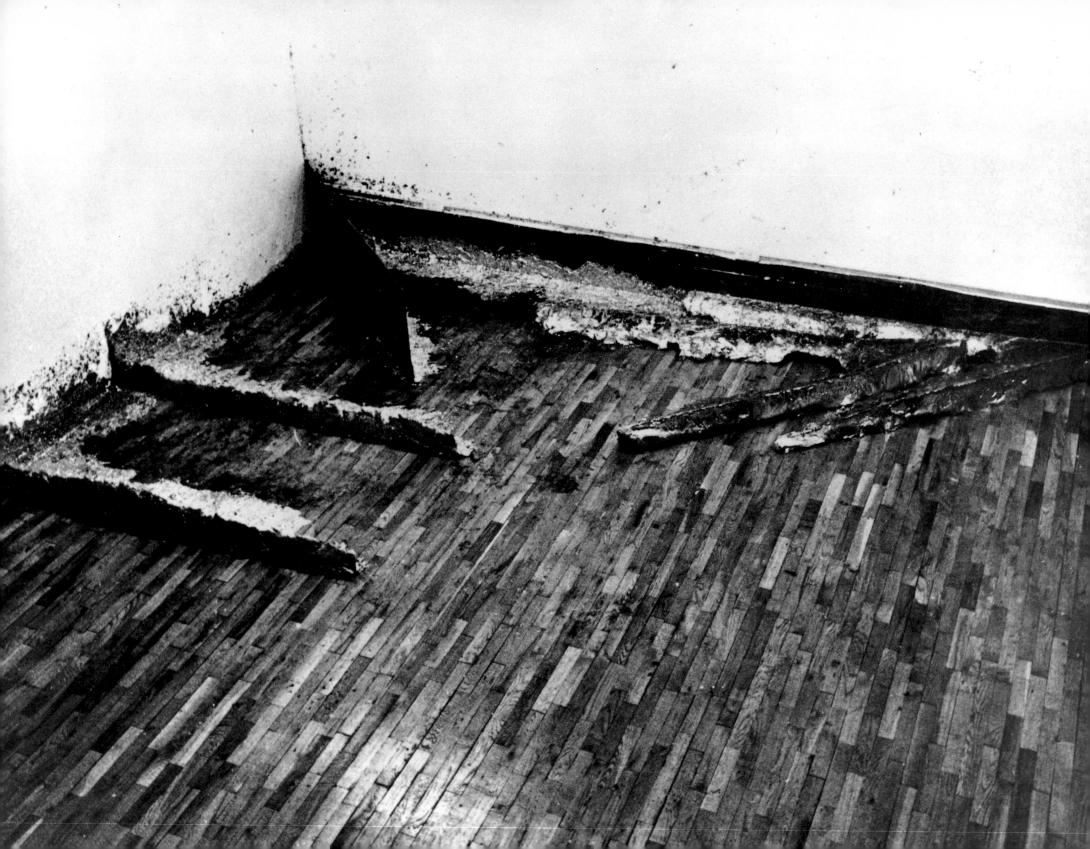

Photo, pl. 52: Peter Moore

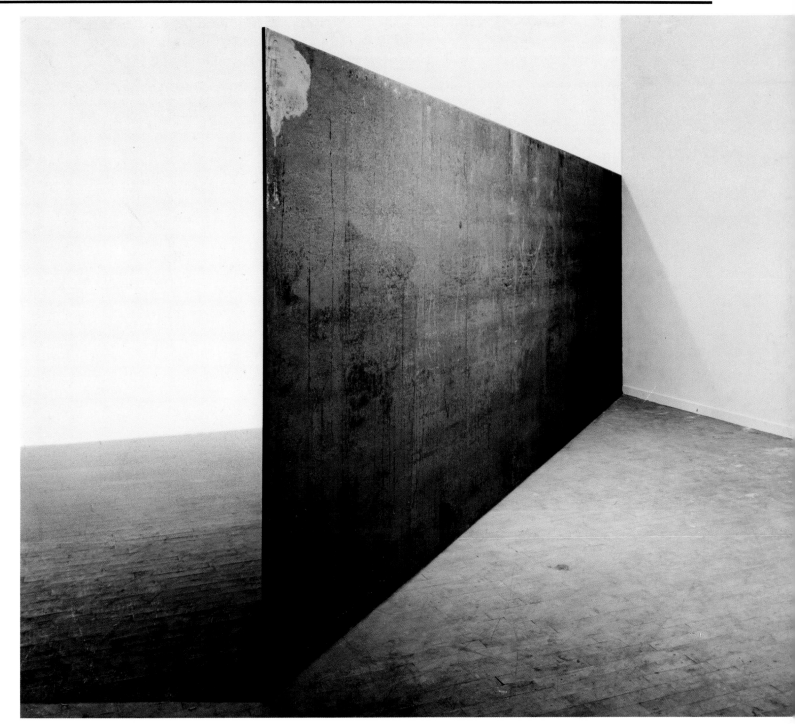

51. Opposite: *Splash Piece: Casting*. 1969–70
Lead, 19″ x 9′ x 14′11″
Collection Jasper Johns, New York

52. *Strike: To Roberta and Rudy*. 1969–71
Hot rolled steel, 8 x 24′ x 1″
Collection Giuseppe Panza di Biumo,
Varese, Italy

53. Following pages: *Davidson Gate*.
1969–70
Hot rolled steel, two plates, each 8 x 8′ x ⅞″
National Gallery of Canada, Ottawa, Gift of
Mr. and Mrs. R. Davidson, Toronto

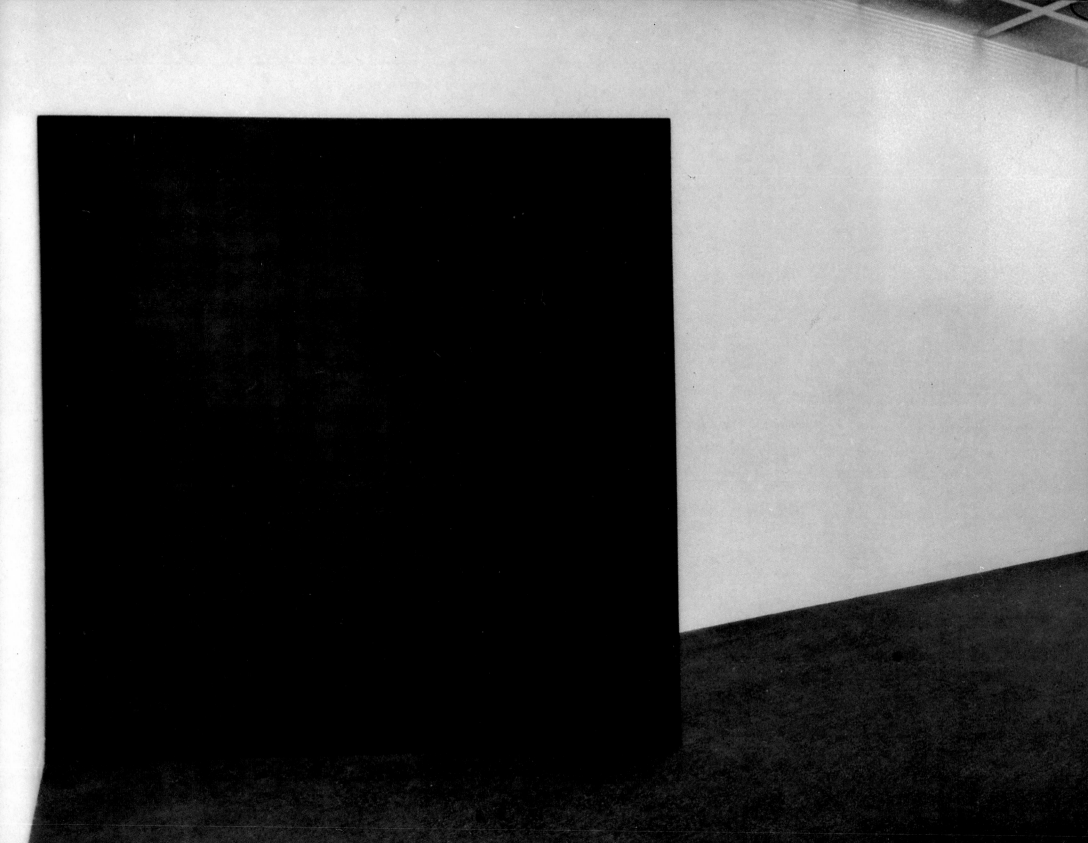

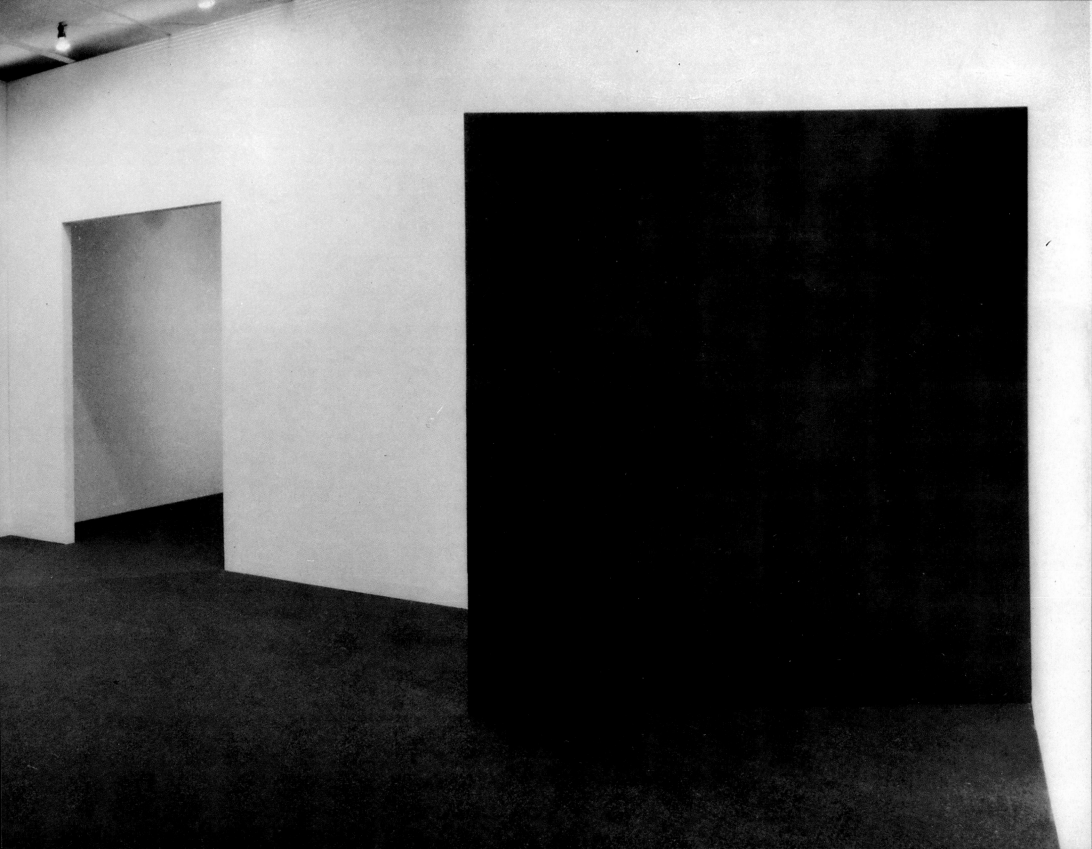

54

54. *Base Plate Deflection: In It, on It.* 1970
Hot rolled steel, ⅜″ x 8 x 16′
Norton Simon Museum of Art,
Pasadena, California

55. Opposite: *Balanced.* 1970
Hot rolled steel, 8′1″ x 62 x 1″
Saatchi Collection, London

56. Opposite: Untitled (Steel Corner Prop).
1970
Hot rolled steel, plate 54 x 54 x ⅜″;
bar 3 x 6″ x 7′
Art Gallery of Ontario, Toronto, Purchase

57. Opposite: *Duplicate.* 1971
Hot rolled steel, 12″ x 12′ x 26″
Allen Memorial Art Museum, Oberlin
College, Oberlin, Ohio, NEA Museum
Purchase Plan

58. Opposite: *Equal (Corner Prop Piece).*
1969–70
Lead plate and lead tube rolled around steel
core, plate 48 x 48 x ¾″; tube 7′¼″ x 4 ⅜″
diameter; overall 52″ x 7′¼″ x 7′8″
The Museum of Modern Art, New York,
Gilman Foundation Fund

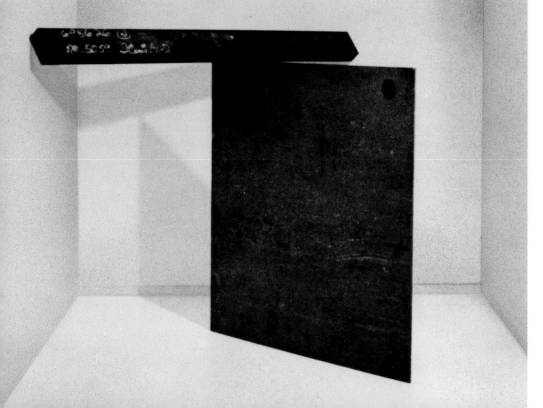

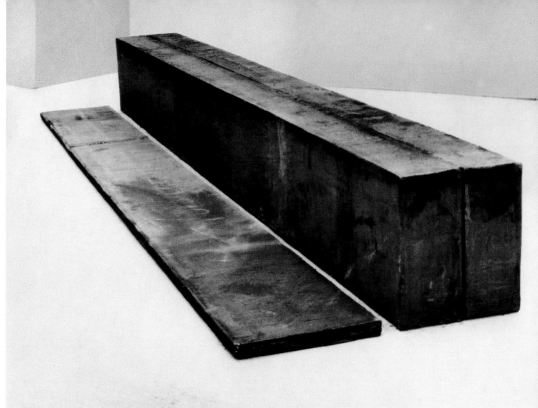

55

56 ▼

57

58 ▼

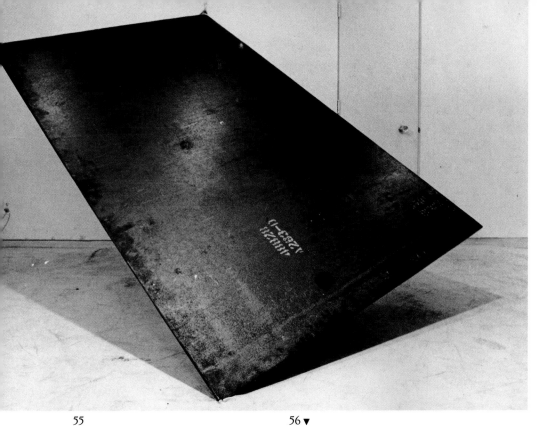

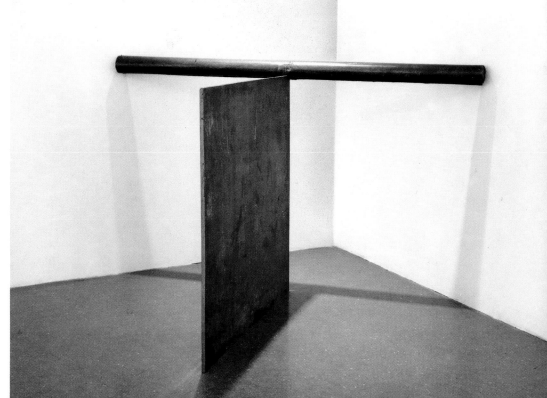

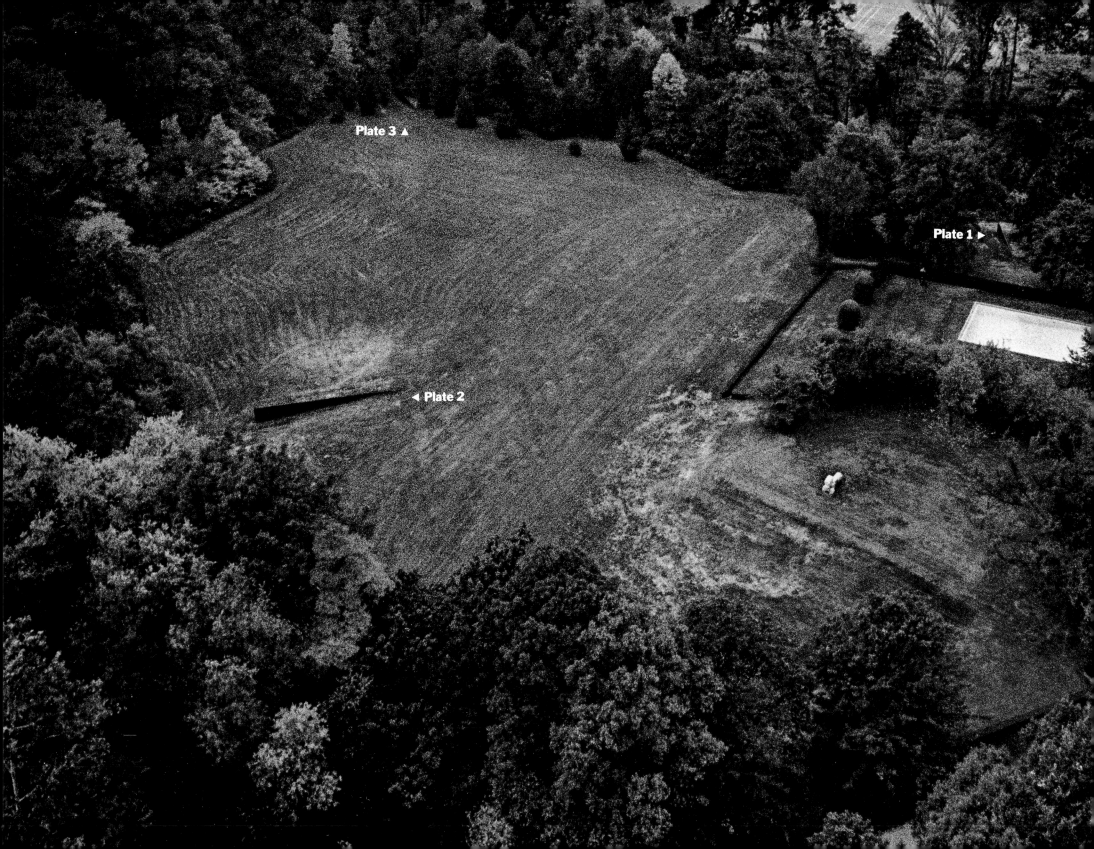

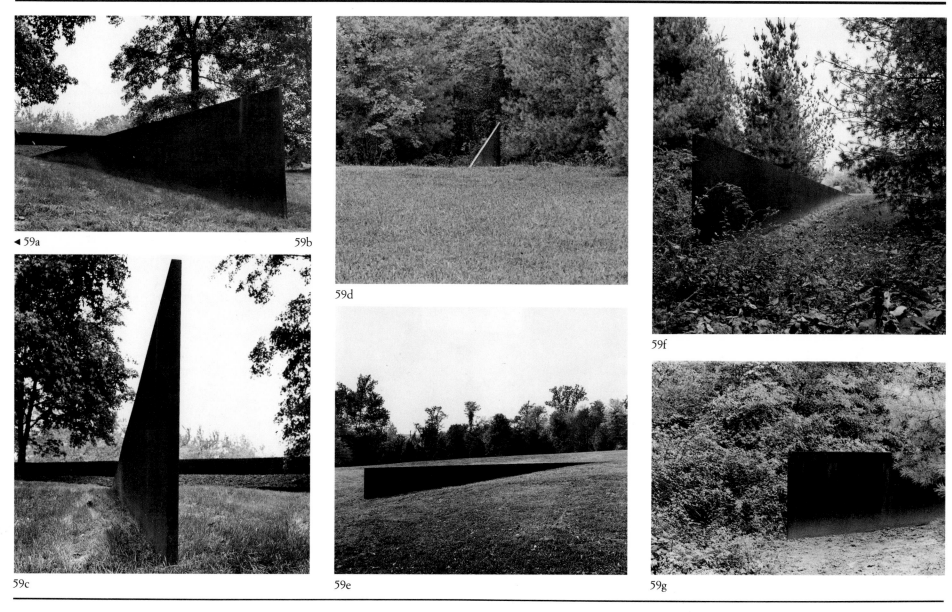

◄ 59a

59b

59d

59f

59c

59e

59g

59a–g. *Pulitzer Piece: Stepped Elevation.*
1970–71
Cor-Ten steel, three plates, (1) 60″ x 40′3″ x 2″,
(2) 60″ x 45′11″ x 2″, and (3) 60″ x 50′7″ x 2″,
located in 450 x 450′ area
Collection Mr. and Mrs. Joseph Pulitzer, Jr.,
St. Louis

59b/c. Details, plate 1

59d/e. Details, plate 2

59f/g. Details, plate 3

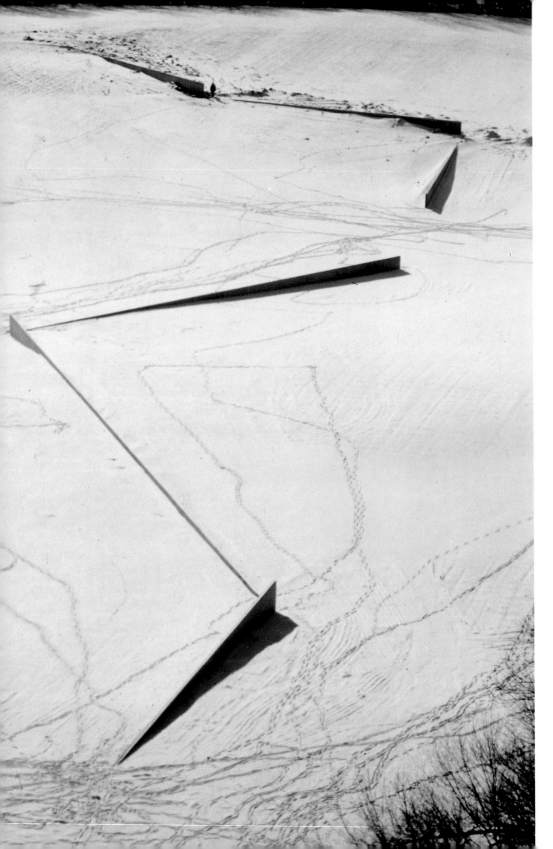

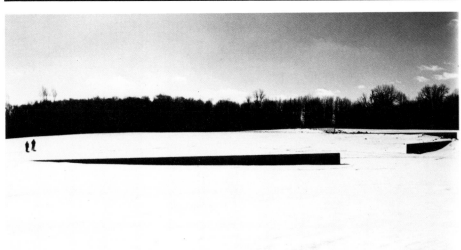

◀ 60a 60b

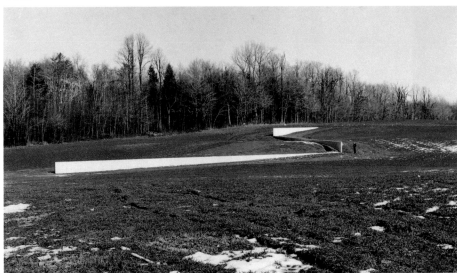

60c

60a—g. *Shift.* 1970–72
Concrete, six sections, 60″ x 90′ x 8″,
60″ x 240′ x 8″, 60″ x 150′ x 8″, 60″ x 120′ x 8″,
60″ x 105′ x 8″, and 60″ x 110′ x 8″; overall 815′
Installed King City, Ontario, Canada
Collection Roger Davidson, Toronto

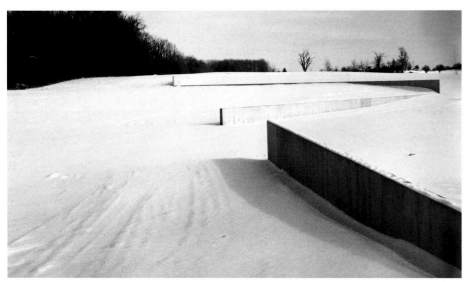

60d

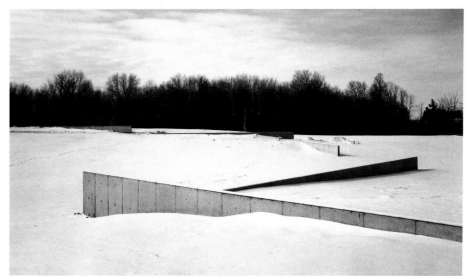

60f

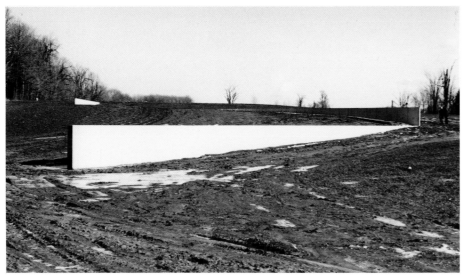

60e

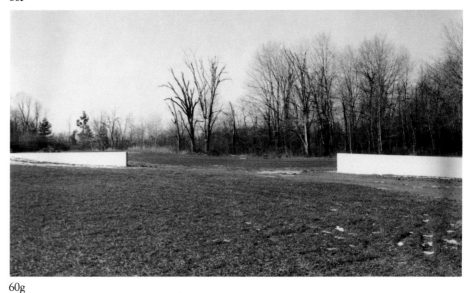

60g

61. Following page: Untitled. 1971
Cor-Ten steel, two plates, overall 8 x 16′ x 12′ 6″
Dallas Museum of Art, Matching Grants from
the National Endowment for the Arts and
The 500, Inc., in Honor of Mr. and Mrs.
Leon Rabin

62. Following page: *Mozarabe*. 1971
Cor-Ten steel, four plates, overall 8 x 30 x 20′
The Detroit Institute of Arts, Founders Society
Purchase with Funds from W. Hawkins Ferry

63. Following page: *Moe*. 1971
Hot rolled steel, three plates, overall 8 x 20 x 12′
Museum Ludwig, Cologne, West Germany

64. Following page: *Five Plates, Two Poles*.
1971
Cor-Ten steel, plates, each 8 x 8′ x 2″; poles,
each 12′ x 7″ diameter; overall 8 x 23 x 18′
Walker Art Center, Minneapolis, Gift of
Mr. and Mrs. Kenneth N. Dayton

65. Following pages: *Joplin*. 1970
Hot rolled steel, three plates, each 8 x 8′ x 2″;
overall 8 x 12 x 16′
Private collection

Photo, pl. 63: Peter Moore

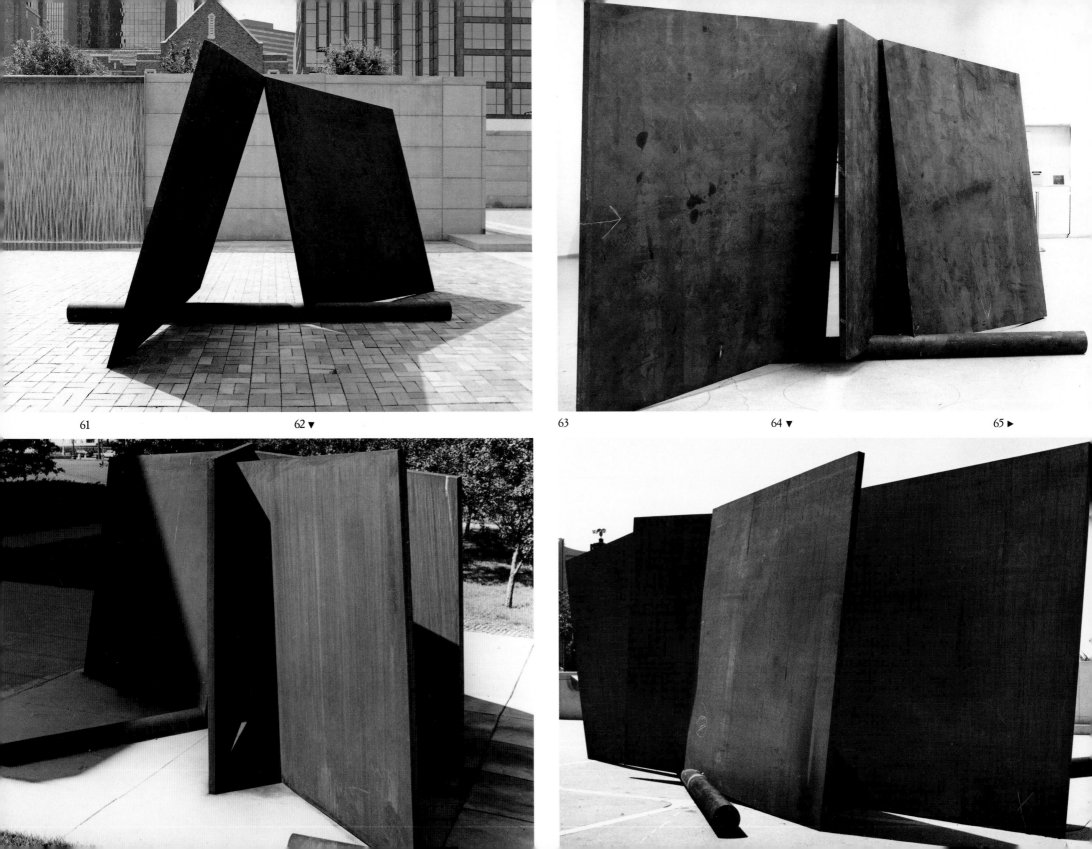

61 62 ▼ 63 64 ▼ 65 ▶

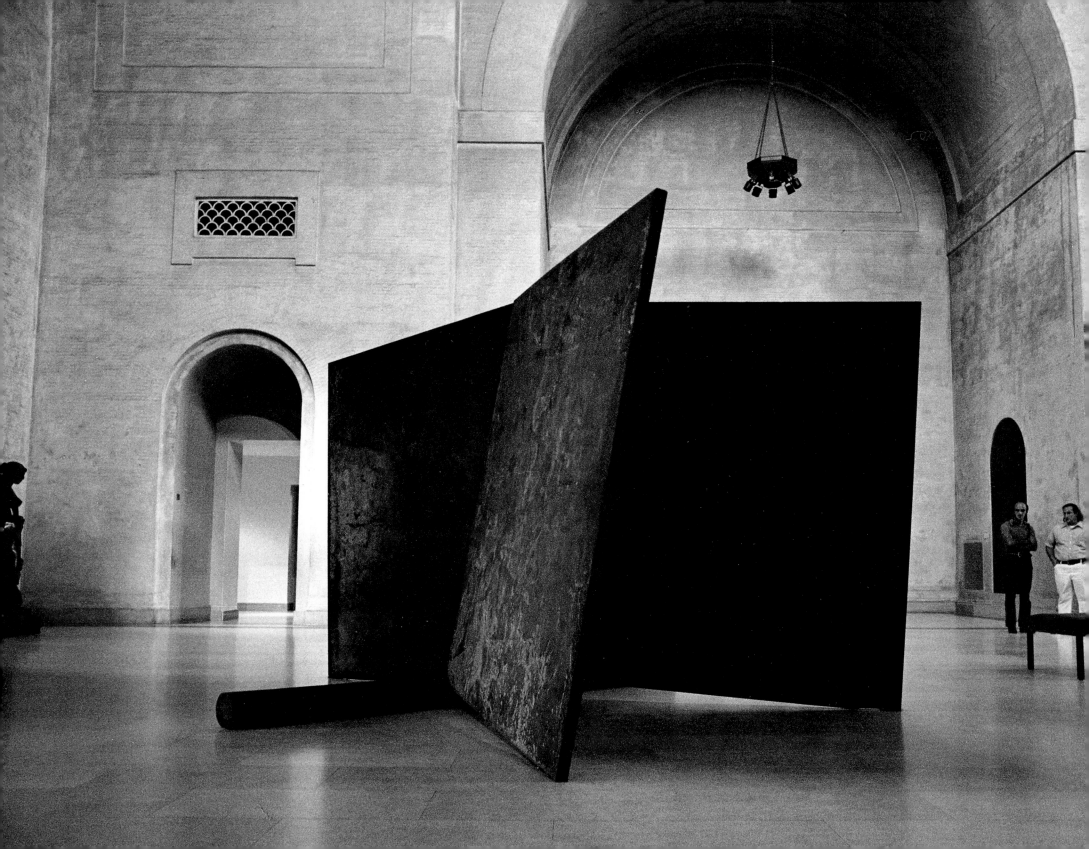

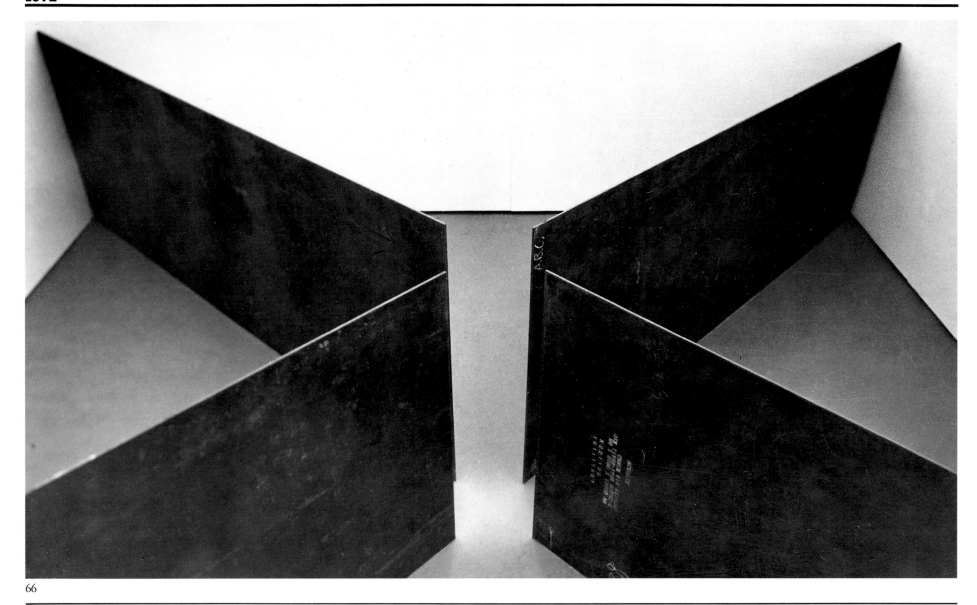

66

66. *Circuit.* 1972
Hot rolled steel, four plates, each 8 x 24' x 1";
overall 8 x 36 x 36'
Galerie m, Bochum, West Germany

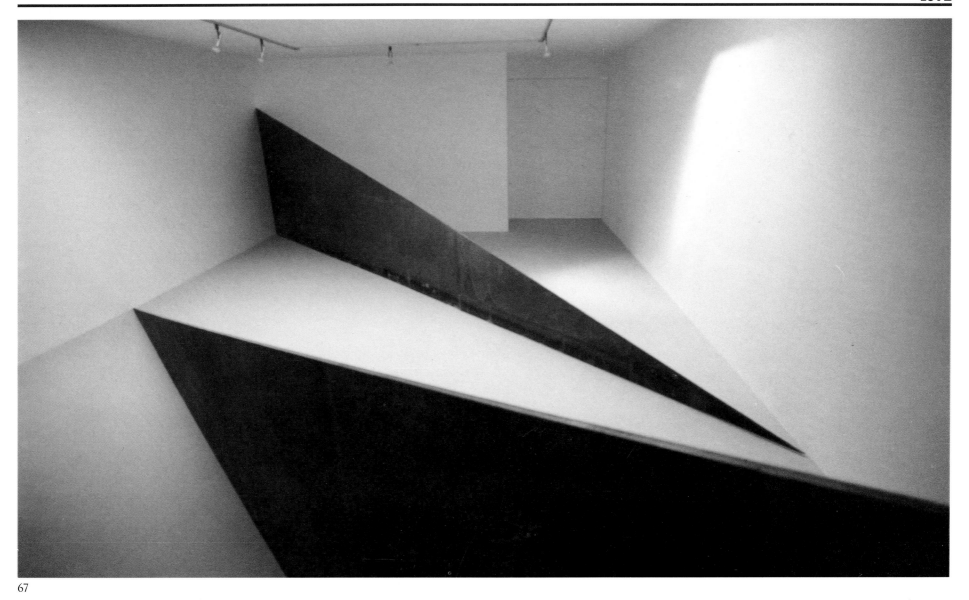

67

67. *Twins: To Tony and Mary Edna.* 1972
Hot rolled steel, two plates, each 8 x 42′ x 1½″
Collection Giuseppe Panza di Biumo,
Varese, Italy

68

68. *Spoleto Circles.* 1972
Steel, one circle flush to the ground, one circle
in the ground, ¼″ x 8′ diameter
Collection Fabio Sargentini, Rome, and
collection the artist

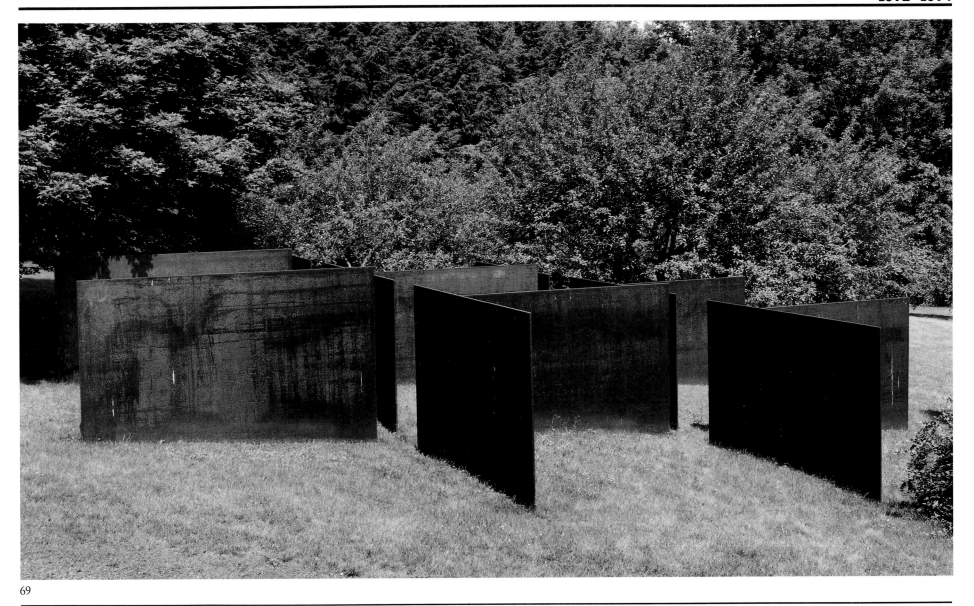

69

69. *Five Elevations.* 1972–74
Hot rolled steel, twelve plates, each 8 x 12' x 1"
Collection Mr. and Mrs. Morton J. Hornick,
New York

70. Following page: *Spin Out: For Bob Smithson.*
1972–73
Hot rolled steel, three plates, each 10 x 40' x 1½"
Rijksmuseum Kröller-Müller, Otterlo,
the Netherlands

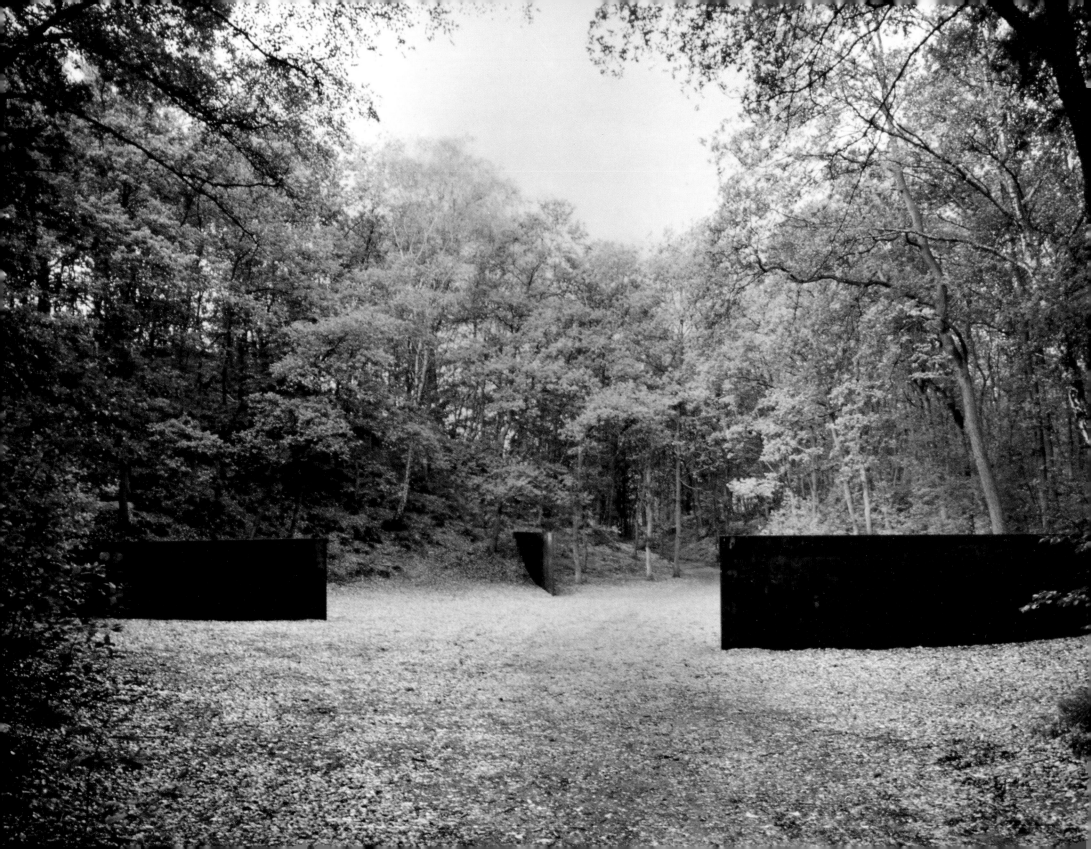

◀ 70 71a 71b ▶

71a/b. *Sight Point.* 1971–75
Cor-Ten steel, three plates, each 40 x 10′ x 2½″
Installed Amsterdam (b); view from
interior (a)
Stedelijk Museum, Amsterdam

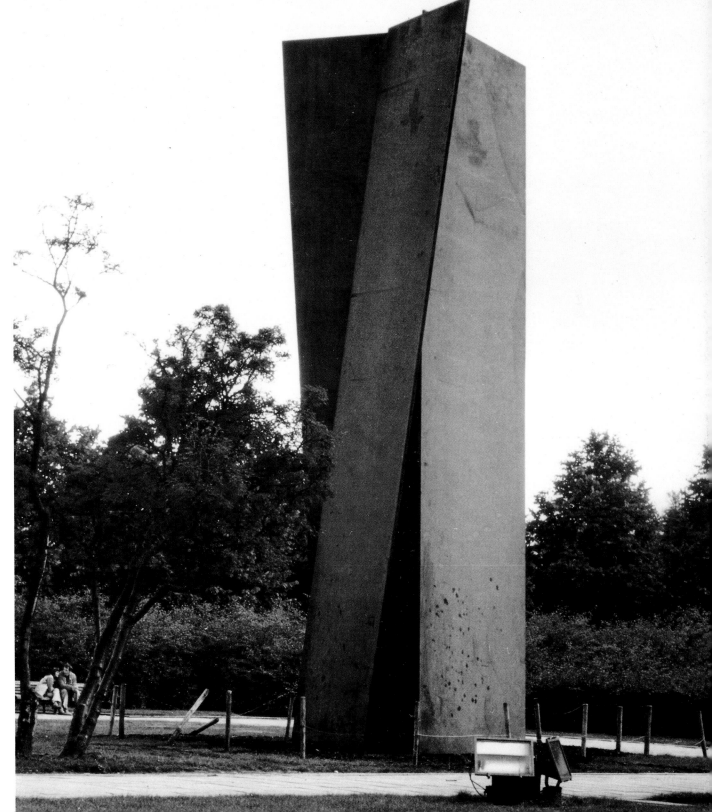

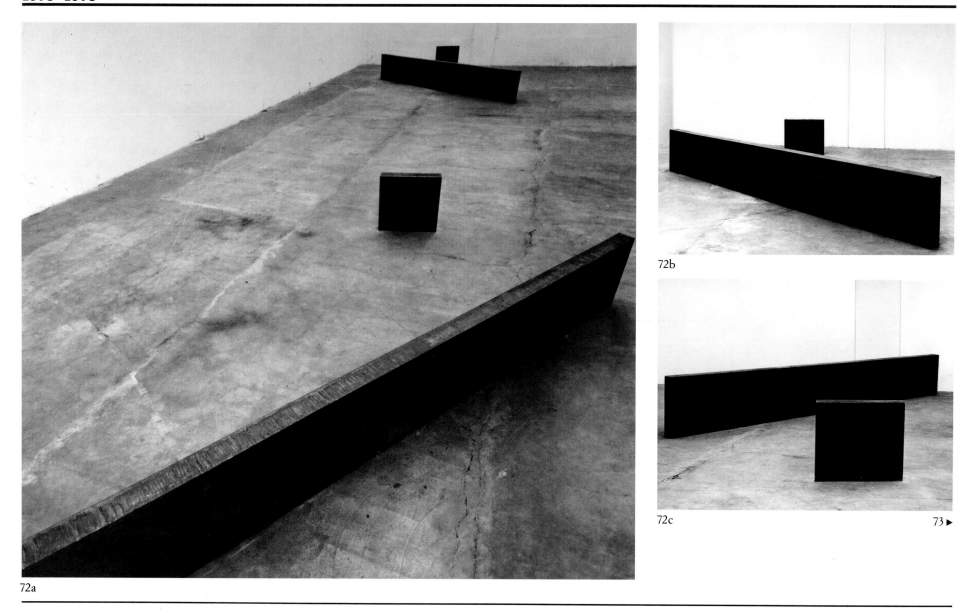

72a

72b

72c

73 ▶

72a–c. *Equal Parallel and Right Angle Elevations.* 1973
Hot rolled steel, four elements,
two 24″ x 14′9″ x 5¼″; two 24 x 27 x 5¾″
Private collection

73. Opposite: *Unequal Elevations.* 1975
Steel, two blocks, 12 x 24 x 12″ and
10 x 24 x 12″
Collection Giuseppe Panza di Biumo,
Varese, Italy

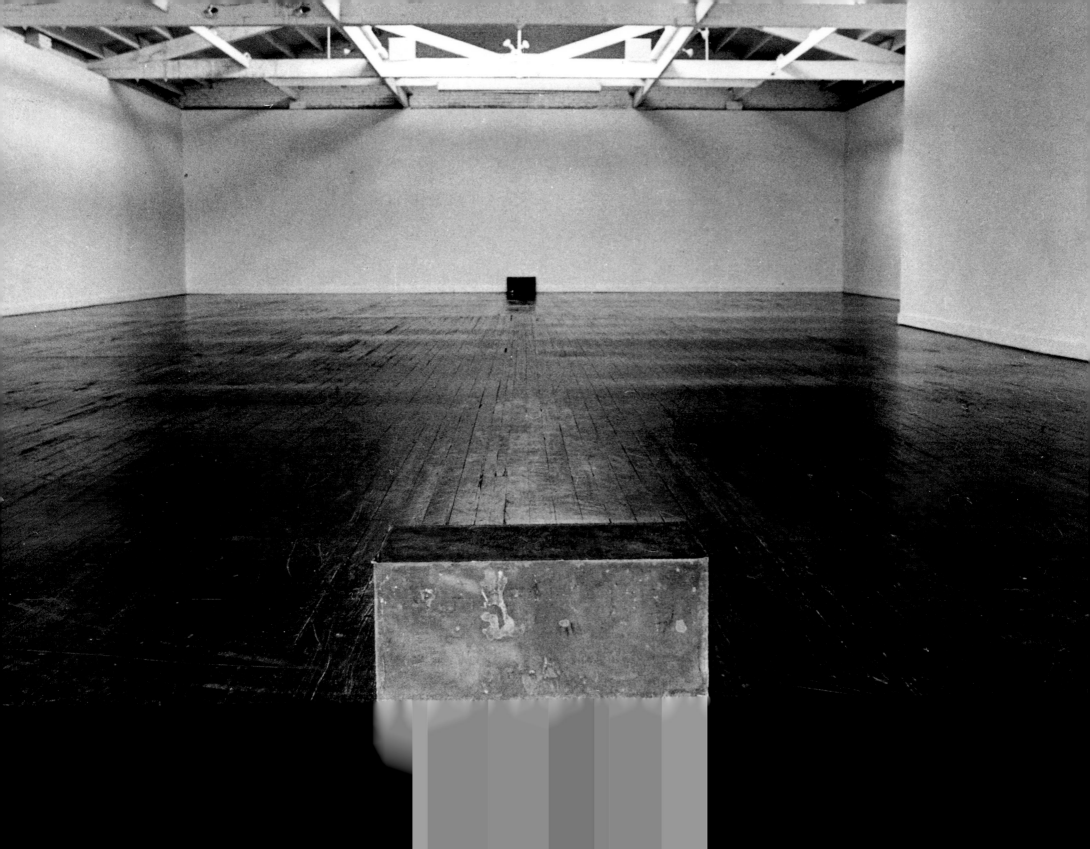

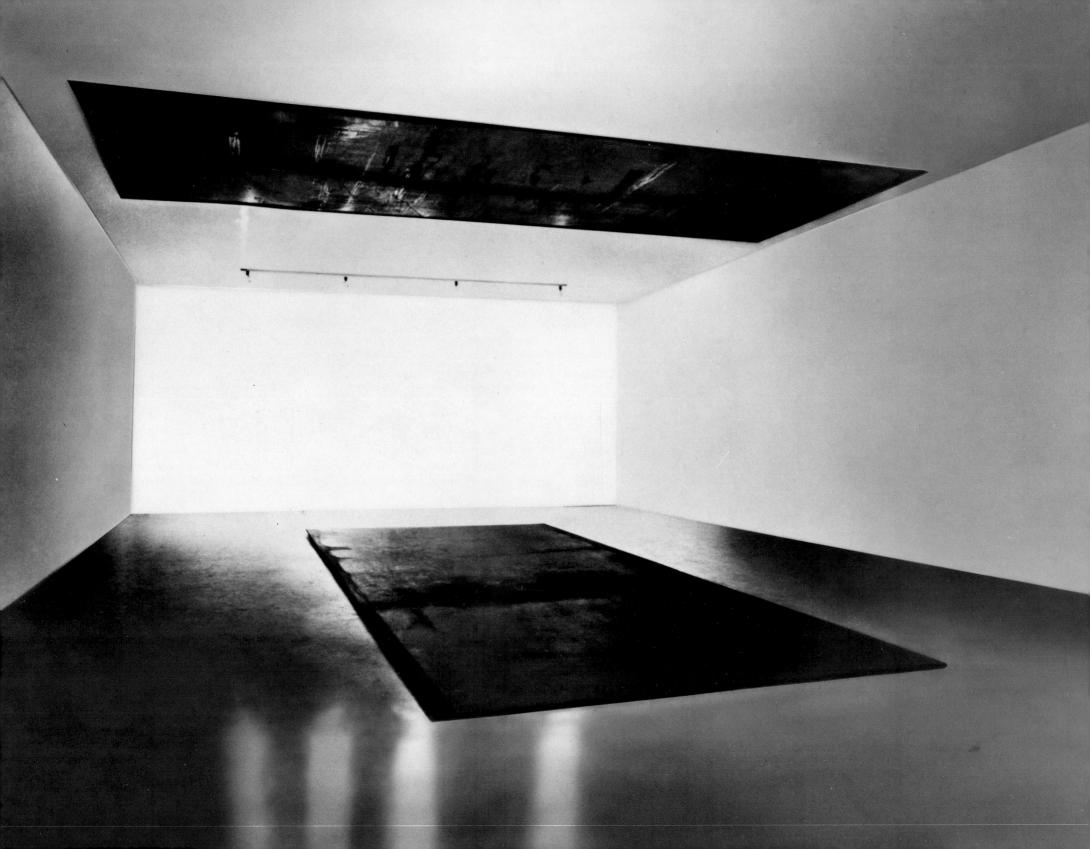

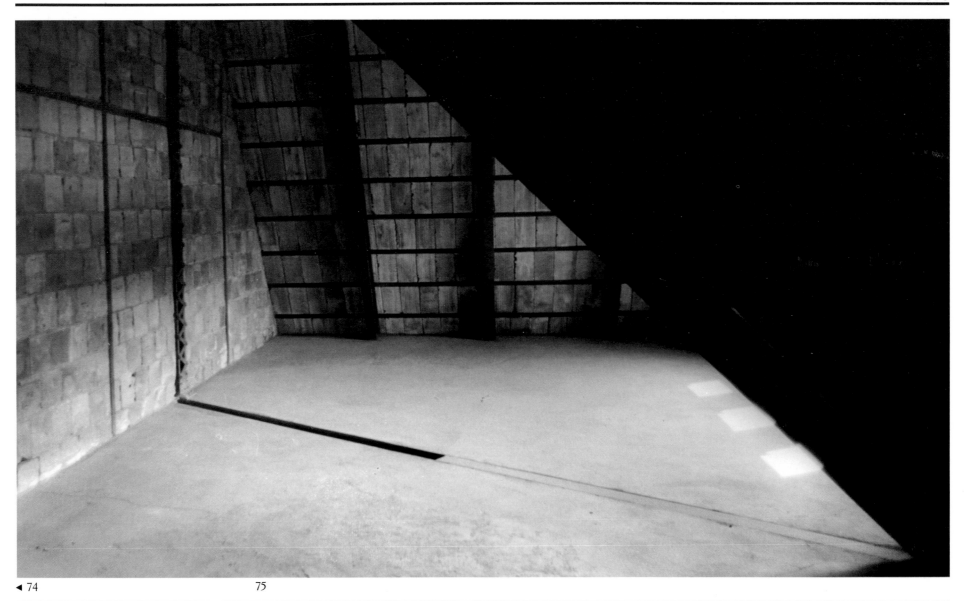

◄ 74 75

74. Opposite: *Delineator*. 1974–75
Steel, two plates, each 1″ x 10 x 26′
Collection the artist and Ace Gallery, Venice,
California

75. *P.S. 1.* 1976
Hot rolled steel, two channels, 2 x 5″ x 30′
P.S. 1, Long Island City, New York, Gift of
the artist

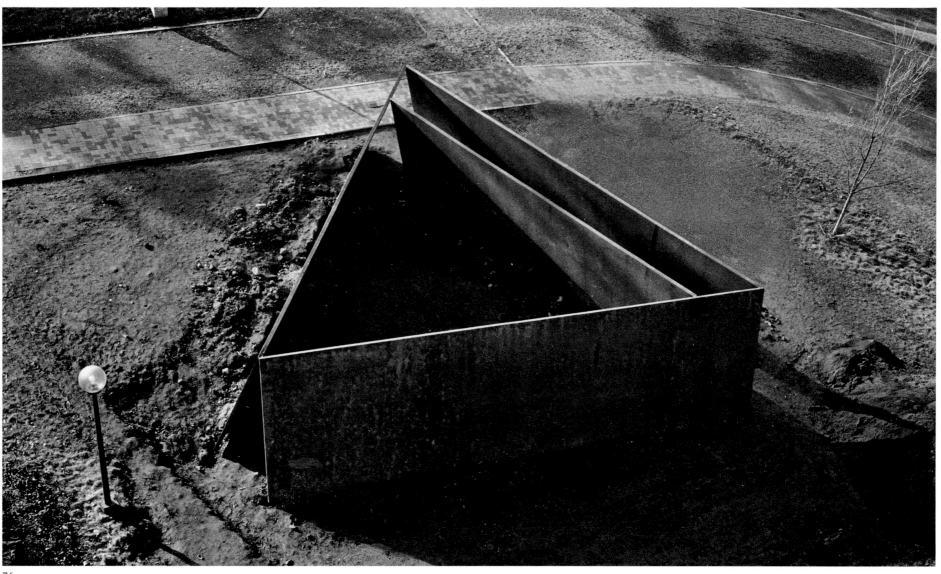

76a

76a—c. *Wright's Triangle.* 1976–80
Cor-Ten steel, 10 x 36 x 36'
Western Washington State University,
Bellingham

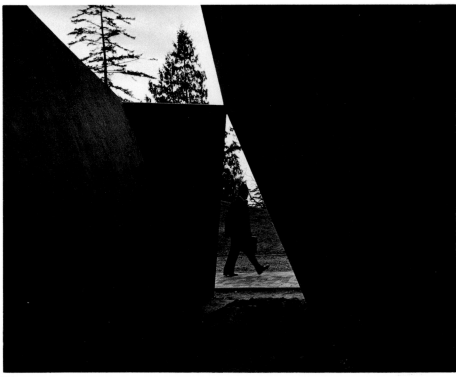

76c

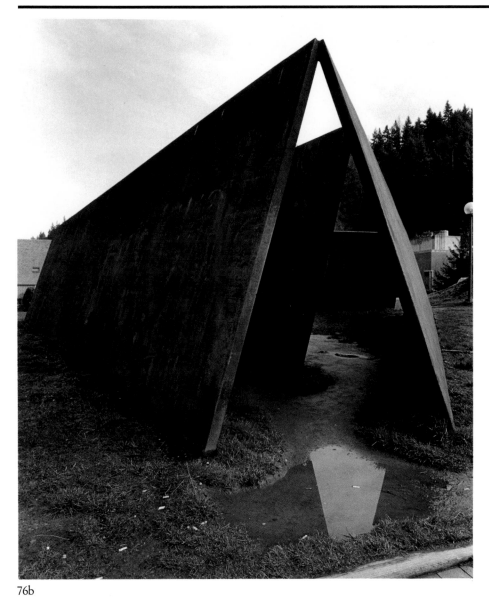

76b

77a

77b

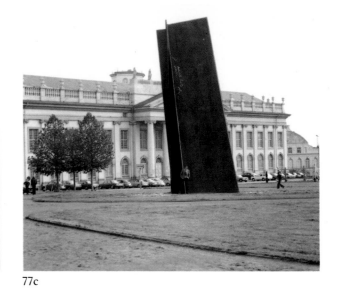

77c

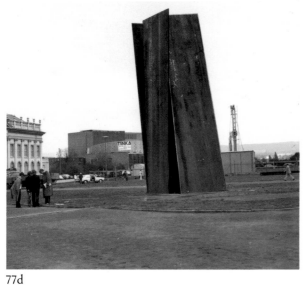

77d

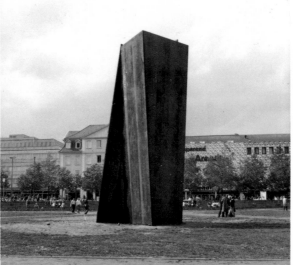

77e

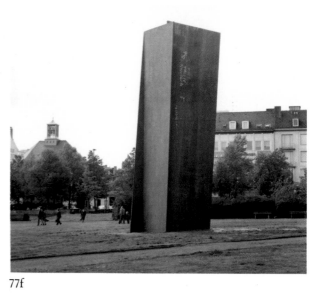

77f

77a–h. *Terminal.* 1977
Cor-Ten steel, four trapezoidal plates,
each 41′ x 12 to 9′ (irregular) x 2½″
Installed Documenta 6, Kassel, West Germany
(a–f), and Bochum, West Germany (g);
view from interior (h)
Stadt Bochum, West Germany

◄ 77g 77h

78

78. *Span: To Alexander and Gilbert.* 1977
Steel, three square beams, overall 9'11" x
36'3" x 8"
Galerie Daniel Templon, Paris, Leo Castelli
Gallery, New York, and collection the artist

79a

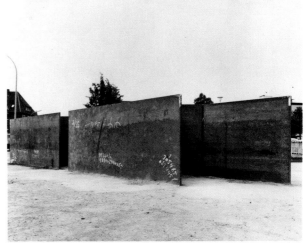

79b

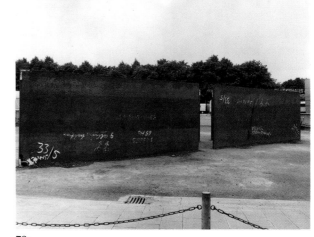

79c

79a–c. Untitled Piece for Münster. 1977
Cor-Ten steel, six plates, overall 10 x 44 x 7'
Galerie m, Bochum, West Germany

80. Following pages: *Berlin Block for Charlie Chaplin*. 1977
Forged steel, 6'3" x 6'3" x 6'3"
Nationalgalerie Berlin, Staatliche Museen
Preussischer Kulturbesitz

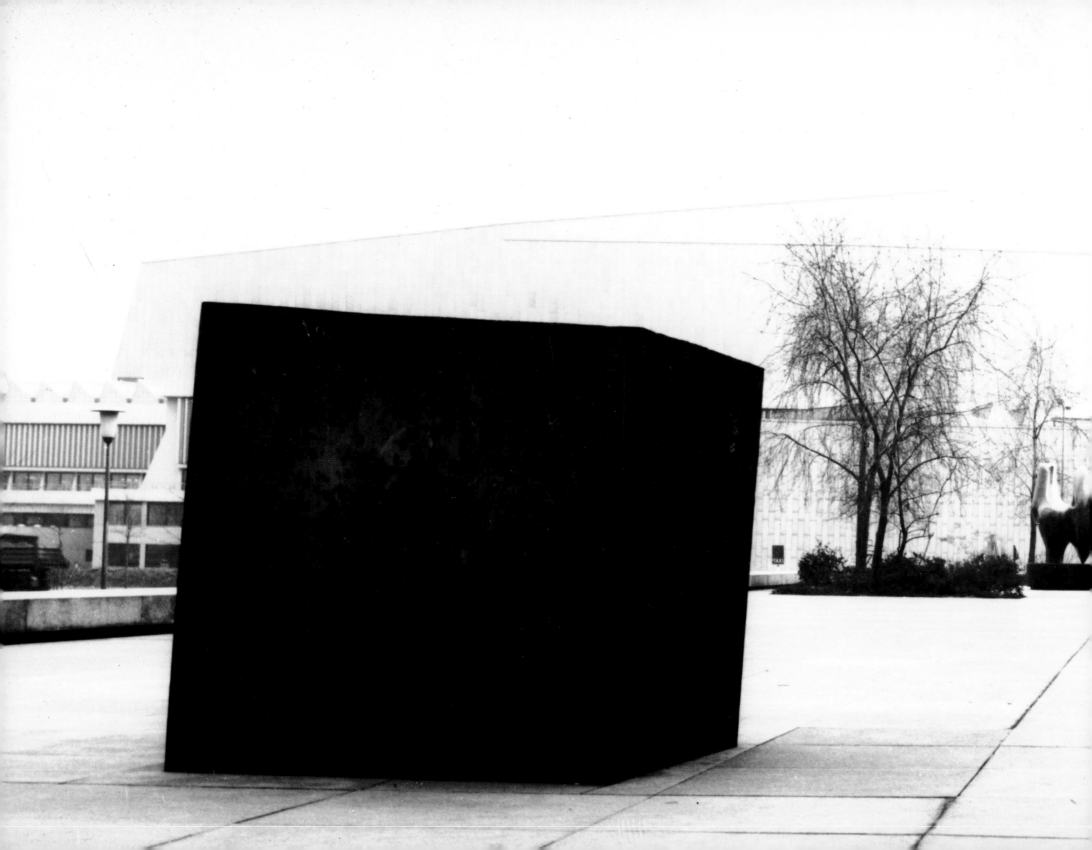

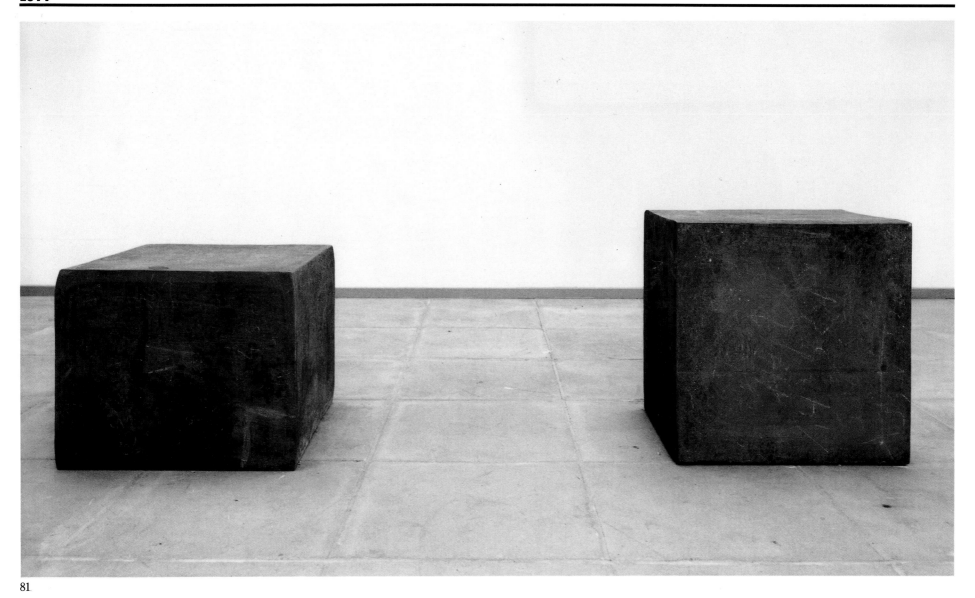

81

81. *Consequence.* 1977
Forged steel, two blocks, 17¾ x 21⅝ x 21⅝"
and 21⅝ x 21⅝ x 17¾"
Städtisches Museum Abteiberg,
Mönchengladbach, West Germany

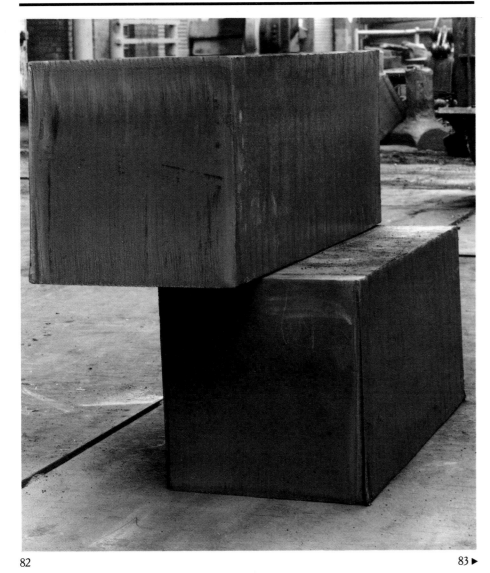

82

83 ▶

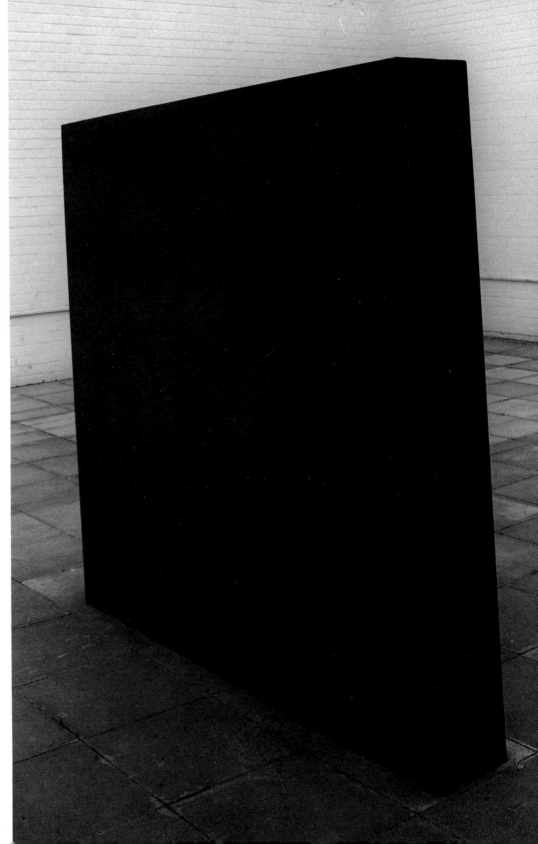

82. Untitled. 1978
Forged steel, two blocks, 27½ x 27½ x 59″ and
27½ x 27½ x 71″
Skulpturenmuseum Glaskasten, Marl,
West Germany

83. *Tot.* 1977
Forged steel, 6′5½″ x 6′5½″ x 10″
Staatsgalerie Stuttgart

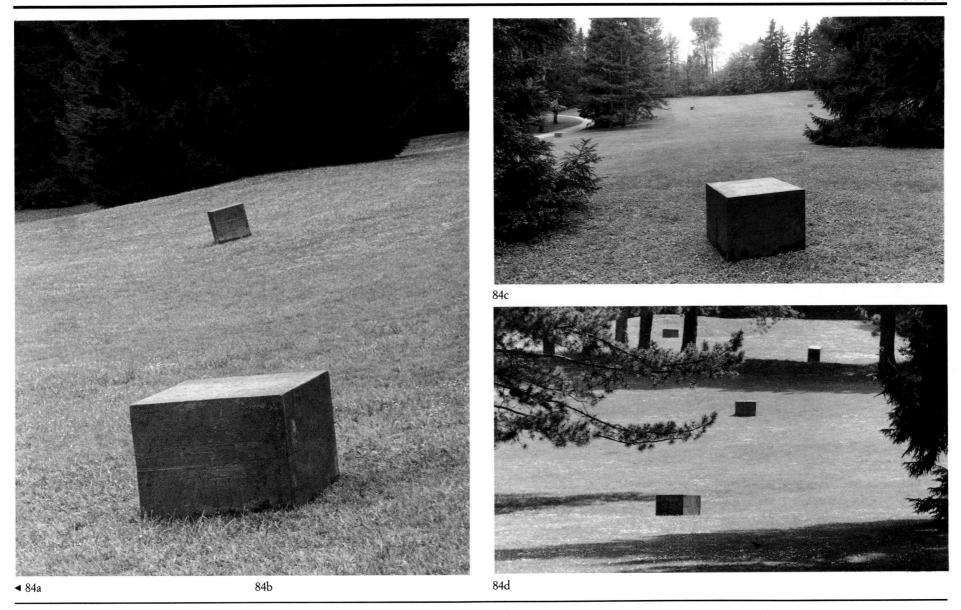

◄ 84a　　　　　　　84b　　　　　　　84c　　　　　　84d

84a—d. *Open Field Vertical/Horizontal*
Elevations: For Brueghel and Martin Schwander.
1979–80
Forged steel, ten cubes, each 29 x 27½ x 22″
Installed Wenkenpark, Riehen/Basel
Emanuel-Hoffmann-Stiftung, Basel, Switzerland

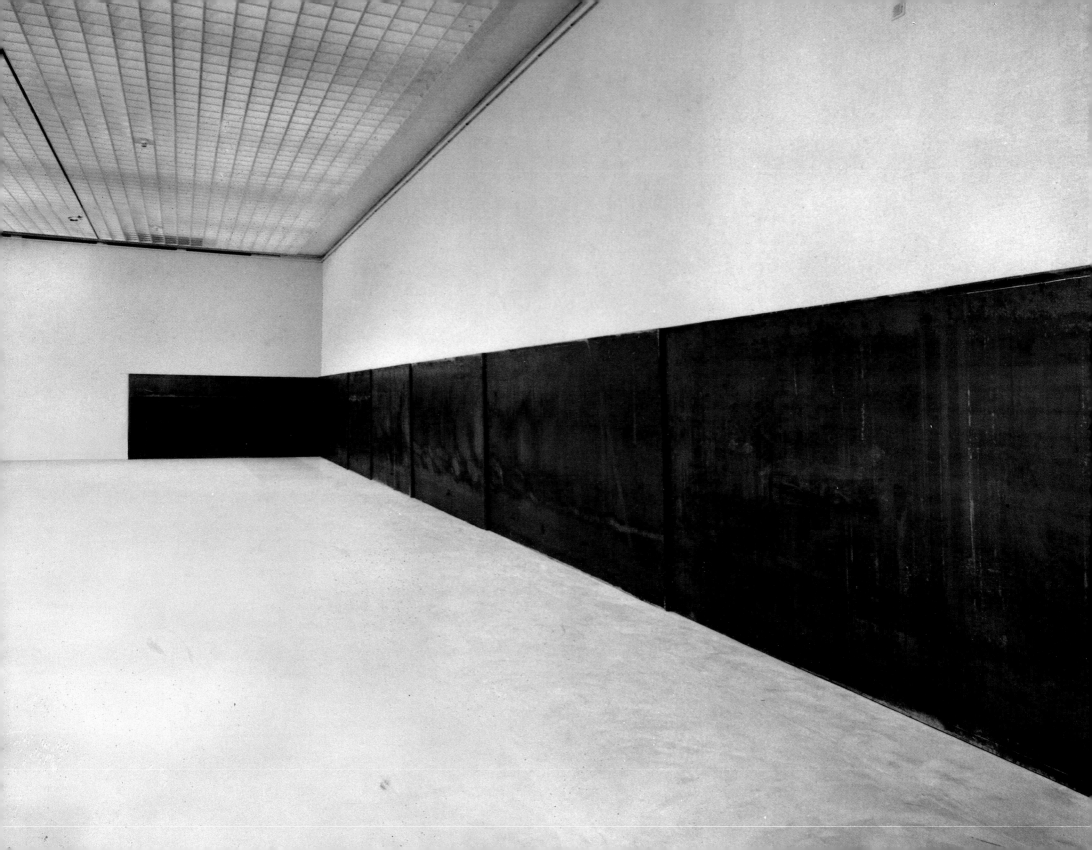

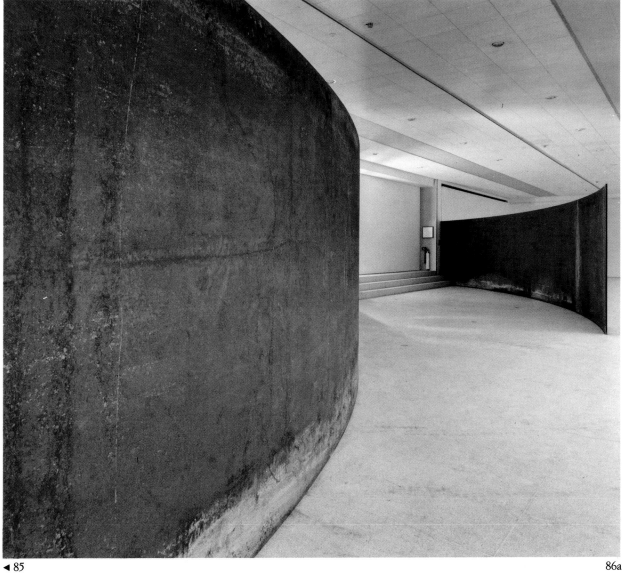

86b

◄ 85

86a 86c

85. Opposite: *Extended Cantilever*. 1980
Steel, eighteen plates, nine at each end of
room; each plate 6′6¾″ x 14′9⅛″ x 1″; overall
6′6¾″ x 106′ 5½″ x 84′
Installed Museum Boymans–van Beuningen,
Rotterdam, 1980
Collection the artist

86a/b. *Waxing Arcs*. 1980
Hot rolled steel, two plates, each 9′10″ x 40′4″
x ¾″
Museum Boymans–van Beuningen, Rotterdam

86c. Plan for installation, *Waxing Arcs*, 1980
Engineering drawing by Malcolm Graff Asso-
ciates, New York

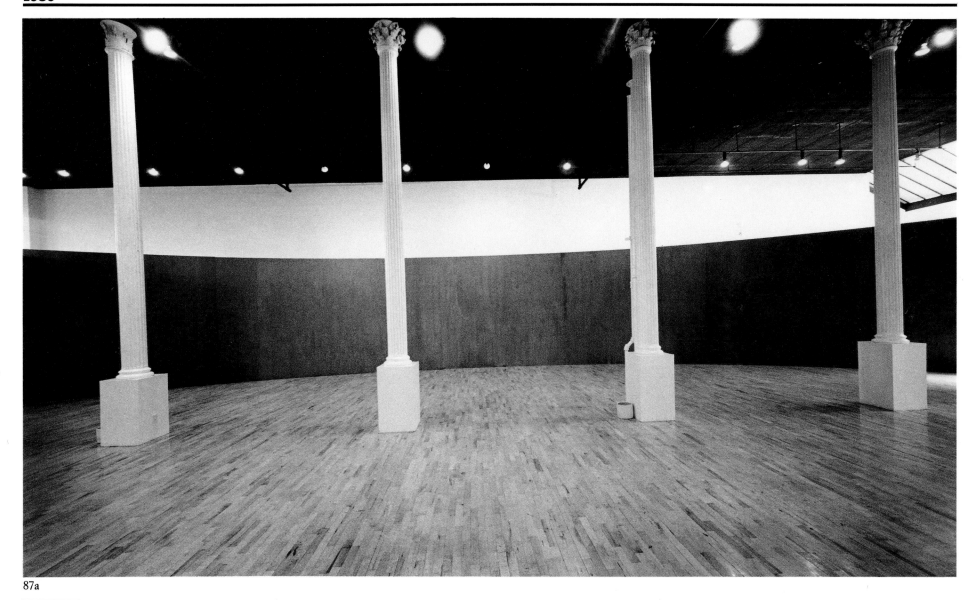

87a

87a–d. *Slice.* 1980
Cor-Ten steel, 10′ x 124′6″ x 1½″
Leo Castelli Gallery and Blum Helman Gallery,
New York, and collection the artist

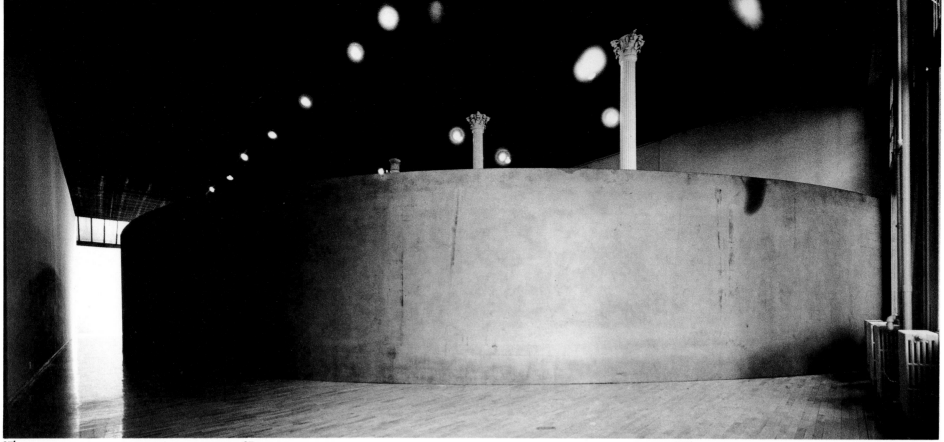

87b

87c ▼

87d ▼

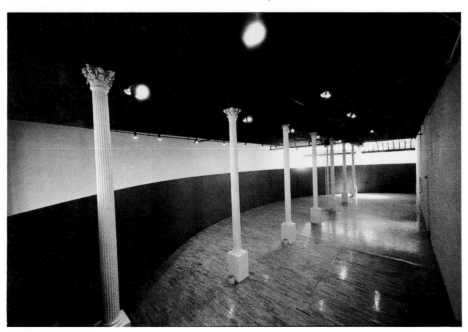

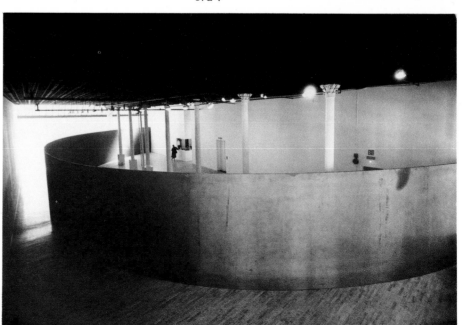

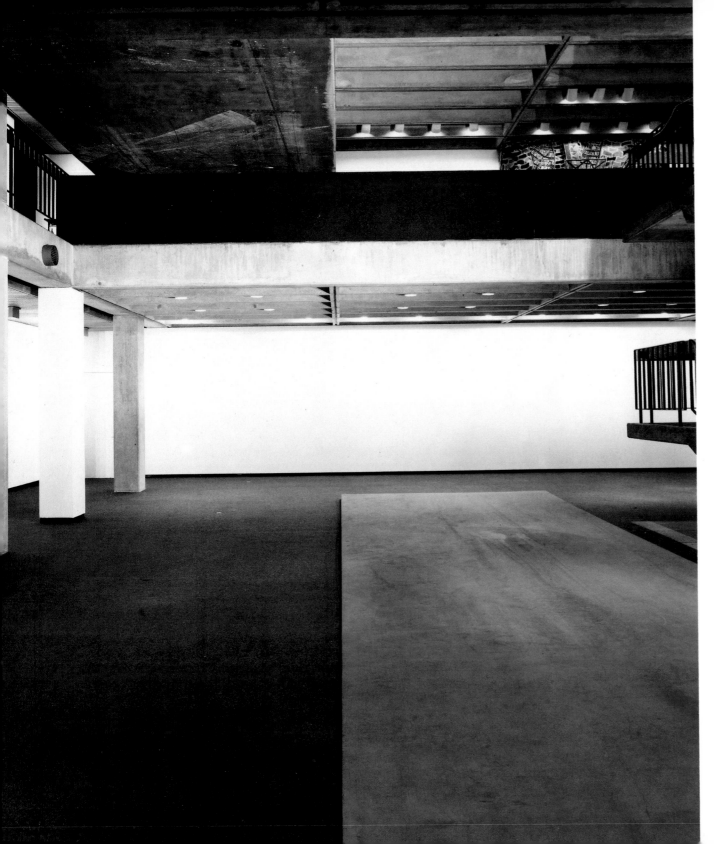

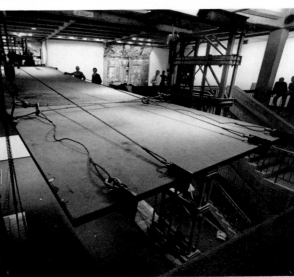

◄ 88a 88b

88c 89a/b ►

88a. *Elevator.* 1980
Cor-Ten steel, two plates, each 2½″ x 12 x 40′;
one plate at floor level, one cantilevered above
Installed The Hudson River Museum,
Yonkers, New York, 1980
Collection the artist

88b/c. Rigging of *Elevator,* 1980

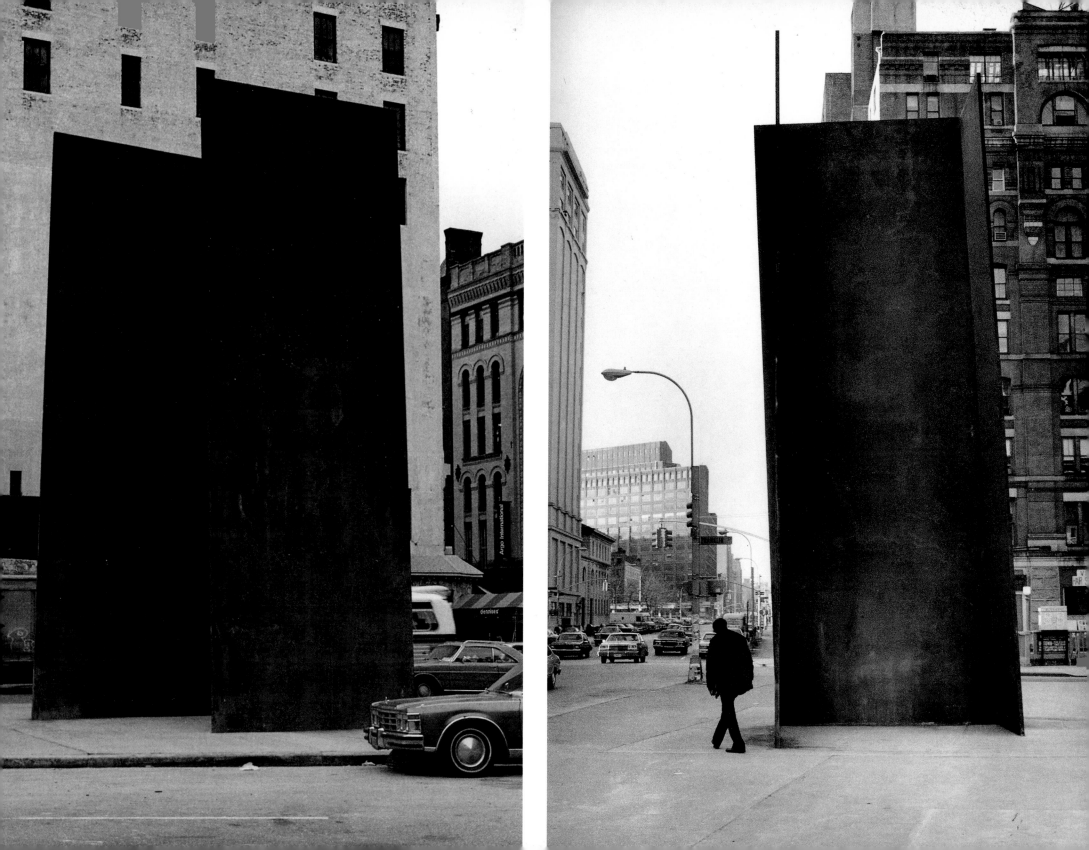

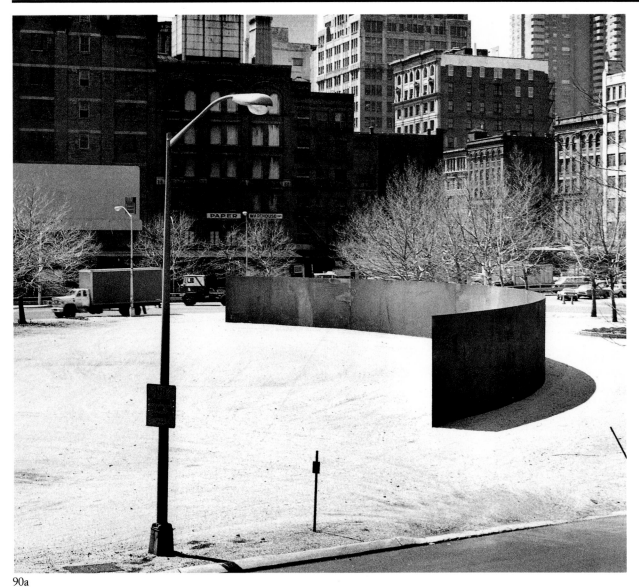

90a

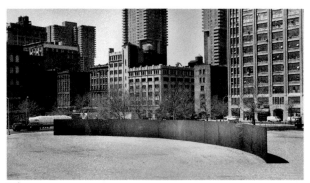

90b

90c

90d 90e ▶

89a/b. Preceding page: *T.W.U.* 1980
Cor-Ten steel, three plates, each 36 x 12′ x 2¾″
Installed West Broadway between Leonard
and Franklin streets, New York, 1981–82
Galerie m, Bochum, West Germany

90a—e. *St. John's Rotary Arc.* 1980
Cor-Ten steel, 12 x 200′ x 2½″
Installed Holland Tunnel exit, New York
Leo Castelli Gallery, New York

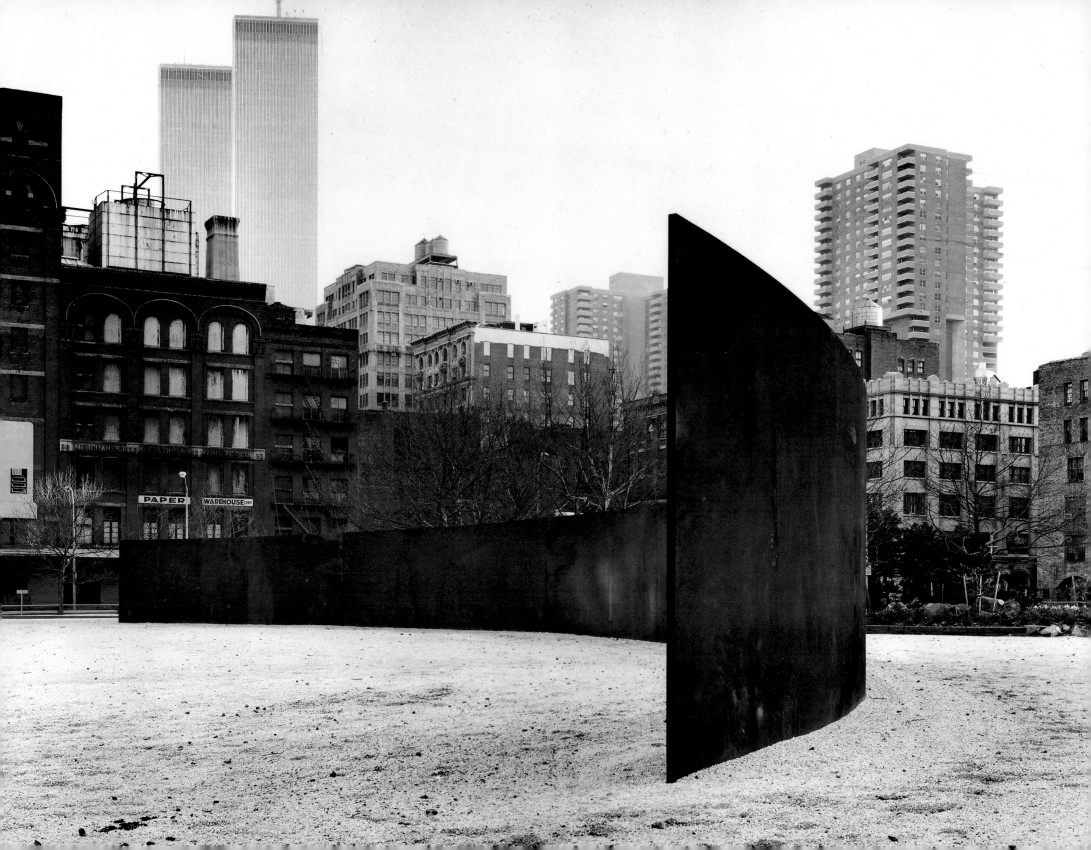

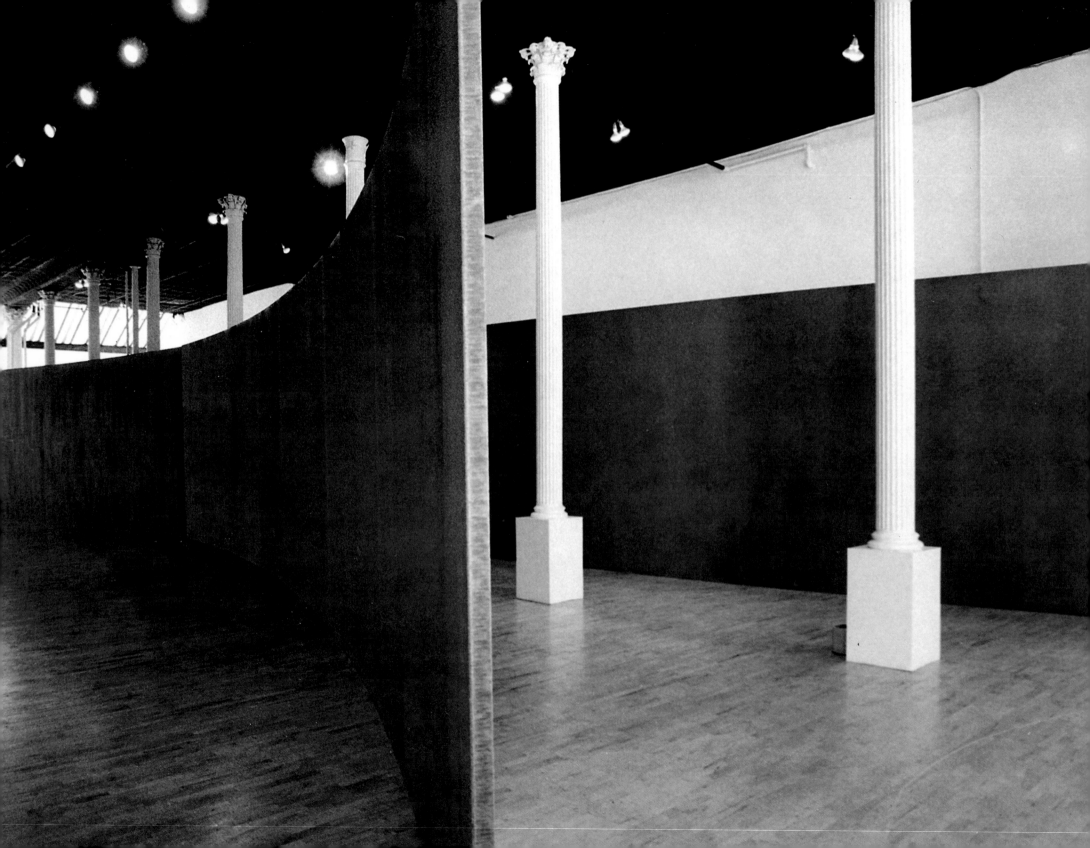

◄ 91a

91b

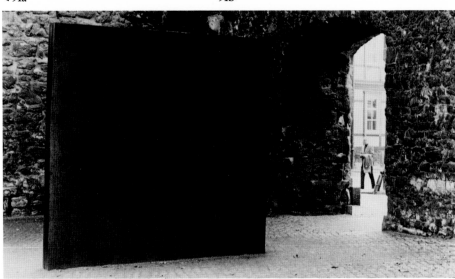

92a

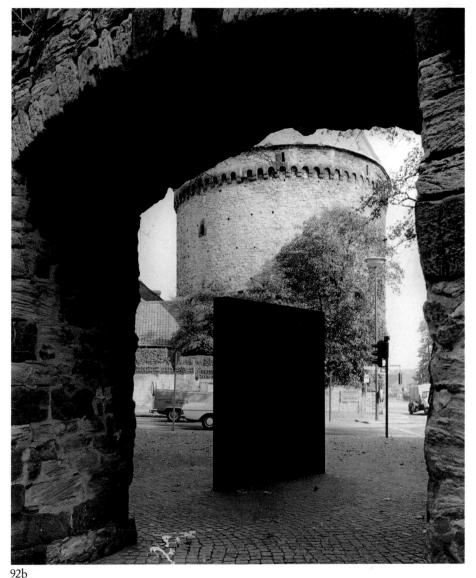

92b

91a. Opposite: *Marilyn Monroe–Greta Garbo (A Sculpture for Gallery-Goers).* 1981
Cor-Ten steel, two elements, each 10 x 85′ x 1½″
Leo Castelli Gallery and Blum Helman Gallery, New York, and collection the artist

91b. Plan for installation, *Marilyn Monroe–Greta Garbo (A Sculpture for Gallery-Goers),* 1981
Engineering drawing by Malcolm Graff Associates, New York

92a/b. *Gedenkstätte Goslar.* 1981
Forged steel, 9′2″ x 9′2″ x 11″
Stadt Goslar, West Germany

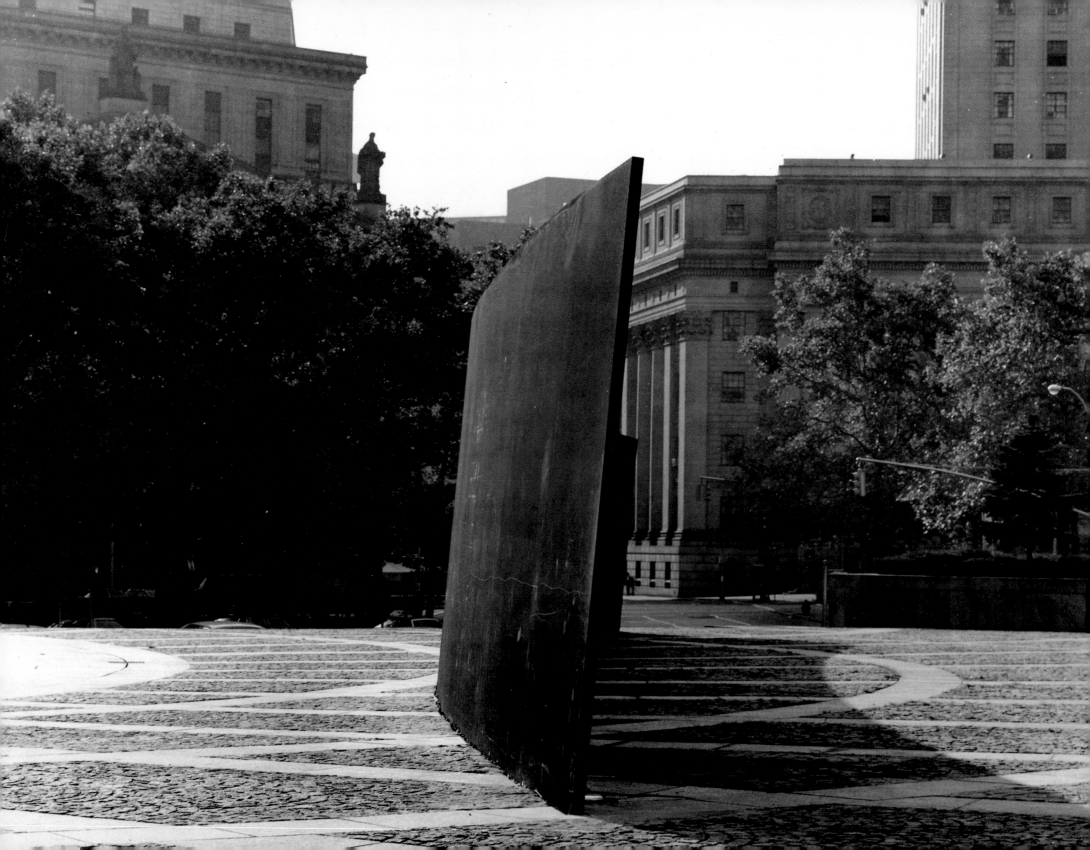

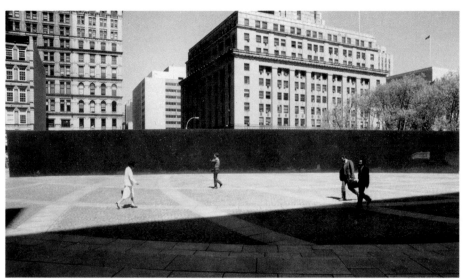

93c

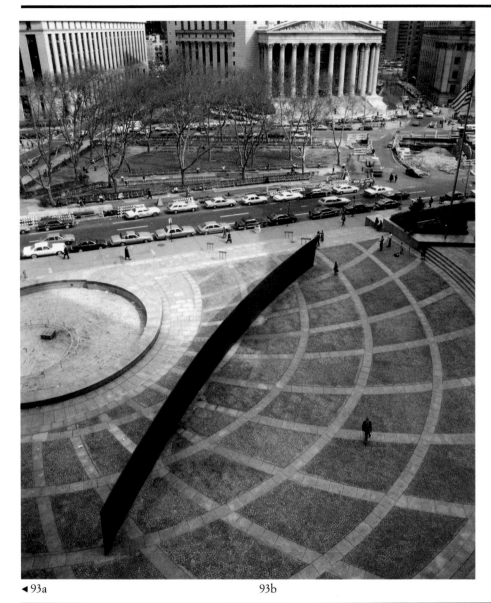

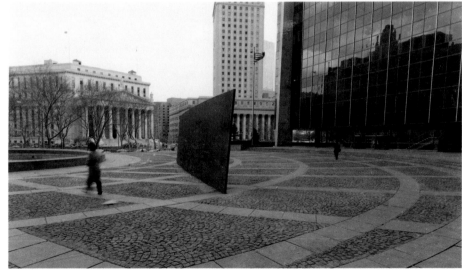

◄ 93a 93b 93d

93a–d. *Tilted Arc.* 1981
Cor-Ten steel, 12 x 120′ x 2½″
Installed Federal Plaza, New York
General Services Administration,
Washington, D.C.

93e–h. Following pages: *Tilted Arc.* 1981

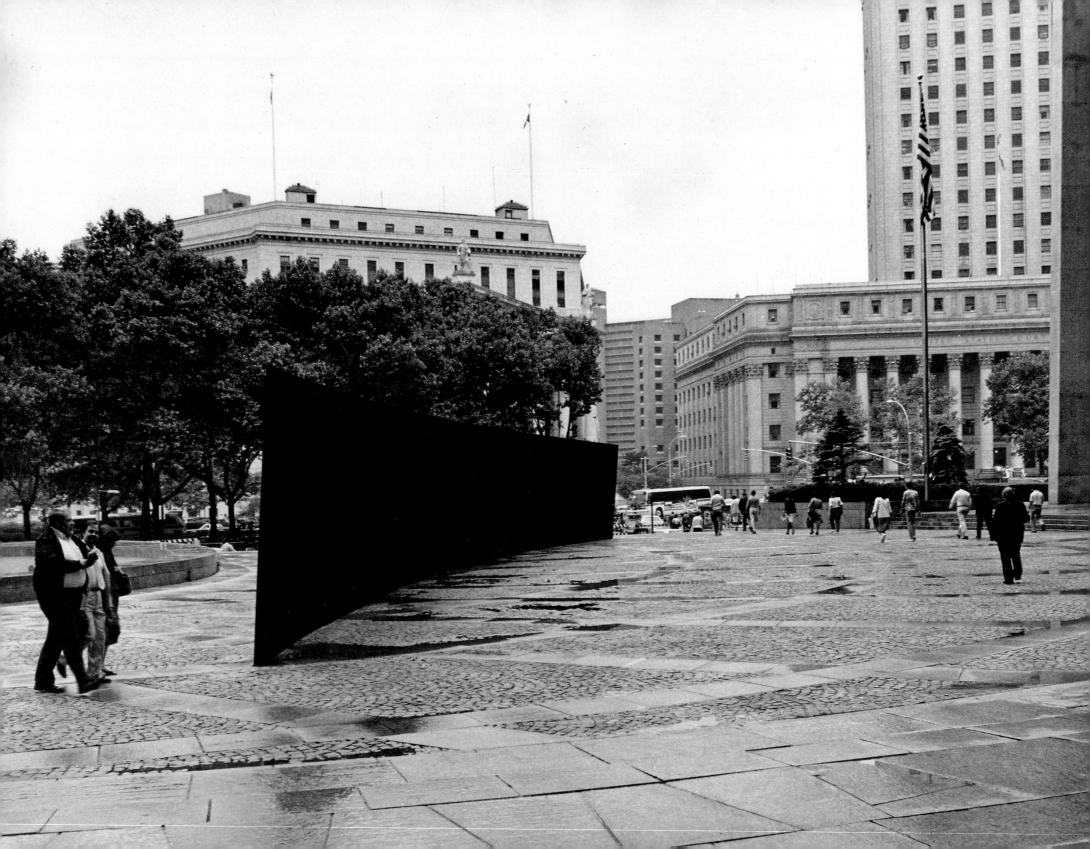

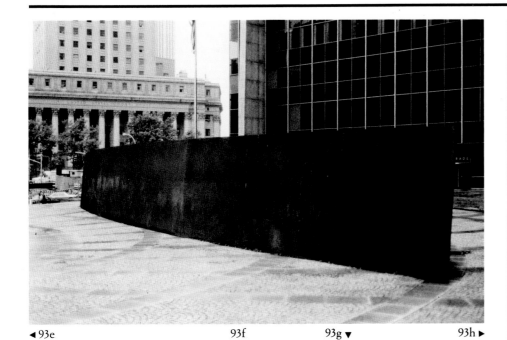

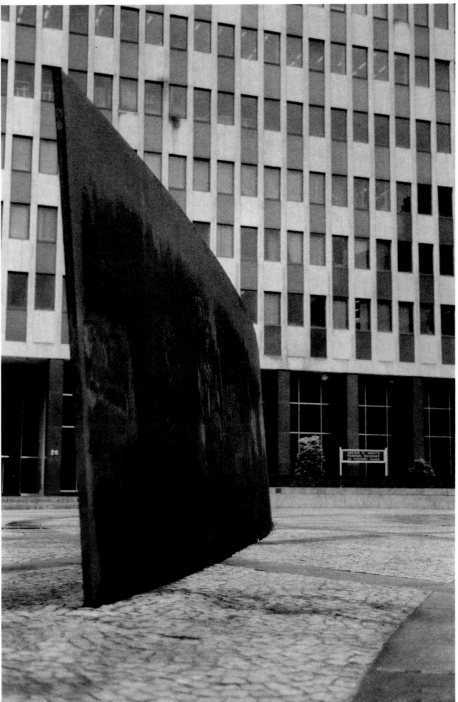

◄ 93e 93f 93g ▼ 93h ►

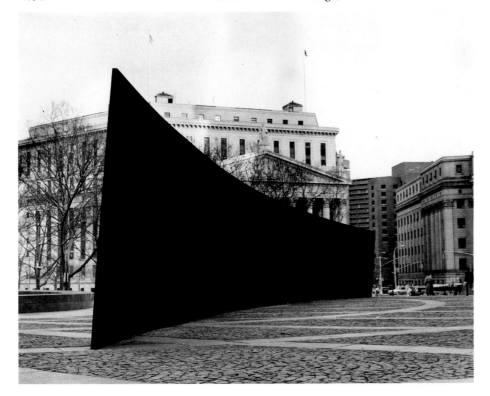

◄ 94a 94b

94a—c. *Twain.* 1974—82
Cor-Ten steel, eight plates: seven plates, each
12 x 40′ x 2″; one plate, 12 x 50′ x 2″
St. Louis

94c

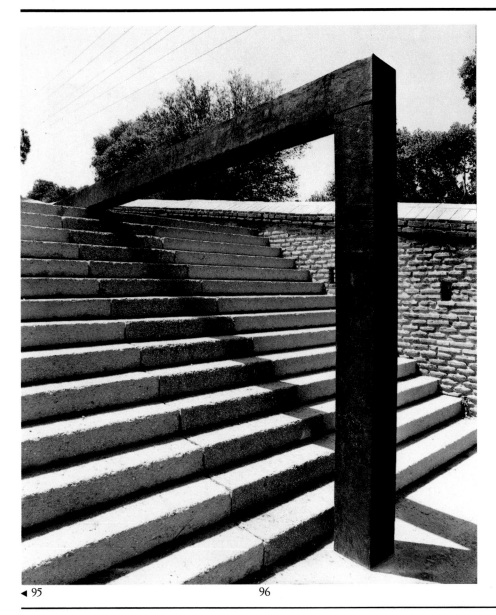

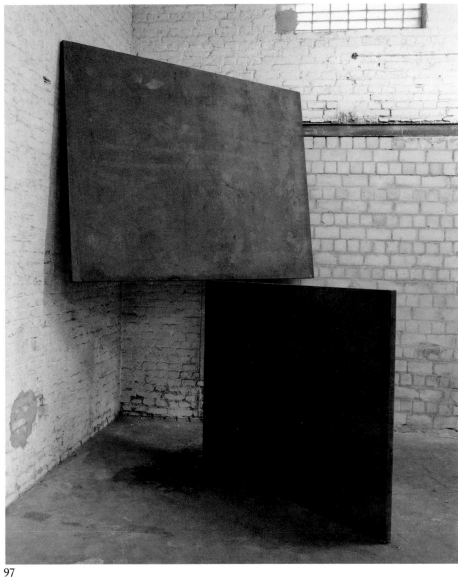

◄ 95 96 97

95. Opposite: *Colombino di Firenzuola*. 1982
Eight stones, each 7′ x 4′10″ x 4′10″
Collection Giuliano Gori, Fattoria di Celle,
Santomato di Pistoia, Italy

96. *Step*. 1982
Steel, two square beams, approx. 9 x 24′ x 10″
Collection Jacques Hachuel, Madrid

97. *Do It*. 1983
Hot rolled steel, overall 10′ 11″ x 8′6″ x 11′9″
Galerie Reinhard Onnasch, Berlin

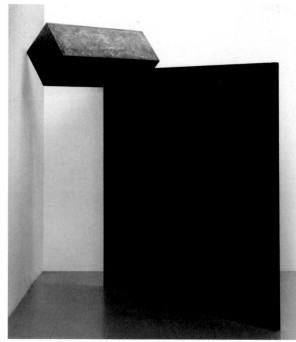

99

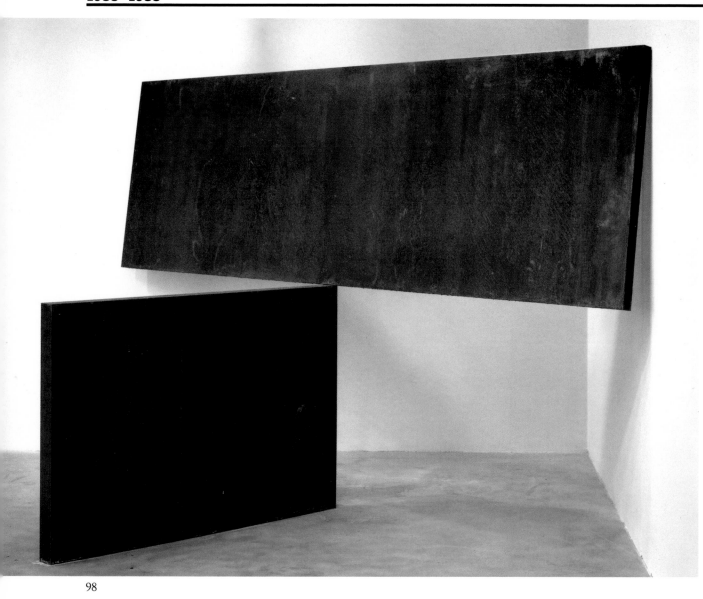

98

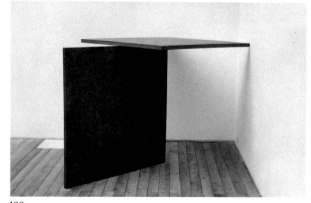

100

98. *Kitty Hawk.* 1983
Cor-Ten steel, upper plate 48″ x 14′ x 2½″;
lower plate 48″ x 6′ x 4″; overall height 7′11½″
Saatchi Collection, London

99. *Corner Block.* 1983
Hot rolled steel, block 11 x 11 x 36″;
plate 60 x 60 x 1½″
Akira Ikeda Gallery, Tokyo

100. *The Dead Egyptians (from Torino).*
1983–85
Hot rolled steel, two plates, overall 55½″ x
8′11″ x 54″
Galleria Stein, Milan, and collection the artist

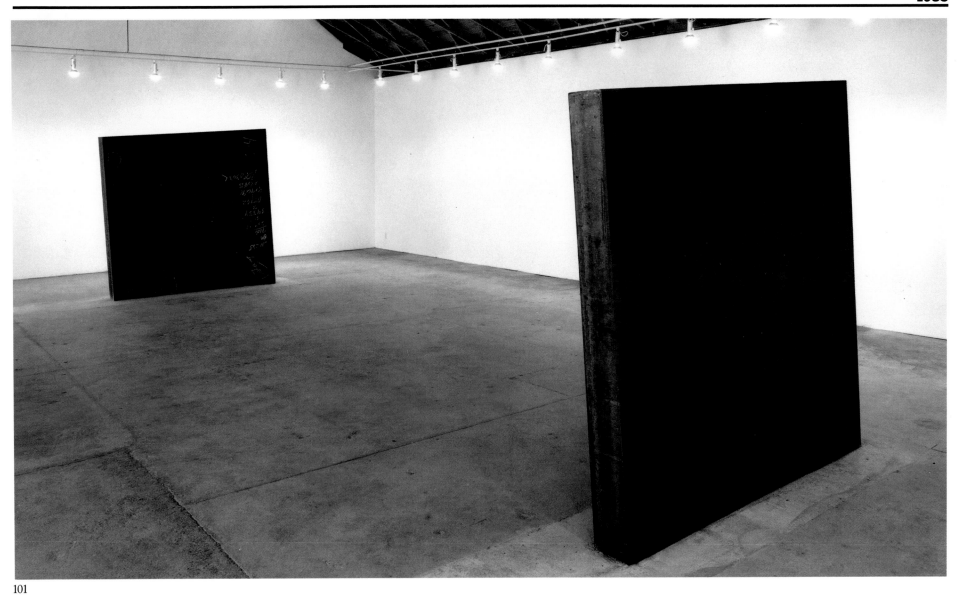

101

101. *Plunge.* 1983
Cor-Ten steel, two slabs, each 8 x 8' x 9";
tilting 3.25° on axis; distance between
elements 32'
Larry Gagosian Gallery, Los Angeles, and
collection the artist

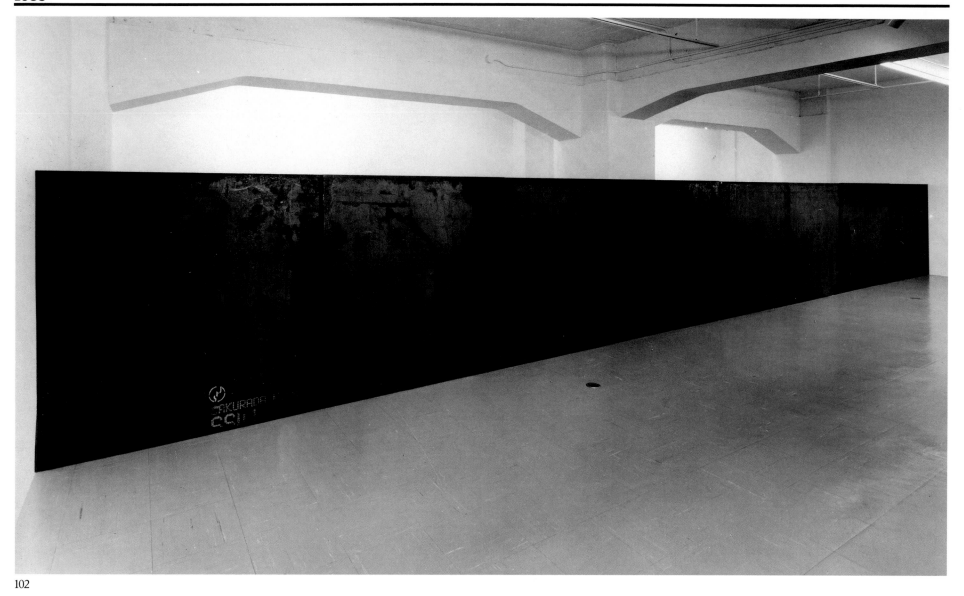

102

102. *Wall to Wall.* 1983
Steel, eight plates propped between two walls,
each plate 54 x 54 x 2″; overall 54″ x 36′ x 2″
Akira Ikeda Gallery, Tokyo

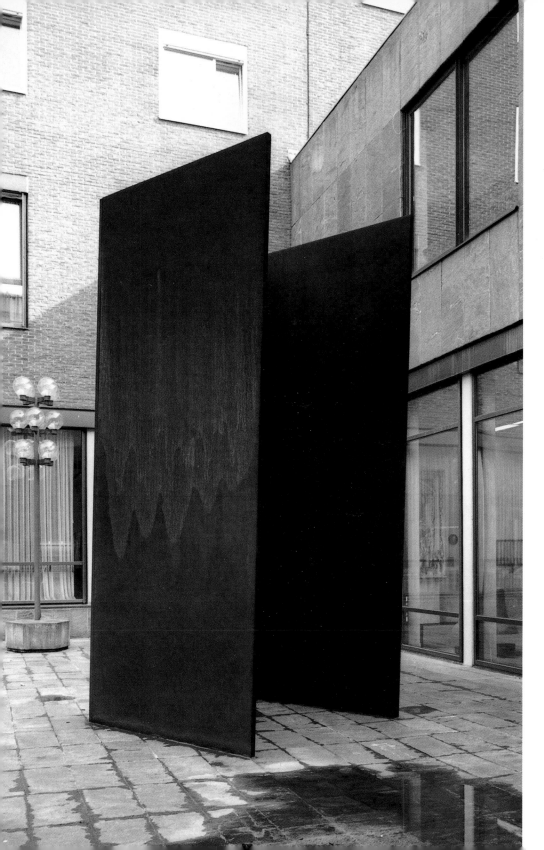

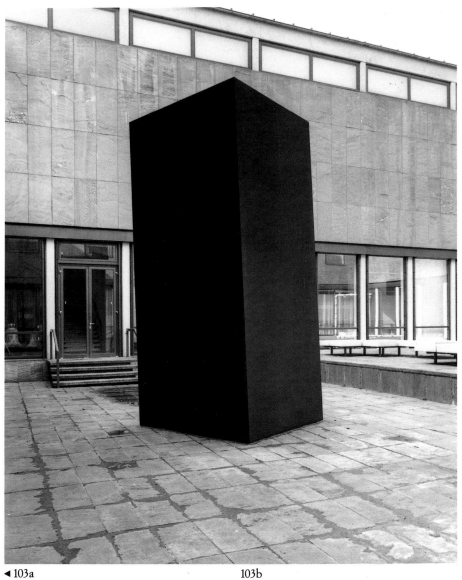

◄ 103a 103b

103a/b. *Fassbinder.* 1983
Cor-Ten steel, three plates, each
16′5″ x 7′1″ x 2″
Westfälisches Landesmuseum für Kunst und
Kulturgeschichte, Münster, West Germany

145

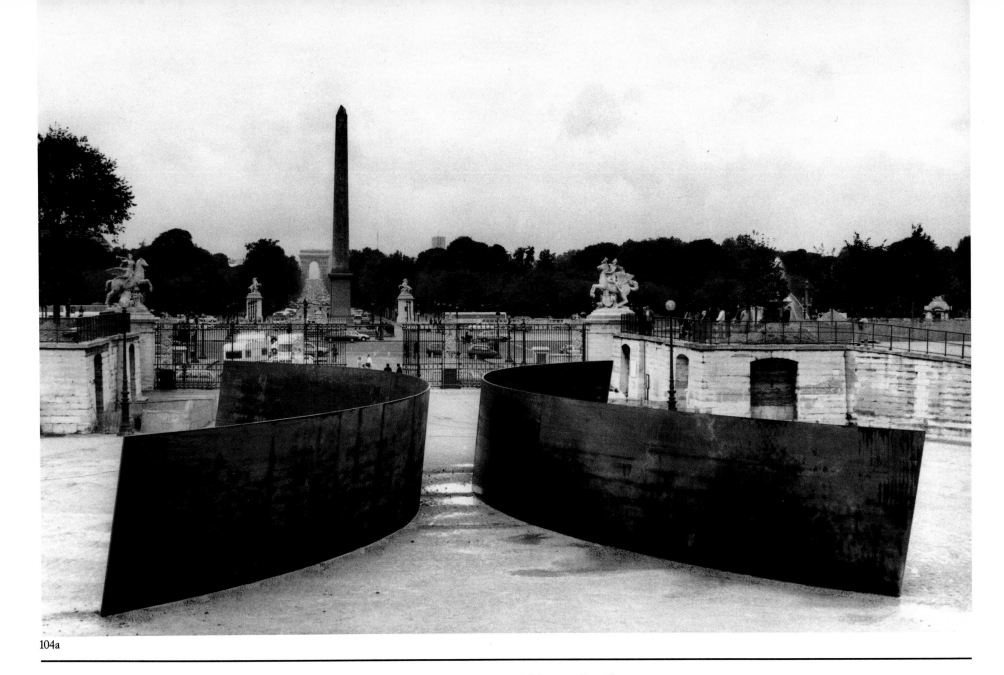

104a

104a–e. *Clara-Clara.* 1983
Cor-Ten steel, two elements, each
12 x 120' x 2"
Installed Place de la Concorde, Paris, 1983–84
City of Paris

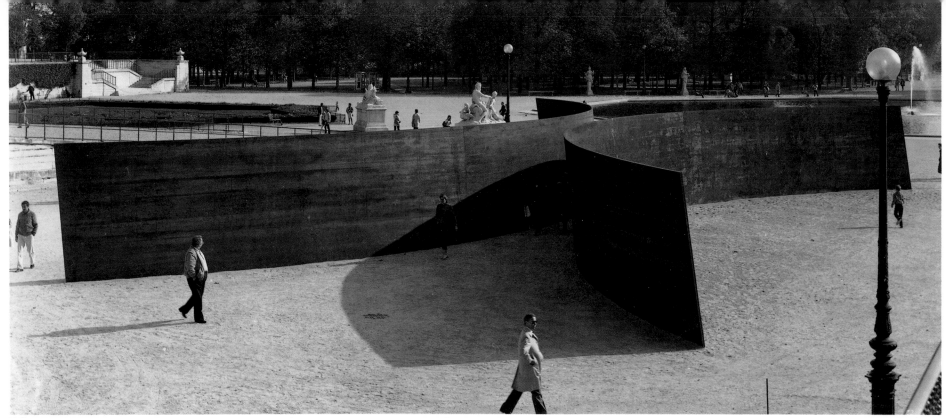

104b

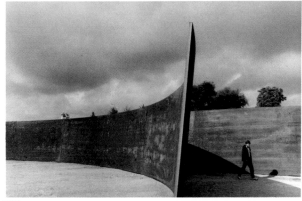

104c

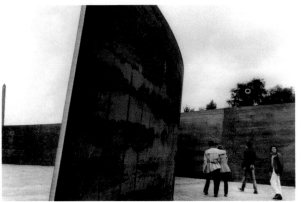

104d

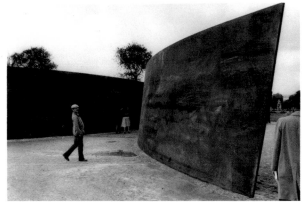

104e

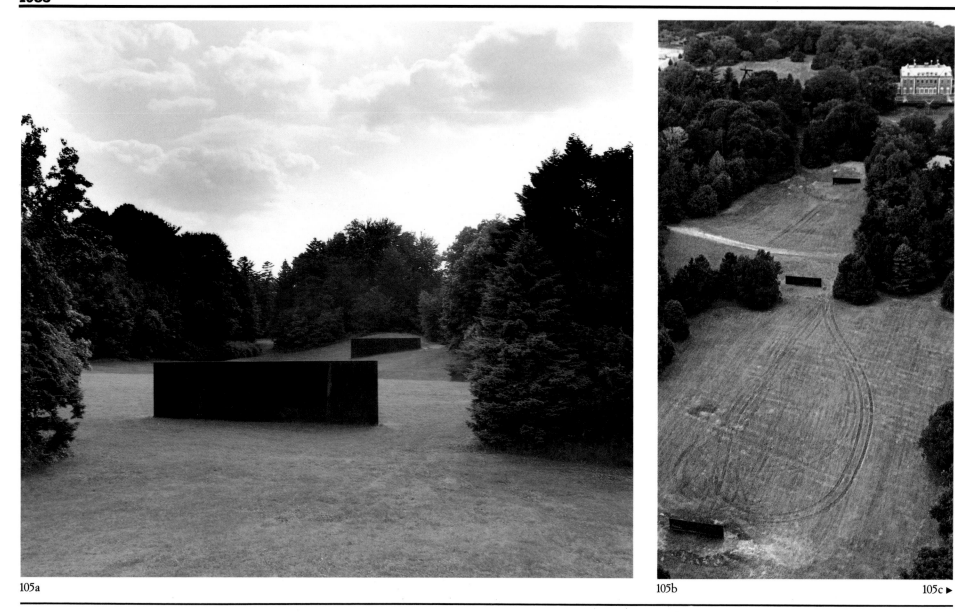

105a

105b

105c ▶

105a–c. *Plumb Run: Equal Elevations.* 1983
Cor-Ten steel, three plates, each 12 x 40′ x 2½″;
overall 12 x 40 x 731′
Installed Nassau County Museum of Fine Art,
Roslyn Harbor, New York
Collection the artist

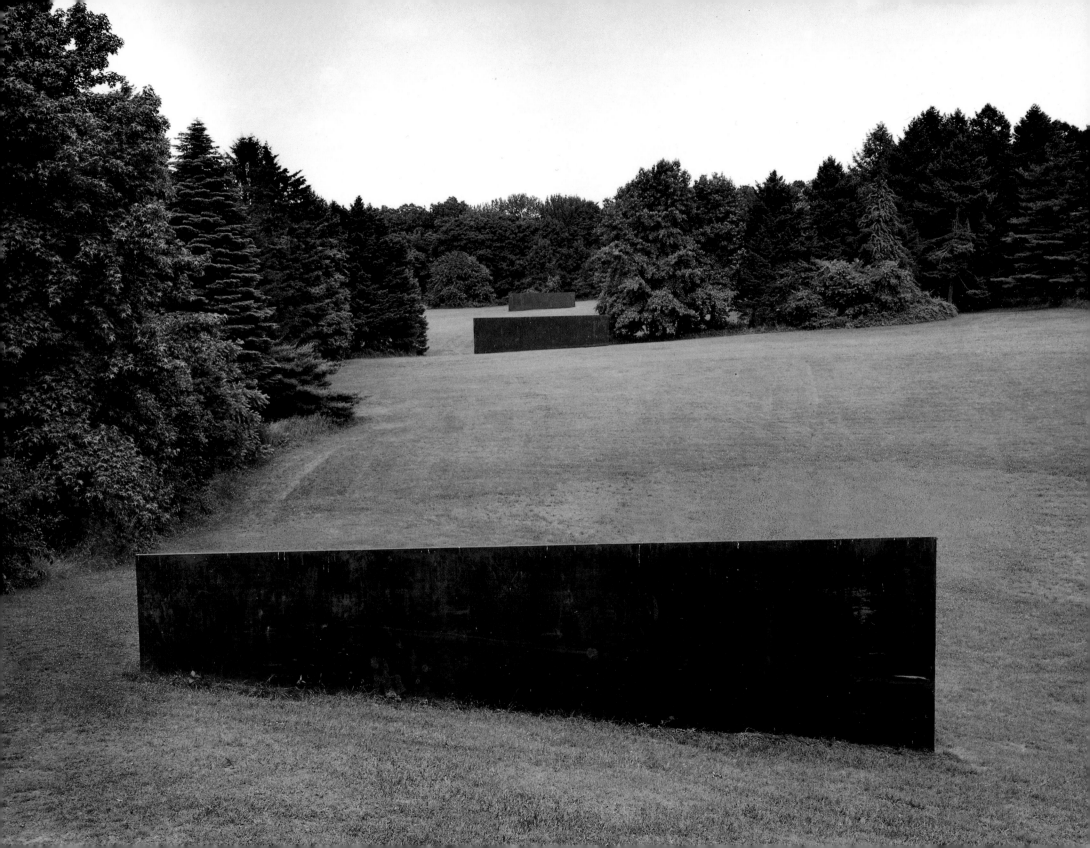

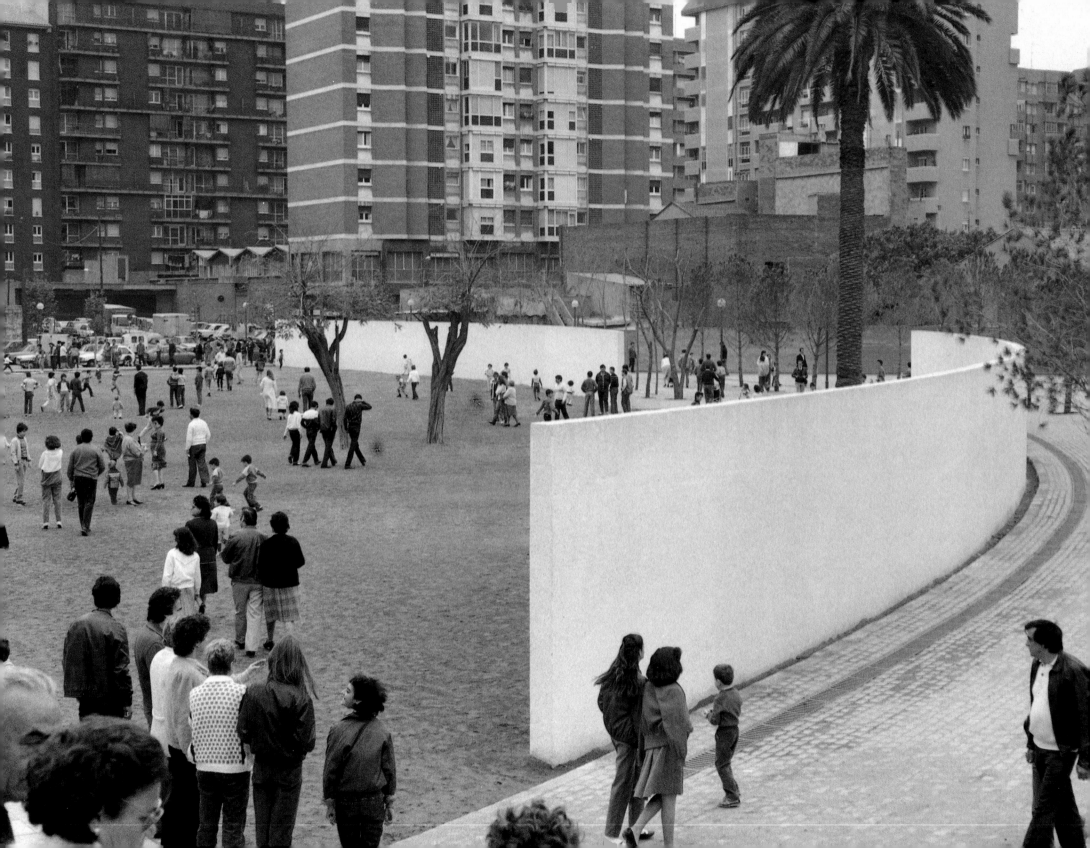

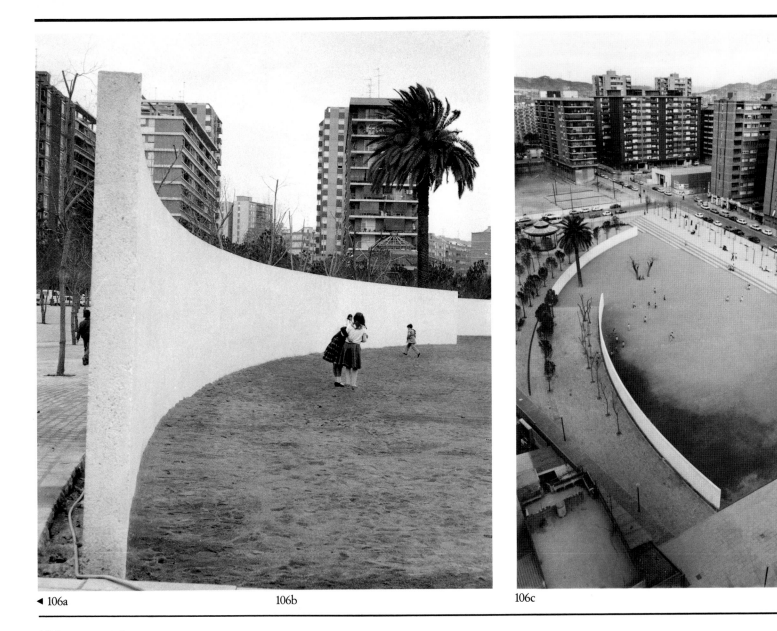

◄ 106a 106b 106c

106a–c. *La Palmera.* 1982–84
Concrete, two curves, each 9 x 165′ x 10″
La Verneda, City of Barcelona, Spain

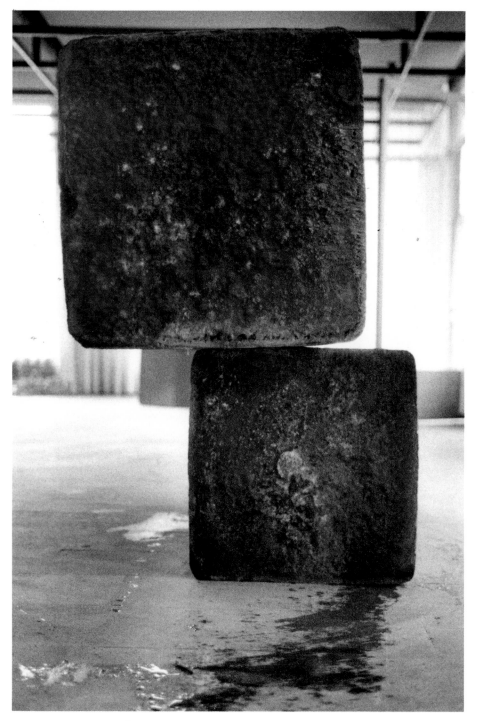

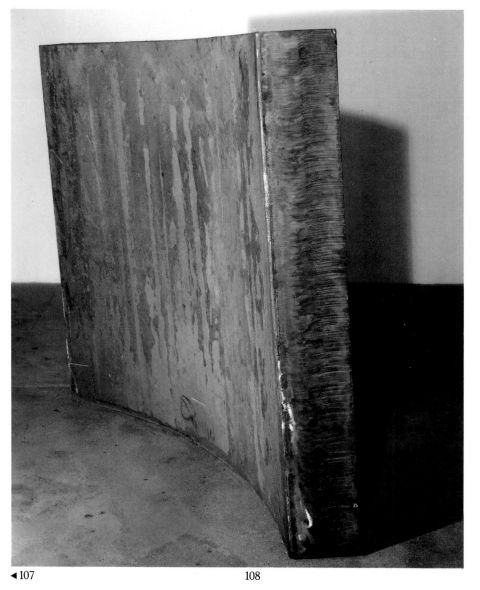

◀107 108

107. *Bilbao.* 1983
Steel, two ingots, 30″ x 7′2 ″ x 30″ and
30 x 68 x 30″
Private collection, Madrid

108. *W.W. I.* 1984
Cor-Ten steel, 55 x 64 x 8″
The Edward R. Broida Trust, Los Angeles

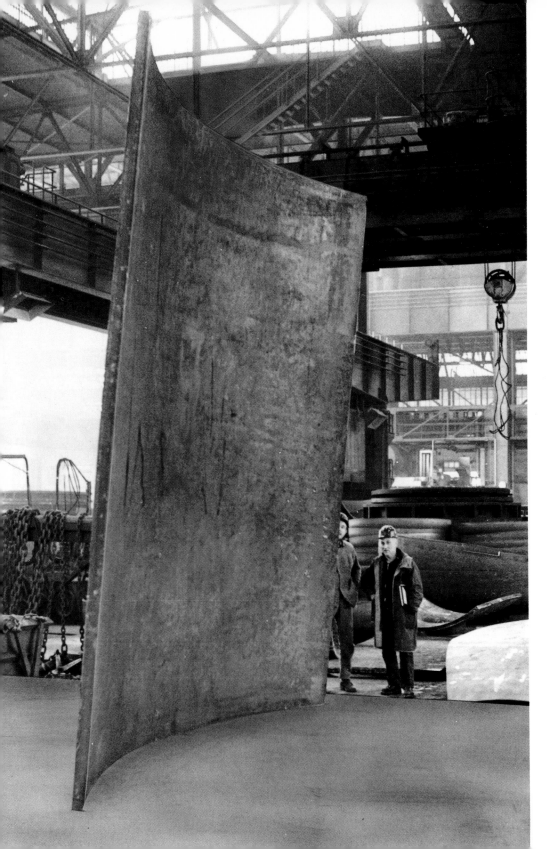

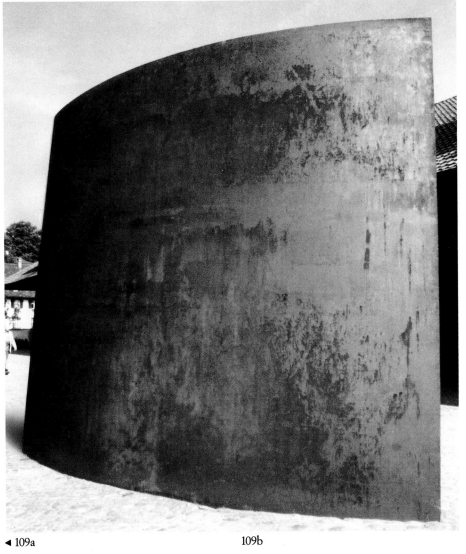

◄ 109a 109b

109a/b. *Weitmar*. 1984
Cor-Ten steel, 14′9″ x 17′4½″ x 3¼″
Galerie m, Bochum, West Germany

110. Following pages: *Schulhof's Curve*. 1984
Cor-Ten steel, 36″ x 40′ x 3″
Collection Mr. and Mrs. Rudolph B. Schulhof,
Kings Point, New York

153

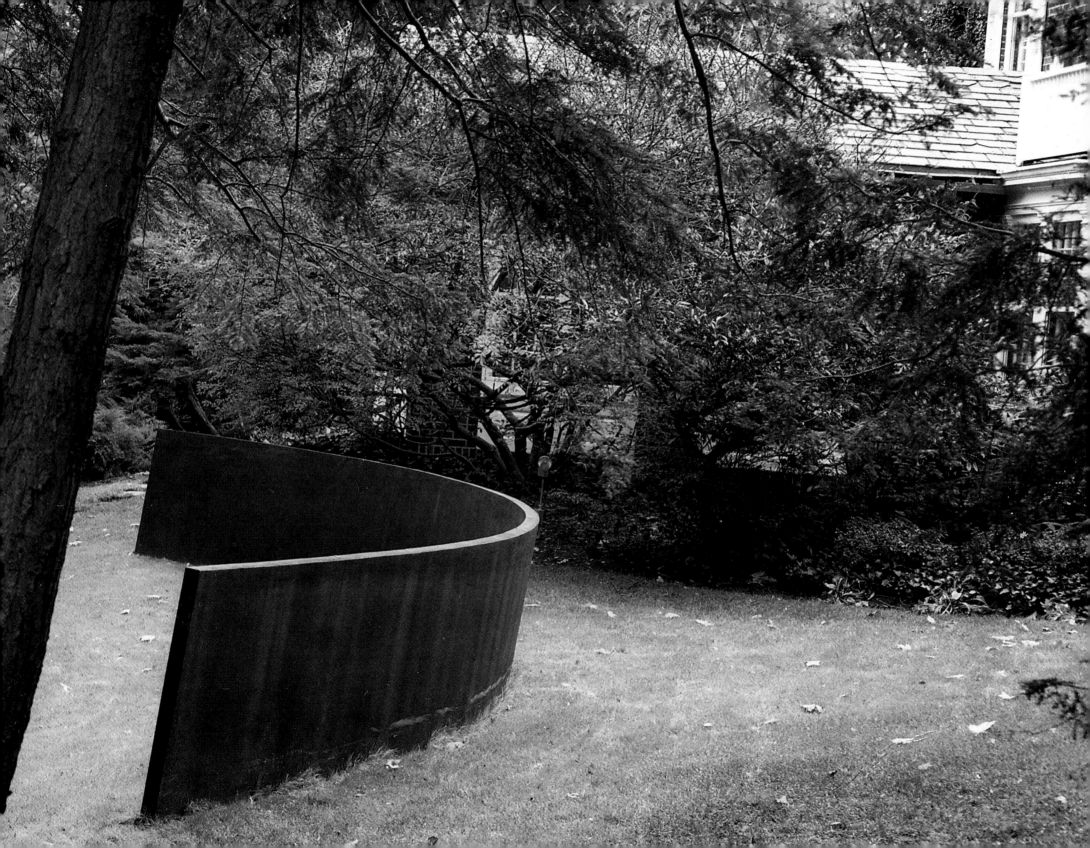

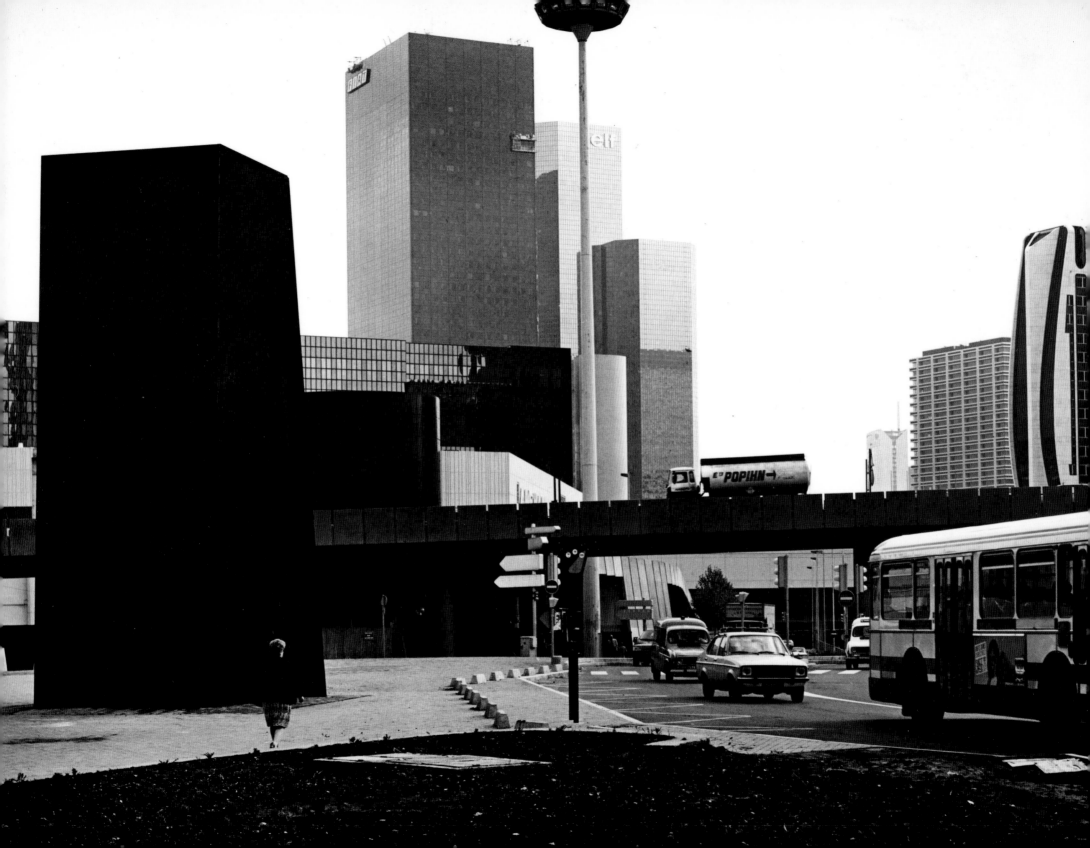

◀ 111a

111b 111c ▶

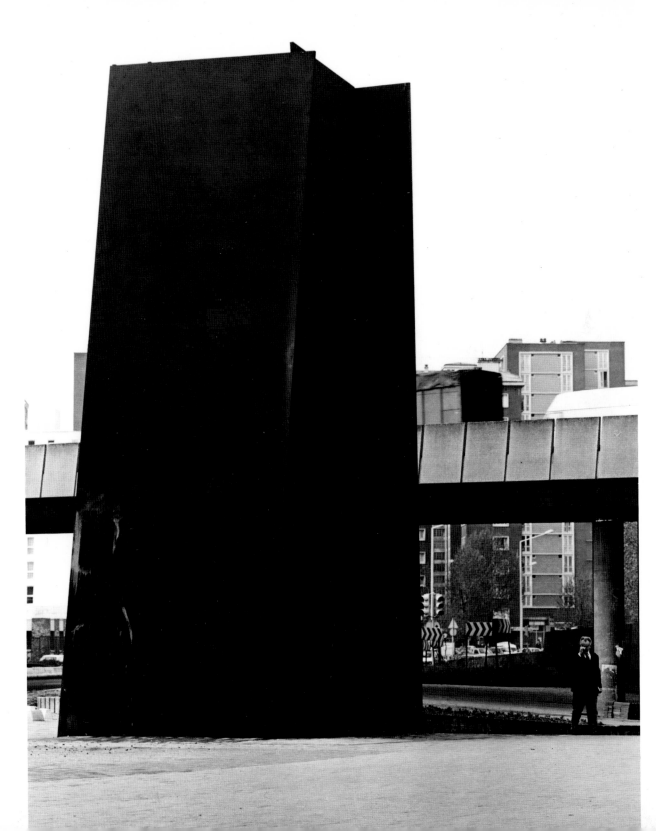

111a–c. *Slat.* 1980–84
Indaten steel, five plates, each 40 x 12′ x 2½″
Installed Paris La Défense (a,c); view from
interior (b)
Etablissement Public pour L'Aménagement de
la Région de la Défense, Paris

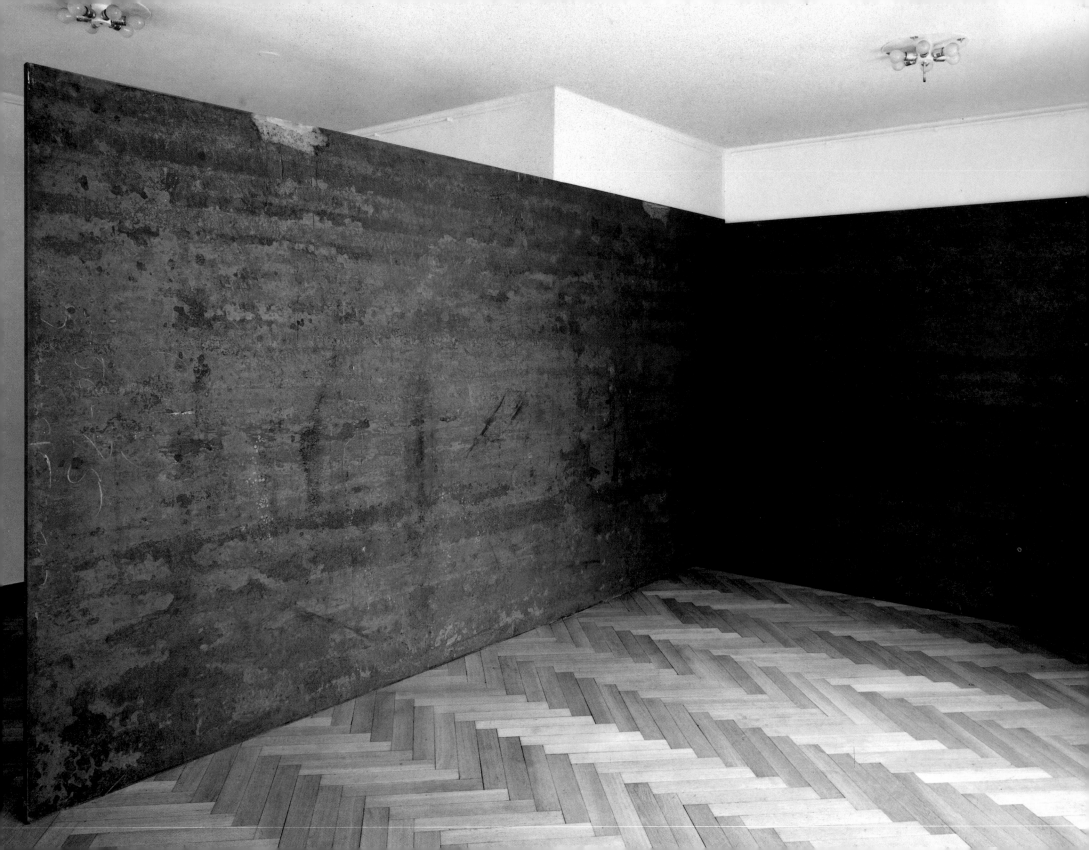

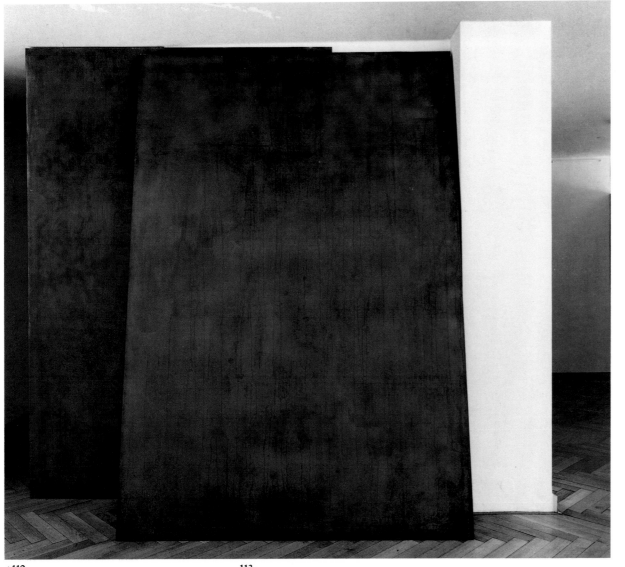 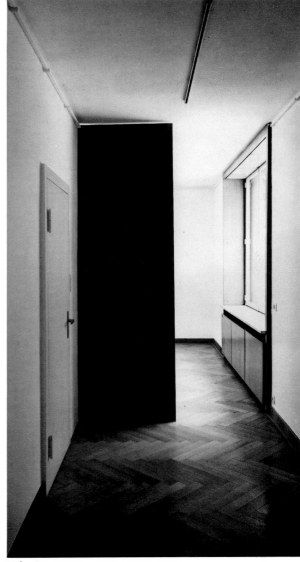

◀112 113a 113b

112. Opposite: *Mies's Corner Extended.* 1985
Steel, two plates, 7′10½″ x 7′10½″ x 1¼″ and
7′10½″ x 16′1″ x 1¼″
Galerie m, Bochum, West Germany

113a/b. *Klein's Wall.* 1985
Steel, two plates, each 9′4¼″ x 6′6¾″ x 1″
Galerie m, Bochum, West Germany

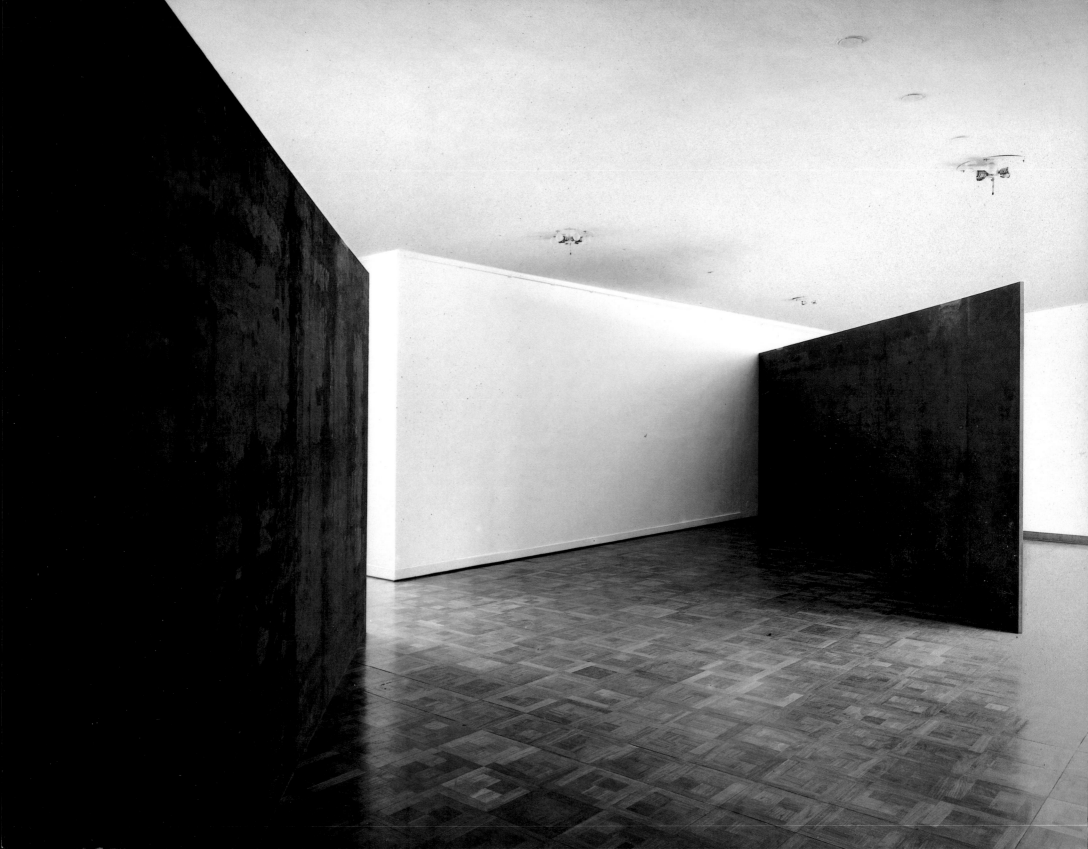

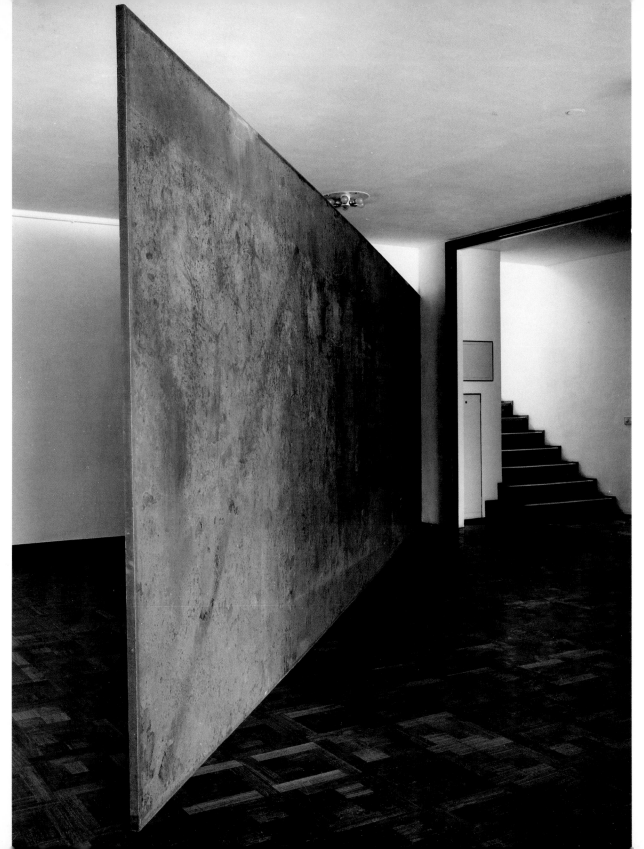

◄ 114a Opposite
◄ 114b

114a/b. *Two 45° Angles for Mies.* 1985
Steel, two plates, each 7′10½″ x 24′ x 1¼″
Galerie m, Bochum, West Germany

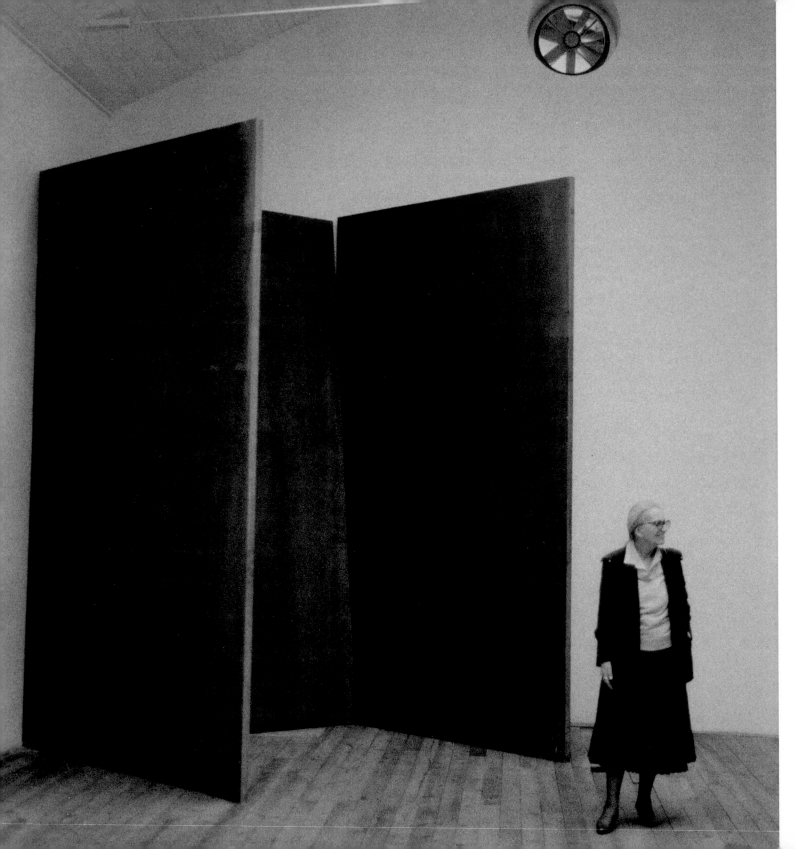

◀ 115 116 ▶

115. *Lo Savio*. 1985
Hot rolled steel, three plates, each 12 x 8′ x 2″
Galleria Stein, Milan, and collection the artist

116. Opposite: *Pasolini*. 1985
Forged steel, two blocks, 30 x 30 x 60″ and
30 x 15 x 15″, 17′ apart
Galleria Stein, Milan, and collection the artist

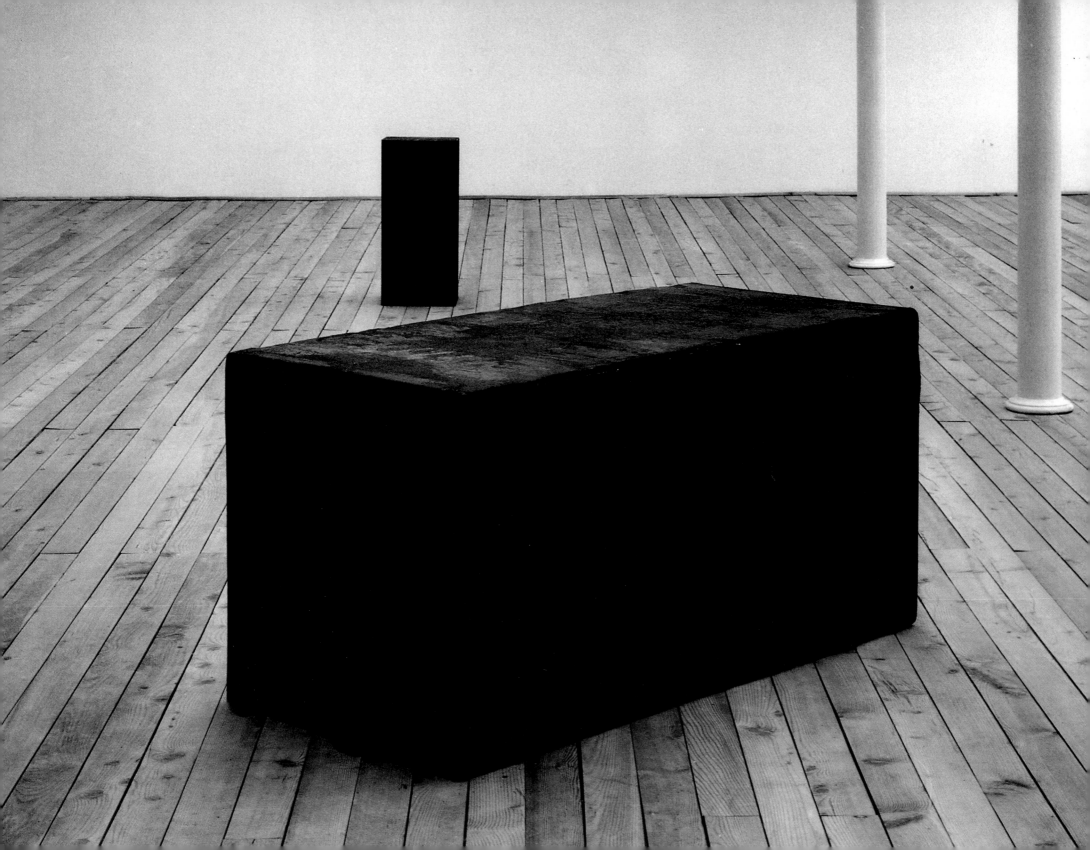

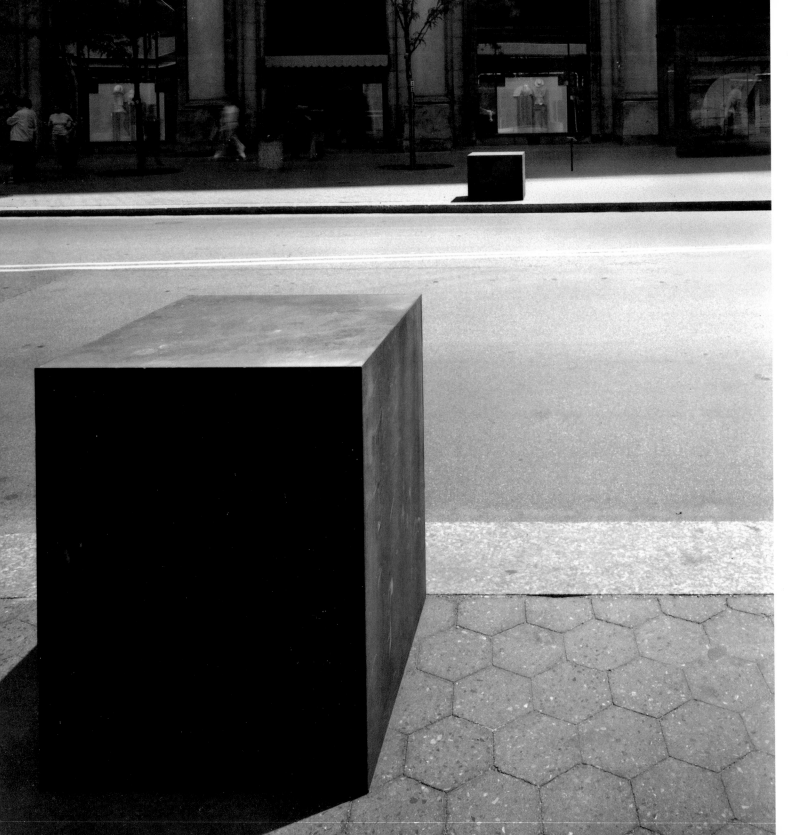

117. *State Street Consequence.* 1985
Forged steel, two blocks, 36 x 29 x 29″ and
29 x 36 x 29″
Installed State Street, Chicago, 1985
Larry Gagosian Gallery, Los Angeles, and
collection the artist

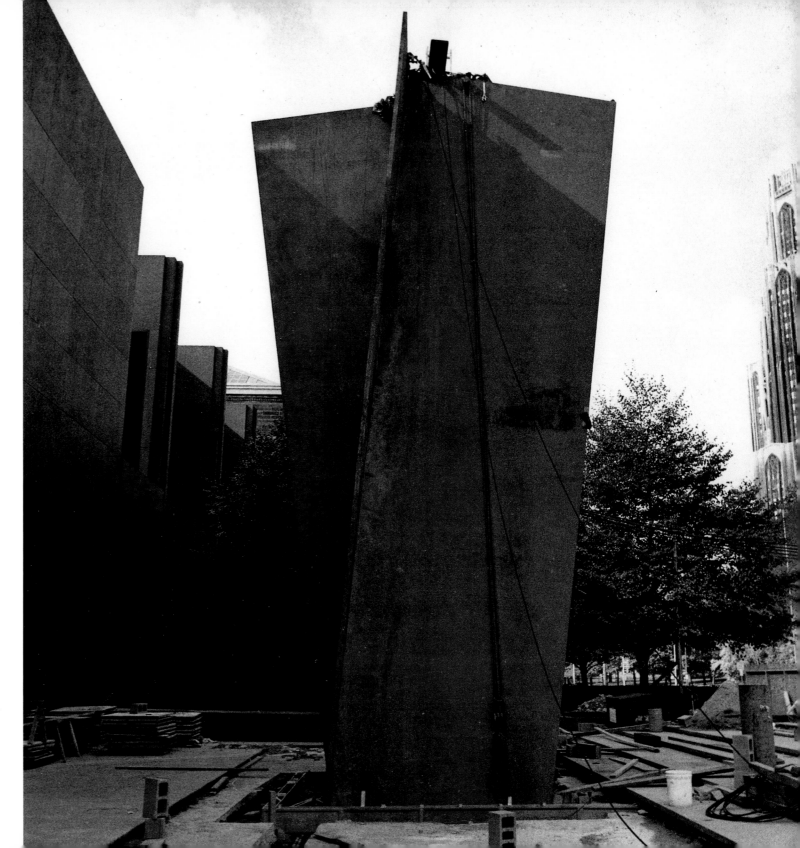

118. *Carnegie.* 1984–85
Cor-Ten steel, 38′ 10″ high
Museum of Art, Carnegie Institute, Pittsburgh,
Museum purchase, Gift of Mrs. William R.
Roesch in memory of her husband

Chronology

1939
November 2, born San Francisco to Tony and Gladys Serra; father from Majorca, Spain, mother a Russian Jew.

1957–61
Studies at University of California at Berkeley and at Santa Barbara, graduating with B.S. in English literature. Works in steel mills to earn a living.

1961–64
Studies at Yale University, New Haven, Connecticut, earning B.A., M.A., and M.F.A. During last year holds position as instructor. Works with Josef Albers on his book *The Interaction of Color* (1963) and comes into contact with artists of New York School: Philip Guston, Robert Rauschenberg, Ad Reinhardt, and Frank Stella.

1964–65
Spends year in Paris on Yale Traveling Fellowship. Meets Philip Glass.

1965–66
Hitchhikes from Athens to Istanbul. Spends year in Florence on Fulbright grant.
In May has first one-man exhibition, "Animal Habitats," at Galleria La Salita, Rome. Student work, it anticipates activity of Arte Povera movement. Travels to Spain and North Africa. Moves to New York.

1966–67
Makes series of rubber and neon-tubing works and scatter pieces. Meets Carl Andre, Liza Bear, Eva Hesse, Nancy Holt, Jasper Johns, Joan Jonas, Donald Judd, Philip Leider, Bruce Nauman, Steve Reich, Robert Smithson, and Michael Snow. Begins working with Philip Glass and Chuck Close. Along with Robert Fiore, Steve Reich, and Philip Glass, supports himself by moving furniture.

1968–69
Begins cooperation with Leo Castelli. Makes series of molten- and cast-lead works (Splashings and Castings) and series of lead rolls and lead props. Props on exhibition at The Solomon R. Guggenheim Museum, New York, in May 1969. Makes first studio films and begins linear drawings. Begins to work in steel. Through Art & Technology Program of Los Angeles County Museum of Art, makes Skullcracker series on grounds of Kaiser Steel Corporation, Fontana, California. Starts series of large, interior steel installations and begins working with structural engineers. Makes series of cut and sawed pieces. Participates in Word Location Project with Philip Glass at Long Beach Island, New Jersey. Collaborates with Joan Jonas on video, film, and performance pieces. First one-man exhibition in United States at Castelli Warehouse, New York. Makes *Splash Piece: Casting* in Jasper Johns's studio, where it is preserved.

Installation of *One Ton Prop (House of Cards)* (pl. 33), Museum of Art, Rhode Island School of Design, Providence, 1969

Richard Serra and Philip Glass at work on *Splash Piece: Casting* (pl. 51), 1969-70, Jasper Johns's studio, New York

Laying out *To Encircle Base Plate Hexagram, Right Angles Inverted* (pl. 47), Ueno Park, Tokyo, 1970

1970

Visits Robert Smithson and Nancy Holt during construction of *Spiral Jetty*, Great Salt Lake, Utah, and helps with its layout.
Travels to Japan with Joan Jonas. Participates in Tokyo Biennale. Installs *To Encircle Base Plate Hexagram, Right Angles Inverted,* in Ueno Park, Tokyo, and also works in Kyoto. Receives Guggenheim Fellowship. Carries out *Sawing Device: Base Plate Measure* involving twelve fir trees, at Pasadena Art Museum, Pasadena, California. In the Bronx, New York, installs *To Encircle Base Plate Hexagram, Right Angles Inverted* in the street. Whitney Annual exhibition catalog documents piece. Starts series of large outdoor urban and landscape works with *Pulitzer Piece: Stepped Elevation,* St. Louis.

1971

Initiates black canvas drawings. Begins working summers in Cape Breton, Nova Scotia, Canada.

1972–74

Begins work with structural engineer Malcolm Graff. After death of Robert Smithson, completes his *Amarillo Ramp* in Texas with Nancy Holt and Tony Shafrazi. Travels to Peru with Rudolph Wurlitzer.

1975–76

Receives Sculpture Award from Skowhegan School of Painting and Sculpture.
Films *Railroad Turnbridge*, Portland, Ore. Plans first curved piece, for Centre Pompidou, Paris. Begins cooperation with Alexander von Berswordt-Wallrabe of Galerie m, Bochum, West Germany.

1977

February 14, mother commits suicide. Exhibits drawings at the Stedelijk Museum, Amsterdam. Accepts commission for project on Pennsylvania Avenue, Washington, D.C., from which he will withdraw in 1978. Works at Thyssen steel mill, Henrichshütte, Hattingen, West Germany, on *Berlin Block for Charlie Chaplin* for Nationalgalerie, Berlin.

1979

June 5, death of father. Commissioned by General Services Administration to create permanent sculpture for Federal Plaza, New York. During election campaign, West German CDU party criticizes installation of *Terminal* (1977) in Bochum. Films *Steelmill/Stahlwerk* in Thyssen mill with Clara Weyergraf.

1980

St. John's Rotary Arc and *T.W.U.* installed in New York. Installation of *Wright's Triangle* at Western Washington State University, Bellingham, and landscape work at Wenkenpark, Riehen/Basel, Switzerland.

1981

Tilted Arc installed at Federal Plaza, New York. Marries Clara Weyergraf. Receives Kaiserring Award for sculpture from city of Goslar, West Germany, and installs *Gedenkstätte* there. Accepts commission for landscape sculpture at Lousiana Museum, Humlebaek, Denmark, for installation in 1986.

1982

Twain installed in St. Louis (project begun in 1974). Travels to Spain and studies Mozarabic architecture. Installs sculpture in landscape at Celle, Santomato di Pistoia, Italy. Works in Bilbao, Basque country of Spain.

1983

Receives honorary fellowship from Bezalel Academy, Jerusalem. Travels to Japan. One-man exhibition at the Musée National d'Art Moderne, Centre Georges Pompidou, Paris, installing *Clara-Clara* in the Tuileries Gardens at Place de la Concorde in conjunction with show. Installs *Fassbinder* in Westfälisches Landesmuseum, Münster, West Germany.

1984

Installs *La Palmera* and designs plaza at La Verneda, Barcelona, Spain. Installation of *Slat* at La Défense, Paris, and *Sean's Spiral* in Dublin street.

1985

One-man exhibition at Mies van der Rohe-designed Museum Haus Lange, Krefeld, West Germany. Public hearing called March 6, 7, 8 to consider removal of *Tilted Arc* (1981) from Federal Plaza, New York. Overwhelming majority of those testifying favor retention, but Acting GSA Administrator directs New York Regional Administrator to seek possible alternate site. Requests National Endowment for the Arts to convene panel to approve or disapprove proposed site. French government commissions sculpture for national historic site at Bourg-en-Bresse, sixteenth-century cloister at Brou. Named Chevalier dans l'Ordre des Arts et des Lettres by the French. *Clara-Clara* installed Square de Choisy, Paris. Commissioned to produce sculpture for hospital in Nagoya, Japan. Installs *Carnegie,* a vertical sculpture, at Museum of Art, Carnegie Institute, Pittsburgh.

Exhibitions

Exhibition dates are listed when known. An asterisk in the entry indicates a published catalog or brochure.

One-Man Exhibitions

1966

Galleria La Salita, Rome
May 24–June

1968

Galerie Ricke, Cologne, West Germany
October 16–November 25

1969

Galleria Françoise Lambert, Milan
June

Castelli Warehouse, New York
December 16, 1969–January 10, 1970. See bibl. 56 and 85

1970

Joseph Helman Gallery, St. Louis
January

University of California, San Diego
February 24–March 31

Pasadena Art Museum, Pasadena, Calif.
"Richard Serra."* February 26–March 1. See bibl. 48 and 100

Ace Gallery, Los Angeles
December. See bibl. 99

Galerie Ricke, Cologne, West Germany

1972

Videogalerie Gerry Schum, Düsseldorf
Opened June 2

Ace Gallery, Los Angeles
November 17–December 31

1973

Galerie Ricke, Cologne, West Germany
January 13–February 8

Galleria Toselli, Milan

Ace Gallery, Los Angeles

Castelli Graphics, New York

1974

Ace Gallery, Los Angeles
"Richard Serra: Large Scale Drawings."
September 28–October 19. See bibl. 101

School of Visual Arts, New York
October 1–November 7. See bibl. 72, 74, and 81

Leo Castelli Gallery, New York
October 12–26. See bibl. 69, 72, 74, and 81

1975

Ace Gallery, Venice, Calif.
"Richard Serra: Delineator." July 1975–February 1976. See bibl. 88 and 114

Portland Center for the Visual Arts, Portland, Ore.
October 30–November 30. See bibl. 76

1976

Ace Gallery, Los Angeles
"Richard Serra: Drawings." Closed April 10

1977

Galerie Daniel Templon, Paris
January 29–March 2. See bibl. 65

Galerie m, Bochum, West Germany
March–June. See bibl. 62

Stedelijk Museum, Amsterdam
"Richard Serra: Drawings 1971–1977."*
November 18, 1977–January 2, 1978. See bibl.
37 and 90

1978

Kunsthalle Tübingen, West Germany
"Richard Serra."* March 8–April 2. See bibl.
52 and 90. Traveled to Staatliche Kunsthalle
Baden-Baden. April 22–May 21. See bibl. 67

Ace Gallery, Venice, Calif.
"Richard Serra: Early Works in Steel and
Lead." April 26–May 31

Blum Helman Gallery, New York
September 26–October 17. See bibl. 93 and 110

1979

Matrix Gallery, University Art Museum, University of California, Berkeley
"Richard Serra: Matrix/Berkeley 20."* February 28–May 27

Staatliche Kunsthalle Baden-Baden
"Richard Serra: Sculpture 1966–1978 Films."
March 10–April 16

KOH Gallery, Tokyo
"Richard Serra: Drawings." March 29–April 21

Richard Hines Gallery, Seattle
"Richard Serra Drawings."* June 20–July 31

Galerie Alfred Schmela, Düsseldorf
October 6–November 5

1980

Museum Boymans–van Beuningen, Rotterdam
October 11–November 16

The Hudson River Museum, Yonkers, N.Y.
"Richard Serra: Elevator 1980."* Opened
November 15. See bibl. 53

1981

Blum Helman Gallery, New York
"Richard Serra: Recent Drawings." February
3–28

Leo Castelli Gallery, New York
"Richard Serra: 'Slice,' 1980." February 28–
April 4. See bibl.70

KOH Gallery, Tokyo
May

Mönchehausmuseum, Goslar, West Germany
"Richard Serra."* September 12–November
22. See bibl. 41

Castelli Graphics, New York
September 19–October 10

1982

Gemini G.E.L., Los Angeles
"Richard Serra: Metal Wall Drawings,
Lithographs." January 18–February 15

Leo Castelli Gallery, New York
"Richard Serra: Model for the St. Louis Project
and Large-Scale Drawings." April 3–24

Leo Castelli Gallery, New York
"Richard Serra: 'Marilyn Monroe–Greta
Garbo,' 1981 (A Sculpture for Gallery-Goers)."
April 3–24

The St. Louis Art Museum
"Richard Serra: Drawings and Studies." April
27–May 23

Carol Taylor Art, Dallas
December 7–31

1983

Blum Helman Gallery, New York.
"Richard Serra: 'Around the Corner,' 1982."
January 12–February 12. See bibl. 86

Larry Gagosian Gallery, Los Angeles
May 14–June 25

Akira Ikeda Gallery, Tokyo
"Richard Serra: New Sculpture."* June 6–July
30. See bibl. 50

Galerie Reinhard Onnasch, Berlin
"Richard Serra: Skulpturen und Zeichnungen
1967–1983."* September 17– October 21. See
bibl. 38 and 102

Musée National d'Art Moderne, Centre
Georges Pompidou, Paris
"Richard Serra."* October 26, 1983–January 2,
1984. See bibl. 28, 31, 47, and 60

Galerie m, Bochum, West Germany
November–March 1984

Larry Gagosian Gallery, Los Angeles

1984

Leo Castelli Gallery, New York
February 18–March 10

Galerie Nordenhake, Malmö, Sweden
May 18–August

Galerie Daniel Templon, Paris
"Richard Serra: Sculpture." September 15–
October 20

Larry Gagosian Gallery, Los Angeles
December 18, 1984–January 31, 1985

1985

Museum Haus Lange, Krefeld, West Germany
"Richard Serra."* January 27–March 24. See
bibl. 44

Le Coin du Miroir, Dijon, France
January 29–March 2

Galerie Maeght Lelong, New York
"Richard Serra: Vertical Structures (Models)."
March 8–April 13

Gemini G.E.L., Los Angeles
"Large Silkscreens." Opened April 27

Galleria Stein, Milan
May

Akira Ikeda Gallery, Tokyo
Opened September 15

Group Exhibitions

1966

Noah Goldowsky Gallery, New York
"From Arp to Artschwager I"

Yale University Art Gallery, New Haven,
Conn.
"Drawings"

1967

Noah Goldowsky Gallery, New York
"From Arp to Artschwager II"

Purdue University, West Lafayette, Ind.
"Directions." November 1–30

Ithaca College Museum, Ithaca, N.Y.
"Drawings 1967"

1968

Noah Goldowsky Gallery, New York
"From Arp to Artschwager III"

Noah Goldowsky Gallery, New York
"Three Sculptors" (with Mark di Suvero and
Walter de Maria). February 17–March 15. See
bibl. 96

Galerie Ricke, Cologne, West Germany
"Programm I." May 29–September 15

Galerie Ricke, Kassel, West Germany
"Primary Structure, Minimal Art, Pop Art,
Anti-Form." June 27–July

John Gibson Gallery, New York
"Anti-Form." October 5–November 7

American Federation of Arts
"Soft and Apparently Soft Sculpture."* Circulating exhibition, October 6, 1968–October
12, 1969

Kunsthalle Cologne, West Germany
"Kunstmarkt 68."* October 15–20

Castelli Warehouse, New York
"Nine at Castelli." December 4–28. See
bibl. 77

Whitney Museum of American Art, New York
"1968 Annual Exhibition: Contemporary
American Sculpture."* December 17, 1968–
February 9, 1969

1969

Washington University Gallery of Art, Steinberg Hall, St. Louis
"Here and Now."* January 10–February 21

The Museum of Modern Art, New York
"New Media: New Methods." Circulating exhibition, February 1969–August 1970

School of Visual Arts, New York
"Series: Photographs"

Wallraf-Richartz Museum, Cologne, West Germany
"Kunst der sechziger Jahre (Art of the Sixties)."* Opened February 28

New Jersey State Museum Cultural Center, Trenton, N.J.
"Soft Art."* March 1–April 27

Stedelijk Museum, Amsterdam
"Op Losse Schroeven, situaties en cryptostructuren (Square Pegs in Round Holes)."* March 15–April 27

Galerie Ricke, Cologne, West Germany
"Sechs Künstler (Six Artists)." March 15–31

Kunsthalle Bern
"When Attitudes Become Form."* March 22–April 27. See bibl. 55. Traveled to Museum Haus Lange, Krefeld, West Germany, and Institute of Contemporary Art, London

Whitney Museum of American Art, New York
"Contemporary American Sculpture, Selection 2."* Assembled by The Howard and Jean Lipman Foundation and the Whitney Museum of American Art. April 15–May 5

Paula Cooper Gallery, New York
"No. 7." Opened May 18

Whitney Museum of American Art, New York
"Anti-Illusion: Procedures/Materials."* May 19–July 6. See bibl. 46

The Solomon R. Guggenheim Museum, New York
"Nine Young Artists, Theodoron Awards."* May 23–July 27. See bibl. 112

Galerie Ricke, Cologne, West Germany
"7 Objekte/69"

The Aldrich Museum of Contemporary Art, Ridgefield, Conn.
"Highlights of the 1968–1969 Art Season."* June 22–September 14

Museum of Contemporary Art, Chicago
"Anti-Form"

Joseph Helman Gallery, St. Louis

Seattle Art Museum
"557,087."* September 5–October 5

Museum of Art, Rhode Island School of Design, Providence
"The George Waterman Collection."* October 22–November 23

Musem of Contemporary Art, Chicago
"Art by Telephone."* November 1–December 14

University of California, Irvine
"Five Sculptors"

Museum Folkwang, Essen, West Germany
"Verborgene Strukturen"

Kaiser Wilhelm Museum, Krefeld, West Germany

1970

Galerie Ricke, Cologne, West Germany
"Programm III"

Tokyo Metropolitan Art Gallery, Tokyo
"Tokyo Biennale '70 (Between Man and Matter, 10th International Art Exhibition of Japan)."* May 10–30. Traveled to Kyoto Municipal Art Museum, Kyoto, June 6–28; Aichi Prefectural Art Gallery, Nagoya, July 15–26; Fukuoka Prefectural Culture House, Fukuoka, August 11–16

Galerie Ricke, Cologne, West Germany
"Zeichnungen Amerikanischer Künstler/ Drawings of American Artists"

Galleria Civica d'Arte Moderna, Turin
"Conceptual Art/Arte Povera/Land Art."* June–July

The Museum of Modern Art, New York
"Information."* July 2–September 20

Kunstverein, Hanover
"Identifications"

Whitney Museum of American Art, New York
"1970 Annual Exhibition, Contemporary American Sculpture."* December 12, 1970–February 7, 1971

Joseph Helman Gallery, St. Louis

Dayton's Gallery 12, Minneapolis
"Castelli at Dayton's"

Whitechapel Art Gallery, London
"3-00: New Multiple Art"

1971

Paris
"7e Biennale de Paris"

Lalit Kala Akademi, New Delhi
"II Triennale India."* Exhibition organized under the auspices of the International Council of The Museum of Modern Art, New York. January 31–March 31

The Solomon R. Guggenheim Museum, New York
"Sixth Guggenheim International."* February 11–April 11. See bibl. 89

Loeb Student Center, New York University, New York
"Body." February

Louisiana Museum, Humlebaek, Denmark
"Amerikansk Kunst (American Painting) 1950–70"

Walker Art Center, Minneapolis
"Works for New Spaces."* May 18–July 25

Galerie Ricke, Cologne, West Germany
"7 Neue Arbeiten"

Städtische Kunsthalle, Düsseldorf
"Prospect 71–Projection"*

The Museum of Modern Art, New York
"Projects: Pier 18." June 18–August 2

Park Sonsbeek, Arnhem, the Netherlands
"Sonsbeek 71, Sonsbeek buiten de perken."* June 19–August 15

Centro de Arte y Comunicación, en el Museo de Arte Moderno de la Ciudad de Buenos Aires
"Arte de Sistemas."* July

Leo Castelli Gallery, New York
"Works on Film" (with Morris, Nauman, Sonnier). September–October

Lo Giudice Gallery, New York
November 28–January 29, 1972. See bibl. 97

Los Angeles County Mueum of Art
"Art & Technology."* See bibl. 33

Art Gallery of Ontario, Toronto
"Recent Vanguard Acquisitions." 1971–72

1972

Galerie Ricke, Cologne, West Germany
"Zeichnungen." April

Leo Castelli Gallery, New York
"Judd/Serra." May 20–June 10

Museum Fridericianum, Kassel, West Germany
"Documenta 5."* June 30–October 8

Rijksmuseum Kröller-Müller, Otterlo
"Diagrams & Drawings."* August 13–September 24

Spoleto, Italy
"Spoleto Arts Festival"

Irving Blum, Los Angeles

Margo Leavin Gallery, Los Angeles

Castelli Graphics, New York

Galerie Ricke, Cologne, West Germany

Leo Castelli Gallery, New York
September 30–October 21

1973

Whitney Museum of American Art, New York
"1973 Biennial Exhibition, Contemporary American Art."* January 10–March 18

Galerie Ricke, Cologne, West Germany
"7 Lithographien." January 13–February 8

The New York Cultural Center
"3D into 2D: Drawing for Sculpture."* January 19–March 11

Kunstmuseum Basel
"Diagrams & Drawings."* January 20–March 4

The New York Cultural Center
"Soft as Art."* March 20–May 6. See bibl. 63

Yale University Art Gallery, New Haven, Conn.
"Options and Alternatives: Some Directions in Recent Art."* April 4–May 16

Lo Giudice Gallery, New York

Amerika Haus, Berlin

Oberlin, Ohio
"Festival of Contemporary Arts"

The Detroit Institute of Arts
"Art in Space: Some Turning Points."*
May 15–June 24

Galleria Toselli, Milan

Centre National d'Art Contemporain, Paris

Whitney Museum of American Art, New York
"American Drawings 1963–1973."* May 25–
July 22

Yale University Art Gallery, New Haven, Conn.
"American Drawing 1970–73"

Cusack Gallery, Houston
"Drawings"

Galleria Françoise Lambert, Milan
"Record as Artwork"

Seattle Art Museum
"American Art: Third Quarter Century."*
August 22–October 14

Leo Castelli Gallery, New York
September 29–October 20

Parcheggio di Villa Borghese, Rome
"Contemporanea."* November 1973–
February 1974

1974

National Gallery of Victoria, Melbourne
"Some Recent Amerian Art."* Exhibition
organized under the auspices of the Interna-
tional Council of The Museum of Modern Art,
New York, February 12–March 10. Traveled to
Art Gallery of New South Wales, Sydney,
April 5–May 5; Art Gallery of South Aus-
tralia, Adelaide, May 31–June 30; West Aus-
tralian Art Gallery, Perth, July 26–August 21;
City of Auckland Art Gallery, Auckland,
October 14–November 17

Leo Castelli Gallery, New York
"Drawings"

The Art Museum, Princeton University,
Princeton, N.J.
"Line as Language: Six Artists Draw."*
February 23–March 31. See bibl. 49

de Saisset Art Gallery, University of Santa
Clara, Santa Clara, Calif.
"Videotapes: Six from Castelli"

Hayden Gallery, Massachusetts Institute of
Technology, Cambridge, Mass.
"Interventions in Landscapes." April 12–
May 11

John F. Kennedy Center for the Performing
Arts, Washington, D.C.
"Art Now 74."* May 30–June 16

Galerie Ricke, Cologne, West Germany
"Record as Artwork"

Diane Stimpson Gallery, Vancouver
"Work on Paper"

Walker Art Center, Minneapolis
"Prints from Gemini G.E.L."* August 17–
September 29. Traveled to Akron Art
Institute, December 15, 1975–January 26,
1976; Ackland Art Center, University of North
Carolina, Chapel Hill, February 23–April 6;
The Winnipeg Art Gallery, May 4–June 15;
Denver Art Museum, July 13–August 24

Galerie Ricke, Cologne, West Germany
"4 x Minimal Art." August 19–September 1

John Berggruen Gallery, San Francisco
"Castelli at Berggruen"

Centre National d'Art Contemporain, Paris
"Art/Voir"

Leo Castelli Gallery, New York
"In Three Dimensions." September 21–
October 12

The Oakland Museum, Oakland, Calif.
"Public Sculpture/Urban Environment."*
September 29–December 29

1975

Daniel Weinberg Gallery, San Francisco
"Drawings"

Museo de Arte Moderno, Bogotá
"Color as Language."* Exhibition organized
under the auspices of the International Coun-
cil of The Museum of Modern Art, New York,
February 24–November 23. Traveled to
Museu de Arte de São Paulo; Museu de Arte
Moderna, Rio de Janeiro; Museo de Bellas
Artes, Caracas; Museo de Arte Moderno,
Mexico City

The Baltimore Mueum of Art
"Fourteen Artists." April 15–June 1

Serpentine Gallery, London
"The Video Show." May 1–26

Städtisches Museum Leverkusen, Schloss
Morsbroich, Leverkusen, West Germany
"U.S.A.: Zeichnungen 3."* May 15–June 29

Hayward Gallery, London
"The Condition of Sculpture: A Selection of
Recent Sculpture by Younger British and
Foreign Artists."* May 29–July 13

Whitney Museum of American Art, New York
"Projected Video."* June 5–18

National Collection of Fine Arts, Smithsonian
Institution, Washington D.C.
"Sculpture: American Directions 1945–1975."*
October 3–November 30. Traveled to Dallas
Museum of Fine Arts, January 7–February 29,
1976; New Orleans Museum of Art, March 31–
May 16

1976

The Museum of Modern Art, New York
"Drawing Now."* January 23–March 9.
Traveled to Kunsthaus Zurich, October
10–November 14; Staatliche Kunsthalle
Baden-Baden, November 25, 1976–January 16,
1977; Graphische Sammlung Albertina,
Vienna, January 28–March 6; Sonja Henie-
Niels Onstad Foundations, Oslo, March
17–April 24; The Tel Aviv Museum,
May 12–July 2

Fine Arts Building, New York
"Scale." February 14–24

Sable-Castelli Gallery, Toronto
"Survey: Part II." March 13–April 3

The Art Institute of Chicago
"Seventy-second American Exhibition."*
March 13–May 9

Whitney Museum of American Art, New York
"200 Years of American Sculpture."* March
16–September 26

The Renaissance Society at the University of
Chicago
"Ideas on Paper." May

Greenwich Arts Council, Greenwich, Conn.
"Sculpture 76."* June–October

Institute for Art & Urban Resources, P.S. 1,
Long Island City, New York
"Rooms."* June 9–26

Nationalgalerie, Berlin
"Amerikanische Kunst von 1945 bis Heute"

Kunsthalle, Kiel, West Germany
"Amerikanische Druckgraphik aus öffent-
lichen Sammlungen der Bundesrepublik
Deutschland"

Heiner Friedrich, New York
"An Exhibition for the War Resisters League"

Berlin Festival, Akademie der Künste, Berlin
"New York—Downtown Manhattan: Soho."
September 5–October 17. Traveled to Loui-
siana Museum, Humlebaek, Denmark,
October 31–December 12

Philadelphia College of Art, Philadelphia
"Private Notations: Artists' Sketchbooks II."
October

1977

Newport Art Association, Newport, R.I.
"Two Decades of Exploration: Homage to Leo
Castelli on the Occasion of his 20th Anniver-
sary." February 13–March 27

Whitney Museum of American Art, New York
"1977 Biennial Exhibition, Contemporary
American Art."* February 19–April 3

The Renaissance Society at the University of
Chicago
"Ideas in Sculpture 1965–77." May 1–June 11

Galerie Loyse Oppenheim, Nyon, Switzerland
"Eleven Artists in New York." May

Musée National d'Art Moderne, Centre
Georges Pompidou, Paris
"Paris–New York."* June 1–September 19

Kassel, West Germany
"Documenta 6."* June 24–October 2. See bibl.
62 and 109

Westfälisches Landesmuseum für Kunst und
Kulturgeschichte, Münster
"Skulptur Ausstellung in Münster."* July 3–
November 13

Whitney Museum of American Art, New York
"20th-Century American Art from Friends'
Collections."* July 27–September 27

Museum of Contemporary Art, Chicago
"A View of a Decade."* September 10–
November 10

The Museum of Modern Art, New York
"American Drawn and Matched."* September
20–December 4

Sable-Castelli Gallery, Toronto
"Drawings." October 1–22

The New York State Museum, Albany
"New York: The State of Art."* October 8–
November 27

John Weber Gallery, New York
"Drawings for Outdoor Sculpture 1946–
1977."* October 29–November 23. Traveled to
Mead Gallery, Amherst College, Amherst,
Mass.; University of California Art Galleries,
Santa Barbara; La Jolla Museum of Contempo-
rary Art, La Jolla, Calif.; Hayden Gallery,
Massachusetts Institute of Technology,
Cambridge, Mass.; Laguna Gloria Art Museum,
Austin, Tex.

The University of Michigan Museum of Art,
Ann Arbor
"Works from the Collection of Dorothy and
Herbert Vogel."* November 11, 1977–January
1, 1978

1978

Julian Pretto Gallery, New York
"Atypical Works." January 4–31

Blum Helman Gallery, New York
"Nauman, Serra, Shapiro, Jenney." February

Worcester Art Museum, Worcester, Mass.
"Between Sculpture and Painting." February
23–April 9

Ace Gallery, Vancouver
April 16–30

Art Gallery of Ontario, Toronto
"Structures for Behavior."* May 13–July 9. See
bibl. 51

Leo Castelli Gallery, New York
"Summer Group Show." July 5–September 23

Whitney Museum of American Art, New York
"20th Century American Drawings: Five Years
of Acquisitions."* July 28–October 1

La Jolla Museum of Contemporary Art,
La Jolla, Calif.
"Selections from the Permanent Collection."
August

Stedelijk Museum, Amsterdam
"Made by Sculptors."* September 14–
November 5

Galerie Daniel Templon, Paris
"Daniel Templon, Dix Ans."* October 7–
November 16

Richard Hines Gallery, Seattle
"Sculpture." December 15–February 10, 1979

Stadelsches Kunstinstitut, Frankfurt,
West Germany
"Z.B. Skulptur"

1979

Rosa Esman Gallery, New York
"Places to Be: Unrealized Monumental Sculp-
ture." January 2–February 10

Galleriet, Lund, Sweden
January 13–31

Museum Haus Lange, Krefeld, West Germany
"The Broadening of the Concept of Reality in
the Art of the 60s & 70s." January 21–March 18

Whitney Museum of American Art, New York
"1979 Biennial Exhibition."* February 6–
April 8

Castelli Graphics, New York
"Drawings by Castelli Artists." March 3–24

Museum of Contemporary Art, Chicago
"Selected Sculpture from the Permanent Col-
lection." March–April

Institute for Art & Urban Resources, P.S. 1,
Long Island City, New York
"Great Big Drawing Show." March 25–April 1

The Aldrich Museum of Contemporary Art,
Ridgefield, Conn.
"The Minimal Tradition."* April 29–
September 2

The Museum of Modern Art, New York
"Contemporary Sculpture: Selections from the
Collection of The Museum of Modern Art."*
May 18–August 7

The Art Institute of Chicago
"73rd American Exhibition."* June 9–August 5

Leo Castelli Gallery, New York
"Summer Group Show." June 23–
September 15

La Jolla Museum of Contemporary Art,
La Jolla, Calif.
"Selections from the Permanent Collection."
July 18–August 19

Sunne Savage Gallery, Boston
"Thirty Years of Box Construction."*
November 2–30

Brooks Memorial Art Gallery, Memphis
"American Masters of the 60s and 70s"

Stedelijk Museum, Amsterdam
"Gerry Schum."

Kunsthaus Zurich
"Weich und Plastisch: Soft Art."* November
16–February 4, 1980

1980

The Bronx Museum of the Arts, New York
"Marking Black."* January 24–March 9

Bell Gallery, Brown University, Providence,
R.I.
"Brown Invitational Exhibition." February
1–24

Blum Helman Gallery, New York
"Kelly/Serra." February 12–April 15

Leo Castelli Gallery, New York
"Leo Castelli: A New Space." Opened Febru-
ary 19

Allen Memorial Art Museum, Oberlin Col-
lege, Oberlin, Ohio
"From Reinhardt to Christo." February 20–
March 19

Grand Palais, Paris
"91e Salon des Artistes Indépendants." March
13–April 13

The Jacksonville Art Museum, Jacksonville,
Fla.
"The Norman Fisher Collection at The Jack-
sonville Art Museum."* March 27–May 4

Hayden Gallery, Massachusetts Institute of
Technology, Cambridge, Mass.
"Mel Bochner/Richard Serra."* April 5–May
11. See bibl. 40

Whitney Museum of American Art, New York
"American Sculpture: Gifts of Howard and
Jean Lipman."* April 15–June 15

Hayward Gallery, London
"Pier + Ocean."* May 8–June 22. Traveled to
Rijksmuseum Kröller-Müller, Otterlo, July
13–September 8

Wenkenpark, Riehen/Basel, Switzerland
"Skulptur im 20. Jahrhundert."* May 10–
September 14

Washington, D.C.
"The Eleventh International Sculpture Con-
ference." June

Whitney Museum of American Art, New York
"50th Anniversary Gifts." June 3–August 31

Castelli Graphics, New York
"Master Prints by Castelli Artists." June 7–28

Venice
"La Biennale di Venezia"*

Galerie Ricke, Cologne, West Germany
"Die ausgestellten Arbeiten sind zwischen
1966 und 1972 entstanden." July 8–Septem-
ber 17

Richard Hines Gallery, Seattle
"Donald Judd, Bruce Nauman, Richard Serra:
Sculpture." July–August

La Jolla Museum of Contemporary Art,
La Jolla, Calif.
"Selections from the Permanent Collections."
July 12–August 31

San Francisco Museum of Modern Art
"20 American Artists."* July 24–September 7

Westfälisches Landesmuseum für Kunst und
Kulturgeschichte, Münster, West Germany
"Reliefs."* Traveled to Kunsthaus Zurich.
August 22–November 2

Ace Gallery, Venice, Calif.
"Key Works from 1969." October 28–
November 22

Württembergischer Kunstverein, Stuttgart,
West Germany
"Donald Judd, Richard Serra: Skulpturen und
Zeichnungen"

A Space, Toronto
"Selected Tapes." November 3–29

Castelli Graphics, New York
"Amalgam." November 22–December 20

The Brooklyn Museum, New York
"American Drawing in Black & White: 1970–1980."* November 22, 1980–January 18, 1981

Leo Castelli Gallery, New York
"Drawings to Benefit the Foundation for the Contemporary Performance Arts, Inc." November 29–December 20

1981

Galleriet, Lund, Sweden
January 17–February 4

Whitney Museum of American Art, New York.
"1981 Biennial Exhibition."* January 20–April 19

Yale University Art Gallery, New Haven, Conn.
"Twenty Artists: Yale School of Art 1950–1970." Opened January 28

The Corcoran Gallery of Art, Washington, D.C.
"The 37th Biennial Exhibition of Contemporary American Painting."* February 19–April 5

Randolph-Macon Woman's College, Lynchburg, Va.
"Seventeenth Annual Exhibition"

Gloria Luria Gallery, Bar Harbour Islands, Fla.
"Leo Castelli Selects for Gloria Luria Gallery." February 27–March 16

Museum Haus Lange, Krefeld, West Germany
"Kounellis, Merz, Nauman, Serra."* March 15–April 26. See bibl. 43

Museen der Stadt, Cologne, West Germany
"Westkunst."* May 30–August 16

Galerie Ricke, Cologne, West Germany
"Einladung zur Eröffnung." July 10–September 10

Margo Leavin Gallery, Los Angeles
"Cast, Carved, and Constructed." August 1–September 19

Sewall Art Gallery, Rice University, Houston
"Variants: Drawings by Contemporary Sculptors." November 2–December 12. Traveled to Art Museum of South Texas, Corpus Christi; Newcomb Gallery, Tulane University, New Orleans; The High Museum of Art, Atlanta

New Gallery of Contemporary Art, Cleveland
"Insights: Small Works from the Past 15 Years." November 6–December 12

Städtische Kunsthalle, Düsseldorf
"Schwarz"

The Architectural League, New York
"Artists and Architects, Collaboration"

"Films by American Artists: One Medium among Many."* Exhibition circulated by the Arts Council of Great Britain

1982

Akira Ikeda Gallery, Tokyo
"Group Exhibit." January 30–February 20

Whitney Museum of American Art, Fairfield County, Conn.
"Surveying the Seventies: Selections from the Permanent Collection of the Whitney Museum of American Art."* February 12–March 31

Centre d'Arts Plastiques Contemporains de Bordeaux
"Arte Povera, Antiform, Sculptures 1966–69."* March 12–April 30

Stedelijk Museum, Amsterdam
"'60–'80: Attitudes/Concepts/Images."* April 9–July 11

"Castelli and His Artists/Twenty-five Years."* Exhibition organized by the Aspen Center for the Visual Arts, Aspen, Colo. Traveled to La Jolla Museum of Contemporary Art, La Jolla, Calif., April 23–June 6; Aspen Center for the Visual Arts, June 17–August 7; Leo Castelli Gallery, New York, September 11–October 9; Portland Center for the Visual Arts, October 22–December 3; Laguna Gloria Art Museum, Austin, Tex., December 17, 1982–February 13, 1983

Whitney Museum of American Art, New York
"Abstract Drawings 1911–1981: Selections from the Permanent Collection."* May 5–July 11

Blum Helman Gallery, New York
"Johns, Kelly, Serra: New York." May 12–June 12

The British Museum, London
"A Century of Modern Drawing."* Exhibition organized under the auspices of the International Council of The Museum of Modern Art, New York. June 9–September 12

Kassel, West Germany
"Documenta 7."* June 19–September 28

Hayden Gallery, Massachusetts Institute of Technology, Cambridge, Mass.
"Great Big Drawings"*

The Solomon R. Guggenheim Museum, New York
"The New York School: Four Decades."* July 1–August 22

Palacio de las Alhajas, Madrid
"Correspondencias: 5 Arquitectos, 5 Escultores."* October–November. See bibl. 24 and 45

American Academy of Arts and Letters, New York
"Hassam and Speicher Fund Purchase Exhibition"

Nationalgalerie, Berlin
"Kunst wird Material"* October 7–September 5

Akira Ikeda Gallery, Nagoya, Japan
"Group Exhibition." October 4–30

Leo Castelli Gallery, New York
"Group Exhibition." October 16–November 6

Margo Leavin Gallery, Los Angeles
"Group Exhibition." December 4–30

1983

Hillwood Art Gallery, C. W. Post Center, Long Island University, Greenvale, N.Y.
"Monumental Drawings by Sculptors."* January 7–February 9. See bibl. 42

Daniel Weinberg Gallery, Los Angeles
"Drawing Conclusions: A Survey of American Drawings 1958–1983." January 29–February 26

Castelli Graphics, New York
"Black & White: A Print Survey." January 29–February 26

Institute of Contemporary Art, University of Pennsylvania, Philadelphia
"Connections." March 11–April 24

Whitney Museum of American Art, New York
"Minimalism to Expressionism: Painting and Sculpture since 1965 from the Permanent Collection."* June 2–December 4

CDS Gallery, New York
"Artists Choose Artists II." June 8–July 16

McIntosh/Drysdale, Houston
"Monuments & Landscapes: The New Public Art." June 14–September 6

Leo Castelli Gallery, New York
"Summer Group Show." June–July

Middelheim, Belgium
"17e Biennale Antwerpen"

Margo Leavin Gallery, Los Angeles
"Black and White"

Daniel Weinberg Gallery, Los Angeles
September 10–October 8

Flow Ace Gallery, Los Angeles
"Aspects of Minimalism." September 30–November 5

Seibu Department Stores, Tokyo
"Hommage to Leo Castelli." Opened October 7

Delahunty Gallery, Dallas
"Contemporary Drawing." October 8–November 9

Nassau County Museum of Fine Art, Roslyn Harbor, N.Y.
"Sculpture: The Tradition in Steel."* October 9, 1983–January 22, 1984

The Art Museum of the Ateneum, Helsinki
"Ars 83 Helsinki."* October 14–December 11

Nippon Club Gallery, New York
"Portfolios." October

Mathews Hamilton Gallery, Philadelphia
"Works on Paper." November 4–30

1984

Zilkha Gallery, Wesleyan University, Middletown, Conn.
"Large Drawings." January 26–March 9

Whitney Museum of American Art, New York
"American Art since 1970." Circulating exhibition, March 10, 1984–June 2, 1985

Hirschl & Adler Galleries, New York
"The Skowhegan Celebration Exhibition."
Opened May 1

The Montreal Museum of Fine Arts
"Drawings by Sculptors: Two Decades of
Non-Objective Art in the Seagram Collection."* May 3–June 10. Circulating exhibition,
including showing at Seagram Building, New
York, December 12–February 10, 1985

The Museum of Modern Art, New York
"Selections from the Permanent Collection,
Painting and Sculpture." May 17–August 15

Merian-Park, Basel, Switzerland
"Skulptur im 20. Jahrhundert."* June 3–
September 30

Venice
"La Biennale di Venezia"*

Art Center College of Design, Pasadena, Calif.
"Castelli at Art Center—Sculpture at Art
Center." June 24–July 21

Hill Gallery, Birmingham, Mich.
June 30–July 28

Margo Leavin Gallery, Los Angeles
"American Sculpture." July 17–September 15

Stedelijk Museum, Amsterdam
"Summer Exhibition/20 Years of Collecting"

ROSC, Dublin
August 24–November 17*

Madrid
"Madrid-Madrid"

Larry Gagosian Gallery, Los Angeles

Leo Castelli Gallery, New York
"Summer Group Show." September

Fine Arts Center, University of Massachusetts
at Amherst
"Prints and Drawings of the New York
School." September 15–October 26

Oil & Steel Gallery, New York
"Contemporary Paintings and Sculpture V:
1957–1984." September 18–November 3

Akira Ikeda Gallery, Nagoya, Japan
"Black: Painting and Sculpture." October 1–30

Hirshhorn Museum and Sculpture Garden,
Smithsonian Institution, Washington, D.C.
"Content: A Contemporary Focus 1974–
1984."* October 4, 1984–January 6, 1985

Blum Helman Gallery, New York
"Drawings." October 10–November 3

Leo Castelli Gallery, New York
"Drawings." October 13–November 3

Wiesbaden, West Germany
"Wiesbadener Skulpturentage"

National Gallery of Art, Washington, D.C.
"Gemini G.E.L., Art and Collaboration."*
November 18, 1984–February 24, 1985

1985

The Greenberg Gallery, St. Louis
"On Paper." January 12–February 23

"Large Drawings."* Exhibition circulated by
Independent Curators Incorporated, New
York. January 15, 1985–May 8, 1986

The Renaissance Society at the University of
Chicago
"Large Scale Drawings by Sculptors." January
27–February 23

Akira Ikeda Gallery, Tokyo
" 'Black': Jasper Johns, Frank Stella, Richard
Serra."* February 4–28

Visual Arts Museum, New York
"The Sculptor as Draftsman." February 11–
March 2

Edith C. Blum Art Institute, The Bard College
Center, Annandale-on-Hudson, N.Y.
"The Maximal Implications of the Minimal
Line."* March 24–April 28

Centro de Arte Moderna, Fundação Calouste
Gulbenkian, Lisbon
"Exhibition-Dialogue/Exposição-Diálogo."*
March 28–June 16

Leo Castelli Gallery, New York
"Group Exhibition." March 30–April 13

The Museum of Modern Art, New York
"Philip Johnson Installation." April 11–
September

Illinois Not-for-Profit Organization, State
Street Mall, Chicago
"Chicago Sculpture International MILE-4."*
May 9–June 9

Leila Taghinia-Milani, New York
"Tension: Examples in Art; the 20th Century."
June 12–July 12

Marian Goodman Gallery, New York
"A Sculpture Show." June 18–July 12

Leo Castelli Gallery, New York
"Summer Group Show." June 20–July 26

ARCA, Marseilles
"New York 85." July 9–August 31

Kunsthalle, Nuremberg, West Germany
"Meister der Zeichnung." October

Museum of Art, Carnegie Institute, Pittsburgh
"Carnegie International"

Films and Videotapes

Films

Hand Catching Lead. 1968
16 mm, black and white, 3 min. 30 sec.
Camera: Robert Fiore

Hand Lead Fulcrum. 1968
16 mm, black and white, 3 min.
Camera: Robert Fiore

Hands Scraping. 1968
16 mm, black and white, 4 min. 30 sec.
Camera: Robert Fiore

Hands Tied. 1968
16 mm, black and white, 3 min. 30 sec.
Camera: Robert Fiore

Frame. 1969
16 mm, black and white, sound, 22 min.
Camera: Robert Fiore

Three untitled films. 1969
16 mm, black and white, 3 min. each

Tina Turning. 1969
16 mm, black and white, 2 min.
Camera: Robert Fiore

Untitled. 1969
16 mm, black and white, 25 min.

Untitled. 1969
16 mm, black and white, 30 min.

Color Aid. 1970–71
16 mm, color, sound, 36 min.
Camera: Robert Fiore

Paul Revere. 1971
16 mm, black and white, sound, 9 min.
Collaborator: Joan Jonas

Veil. 1971
16 mm, black and white, 6 min.
Collaborator: Joan Jonas

Match Match Their Courage. 1974
16 mm, color, sound, 34 min.

Railroad Turnbridge. 1976
16 mm, black and white, 19 min.

Steelmill/Stahlwerk. 1979
16 mm, black and white, sound, 29 min.
Collaborator: Clara Weyergraf

Videotapes

Anxious Automation. 1971
Black and white, sound, 4 min. 30 sec.

China Girls. 1972
Black and white, sound, 11 min.

Surprise Attack. 1973
Black and white, sound, 2 min.
Camera: Babette Mangolte

Television Delivers People. 1973
Color, sound, 6 min.

Boomerang. 1974
Color, sound, 10 min.

Prisoner's Dilemma. 1974
Black and white, sound, 60 min.
Collaborator: Robert Bell

Selected Bibliography

Statements, Writings, Interviews, Letters by the Artist

Arranged chronologically by publication date

1. "Play it Again, Sam," *Arts Magazine* (New York) vol. 44, no. 4 (February 1970), pp. 24–27. Reprinted in bibl. 53. Includes excerpts from bibl. 8, as printed in bibl. 33.

2. "The Artist and Politics: A Symposium," *Artforum* (New York), vol. 9, no. 1 (September 1970), pp. 35–39.

3. [Statement] *Art Now: New York* (New York), vol. 3, no. 3 (September 1971).

4. "Statements," *Artforum* (New York), vol. 10, no. 1 (September 1971), p. 64.

5. Joan Jonas and Richard Serra. "Paul Revere," *Artforum* (New York), vol. 10, no. 1 (September 1971), pp. 65–67.

6. [Documents] *Avalanche* (New York), no. 2 (Winter 1971), pp. 20–21. Includes "Verb List Compilation 1967–68," reprinted in bibl. 34 and 53.

7. "Proposal for Los Angeles County Museum in Conjunction with Kaiser Steel" [statement 1969]. Printed 1971 in bibl. 33, p. 298.

8. "Skullcracker Stacking Series" [statement 1969]. Printed 1971 in bibl. 33, pp. 299–300. See also bibl. 1.

9. "Letters," *Artforum* (New York), vol. 10, no. 7 (March 1972), p. 6. See bibl. 97.

10. Rosalind Krauss, ed. "Richard Serra: Shift," *Arts Magazine* (New York), vol. 47, no. 6 (April 1973), pp. 49–55. Reprinted in bibl. 53.

11. "Document: Spin Out '72–'73 for Bob Smithson" [interview by Liza Bear], *Avalanche* (New York), no. 8 (Summer/Fall 1973), pp. 14–15. Reprinted in bibl. 53.

12. "Prisoner's Dilemma" [interview by Liza Bear], *Avalanche* (New York), no. 9 (May–June 1974), pp. 26–28. Reprinted in bibl. 53.

13. "Text: Television Delivers People," *Art-Rite* (New York), no. 7 (Autumn 1974), p. 5.

14. "Richard Serra: Sight Point '71–75/Delineator '74–76" [radio interview by Liza Bear], *Art in America* (New York), vol. 64, no. 3 (May–June 1976), pp. 82–86. Reprinted as "Richard Serra: Faire l'expérience de la sculpture," *Art Press* (Paris), no. 6 (April 1977), pp. 9–11. Also reprinted in bibl. 53.

15. [Interview by Lizzie Borden, 1977]. Printed 1977 in bibl. 37 and reprinted in bibl. 52 and 53.

16. "Skulptur als Platz" [interview by Friedrich Teja Bach, 1975, 1976], *Das Kunstwerk* (Baden-Baden), vol. 31, no. 1 (February 1978), pp. 3–14. Interview 1975 reprinted in bibl. 53.

17. "The Films of Richard Serra: An Interview" [interview by Annette Michelson and Clara Weyergraf], *October* (Cambridge, Mass.), no. 10 (Fall 1979), pp. 68–104. Reprinted in bibl. 53.

18. "Rigging" [based on interview by Gerard Hovagimyan], *Cover* (New York), vol. 2, no. 1 (January 1980), pp. 41, 45–47. Edited and reprinted in bibl. 53.

19. "St. John's Rotary Arc," *Artforum* (New York), vol. 19, no. 1 (September 1980), pp. 52–55. Reprinted in bibl. 53.

20. "Richard Serra's Urban Sculpture" [interview by Douglas Crimp], *Arts Magazine* (New York), vol. 55, no. 3 (November 1980), pp. 118–23. Reprinted in bibl. 53.

21. [Interview by Liza Bear, 1976]. Printed 1980 in bibl. 53.

22. "Entretien avec Richard Serra" [interview by Bernard Lamarche-Vadel], *Artistes* (Paris), no. 7 (January–February 1981), pp. 24–29. Edited by Clara Weyergraf and printed in bibl. 53.

23. "Portraits" [conversation with Kathy Acker, Joseph Kosuth, Lawrence Weiner, Sandro Chia, Philip Glass, Barbara Kruger, David Salle], *Artforum* (New York), vol. 20, no. 9 (May 1982), pp. 58–69.

24. "Escultura para Callao (Sculpture for Callao)." Printed 1982 in bibl. 45.

25. "Notes from Sight Point Road," *Perspecta* (Cambridge, Mass., and London), vol. 19 (1982), pp. 172–81.

26. [Statement] *Richard Serra at Gemini, 1980–1981.* Los Angeles: Gemini G.E.L., 1982.

27. "Interview" [interview by Peter Eisenman], *Skyline* (New York), April 1983, pp. 14–17.

28. "Entretien avec Richard Serra" [interview by Alfred Pacquement]. Printed 1983 in bibl. 47.

29. "Extended Notes from Sight Point Road." Printed 1985 in bibl. 39.

General References
Arranged alphabetically

30. Celant, Germano. *Art Povera.* New York: Praeger Publishers, 1969.

31. Krauss, Rosalind E. *The Originality of the Avant-Garde and Other Modernist Myths.* Cambridge, Mass., and London: The MIT Press, 1985. Includes "Richard Serra: A Translation," reprinted from bibl. 47.

32. ———. *Passages in Modern Sculpture.* New York: The Viking Press, 1977.

33. Los Angeles County Museum of Art. *Art & Technology: A Report on the Art & Technology Program of the Los Angeles County Museum of Art 1967–1971.* Essay by Gail R. Scott, pp. 298–305. New York: The Viking Press, 1971. Includes bibl. 7 and 8. See also bibl. 1.

34. Müller, Grégoire, and Gorgoni, Gianfranco. *The New Avant-Garde: Issues for the Art of the Seventies.* New York, Washington, and London: Praeger Publishers, 1972. Includes bibl. 6.

35. Pradel, Jean-Louis, ed. *World Art Trends 1983/84.* New York: Harry N. Abrams, 1984.

36. Rose, Barbara. "Richard Serra." *Modern Painting, Drawing & Sculpture Collected by Louise and Joseph Pulitzer, Jr.,* vol. 3, pp. 538–42. Cambridge, Mass.: Fogg Art Museum, 1971.

Catalogs and Monographs
Arranged alphabetically

37. Amsterdam. Stedelijk Museum. *Richard Serra: Tekeningen/Drawings 1971–1977.* November 18, 1977–January 2, 1978. Catalog. Interview by Lizzie Borden (see bibl. 15), reprinted in bibl. 52 and 53.

38. Berlin. Galerie Reinhard Onnasch. *Richard Serra: Skulpturen und Zeichnungen 1967–1983.* September 17–October 21, 1983. Catalog. Text by Michael Pauseback.

39. Bochum. Galerie m. *Richard Serra: Recent Sculpture in Europe 1977–1985.* 1985. Monograph. Includes bibl. 29.

40. Cambridge, Mass. Hayden Gallery, Massachusetts Institute of Technology. *Mel Bochner/Richard Serra.* April 5–May 11, 1980. Catalog. Introduction by Kathy Halbreich.

41. Goslar. Mönchehausmuseum. *Richard Serra (Träger des Kaiserringpreises der Stadt Goslar 1981).* September 12–November 22, 1981. Catalog.

42. Greenvale, N.Y. Hillwood Art Gallery, C. W. Post Center, Long Island University. *Monumental Drawings by Sculptors.* January 7–February 9, 1983. Catalog. Text by Judith Van Wagner.

43. Krefeld. Museum Haus Lange. *Kounellis, Merz, Nauman, Serra.* March 15–April 26, 1981. Catalog. Text by Gerhard Storck.

44. ———. *Richard Serra.* January 27–March 24, 1985. Catalog. Text by Marianne Stockebrand.

45. Madrid. Palacio de las Alhajas. *Correspondencias: 5 Arquitectos, 5 Escultores.* October–November 1982. Catalog. Includes bibl. 24.

46. New York. Whitney Museum of American Art. *Anti-Illusion: Procedures/Materials.* May 19–July 6, 1969. Catalog. Essays by James Monte and Marcia Tucker.

47. Paris. Musée National d'Art Moderne, Centre Georges Pompidou. *Richard Serra.* October 26, 1983–January 2, 1984. Catalog. Essays by Yve-Alain Bois and Rosalind E. Krauss; interview by Alfred Pacquement. See bibl. 28, 31, and 60.

48. Pasadena, Calif. Pasadena Art Museum. *Richard Serra.* February 26–March 1, 1970. Catalog.

49. Princeton, N.J. The Art Museum, Princeton University. *Line as Language: Six Artists Draw.* February 23–March 31, 1974. Catalog. Text by Rosalind E. Krauss.

50. Tokyo. Akira Ikeda Gallery. *Richard Serra: New Sculpture.* June 6–July 30, 1983. Catalog. Text by Maki Kuwayama.

51. Toronto. Art Gallery of Ontario. *Structures for Behaviour: New Sculptures by Robert Morris, David Rabinowitch, Richard Serra and George Trakas.* May 13–July 9, 1978. Catalog. Introduction by Roald Nasgaard.

52. Tübingen. Kunsthalle. *Richard Serra: Arbeiten 66–77/Works 66–77.* March 8–April 2, 1978. Catalog. Essays by Clara Weyergraf, Max Imdahl, and B.H.D. Buchloh; interview by Lizzie Borden. See bibl. 15, 61, 75, and 113. See also bibl. 37.

53. Yonkers, N.Y. The Hudson River Museum. *Richard Serra: Interviews, Etc. 1970–1980.* Published 1980 in connection with the exhibition "Richard Serra: Elevator 1980" at The Hudson River Museum. Written and compiled by Richard Serra in collaboration with Clara Weyergraf. Includes bibl. 1, 6, 10, 11, 12, 14, 15, 16, 17, 18, 19, 20, 21, and 22. See also bibl. 37.

Articles, Reviews, Essays
Arranged alphabetically

54. Amaya, Mario. "Toronto: Serra's Visit and After," *Art in America* (New York), vol. 59, no. 3 (May–June 1971), pp. 122–23.

55. Ammann, Jean Christophe. "Schweizer Brief" [exhibition review, Kunsthalle Bern], *Art International* (Lugano), vol. 13, no. 5 (May 20, 1969), pp. 47–50.

56. Baker, Elizabeth C. "Critic's Choice, Serra" [exhibition review, Castelli Warehouse], *Art News* (New York), vol. 68, no. 10 (February 1970), pp. 26–27.

57. Baker, Kenneth. "'Shift,'" *Studio International* (London), vol. 186, no. 959 (October 1973), p. 155.

58. Becker, Wolfgang. "Richard Serra," *Das Kunstwerk* (Baden-Baden), vol. 25, no. 2 (March 1972), pp. 24–29.

59. Bois, Yve-Alain. "The Meteorite in the Garden," *Art in America* (New York), vol. 72, no. 6 (Summer 1984), pp. 108–13.

60. ———. "A Picturesque Stroll around *Clara-Clara,*" *October* (Cambridge, Mass.), no. 29 (Summer 1984), pp. 32–62. Reprinted from bibl. 47 and translated by John Shepley.

61. Buchloh, B.H.D. "Process Sculpture and Film in Richard Serra's Work." Printed in bibl. 52.

62. Catoir, Barbara. "Richard Serra" [exhibition reviews, Galerie m and "Documenta 6"], *Das Kunstwerk* (Baden-Baden), vol. 30, no. 4 (August 1977), pp. 83–84.

63. Collins, James. "Reviews: Soft as Art" [exhibition review, The New York Cultural Center], *Artforum* (New York), vol. 11, no. 10 (June 1973), pp. 89–91.

64. Cornwell, Regina. "Three by Serra," *Artforum* (New York), vol. 18, no. 4 (December 1979), pp. 28–32.

65. Crichton, Fenella. "Paris Letter: Serra" [exhibition review, Daniel Templon], *Art International* (Lugano), vol. 21, no. 2 (March–April 1977), pp. 59, 73.

66. Crimp, Douglas. "Richard Serra: Sculpture Exceeded," *October* (Cambridge, Mass.), no. 18 (Fall 1981), pp. 67–78. Translation of "Richard Serra: Le Dépassement de la sculpture," *Artistes* (Paris), no. 7 (January–February 1981), pp. 30–37.

67. Dienst, Rolf-Gunter. "Richard Serra" [exhibition review, Staatliche Kunsthalle, Baden-Baden], *Das Kunstwerk* (Baden-Baden), vol. 31, no. 3 (June 1978), pp. 84–85.

68. Dippel, Rini. "Richard Serra," *Museumjournaal* (Amsterdam), series 21, no. 4 (August 1976), pp. 161–66.

69. Dreiss, Joseph. "Richard Serra" [exhibition review, Leo Castelli], *Arts Magazine* (New York), vol. 49, no. 4 (December 1974), p. 13.

70. Frank, Elizabeth. "Review of Exhibitions: New York" [exhibition review, Leo Castelli], *Art in America* (New York), vol. 69, no. 6 (Summer 1981), p. 126.

71. Gilbert-Rolfe, Jeremy. "Capital Follies," *Artforum* (New York), vol. 17, no. 1 (September 1978), pp. 66–67.

72. ———. "Reviews: Richard Serra" [exhibition reviews, Leo Castelli and School of Visual Arts], *Artforum* (New York), vol. 13, no. 4 (December 1974), pp. 70–71.

73. Hahn, Otto. "Richard Serra," *Art Press* (Paris), vol. 9 (February 1974), pp. 10–11.

74. Herrera, Hayden. "New York Reviews: Richard Serra, Drawings" [exhibition reviews, Leo Castelli and School of Visual Arts], *Art News* (New York), vol. 74, no. 2 (February 1975), pp. 82–83.

75. Imdahl, Max. "Serra's 'Right Angle Prop' and 'Tot': Concrete Art and Paradigm." Printed in bibl. 52.

76. Kimbrell, Leonard B. "Richard Serra: Offering More with Less" [exhibition review, Portland Center for the Visual Arts], *Artweek* (Oakland, Calif.), vol. 6, no. 40 (November 22, 1975), p. 1.

77. Kozloff, Max. "9 in a Warehouse: An Attack on the Status of the Object" [exhibition review, Castelli Warehouse], *Artforum* (New York), vol. 7, no. 6 (February 1969), pp. 38–42.

78. Krauss, Rosalind E. "Richard Serra: Sculpture Redrawn," *Artforum* (New York), vol. 10, no. 9 (May 1972), pp. 38–43.

79. ———. "Sense and Sensibility: Reflection on Post '60s Sculpture," *Artforum* (New York), vol. 12, no. 3 (November 1973), pp. 43–53.

80. ———. "A View of Modernism," *Artforum* (New York), vol. 11, no. 1 (September 1972), pp. 48–51.

81. Kuspit, Donald B. "Review of Exhibitions: New York" [exhibition reviews, Leo Castelli and School of Visual Arts], *Art in America* (New York), vol. 63, no. 1 (January–February 1975), pp. 85–86.

82. ———. "Richard Serra: Utopian Constructivist," *Arts Magazine* (New York), vol. 55, no. 3 (November 1980), pp. 124–29.

83. ———. "Richard Serra's City Piece," *Arts Magazine* (New York), vol. 49, no. 5 (January 1975), pp. 48–51.

84. Larson, Kay. "Ups and Downs," *New York* (New York), December 22, 1980, pp. 58–59.

85. Leider, Philip. "New York: Richard Serra" [exhibition review, Castelli Warehouse], *Artforum* (New York), vol. 8, no. 6 (February 1970), pp. 68–69.

86. Licht, Matthew. "Arts Reviews: Richard Serra" [exhibition review, Blum Helman], *Arts Magazine* (New York), vol. 57, no. 7 (March 1983), p. 39.

87. Linker, Kate. "Reviews: Paris" [review, Jardin des Tuileries, Paris], *Artforum* (New York), vol. 22, no. 6 (February 1984), pp. 91–92.

88. Marmer, Nancy. "Reviews: Los Angeles" [exhibition review, Ace Gallery, Venice, Calif.], *Artforum* (New York), vol. 14, no. 10 (June 1976), p. 74.

89. Monte, James. "Looking at the Guggenheim International" [exhibition review, The Solomon R. Guggenheim Museum, New York], *Artforum* (New York), vol. 9, no. 7 (March 1971) pp. 28–31.

90. Morschel, Jürgen. "Richard Serra" [exhibition reviews, Stedelijk Museum, Amsterdam, and Kunsthalle Tübingen], *Das Kunstwerk* (Baden-Baden), vol. 31, no. 1 (February 1978), pp. 48, 53.

91. Müller, Grégoire. "The Scale of Man," *Arts Magazine* (New York), vol. 44, no. 7 (May 1970), pp. 42–43.

92. Parent, Beatrice. "Le Néon dans l'art contemporain," *Chroniques de l'art vivant* (Paris), no. 20 (May 1971), pp. 4–6.

93. Perrone, Jeff. "Reviews: New York" [exhibition review, Blum Helman], *Artforum* (New York), vol. 17, no. 4 (December 1978), pp. 69–70.

94. Pierre, José. "Les Grandes Vacances de l'art moderne," *L'Oeil* (Paris), no. 173 (May 1969), pp. 10–18, 72.

95. Pincus-Witten, Robert. "Entries: Oedipus Reconciled," *Arts Magazine* (New York), vol. 55, no. 3 (November 1980), pp. 130–33.

96. ———. "New York" [exhibition review, Noah Goldowsky], *Artforum* (New York), vol. 6, no. 8 (April 1968), p. 65.

97. ———. "New York" [exhibition review, Lo Giudice], *Artforum* (New York), vol. 10, no. 5 (January 1972), pp. 80–81. See bibl. 9.

98. ———. "Richard Serra: Slow Information," *Artforum* (New York), vol. 8, no. 1 (September 1969), pp. 34–39. Reprinted in Robert Pincus-Witten. *Postminimalism.* New York: Out of London Press, 1977.

99. Plagens, Peter. "Los Angeles" [exhibition review, Ace Gallery], *Artforum* (New York), vol. 9, no. 1 (September 1970), p. 81.

100. ———. "Los Angeles: Craig Kauffman, Richard Serra" [exhibition review, Pasadena Art Museum], *Artforum* (New York), vol. 8, no. 8 (April 1970), pp. 84–86.

101. ———. "Reviews" [exhibition review, Ace Gallery, Los Angeles], *Artforum* (New York), vol. 13, no. 3 (November 1974), pp. 74–75.

102. Pohlen, Annelie. "Reviews: West Berlin" [exhibition review, Reinhard Onnasch], *Artforum* (New York), vol. 22, no. 8 (April 1984), pp. 91–92. Translated by Martha Humphreys.

103. Pulitzer, Emily Rauh. "Space, Time, and Sculpture," *Bryn Mawr Alumnae Bulletin* (Bryn Mawr, Pa.), vol. 65, no. 1 (Fall 1983), pp. 8–10.

104. Ratcliff, Carter. "Adversary Spaces," *Artforum* (New York), vol. 11, no. 2 (October 1972), pp. 40–44.

105. Rose, Barbara. "Problems of Criticism, VI: The Politics of Art, Part III," *Artforum* (New York), vol. 7, no. 9 (May 1969), pp. 46–51.

106. ———. "Serra," *Vogue* (New York), vol. 160, no. 4 (September 1, 1972), pp. 252–53, 303.

107. Saunders, Wade. "Hot Metal," *Art in America* (New York), vol. 68, no. 6 (Summer 1980), pp. 90–91.

108. Senie, Harriet. "The Right Stuff," *Art News* (New York), vol. 83, no. 3 (March 1984), cover and pp. 50–59.

109. Siegel, Jeanne. "Notes on the State of Outdoor Sculpture at Documenta 6" [exhibition review, "Documenta 6"], *Arts Magazine* (New York), vol. 52, no. 3 (November 1977), pp. 130–33.

110. Smith, Roberta. "Review of Exhibitions: Richard Serra at Blum Helman," *Art in America* (New York), vol. 67, no. 2 (March–April 1979), p. 156.

111. Thwaites, John Anthony. "Working Out," *Art and Artists* (London), vol. 8, no. 12 (March 1974), pp. 34–37.

112. Wasserman, Emily. "New York" [exhibition review, The Solomon R. Guggenheim Museum, New York], *Artforum* (New York), vol. 8, no. 1 (September 1969), pp. 58–59.

113. Weyergraf, Clara. "From 'Trough Pieces' to 'Terminal': Study of a Development." Printed in bibl. 52.

114. Wortz, Melinda. "The Nation: Los Angeles: Magic and Mysteries" [exhibition review, Ace Gallery, Venice, Calif.], *Art News* (New York), vol. 75, no. 5 (May 1976), pp. 83–84.

NEW PARTITION (TYP.)

Ⓑ/2 Ⓐ/2 Ⓑ/2

CIRCUIT
(WT. = 33,000#)

₤ 1"×10'×20' (TYP.)

45°
45°

₤ 10'-0"×2½"×6'-0"

TWO PLATE PROP
(WT. = 8200#)

₤ 4'-6" × 2½" × 4'-6"

SPLASH PIECE

Ⓑ/2

Ⓐ/2

3'-0" 3'-0"

3'-0" 3'-0"

LEAD ₤ 1"× 4'×4'(TYP.)

HOUSE OF CARDS
(WT. = 3800#)

₤ 4'-0"× 4'-0"× 1½"
(TYP.)

EQUAL

EQUAL

4"∅×6'-0"
STEEL BAR

1-1-1-1
(WT. = 7,000#)

DELINEATOR
(WT. = 16,500#)

FLOOR PLATE
₤ 7"×10'-0"

EQUAL EQUAL

STEEL BAR
35½"×6"×15'-4½"(TYP.)

EQUAL (TYP.)

3'-0" 3'-0"

3'-0"

7'-0"

7'-0"

3'-0"

EQUAL

GRIND ₤
₤1"×10'×20'
(SEE TYP. DET.)

45°

STEEL BAR
35½"×6"×35½"
(TYP.)

45°

45°

45° 45°

EQUAL (TYP.)

ELEVATIONS
(WT. = 14,000#)

EQUAL

EQUAL

EQUAL

EQUAL

4'-0" 4'-0"

6'-0"

LOBBY

11'-6"

7"∅ BAR
(#1)

W.P.

90°

7"∅ BAR
(#2)

REF. LINE

₤ 0'-0"×0'-0"× 2" (TYP.)

3-₤ 10'-0"×1"× 19'-9"

R = 72'-1"

57'-7"

6'-0"

TWO CORNER CURVE
(WT = 24,000#)

№ 5
(WT. = 30,000#)

Works in the Exhibition

1. *One Ton Prop (House of Cards)*. 1969
Lead antimony, four plates, each 48 x 48"
Collection the Grinstein Family, Los Angeles

2. *Casting*. 1969–86
Lead, size variable
Collection the artist

3. *1-1-1-1*. 1969–86
Steel, four plates, each 48 x 48"; pole 7'
Saatchi Collection, London

4. *Five Plates, Two Poles*. 1971
Cor-Ten steel, plates, each 8 x 8' x 2";
poles, each 12' x 7" diameter; overall 8 x 23 x 18'
Walker Art Center, Minneapolis,
Gift of Mr. and Mrs. Kenneth N. Dayton

5. *Circuit, II*. 1972–86
Steel, four plates, each 10 x 20' x 1"
Galerie m, Bochum, West Germany

6. *Equal Parallel and Right Angle Elevations*.
1973–83
Hot rolled steel, four elements,
two 35½" x 18'4½" x 6"; two 35½ x 33½ x 6"
Galerie m, Bochum, West Germany

7. *Delineator, II*. 1974–86
Steel, two plates, each 10 x 20' x 1"
Galerie m, Bochum, West Germany

8. *Modern Garden Arc*. 1986
Steel, 12 x 13' x 3"
Leo Castelli Gallery, New York,
and collection the artist

9. *Two Corner Curve*. 1986
Steel, 10 x 60' x 1"
Collection the artist

10. *Two Plate Prop*. 1986
Steel, two plates, 6 x 10' x 2" and 54 x 54 x 2"
Collection the artist

Preliminary plans for exhibition installation,
The Museum of Modern Art, New York, 1986
Engineering drawings by Malcolm Graff
Associates, New York

Photo Credits

Photographs reproduced in this volume have been provided in the majority of cases by the owners or custodians of the works indicated in the captions. The following list, keyed to page or plate number, applies to photographs for which an additional acknowledgment is due. Individual works of art appearing here may be additionally protected by copyright in the United States of America or abroad, and may not be reproduced in any form or medium without the permission of the copyright owners.

Front cover:
© 1985 Susan Swider, New York

Pages:
14: © Gianfranco Gorgoni, New York
21: Courtesy Paula Cooper Gallery, New York
23: top left: Eric Mitchell, Philadelphia
27: top: Malcolm Lubliner Photography, Los Angeles
36: © Gianfranco Gorgoni, New York
40: © Knut Garthe, Düsseldorf
47: top: © 1980 Jon Abbott, New York
47: bottom: Dirk Reinartz, Buxtehude
48: © 1981 Gianfranco Gorgoni, New York
49: © Gianfranco Gorgoni, New York
52: Michael Abramson, New York

Plates:
15: © Shunk-Kender, New York
16: Eric Pollitzer, New York
20: © Harry Shunk, New York
22: © Harry Shunk, New York
25: Gian Sinigaglia, Milan
40: Courtesy National Museum of American Art, Smithsonian Institution, Washington, D.C.
47: Kuwashi Maruyama, Tokyo
55: Malcolm Lubliner Photography, Los Angeles
57: Wolfgang Keseberg
58: The Museum of Modern Art (Mali Olatunji)
59b: © Shunk-Kender, New York
59c, e, f: © Harry Shunk, New York
62: Brad Iverson, Huntington Woods, Michigan
65: © Harry Shunk, New York
69: Gwen Thomas, New York
71b: Claes Oldenburg, New York
74: Gordon Matta-Clark
75: © Tina Girouard
76a: Jim Ball, Seattle
76b: Don Anderson, Bellingham, Washington
76c: Jim Ball, Seattle
77a–f, h: Dieter Schwille, Cologne
78: Babette Mangolte, New York
80: © Reinhard Friedrich, Berlin
83: Dirk Reinartz, Buxtehude
84a–c: © Andreas F. Voegelin, Basel
84d: © Kurt Wyss, Basel
86a: © Cor van Weele, Amsterdam
86b: Dick Wolters, Overzande, Holland
87a–d: © 1981 Gianfranco Gorgoni, New York

88a: © Jon Abbott, New York
88b–c: © 1980 Jon Abbott, New York
89a: Gwen Thomas, New York
89b: © Gianfranco Gorgoni, New York
90a–b: Gwen Thomas, New York
90c: © Gianfranco Gorgoni, New York
90d: © Jon Abbott, New York
91a: Glenn Steigelman, Inc., New York
93a: Glenn Steigelman, Inc., New York
93b: Kim Steele, New York
93c: Robert R. McElroy, New York
93d: Michael Abramson, New York
93e, g: © 1985 Susan Swider, New York
94a–b: Robert Pettus, St. Louis
94c: David Finn and Amy Binder, New York
95: Aurelio Amendola, Pistoia, Italy
96: Rafael S. Lobato, Madrid
97: Hermann Kiessling, Berlin
98: © Douglas M. Parker, Los Angeles
99: Akiyoshi Terashima, Tokyo
101: © Douglas M. Parker, Los Angeles
102: Akiyoshi Terashima, Tokyo
104a, c–e: Dirk Reinartz, Buxtehude
105a, c: Gwen Thomas, New York
105b: Tom Bills, New York
108: David Dufor, Los Angeles
109a: Gerd Geyer, Hattingen
109b: © Kurt Wyss, Basel
110: Otto E. Nelson, New York
111a, c: J. P. Salomon, Courbevoie, France
117: Michael Tropea, Chicago
118: Kevin Brunelle, Pittsburgh